JON LEWIS

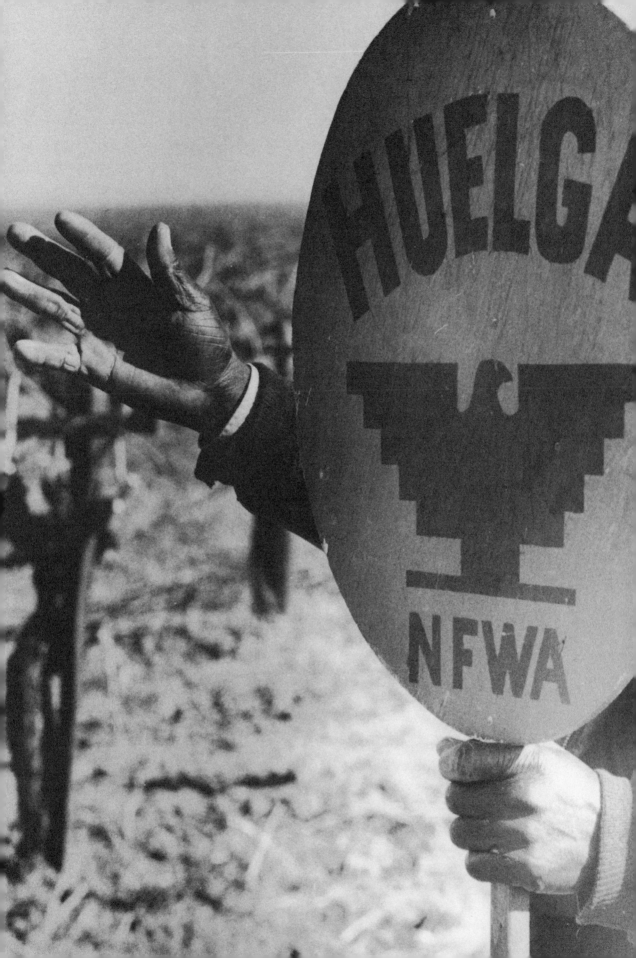

JON LEWIS

PHOTOGRAPHS
of the CALIFORNIA
GRAPE STRIKE

Richard Steven Street

UNIVERSITY OF NEBRASKA PRESS / LINCOLN AND LONDON

An earlier version of this work appeared as "Delano
Diary: The Visual Adventure and Social Documentary
Work of Jon Lewis, Photographer of the Delano,
California, Grape Strike, 1966–70" in *Southern
California Quarterly* 91 (Summer 2009): 191–235.

Library of Congress Cataloging-in-Publication Data
Street, Richard Steven.
Jon Lewis : photographs of the California
Grape Strike / Richard Steven Street.
pages cm
Includes bibliographical references and index.
ISBN 978-0-8032-3048-4 (hardback: alk. paper)
1. Lewis, Jon, 1938–2009. 2. Photojournalists—United
States—Biography. 3. Grape Strike, Calif., 1965–1970—
Pictorial works. I. Lewis, Jon, 1938–2009. II. Title. III.
Title: Photographs of the California Grape Strike.
TR140.L485S77 2013
770.92—dc23 2013017213

Set and designed by Nathan Putens in Minion.

Frontispiece: "The sign obscures the picketer's face,
but perhaps directs attention to the out-thrust hand
pleading for support." Winter 1966.

For Tom McCormick

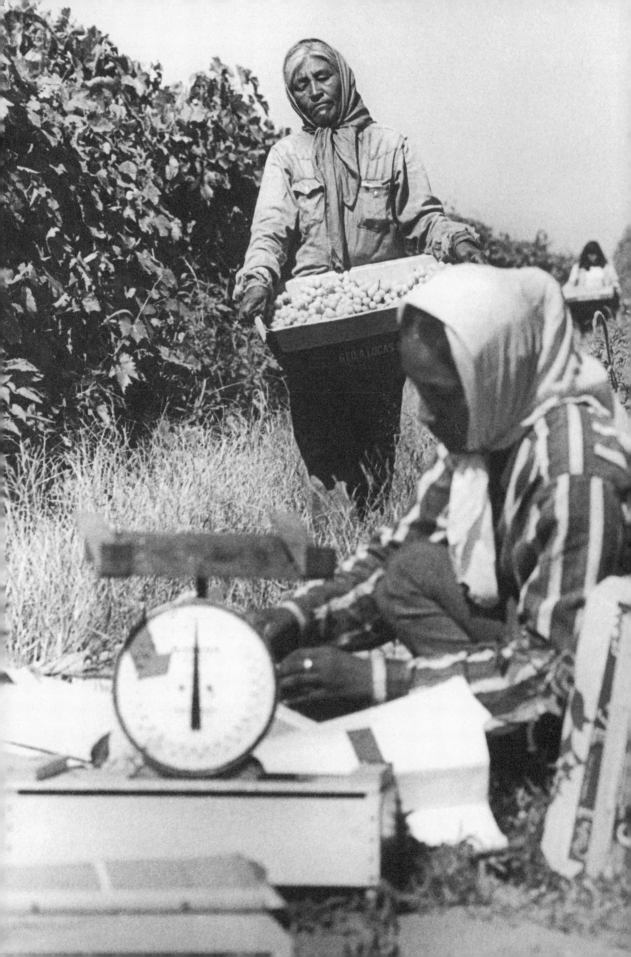

Contents

2. "A very fortunate few minutes when this weathered, compelling face appeared. I hung around that row and got several shots of her that are among my favorites. To make such a life easier and more secure is what it was all about." Winter 1966.

Illustrations

Acknowledgments

My greatest debt is to Jon Lewis. Reluctantly at first, and then enthusiastically, Lewis shared his life and work, and always a pot of coffee and music, in his cramped apartment on Valencia Street in San Francisco's Mission District. The Archibald Hanna Fellowship at Yale University's Beinecke Library allowed me to tap into valuable materials in the Jacques Levy Collection. George Miles, curator of Western Americana in the Beinecke Library, wisely obtained the entire Jon Lewis photo collection. George Ballis, Leroy Chatfield, Gerhard Gscheidle, John Kouns, Nick Pavloff, and Paul Sequeira provided valuable materials, photographs, memories, and beer. Ted Lehman allowed me to use and copy material in the Eugene Nelson papers and collection, which he wisely preserved. Merry Ovnick and the Historical Society of Southern California allowed me to use material that had appeared previously in *Southern California Quarterly*. Stephen Barnett copyedited the book. Angelika Bommer improved every page. I began assembling the study while teaching liberation photography in the James Weldon Johnson Institute for Advanced Interdisciplinary Studies, Emory University. I finished it while at the Tanner Humanities Center, University of Utah, and while serving as Anschutz Distinguished Visiting Fellow, Princeton University.

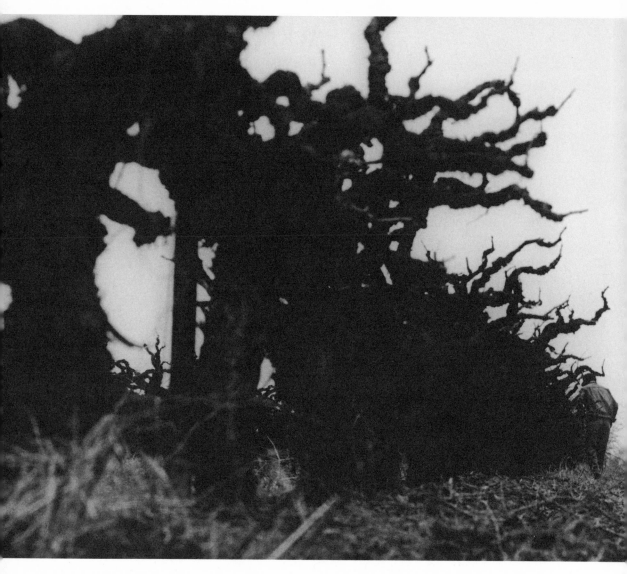

3. "One of two shots of winter pruning where the branches appear menacing and capable of devouring the workers." Winter 1966.

PUBLICATION OF THIS BOOK

IS SUPPORTED BY A GRANT FROM

Jewish Federation of Greater Hartford

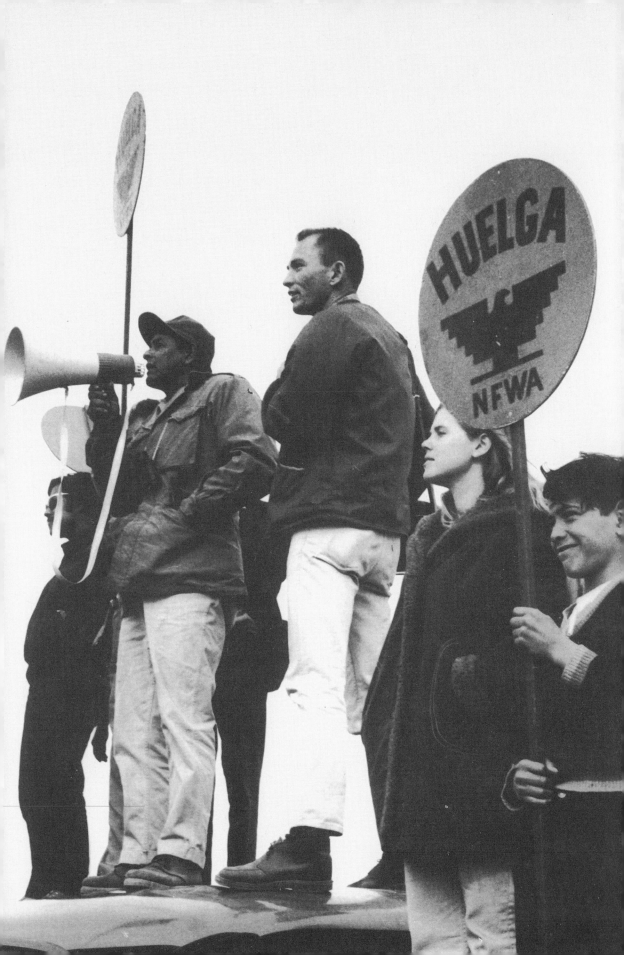

Introduction

Wandering through the agricultural districts of California, I would eventually peel off the old Nikon cameras, scratched and dented everywhere, brass showing on the corners, hot shoe rusted from dripping sweat, one lens hood marking an intercepted kick. I would then grab a meal, chat with the prostitutes, and collapse late at night in the Fresno Three Penny Inn or in the Motel 6 downwind of the stinking Harris Ranch feedlots where Interstate 5 intersects Highway 198. Early in my forays, I discovered places to sleep along the way. Among them was a favorite spot west of Coalinga, tucked behind some large oil storage tanks, and a cul-de-sac west of Salinas, accessed by a hard right turn after crossing the bridge over the Salinas River. Hot, tired, and dirty, I would sponge bath and clean up as best I could, gobble whatever food was available, pop the hatch on my Buick Apollo, toss a tarp over the car, and pass a wary night. Occasionally I shared these spots with equally grungy female photographers who were also using the camera to carry them into the world. I abandoned my camp spots after learning that some had been favorite stalking grounds for serial killers and the sites of numerous gang rapes.

After days on the move, with my stomach growling, afflicted with bad breath, and left knee throbbing from an old blood clot, I would think, What a great life, what fun, who would ever believe it, a scholar gone astray, following sometimes quite literally in the footsteps of Dorothea Lange, the greatest photographer of American farm labor, and Otto and Hansel Mieth Hagel, two Germans on the lam from Nazi Germany, who may have been the most astute visual observers of rural California. Out photographing in the fields, I would sometimes see their very same images appearing in my camera viewfinder, then debate whether to take the same shot,

4. "The photographer in his first week on the picket line in January 1966. Was there already taking shape the notion of not returning to San Francisco at month's end to start graduate school and joining the struggle at \$5 a week? Preposterous. Banish the thought. John Kouns shot the picture." Winter 1966.

only in color. At first I passed them up, regarding such images as a kind of visual plagiarism. Eventually I began recording them as evidence of how much things had or had not changed three-quarters of a century later, and the extent to which my thinking and experiences frequently paralleled those of my predecessors.[1]

The book in hand presents the work of one predecessor, Jon Lewis, who photographed the Delano, California, grape strike and farmworker movement from 1966 to 1970. Everything about Jon Lewis and what he did, why he did it, and how, is honorable and heroic. Here is a former Marine, on his way to a graduate degree in photojournalism at San Francisco State University, who put professional aspirations on hold and moved to Delano, "the armpit of the San Joaquin Valley," in January 1966. Lewis photographed twenty-four hours a day through the fall of 1967, and then on and off again until July 29, 1970, when the United Farm Workers Organizing Committee (UFWOC) signed contracts with the entire California table grape industry.

During these years, Jon Lewis lived a remarkable visual adventure. He discovered his calling as a photographer. He submerged in the grape strike and boycott. He fought through professional isolation and personal loneliness to produce an extraordinarily intimate and comprehensive photographic record not only of César Chávez but also of field hands, activists, clergy, nuns, radicals, Mexicans, Anglos, Filipinos, politicians, actors, and professional activists who forged the modern farmworker movement. Although photographers had been photographing farmworkers for a half-century, Lewis was the first to document completely a farm labor strike.

As a guide, Jon Lewis is a powerfully enervating and instructive presence. He frames scenes simply and with wisdom. A fly-on-the wall presence, he refuses to intrude. Yet he captures solid, substantial images that hit between the eyes, punch the gut, stab through the heart, and prove the old dictum: If your images are weak, you are too far away from your subject.

At Delano, Lewis interrogated the inequalities of an economic system and celebrated the triumph of the human spirit. Looking at his work one finds themes of faith, courage, sacrifice, and solidarity alongside danger, hunger, poverty, injustice, and intimidation — reminders of the depth of his commitment in the fight against complacency that is part of the struggle for democratic reform around the world. Tedium and excitement stand side by side with drama and quiet moments as Lewis at times wavers between catastrophe and accomplishment, starvation and scrounging for film.[2]

Like most members of the farmworker movement, Lewis was highly motivated. Because he was motivated, he never lost his concentration. No cowboy photographer riding in for a few snaps, he was there for the duration. Lewis loved what he did and remained creative, enthusiastic, and persistent. He mastered his tools and his

craft. He took risks. He personified the type of strategically resourceful people who form the backbone of humanistic photography — those who fulfill what Rudyard Kipling once said of other great, accomplishing personalities:

> From time to time
> God causes men to be born . . .
> who have the lust to . . .
> risk their lives and discover news . . .
> these souls are very few;
> and of these few,
> not more than three are the best."[3]

Lewis gained nothing from his effort. A stoic, surrounded by memories of the Delano grape strike, he enjoyed simple pleasures like strong coffee and a morning newspaper, watching the San Francisco 49ers with grape strike photographers John Kouns and Gerhard Gscheidle, and an evening beer while listening to Joan Baez sing "De Colores" or Lalo Guerrero singing "El Corrido de Delano" on a scratchy old vinyl record. Lewis never owned a car, never married, and had few friends (most of them dating back to his days in Delano). He received little payment for hundreds of photographs used by newspapers, magazines, and book publishers around the world. In his declining years, he grew increasingly frustrated at his inability to publish the project that defined him an artist and as a human being.[4]

On the afternoon of December 20, 2009, Lewis collapsed while picking up his mail. He died on the steps of his San Francisco flat. No obituary appeared in the *San Francisco Chronicle*. A single farmworker website noted his death.[5]

Lewis deserves better. He should have been awarded fat fellowships and grants. He should have been profiled in *American Photographer*, *Aperture*, *California Magazine*, *Popular Photography*, *News Photographer*, the *San Francisco Chronicle*, and any of a dozen other publications. He should have held an endowed chair as a photography professor. He should have been on the faculty at a major West Coast university. He should have been an invited speaker at photographic gatherings. His prints should have been displayed in museums and galleries and been made widely available to the public in catalogs. His innovative eleven-minute 16-millimeter Spanish language film *Nosotros Venceremos* (We Shall Overcome) should have been hailed as a pioneering work of activist filmmaking. His single-handed, self-financed efforts to publicize and publish his work should have reached the audience they deserved. His name should stand alongside those of other brave civil rights photographers. Perhaps one day those photographers who knew him will unite with surviving union volunteers to scatter his ashes around the grave site of César Chávez, to whom Lewis

was ever-loyal, or better, in the dust near Forty Acres, California, where Lewis threw himself into the task of constructing a farmworker movement from the ground up.[6]

Jon Lewis is one of those talented members of the photographic profession whom historian Michael Lesy describes as "accomplished but not celebrated . . . people who persisted in their vision." But you will not encounter a single image by Jon Lewis in general and regional accounts of photography. Nor will you find his name in the index to any photographic history. While studies of the Delano grape strike use his images, mostly without attribution or payment, none describe his role as volunteer, activist, picket, and publicist. Although the persuasive and protective power of civil rights photography has been recognized, no one has mentioned the role that Lewis played in helping to dismantle oppression, overcome journalistic and photojournalistic neglect, and open the public's eyes to injustice. How tragic that forty years passed and Jon Lewis had been cremated before we began to appreciate the full story of this tenacious and remarkable photographer.[7]

I want to know how someone possessing an inquisitive nature and adventurous personality merged artistic impulse and strong politics while working under pressure in austere, hostile, uncertain, hothouse circumstances. I want to know what Lewis had to overcome, the choices that he made, and why. I am less interested in an art talk reading of his images than I am in probing the nuts and bolts of how he went about his business. Watching him make decisions, select images, choose vantage points, and develop a larger, sequenced narrative, we gain insight into the way an inquiring mind grapples with a significant human question, even while we are transported through a pivotal moment in history and meet face to face its principal characters.[8]

Jon Lewis picked up a camera at a critical juncture in his life and in the life of a social movement. He did so the same way others married or became lawyers, teachers, mothers, and fathers. He did not become a photographer because he calculated that it would make him rich or famous. He was not an academic casting about for a subject. He was not riding the backs of the poor in order to make a name for himself. He was certainly not trying to create art. Nor was he sublimating pain or trying to advance the class struggle. Explaining that Lewis was motivated by some burning inner drive doesn't get us far. There is always a mystery to such people, the same creative mystery residing deep within every living soul.

By understanding why Lewis clung to his goals and never lost hope we may begin to comprehend much more than the forgotten portfolio of an unappreciated artist and forgotten documentarian. As we splinter, compartmentalize, and withdraw into professional tribes, we all need to know — especially on the down side of life as we face the inevitability of demise — that we can benefit from reaching out, learning from each other's experiences, and extracting whatever encouragement and lessons

apply. "This," explains Harvard University literature professor Walter Jackson Bate, "is what biography can do for us as nothing else can."[9]

More than anything else, Lewis exemplifies a mastery of that unique and powerful way of seeing that has shaped so much of the visual culture in the twentieth century and has so many great names associated with it. Scholars have never been very comfortable with definitions of social documentary photography. Terms such as "historical" and "factual" have been considered and tossed aside as too cold and unconcerned with the magical power of photography to keep people looking again and again.

The debate over what is and is not social documentary photography has ebbed and flowed for over three-quarters of a century. Social documentary photography is a radically democratic genre. No, it is something only a few know how to practice. Social documentary photography dignifies the unusual. No, it levels the ordinary. Social documentary photography praises the common man. No, it ridicules the high and mighty. Social documentary photography makes the unremarkable remarkable. No, it makes remarkable the unremarkable. Social documentary photography explores what is unique and newsworthy. No, it focuses on the ordinary and meaningful. Social documentary photography is proletarian. No, it has no particular political bias. Social documentary photography is special. No, it pervades the culture. Social documentary photography is compelling, persuading truth. No, it is subjective, biased propaganda. Social documentary photography has been changing over the past eighty years, and there is no standard model. No, social documentary photography has always been about slicing a decisive moment from the larger narrative in the service of deeper understanding. Social documentary photography is the antithesis of art photography. No, the aims of documentary and art need not get in one another's way. And so it goes.

About all that anyone can agree on is that a good social documentary photographer is concerned mainly with conveying messages and telling stories, usually centered on the less fortunate; that such photography should originate in reality, not one's own inner creativity; and that it is akin to being an eye witness. A good social documentary photographer does not set out to create art, although art might and often does result from the effort.

For all the haggling over definitions, we know good social documentary photography when we see it. In the work of Jon Lewis we see a positive exemplar, performed on the deepest level, with a rigorous attitude of engagement rarely found in an increasingly narcissistic society. We feel the immediacy of photo-reportage, the way it concentrates, condenses, and explains. It is as if with the click of the shutter the fog of time dissipates and we are watching history unfold. Here is the camera being

used as a potent and radical tool of compassionate inquiry. Here is a photographer deploying his talents to compose images that raise complex issues, gash out emotions, grapple with universal themes, and record enduring human qualities.

Jon Lewis reminds us that today most of the world's goods are produced by the same family of second-class citizens engaged in large-scale, unmechanized manual labor. He makes clear — as no photographer before or since — the tenuous, spur-of-the moment nature of a movement squeaking by through wit and persistence. Perhaps his "Salt of the Earth" exploration will someday gain him entry into the pantheon of great California photographers. Perhaps someday he will be recognized as one of the most important activists who converged on the small San Joaquin Valley farm town of Delano. Perhaps he will eventually be recognized for his role shaping the cultural blueprint of life in the Golden State. Perhaps he will even achieve his place in the story of the farm labor movement. Perhaps upon seeing his work curators and historians will cease recycling the same tired, iconic figures and begin rooting about in search of those other truly accomplished photographers who have remained unappreciated.

To understand what Jon Lewis accomplished, I have broken with standard academic approaches. Rather than fitting Lewis into "the literature," I let the reader encounter him as he embarked on the adventure of his lifetime. Rather than a straight, sequential narrative deploying blocks of images displayed one per page in a kind of disembodied, museum wall exhibition, I remained loyal to the unusual, asymmetrical, sequence that Lewis first proposed. Merging words and images, *Jon Lewis* is simultaneously an extended, multiyear photo essay on the farmworker movement during its formative phase; a succinct history of the Delano grape strike and boycott; a study of a visual activist who threw mind, body, and soul into La Causa; and the fifth in a multivolume and ever-expanding narrative of California farmworkers from their origins into the present.[10]

Enlarged sections of contact sheets help reveal the way Lewis worked through his encounters — how he first viewed them and proceeded to evaluate, select, compose, and crop before moving on to the next subject. Captions written by Lewis on the back of work prints shortly before his death add meaning to his images and provide insight into his thinking (the captions were edited for consistency and clarity). When necessary, I follow his recollections with supplemental information. My goal is not just to illustrate. By comingling words and images, *Jon Lewis* traverses a pivotal but underappreciated phase in the civil rights struggle to reveal the ad-lib nature of a movement that has always existed on the edge of failure.[11]

For those of us who remember from personal experience the scenes Lewis captured, a book like this can hone old memories drawn from some of the most challenging

moments of our existence. For those of us who study the past and try to learn from it, a story such as this confirms the huge changes that have taken place in farm labor relations. The birth and survival of the United Farm Workers union (UFW); laws requiring toilets and cool, clean drinking water in the fields; the end of *el cortido*, the short-handled hoe, a back-breaking tool which required field hands to stoop over in the shape of a question mark while waddling down furrows; and the passage of legislation extending social security, worker's compensation, and collective bargaining rights to farmworkers — all had their origins in the events captured by Jon Lewis.

Lewis would be the first to say that problems remain. Racism, poverty, and ignorance threaten to undermine the farmworker movement. Waves of first-generation undocumented immigrant workers continue to pour into the fields. Farmworkers today remain an unacknowledged American peasantry. Unaware that there was, and is, an alternate path, many young undocumented farmworkers are likely to identify César Chávez as a champion Mexican boxer, not a famous Chicano leader.

Through the lens of Jon Lewis, we revisit a more hopeful time. There is Chávez, hair falling carelessly across his forehead, wearing a plaid shirt, in a room full of farmworkers. Lewis captured all of the early movement leaders, from Dolores Huerta silhouetted at dawn as she shouts to strikebreakers through a bullhorn to Luís Valdéz mocking growers at a performance of El Teatro Campesino (The Farm Workers Theater). Whether he is documenting Filipinos packing their bags after being evicted from a labor camp and field hands jammed into the union hall at the end of a hard day on the picket lines or union members marching north beside Highway 99 toward a mass rally of ten thousand people spilling into the State Capitol on Easter Sunday, 1966, Lewis is on the spot getting the picture.

Jon Lewis chose loyalty and integrity over fame and money. He threw himself into a cause, took a chance, and discovered his vision. He embodies the key qualities that all great photographers possess — patience, passion, persistence, and empathy — and that provide the motif for stepping forth into the world and making sense of it. At a time when the image-saturating power of television and digital technology undermines the veracity of documentary images and dilutes universalist and communitarian ideals, Jon Lewis adhered to the hard, solitary, idealistic strain of still photography. During an era when so many other photographers narrowed their field of vision to their own personal concerns and large-circulation magazines tipped in favor of celebrity pictures and sanitized, sentimentalized, lifestyle, consumerist fantasies, Lewis maintained a focus on social justice and human values. By understanding what he did, we can begin to see not only a curious mind struggling to survive but also a quiet hero who, like so many great, accomplishing personalities, died long before his work was done and his full story could be appreciated.[12]

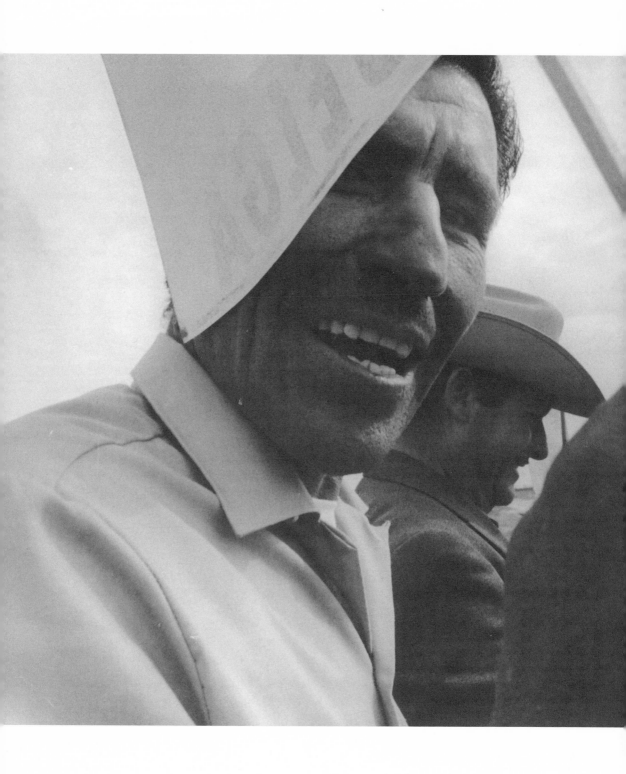

1. Epicenter

Derelict buildings dissolve into a dusty clutter of weeds and beer cans patrolled by scruffy dogs near the intersection of Garces Highway and Mettler Road on the west side of Delano, in California's San Joaquin Valley.

Peach and nectarine blossoms drift out of the orchards each spring, piling up in clumps, lodging in crevices, snagging on every protrusion, sprinkling color in an otherwise drab landscape. A smoky haze of burning trash and decaying garbage from the dump a few miles west lingers in the morning air. A red sun topping the Sierra Nevada to the east splits into a fan of golden rays that town chambers of commerce depict on their welcome signs and official insignia. Just across the highway, an old Voice of America transmitter once broadcast to blighted countries around the world.

We are in the heart of the heartland, in the center of the most productive agricultural system on the planet, surrounded by vineyards. Delano is the vintage location for table grape production.

Before dawn, highways fill with vans, trucks, and cars packed with field hands heading out to work. A passing labor bus stops to pick up a clump of farmworkers on a roadside demarked by stacks of yellow and red picnic coolers. As they load, a man balancing Styrofoam cups of coffee and foil-wrapped burritos hustles onboard from "El Taco Tren" (The Taco Train) parked

5. "From the march to dedicate the Forty Acres a year after La Peregrinación. I was well enough known by this time to not hesitate shoving a camera in someone's face." Spring 1967.

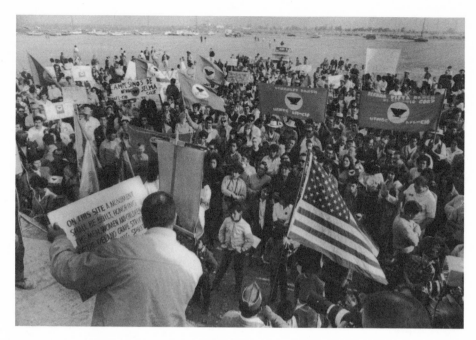

6. "I remember those long, hot days digging the oil-changing pit for the gas station [at Forty Acres] and making thousands of adobe bricks. A beer at the end of the day was our reward." Spring 1967.

on the edge of an orchard. As the bus pulls out, a tractor towing a micro-mist spray rig chugs to a stop, shuts off the flow of mildewicide, then makes a U-turn on the highway before ducking down the next row. For decades the farmworker movement would raise hell about pesticides and the soup of chemicals applied to the fields, orchards, and vineyards, pointing to armless, legless, and otherwise maimed clusters of children in nearby Earlimart and McFarland as their poster children.

Once upon a time, someone erected a sign here. People made speeches. Trees were planted. A pasture was established and several head of cattle set to grazing. The place was called Forty Acres.

Jon Lewis photographed the sign: "ON THIS SITE A MONUMENT SHALL BE BUILT, HONORING THE MEN, WOMEN, AND CHILDREN OF THE DELANO GRAPE STRIKE AND THE ENDURING SPIRIT WITH WHICH THEY DEFENDED THEIR FARM WORKERS UNION."[1]

The sign disappeared. For a generation there was no monument. No plaque. No posters. No flags. No fruit trees. No pasture. No highway directions led you here. Hard to imagine this place as the epicenter of a West Coast revolution, where César Chávez, Dolores Huerta, and a small band of Mexicans, Filipinos, and Anglo volunteers challenged the rural power structure and established the headquarters of the National Farm Workers Association (NFWA).

For many years, if you asked about Chávez, the NFWA, and the cinderblock buildings, tin-roofed sheds, and derelict adobe gas station, all you got from the clerk at the Delano Chamber of Commerce was a blank stare and a booklet larded with statistics about new homes and planned shopping centers. A clue was found in the faded words, barely visible, identifying one building as the Rodrigo (Roger) Terronez Memorial Clinic. It was the first medical clinic dedicated to the needs of California farmworkers, named after a twenty-eight-year-old immigrant and farmworker union leader. Another building once served as a hiring hall — the first farmworker union hiring hall — where the farmworker union dispatched workers to jobs throughout the Valley. A single-story building with long corridors and doors every fifteen feet suggested that the tile-roofed cinderblock structure had once been a motel. But names and numbers beside each door recalled a day when it had been called the Paulo Agbayoni Retirement Village. In the compound, sixty Filipino American farmworkers, too old to prune and pick grapes, lived out their final days.

In the late 1970s, I encountered some of those old Filipinos doing their laundry and spreading their clothes to dry on the nearby bushes. In their latter years, they had few visitors and seldom spoke even among themselves. They were the last of some thirty thousand unmarried Filipino American men who had spent their entire lives working in the vineyards. Recruited as young men, they had been forbidden by California's anti-miscegenation laws to marry outside their race. When they were evicted from their labor camps early in the Delano grape strike, they had no place to live.

The old Filipinos were long gone by February, 21, 2011, when United States Department of Interior Secretary Ken Salazar officially designated Forty Acres as a National Historical Landmark, one of about twenty-five hundred such markers identifying places of exceptional historical value. It was a joyous occasion, attended by eight hundred schoolchildren and teachers and scores of union supporters. Old farmworker activists gave speeches, mariachi bands played, and Delano High School dancers danced. During one of the speeches, Richard Chávez recalled a moment years earlier when he had wondered about the consequences of his brother's passion. "He's nonviolent and all that," Richard told one union member. "But he's going to kill us."[2]

In 1967, a year after leading a great pilgrimage to Sacramento, César Chávez scrounged up $2,500 to purchase the dusty lot on Garces Highway. He named it Quarenta Acres, "Forty Acres," a reference to the small Arizona farm his family had lost during the Great Depression, and announced that his struggling union would build a cooperative farm, a model for the future, and a national headquarters. Inside

brown adobe walls, beneath roofs of red tile, sunshine and laughter would fill the corridors, and the farmworker movement would blossom.

For several years Chávez had an office in the northeast corner of one building. His wife ran a credit union, LeRoy Chatfield operated a health and welfare program, Larry Itliong looked after Filipino American farmworkers from offices just down the hall, and union staff members gathered in a $50,000 administrative building dedicated to the memory of United Auto Workers union leader Roy Reuther.[3]

Although the United Farm Workers union (UFWOC), successor to the NFWA, has moved its headquarters to La Paz, in the Tehachapi Mountains, thirty miles south of Bakersfield, Forty Acres retains its status as the California equivalent to what Selma, Alabama, is to the African American civil rights cause. Chávez began a fast here on February 15, 1968. Twenty-five days later he left his room in the old gas station to receive Holy Communion with Robert F. Kennedy before four thousand farmworkers in a much-photographed scene in Delano Park. On July 29, 1970, Chávez and the leadership of UFWOC gathered here inside Roy Reuther Hall to sign the first union contracts with California growers. Jesse Jackson was here on August 21, 1988, when Chávez ended a thirty-six-day fast, the last of his many death-defying fasts in the most photographed event in farmworker history. On April 23, 1993, a week after Chávez died, ten thousand farmworkers and supporters marched behind a plain pine coffin in a three-mile-long procession through the streets of Delano to a resting place at Forty Acres.[4]

7. "A year after La Peregrinación we dedicated Forty Acres, which the union had just acquired on the outskirts of town [Delano] and on which the union would build its headquarters. The thunderbird banner once again was backdrop on a flatbed truck, while César [Chávez] sported the white Filipino wedding shirt he wore on special occasions." Spring 1967.

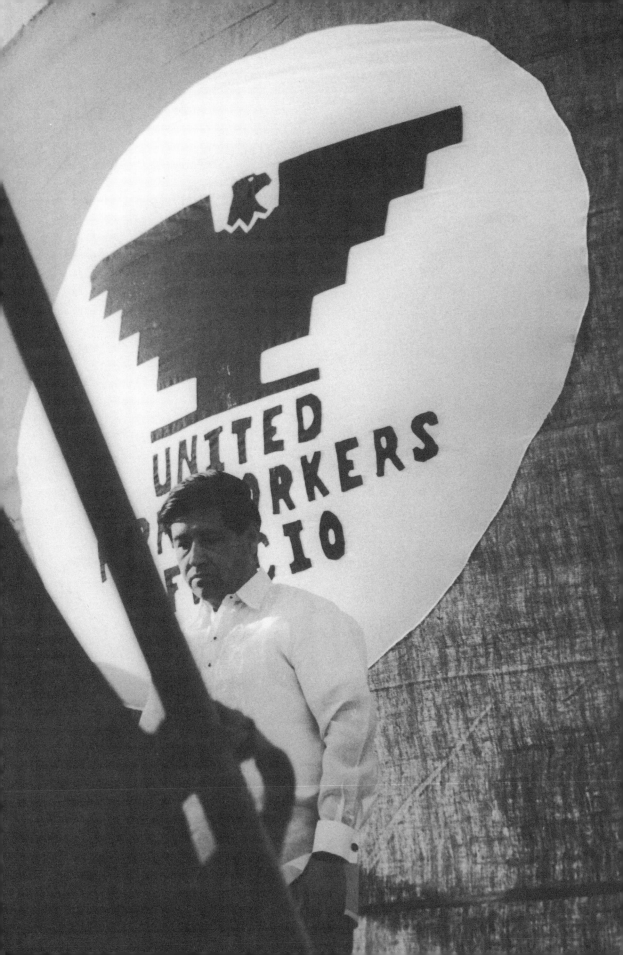

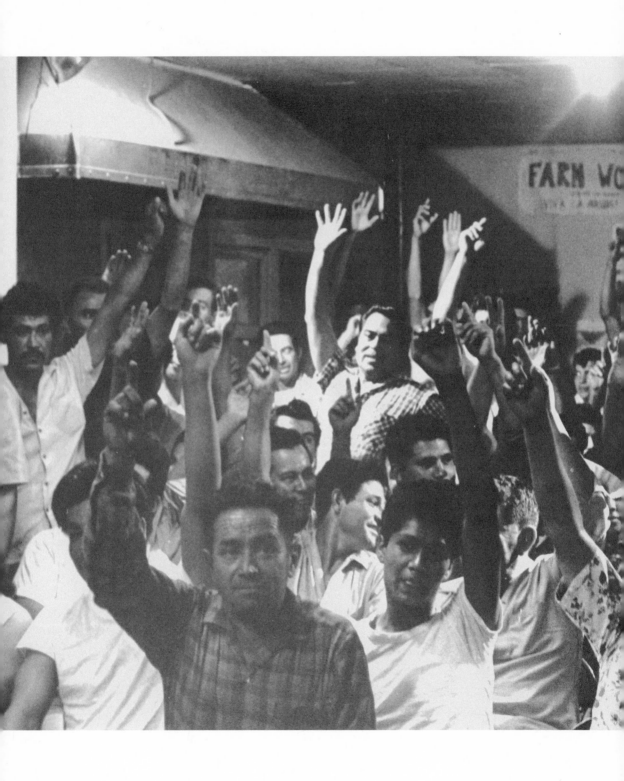

2. Memory

For more than a half-century, history and memory have fought alternately to wipe away and sustain a picture of what happened at Forty Acres, Delano, and in the surrounding vineyards. The landscape is the same. Huge blocks of red, green, and black table grapes hang as heavy reminders of the army of humanity required to pick, pack, and tend the table grape crop. But the memory of what happened in those vineyards from 1965 to 1970 is not synonymous with the history of those events.

Farmworker history is in fact the enemy of memory. Memory is a living thing that survives in the minds of still-living humans and cannot be extracted without morphing into something else. Memory constantly rearranges the past to make sense of the present. You quickly realize this over coffee in the café at the Stardust Motel, near Cecil Avenue and Highway 99, where Peter Matthiessen lived while writing *Sal Si Puedes*, his account of the farmworker movement, and where farmworkers negotiated with agribusinesssmen. Here you might bump into a few surviving policemen and elected officials, long retired, perhaps a grape grower or two, who will spit out their version of what happened in Delano and the surrounding vineyards.[1]

You can still see Slavonian Hall, a plain, auditorium-sized building surrounded by a cyclone fence topped in barbed wire,

8. "It was always an adventure shooting a group of people indoors. Unless I was lugging the strobe along, most frames were fuzzy and underexposed. This is one of the few such acceptable shots, but I don't recall where it was or what occasion. But you take what you can get and get what you take." Winter 1966.

where the growers — still mostly Slavs — belly up to a bar and cook steaks over an outdoor charcoal grill. An evening there can be as down home as any family gathering. Open bar. Fruit bowls on folding banquet tables. Balding, stocky men in T-shirts and khakis. Goodies from National Market, not Vons, whose managers will never be forgiven for supporting the table grape boycott. Curses and accusations as old growers relate bitter stories about fighting the farmworker union. "God-damned Chávez. That strike was a sham. Our grape pickers are the best-paid farmworkers in America!" Uproarious laughter after a bartender takes the floor, asks what's the difference between herpes and AIDS, and explains that herpes is a love story, but AIDS is a fairy tale! Good times at the Slavonian Hall.

After enduring an evening of such jokes, the travel writer Bill Baruch left with a sickly feeling reminiscent of mindless high school locker room banter. "With a sinking heart," he wrote, "I understood that the distance between the Slavonian Hall and Ward 5A [the AIDS ward] at San Francisco General Hospital was so imponderable at the moment that only a stoop laborer might know how to calculate it."[2]

Different stories unfold over at Filipino Hall, at the intersection of Cecil and Glenwood Streets, near the Elks Club, originally built to honor veterans of foreign wars, and inside People's Bar, on the west side of town, a favorite watering hole on the wrong side of the railroad tracks. Each still stands. Each serves as an incubator of recollections. Each became a gathering place where one could talk revolution and philosophy. During various functions at Filipino Hall you can still find old *abuelos* and *abuelas*, index finger pressed to lips, telling their grandchildren:

Sh-u-u-u-u! Sh-u-u-u-u!
Silencio! Niños.
Listen. Escuchame.
A story of the grape conflict. About your grandfather
and what he did in the Huelga . . ."[3]

A trip to the library uncovers shelves filled with books on farm labor relations and the grape boycott. But an afternoon spent perusing these dry tracts leaves you asking for human details. Where, exactly, did Luís Valdéz and Augustín "Augi" Lira compose those ribald skits and hauntingly funny songs that El Teatro Campesino performed on the picket lines and at that first Friday evening rally on September 24, 1965? What was the scene along Main Street when hundreds of farmworkers preparing to march 280 miles north to Sacramento squared off with the Delano Chief of Police on March 14, 1966? What sense of desperation and anger inspired 117 families and 75 single men to walk out of the vineyards and live on $5 a week in strike benefits while they picketed, boycotted, and organized?

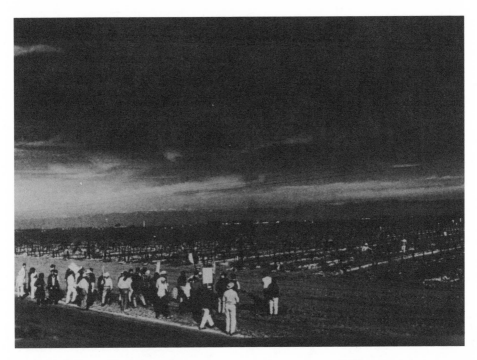

9. "I would later shimmy up a few phone poles on the march, but here there was fortunately one of those circular cement water sumps some eight to ten feet tall with a wooden ladder leaning against it. It was precarious perch but I got off four to five frames with a unique perspective." Winter 1966.

History takes us only so far into a saga that exists in a dramatic netherworld of class and ethnic conflict. Union newspapers and journalistic exposés, official documents and government investigations, eyewitness accounts and biographies — including accounts that until recently have been locked away — exert a profound impact, even as we rush to collect them before the time arrives when all those who participated in the Delano grape strike are dead.[4]

To create images bridging the gap between hagiography and revisionism, Jon Lewis paid a terrible price. When he died, Lewis was living on social security and a tiny pension in a rent-controlled apartment on Valencia Street in San Francisco. He was broke and desperate. Every museum and library in California had ignored or rejected his efforts to find a home for his photography. The Smithsonian Institution, Huntington Library, and Denver Public Library all passed on his work. Bonhams refused to appraise it. Curators failed to reply to his letters or to the letters of those writing on his behalf. Perhaps most galling of all, the Center for Creative Photography dismissed his work as "not in the creative mold," even though his intrepid, angst-driven coverage of the Delano grape strike was one of the most important photographic projects of the civil rights era.[5]

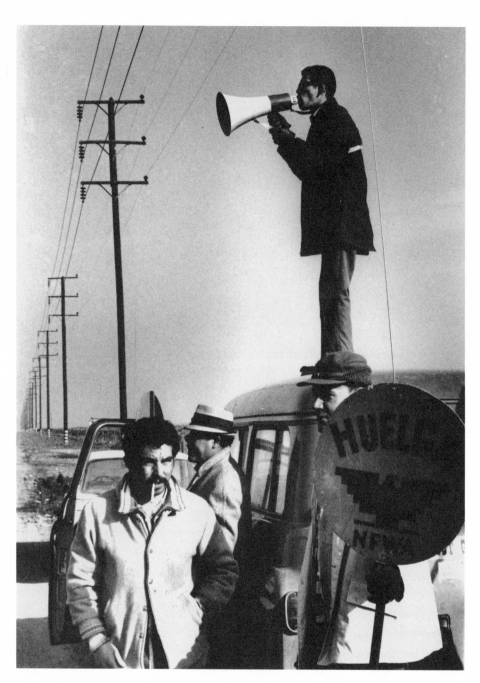

10. "Our green van was put to many uses, including as a platform affording a better view of the fields. No matter how distant the field, there always seemed to be telephone poles and overhead wires to add a little perspective to the scene." Winter 1966.

After leaving Delano, Lewis drifted between cheap apartments in the seamier sections of San Francisco. He avoided the darkroom. He stored his photographs under less-than-ideal archival conditions. Some went up in flames when a fire destroyed the garage in which he stored many large, matted, dry-mounted master prints. Some were borrowed by reputable people who promised payment and publication but did neither. Hundreds of publications used his photographs, as did scholars, without attribution or payment, while he struggled to keep a roof over his head and food on the table. For many years he feared that his work would meet the fate of so many other photographic collections — thrown out after his death by whoever purchased or inherited them.[6]

And then, redemption. George Miles, curator of Western History at Yale University's Beinecke Library, stepped forward and purchased all of the negatives that Lewis made at Delano, along with uncounted hundreds of vintage prints. Suddenly lifted out of poverty, Lewis threw himself into the task of editing and printing images that he had not touched in forty years.[7]

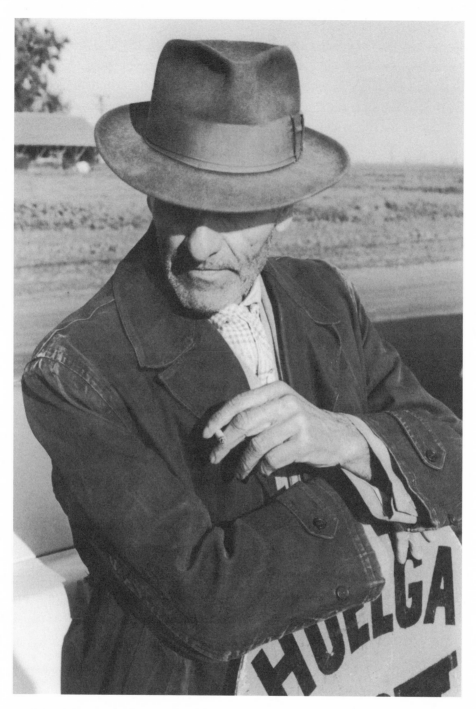

11. "This dapper gentleman was on the picket line only once, as far as I can recall. He looks like an 'Okie' immigrant might have during the 1930s depression." Winter 1966.

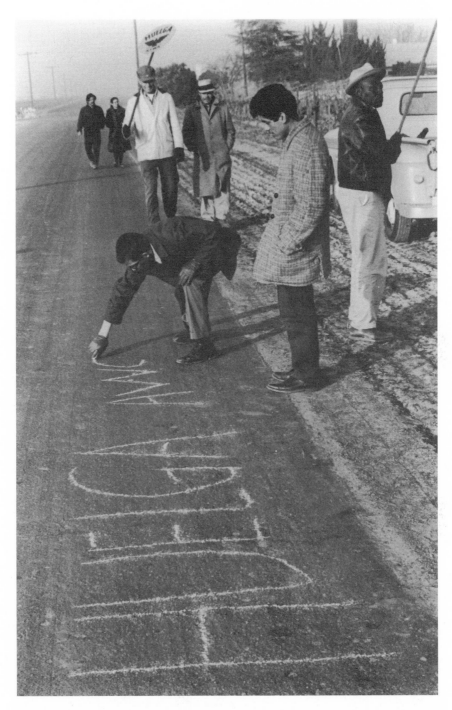

12. "Rain would soon wash away the chalked 'Huelga,' but it wasn't visible from the fields anyway. A latter-day version of 'Kilroy was here.' One of the first pictures I made after arriving in Delano." Winter 1966.

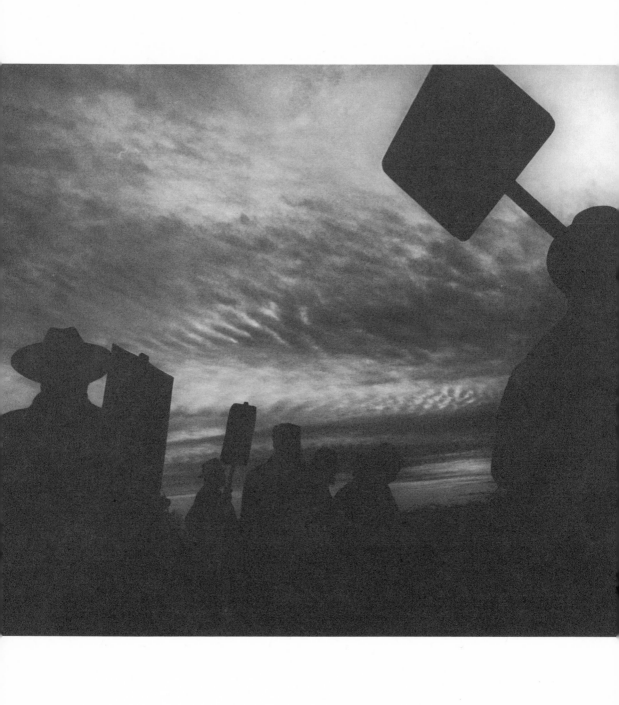

3. Predecessors

A few years into the loneliest and most reclusive part of his life, I met Jon Lewis in a bar sandwiched between strip joints and sex shops in the North Beach section of San Francisco. The way this happened is a saga that seemed to morph logically as an extension of my scholarship and finally culminated in friendship with a kindred spirit whose path I had traced and continued to retrace in my own photographic perambulations.

Although I trained as an academic historian, for many years I had roamed widely through the hinterlands as a commercial photographer shooting for chemical companies, corporate farmers, advertising agencies, farm magazines, water agencies, and immigrant advocacy groups, mostly in California but as far north as British Columbia and south into Mexico, with off-season sojourns to Haiti and other developing countries. During this time I used the travel opportunities and expense accounts from my assignments to conduct a research project aimed at producing a comprehensive multivolume history of California farmworkers, 1769 to the present. Eventually I planned to return to the academic life so long-delayed with the idea of teaching from the standpoint of someone who had practiced what he preached and who had witnessed, recorded, and participated in the contemporary side of the story.[1]

13. "I never did get really sharp images of the picket line at daybreak, but the sky was more interesting than at midday. Not having a tripod I never did attempt anything by moonlight at midnight. Could have been the best of the lot." Spring 1966.

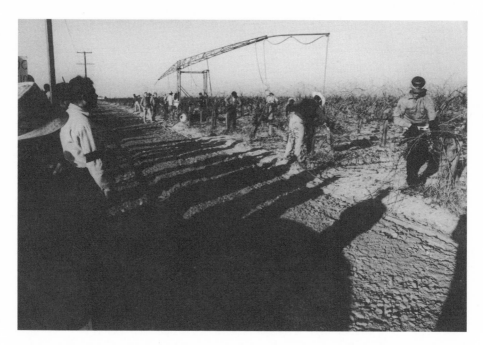

14. "You don't see much of the picket line, but once again shadows carry the day. The contraption in the fields is a pneumatic pruning machine, which uses compressed air to power the pruning shears. It could be considered a labor-saving device, but this is the only time I ever saw it." Winter 1966.

As I went about my business, I developed an intense curiosity about my predecessors. Since the Gold Rush, photographers had been fascinated by the agricultural environment: its threshing machines, symmetrical fields, irrigation canals, state fairs, pyramids of peaches, and trees so heavy with fruit that limbs bent to the breaking point. I wanted to know why others focused on farmworkers, on people who were radically different from themselves. I wanted to learn about the sources of their inspiration, the evolution of their ideas, the nature of the problems they encountered, and above all, how they photographed in the fields, what they accomplished, and whether they made a difference.[2]

I was surprised to discover that while photographers had been documenting farmworkers since the early 1850s, they seldom did so with a critical eye. Constrained by their cumbersome daguerreotype and glass plate equipment and employed almost entirely by commercial interests, they mostly hyped the agricultural industry, recording farmworkers mainly as elements of scale in a landscape, props beside the latest piece of equipment, or decorations in an impressive harvest. Their images, while valuable as artifacts, lack the quality that art historian Paul Von Blum calls an "attitude of engagement."[3]

Concern for farmworkers as human beings developed relatively recently. It did not take root until midway through the Great Depression, when Dorothea Lange and other Farm Security Administration (FSA) photographers pushed aside older, less-engaged approaches and directed to farmworkers and other migrants a form of humanistic, socially oriented documentary photography. Holding up a mirror to society by focusing on painful facts and little-known people in the hope of making beneficial changes, social documentary photography coalesced as the primary method of visual enquiry into the lives of California farmworkers, as well as becoming an influential subdiscipline of visual enquiry picking at the social wounds and fissures of society.

More than style and tradition impeded a realistic engagement with life and labor in the fields. Composing pictures through large, bulky view cameras that recorded images on heavy glass-plate negatives, photographers found it difficult to capture motion or to work spontaneously. But even if photographers had been able to break free of such constraints, where was the market for anything other than static, laudatory views? Portrayed (with few exceptions) less as living, breathing human beings than as figures cut from cardboard, California farmworkers as late as the beginning of the twentieth century remained untouched by photographic trends outside the state, where older Victorian concepts were beginning to link up with newer reform attitudes to produce a new way of photographing. At a time when California was moving to the forefront of the Progressive movement and the state legislature was enacting an unprecedented set of laws designed to humanize the work environment and protect labor, Progressive Era photographers had little to say, in words or in pictures, about the various issues they encountered in the countryside. Failing to see the camera as a mechanism either for exposing painful social realities or for righting wrongs, photographers in California did not attempt to inspire change or promote a more democratic and egalitarian farm labor system, nor did they confront farmworkers themselves, explore the lives they led, identify the challenges they faced, or delineate the obstacles they had to overcome. Even when bloody strikes erupted in the state's valleys and the California Commission of Immigration and Housing investigated atrocious living conditions, photographers remained peripheral to the process. None ever explored farm labor on their own initiative or seemed to have been inspired to apply a variant of the candid street photography used by Arnold Genthe in San Francisco's Chinatown.

Well into World War I, photographers continued to churn out generic, Chamber of Commerce–style images portraying the countryside as free of poverty, conflict, and hard labor. Even as tens of thousands of Mexicans arrived, photographers failed to explore in even a superficial way the triumphs, challenges, and hardships

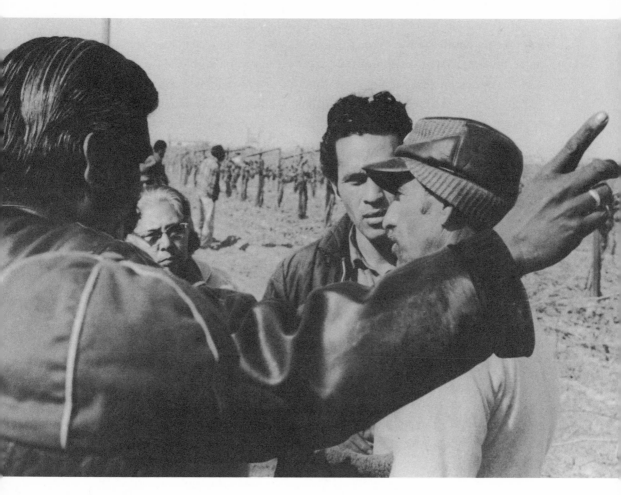

15. "Talking to a strikebreaker up close and personal, without need of the bullhorn." Winter 1966.

of their journey, the reasons why they came north, the places that they settled, and their various adaptive responses, including their role as the first field hands to work in permanent family units and the first to adopt the automobile en masse. During World War II this orientation dissipated but did not disappear. Over the next twenty years, a handful of remarkably talented photographers applied documentary techniques to the challenge of photographing California farmworkers. Amplifying and in many cases going far beyond Lange and other FSA photographers, they extended photographic coverage across borders, into the realms of labor organizing, field sanitation, the predawn shape-up, pesticide exposure, so-called "Black Okie" cotton pickers, illegal or undocumented workers, and small, dysfunctional farm towns on the west side of the San Joaquin Valley.[4]

Jon Lewis stands with those photographers — as well as modern photo essayists like W. Eugene Smith, Robert Frank, and Eugene Richards — who throw caution the wind, let the chips fall where they may, produce memorable bodies of work, retain control of their images, and sacrifice all, sometimes even their families, for the chance to do something unique.[5]

16. "The picket line could be boring and tedious and I was probably more observant earlier in those mornings. I was on my toes here when this shot presented itself. It wasn't there long so I only got the one frame. He's one of Felipe Cantú's boys and if he could be reached I'd send him a print. I wasn't able to do that at the time, but hope people . . . come upon a pix [photograph] of themselves, or their parents and maybe grandparents. That would assuage my conscience over a photographer's broken promises." Winter 1966.

4. Obscurity

During the years I searched for Jon Lewis, people would recall his work and remember him fondly but did not know his whereabouts. Again and again I heard the same refrain. He's dead. No, he's alive. Somewhere in San Francisco. No, San Jose. Teaching here. Working there. Ask so and so. See this person. Try this telephone number. Say hello.

The UFW, which should have known about Lewis, had not the foggiest notion who I was asking about. Photojournalism professors at San Francisco State University vaguely remembered him. But none had actually seen or talked to him. Year after year I scribbled down leads, rumors, sightings, and addresses that led nowhere. In my mind Lewis began to assume mythical proportions, the phantom photographer.

When I finally succeeded in tracking him down and setting up a meeting I thought I might encounter a confident and successful photographer whose work at Delano had propelled him forward. Perhaps he was now a world traveler, always on the go, still taking chances. Instead I found a gaunt, thin, unemployed man whose adventure at Delano had been the high point of a life that had unfairly beaten him down.[1]

Lewis could not provide me with any images because he did not have space in the small room in the residential hotel where he lived. He had stashed all of his negatives and color transparencies at a friend's home. He was just trying to survive. He had not benefitted financially or professionally from what he had done at Delano. To those around him, Lewis was just another person living on the margin in the cheaper sections of town, not someone whose work is as central to California photography as that of Edward Weston and whose images are as important to farmworkers as are politicians, picket captains, leaders, reporters, legislation, and the usual array of volunteers and sympathetic bystanders.[2]

Getting information out of Lewis required a process that was one part cajoling, one part pestering, one part father confessor, one part friendship, one part torture, and always a beer or two. Over a quarter of a century Lewis gradually opened up

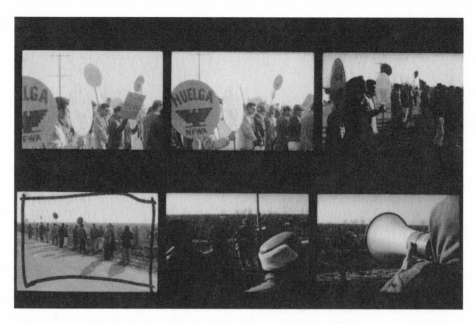

17. "First day on the picket line — didn't yet know anybody or get much." Enlarged frames from Jon Lewis contact sheet number 2. Grease pencil marks a frame to be enlarged and printed. Winter 1966.

to me about being part of a small and audacious group of freelancers present at the inception of the farmworker movement. Out of this eventually emerged a picture of the California grape strike, the photographers who covered it, the role of visual information in a labor dispute, and the story of an idealistic, thick-headed, quixotic, unappreciated loner.

On a shoestring budget, with two cameras and three lenses, Lewis cut to the core of the conflict and produced images possessing a graphic power and verity paralleling the cry for human dignity that Charles Moore, Bob Adelman, Steve Schapiro, Danny Lyon, Bruce Davidson, and other civil rights photographers captured in the American South. Lewis accomplished this without any institutional affiliation, independent from any newspaper or photo agency, by setting his own deadlines, bringing his raw talent and sense of adventure to his assignment, winning the trust of those around him, absorbing the culture and environment of the NFWA, and accepting the day-to-day grind of picketing, protests, meetings, and the highly charged atmosphere of demonstrations and confrontations.[3]

Delano became for Lewis a composite symbol of revolutionary forces seething beneath the bucolic facade of rural California. His talent consisted of breaking free from orthodox photojournalistic approaches and stereotypical pictures of farm life. Lewis was the quintessential freelance photographer. Like most freelancers, he paid

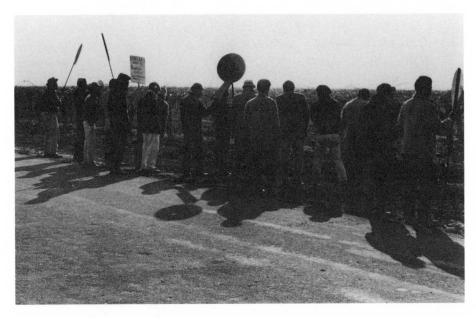

18. "A rear view of the picket line provides a varied perspective, but this one is not particularly distinguished." Winter 1966.

a physical, emotional, and financial price. Ultimately the Delano grape strike was too much for any one person to witness on very limited resources.

Had Lewis just caught a break, could he have become a seminal figure in West Coast photography? How many other photographers unknown to historians and curators created similar bodies of powerful, historically charged images that reside in attic and basement archives on the verge of spontaneous combustion or being tossed out with the trash? What will it mean for established interpretations of photographic history when we begin to incorporate these orphan figures into the story of social documentary photography and photography in the Golden State?[4]

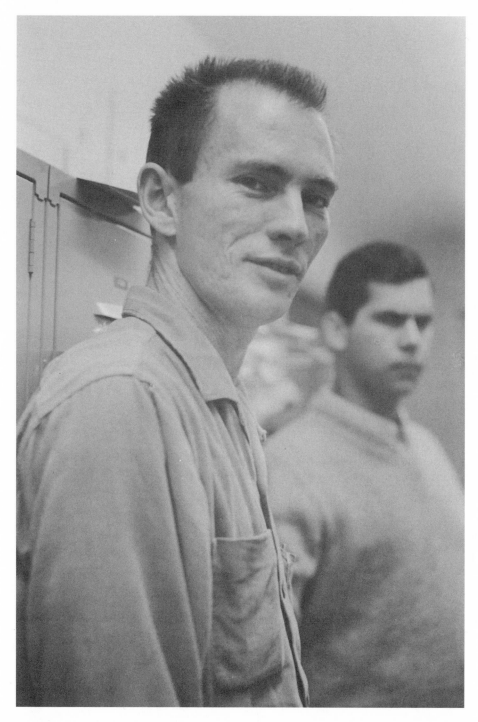

19. Jon Lewis, just out of the Marine Corps, as an undergraduate at San Jose State University. Photograph by Paul Sequeira, soon to become an award-winning Chicago-based photographer. Spring 1966.

5. Marine

Jon Lewis was born in Burwell, Nebraska, the seat of Garfield County, astride Highway 91 in the heart of the mixed-grass and sand dunes in north-central Nebraska, on April 18, 1938, to Lloyd and Margaret Lewis, two tired corn farmers just trying to survive. During World War II, Lloyd sold the farm and moved west to work in the defense industry around San Diego, where Jon's sister, Gloria Jean, was born in 1940.

A high school science and mathematics wiz in the 1950s, Lewis had little acquaintance with photography other than as the subject for the odd family snapshot. He became interested in journalism while "hanging out with the bohemian set" during his sophomore year at San Diego State University in 1957. He soon changed his major from engineering to social sciences, with a minor in journalism. He later recalled that the photography component to the journalism program "grabbed me by the balls."[1]

To further pursue his growing interest in photography, Lewis enlisted in the Marines, where he trained as a combat and military photographer. He spent 1959–60 at Camp Pendleton covering events for the base newspaper. By day he photographed with a bread box–sized 4-by-5-inch Speed Graphic camera. At night he processed film and printed images in the base photo laboratory. While visiting Tokyo during a tour of duty with a Pacific naval task force in 1961, Lewis purchased a Nikon 35-millimeter camera and three lenses. He would use that camera and those lenses for the rest of his life.

While stationed in Hawaii, Lewis took classes at the University of Hawaii. After finishing his military service, he enrolled in the photojournalism program at San Jose State University (SJSU) and began covering politics and culture around the state. When President John F. Kennedy visited California in 1963, Lewis documented a crowd of supporters desperately stretching their hands out to touch Kennedy's face. Lewis made equally iconic images at a Joan Baez concert, again concentrating

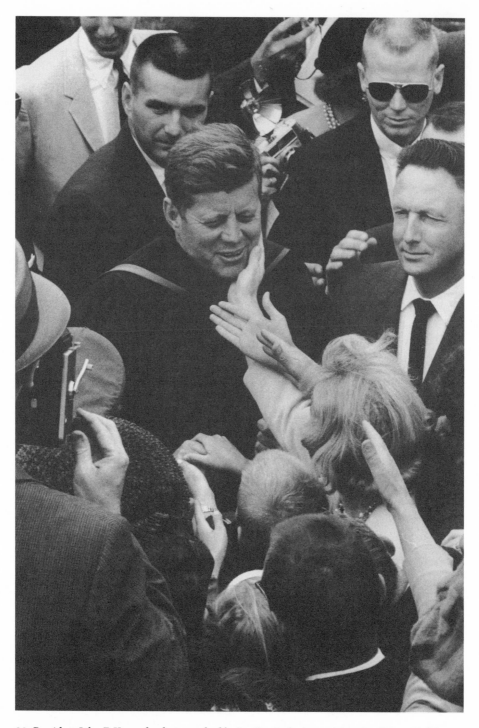

20. President John F. Kennedy photographed by Jon Lewis during a visit to San Diego, California. "This may be my best photograph." Spring 1963.

21. Jon Lewis photograph of Luís Valdéz performing on stage at San Jose State University. Circa 1965.

on the interaction between the famous and the common. Nick Pavloff, one of a talented group of aspiring photojournalists at sjsu, later recalled:

> It was clear from the beginning that Jon's work had a special look. It was this look that resonated in his images of . . . JFK . . . an animated young Joan Baez in concert, and Jon's commanding portfolio of theatre, music, and dance, which was published in sjsu's feature magazine, *Lyke*. He was an astute photographer with a keen insight into the fleeting emotions a face might reveal. Jon's work embraced life, happy or hard.[2]

To earn a little extra money, Lewis photographed university theatrical productions. On the set of the 1964 production of *The Shrunken Head of Pancho Villa* he met Luís Valdéz. An aspiring Mexican American actor, Valdéz had been born in Delano and grew up working in the fields. When he was six years old, Valdéz had watched a teacher use part of a paper bag to make papier-mâché masks for a school play and had not stopped thinking about the theater since. After his family moved to San Jose, he attended James Lick High School and won a mathematics and physics scholarship to sjsu. His early fascination with acting soon reemerged, and he switched his major to theater. After graduation he visited Cuba, then landed a gig with the San Francisco Mime Troupe.

During the winter of 1965, Lewis enrolled in the graduate photojournalism program at San Francisco State University. After moving to San Francisco, he looked up

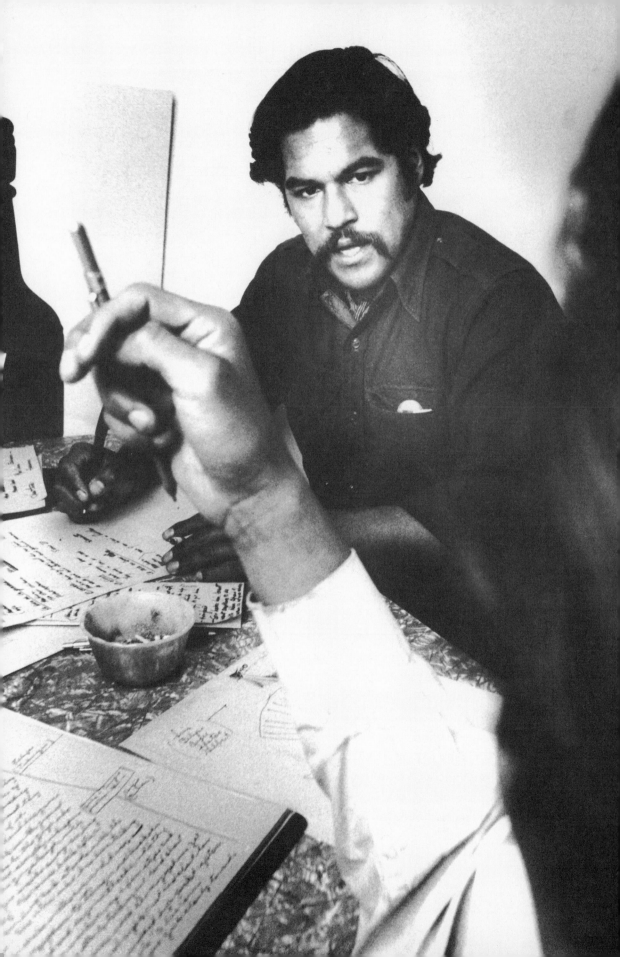

Valdéz, who said that something was happening in Delano. Grape pickers were on strike. A group called the National Farm Workers Association had been formed by a charismatic leader named César Chávez. The strike had entered a protracted phase that journalists compared to the trench warfare of World War II.[3]

Valdéz was headed home to check it out. He wanted to speak with Chávez about creating a theatrical component to the strike. Valdéz called it El Teatro Campesino. By creating simple, one-act skits, or *actos*, he hoped to educate farmworkers and the general public about the union and the issues. Valdéz was not going to do this from a theater stage. He was going to use mobile stages on flatbed trucks that would be towed to various locations as the harvest shifted location. He had already recruited a cast of memorable actor-farmworkers — Augustín Lira, Errol Franklin, Gilbert Rubio, and Filipe Cantú (who would later play The Snakeman in the movie *La Bamba*). The theater needed a photographer. Valdéz thought that Lewis might be the right man at the right place at the right time. Did he want to join them?[4]

Lewis had time on his hands. He did not think he would remain very long in Delano, perhaps a week. After that he would head north to Ashland, Oregon, where he had been invited to photograph the Shakespearean Festival. When summer school began, he planned on returning to San Francisco and continuing his photojournalism studies. He wanted to teach photography. He hoped that any images from Delano and Ashland might be of some use in his MA thesis.

Lewis was not thinking about photographing history as it was unfolding. He had no burning desire to right wrongs, update Dorothea Lange's work from the Great Depression, or extend the social documentary tradition into the fields. He did not know a table grape from a wine grape. He had never been to Delano. He had not worked in the fields. He did not speak Spanish. Other than Valdéz, he had no Mexican American friends.

Within days, this all changed. Lewis had taken the first step in an odyssey that would yield over ten thousand pictures during 1966, and another three thousand from 1967 to 1968, and hundreds more, on and off, into 1969 and 1970.[5]

22. "Luís Valdéz doesn't sport a mustache these days, and that still-abundant head of hair has turned grey, but the fiery presence of those days remains. Here he and Augi Lira work on an acto that will probably make its way on stage in a matter of days." Winter 1966.

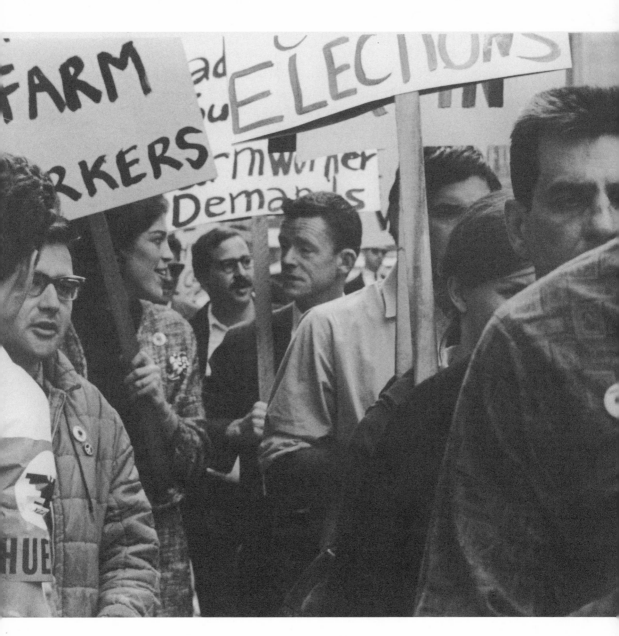

6. Ganz

Neither Valdéz nor Lewis owned a car. And a bus ticket was beyond their limited financial resources. Hoping to snag a ride, they headed over to the NFWA office on Silver Avenue in the outer Mission District. After a day helping NFWA member Roger Terronez move a refrigerator into his house, Marshall Ganz, a Bakersfield rabbi's son who had left Harvard University to work for the Student Nonviolent Coordinating Committee (SNCC) in Mississippi during Freedom Summer, arrived and offered a lift.[1]

In the South Ganz had acquired what he called "the Mississippi eyes." Now in California he was beginning to see his home community differently. After reading an article in an SNCC newspaper about the strike, Ganz had spent one weekend driving Chávez to fund-raising events around the San Francisco Bay Area. Suddenly Bakersfield and the San Joaquin Valley looked different to him. What was happening in California did not seem all that different from Mississippi. Farmworkers in California faced many of the same challenges as their African American counterparts in the South. Rather than returning to Harvard for the fall semester, Ganz was headed to Delano to see if he could apply his experiences in the civil rights movement to events unfolding in California.[2]

Because his little red two-door automobile could not accommodate all three men along with their gear, Lewis lashed his

23. "Boycott picket line in downtown San Francisco with Marshall Ganz in the [center] background. I have yet to make contact sheets of later boycott activity, let alone prints." Summer 1966.

Marine sea bag to the trunk and squeezed in for the foggy, five-hour, 180-mile drive into the heart of the richest and most productive farming system on the planet. Valdéz soon fell asleep. He started snoring just after Ganz cleared the Altamont Pass. Lewis remained wide awake and watched the Valley whiz past his window.

Lewis had heard friends often complain that the drive into the Central Valley was long and boring. It was a trip to the land of hicks, rednecks, bad country music, right-wing talk shows, evangelical religion, and interchangeable farm towns, each distinguished by little more than whatever particular crop flourished nearby. But to Lewis, the journey was a variety of high speed wandering, a technique for losing oneself in the pleasures of an experience, something that the writer Rebecca Solnit would later describe as traversing geography through a sequence of stories in a landscape as rich and complex as that of Ireland, France, or any other nation.[3]

One hour from San Francisco, Lewis noticed a sign for Hop Yard Road, on the outskirts of Pleasanton, a town whose name originates not in "pleasant town," as the spelling would suggest, but for General Alfred Pleasanton, a veteran of the Mexican War, whose name was misspelled when applied to the post office on July 4, 1867. The town enveloped land once controlled by the Pleasanton Hop Company, the largest hop-growing operation in the world. Fifteen minutes later Lewis passed Livermore, home to vineyards and the Lawrence Radiation Laboratory. The town was originally known as Laddville, for Alfonso Ladd, who erected its first building in 1864, then was briefly named Nottingham, but within the same year became Livermore, after Robert Livermore, an English sailor and cosigner of Rancho Las Positas in 1839.

Ten minutes later, the trio cleared the Altamont Pass, which suggested to Lewis questions of etymology. Altamont Pass seemed a perfect example of a place name bringing out a story touching on the whole range of California history. *Alta* was Spanish for "upper" or "high." It is often tacked to other words such as *vista* (view), as in Altavista in Sonoma County, or at the end of place names such as Piedras Altas (high rocks) in Monterey County; or, in the case of Altadena, coupled to last part of Pasadena, indicating the little town's position upslope of its more famous twin. In 1869, Central Pacific Railroad applied *alta* to *monte* (mountain) to identify a remote railroad station high in the Livermore Pass. Although the station was gone by 1965, rail lines still hauled traffic over the pass. Lewis noted that Ganz crossed them three times, once at the western side of the pass, where they begin their long and winding ascent through the Coastal Range, and again on the eastern side, where the tracks briefly paralleled then crossed and recrossed the highway, finally remaining alongside the road on the right as the men flew down the slope.[4]

Lost in the dissolving mists of intermittent fog, the three men dropped through leaden skies into the Central Valley. Lewis recalled from his reading how the experience served as fodder for well-worn scene openers, exploited with varying success by novelists, geographers, explorers, missionaries, and travel writers of all stripes and abilities.

In a note saved from his journey, Lewis wrote,

the place had its own sensation. Leaving the city lights and crowds behind, you caught glimpses of irrigation canals the size of rivers, rusty threshers and combines, and tumble weed piled up against barbed wire fences. The odors changed every mile and you tasted them — now tarweed, a whiff of pesticides. You sensed that you were entering another place, a different region, flat and gritty. You had crossed some kind of border. You were now entering a barony where masses of migrants did the bidding of a landed gentry.[5]

From the Altamont Pass, I've seen the Valley decorated in giant, cottony puffs of winter fog. I've seen it through the fine, cool mist of a spring shower, with rainbows arching over the Tracy Pumping Plant. I've also seen it washed out under the white light of an oppressive, hazy, midday sun and choked with smog from piles of burning orchard trimmings.

On several occasions I have seen mirages appearing as great flittering lakes spreading across the Valley between the Coastal Range and the Sierra Nevada. At times I've seen this vista as a verdant, golden landscape; as a Thomas Kinkade monstrosity; and as a luminescent Albert Bierstadt painting. It is all of that and more.

7. Cornucopia

You can easily imagine the Great Central Valley as paradise. Delete those power poles. A little backlighting for that pearly, golden glow. Bring up the Sierra Nevada, nicely frosted with snow, a long, thin bank of clouds on the horizon. Sprinkle some golden poppies here, dashes of yellow, scarlet, tan, each a mile or more in width. Do that and you approach the original Valley landscape in spring.[1]

Before the first plows broke virgin soil, the Great Central Valley was home to five Indian tribes — Wintun, Maidu, Miwok, Costenoan, and Yokut. Every spring, rivers topped their banks, leaving vast stands of bulrushes and tule reeds. Wildflowers carpeted the floodplain, and dense riparian forests of huge live oaks, cottonwoods, and sycamores bordered every creek. Elk, antelope, and deer roamed in herds of hundreds and on occasion thousands. Pumas, grizzly bears, foxes, coyotes, and wolves hunted in the dense grasses and thick forests. Annual floods turned lowlands into lakes that provided habitat for millions of geese, ducks, herons, and egrets. Rivers were choked with salmon, trout, steelhead, catfish, crayfish.[2]

Depending on whether they arrived early in the spring, when the Valley's wild-flowers formed a Mediterranean "crazy quilt of color," or late in the year, following summer drought, when the rivers were dry and the ground swirled into dust devils, early visitors tended to view the San Joaquin Valley either as a godforsaken waste-land or a region bursting with potential. To Thomas Jefferson Farnham, the Valley was nothing but stagnant pools of pestilence and killing summer heat. John Muir stood transfixed at his first springtime view of the Valley, calling it a four-hundred-mile-long sweet-bee garden of honey bloom, a "sheet of plant gold," so incredibly profuse that, in walking from one end of it to the other, "your foot would press about a hundred flowers at every step."[3]

Edwin Bryant, a bold Kentucky journalist who traveled west in 1847 and wrote *What I Saw in California*, described "a truthful and not exaggerated and fanciful account" of what he saw on August 30 when his party topped the Sierra and paused on a promontory following a momentous trek across the Great Salt Lake Desert

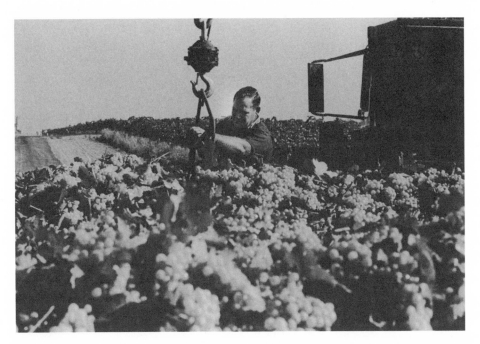

24. "Preparing a gondola of wine grapes for lifting onto a flatbed truck." Fall 1966.

and the Sierra Nevada. Below was "a broad line of timber running through the center of the valley indicated the course of the main river, and the smaller lines on either side of this its tributaries. I contemplated this most welcome scene with such emotions of pleasure . . . [that] I shouted . . . Very soon the huzzas of those behind were ringing and echoing through the hills, valleys, and forests."[4]

Coming into the Valley at night from the opposite direction a century later, Lewis found himself wide awake in anticipation of what lay before him. An hour east of San Francisco, on the downslope of the Altamont Pass, the Coastal Range flattened. Suddenly, framed before him in the dazzling cosmos of flickering lights and glowing ribbons of red, Lewis glimpsed the culmination of what so many early travelers had envisioned. Stretching below was a vast, plowed, irrigated, and chemically infused trough. No red barns or rolling pastures here. Family farms going or gone. Lewis was about to encounter agriculture on a colossal scale.

Encompassing over 25,000 square miles, the Great Central Valley was a giant industrial plantation, 430 miles long, and between 30 to 75 miles wide — about the size of England. Walled off on the east by the Sierra Nevada, on the west by the Coastal Range, on the south by the Tehachapi Mountains, and on the north by the Cascade Range, the Valley had a nearly perfect, rain-free growing season. It was drained by two river systems: the Sacramento and its tributaries on the north, and

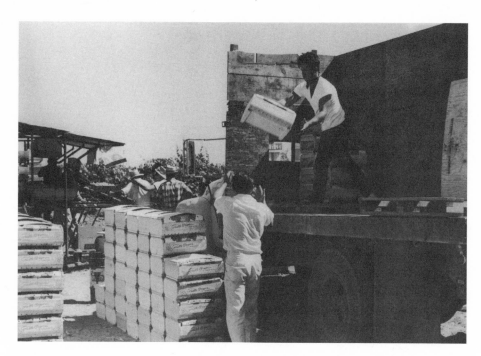

25. "Swampers loading grapes on a bobtail for transportation to cold storage." Summer 1966.

the San Joaquin and its tributaries on the south. Both converged and mingled in the Delta, emptying into the Carquinez Strait and San Francisco Bay, but not before vast amounts of precious water from the melting Sierra Nevada snow pack had been captured in big headwater dams, diverted to storage reservoirs, shunted into forebays, pumped into canals, and sent through the equivalent of an entirely new river system that defied gravity and, where necessary, ran uphill by way of gigantic pumping stations, to finally be delivered to furrows, checks, and drip irrigation systems watering crops in places that were otherwise semiarid grassland.[5]

Two million people lived here. Three hundred commercial crops grew on half of the Valley's fifteen million acres. With a growth rate 2.5 times the state average and a population predicted to triple in two generations, the Great Central Valley was the "Serengeti of North America," an "Inland Empire," "California's modern-day Valley of the Nile," and a "Cornucopia of the World" that kept the Golden State golden long after the mines petered out. This was both the morally neutral landscape of the highway traveler — a symmetrical, capitalist geography devoted to the full commodification of the land — and a blossom trail that tourists passed through and admired.[6]

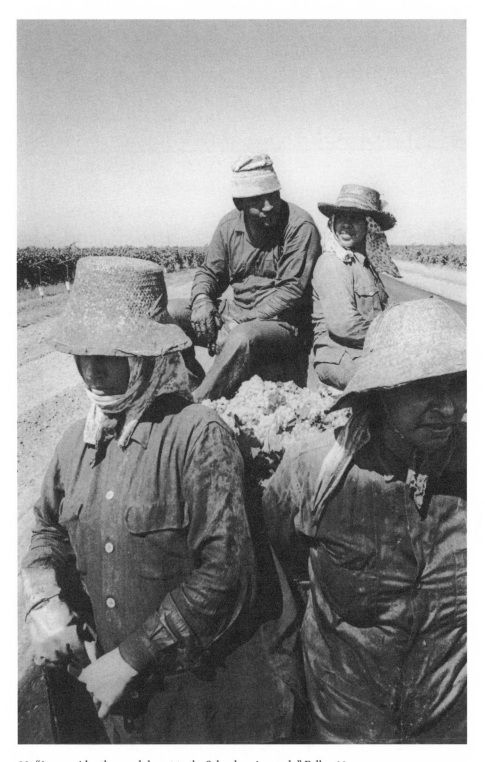

26. "A crew rides the gondola out to the Schenley vineyards." Fall 1966.

8. Steinbeck

Geographers usually separated the Great Central Valley into its northern and southern parts. From Sacramento north to Redding, the Valley was less populated. Orland was famous for its olives. Marysville had its prunes. Yuba specialized in cling peaches. Richland was surrounded by rice fields. Hamilton City was a center of sugar beet production. Chico had huge walnut orchards. Tule Lake in the far northeast corner of California boasted deep peat soils and a Siberian climate that produced the hottest horseradish roots on the planet.

Southwest of Sacramento, the Delta marked a transition point. Dixon produced sweet corn. Woodland grew almonds and canning tomatoes. Winters had its cherries. Fairfield specialized in apricots. Galt grew Bartlett pears. Vacaville boasted an onion dehydrating plant. Looking at rural California, it was easy to say that agriculture was diversified, when in fact it was really a mosaic of crop specialization.[1]

The San Joaquin Valley, farther south, where Lewis, Ganz, and Valdéz were headed, was a flat plain of symmetrical vineyards, orchards, and fields. It was home to three of the top five farming counties in the United States.[2]

San Joaquin Valley farmers grew peaches, apricots, cotton, garlic, melons, eggplant, potatoes, pistachios, broccoli, cauliflower, and lettuce. They also produced more milk, grapes, tomatoes, peaches, nectarines, plums, figs, walnuts, pomegranates, olives, onions, and celery than any other agricultural region in the United States, more cotton than Georgia, and everything from almonds to zucchini. They achieved perfect control by creating a "hydraulic society" where glittering, river-sized concrete troughs watered an apparently peaceful landscape.[3]

Lewis had read California history. He knew all of the California catch phrases. He remembered how muckraking journalist Carey McWilliams had once described the Valley as a place overflowing with irony, paradox, lassitude, and tragedy. Heading east in that tiny car, Lewis stared into the night, thought about the challenges he faced, and then tried to think systematically about what lay ahead.

He was going to confront a subregion of the American West where agricultural

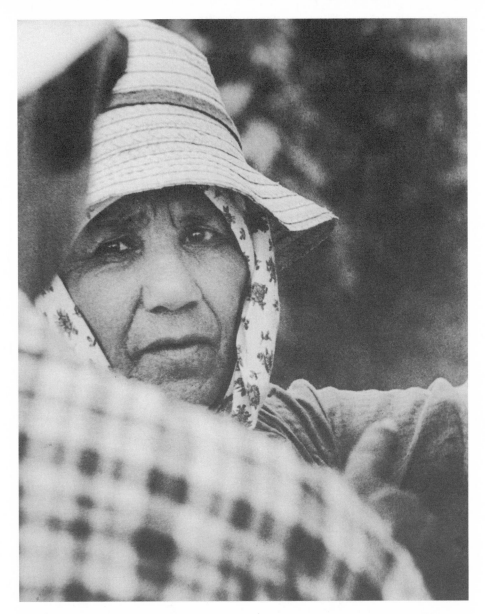

27. "You did not often get much shooting from the edge of the vineyard, so when a strong face loomed before you, you'd best grab it if you could. Every once in a while, you did." Winter 1966.

barons built empires larger than some countries. He would have to prepare himself to see poverty and wealth intermingled with beauty and ugliness in the richest and most productive farming economy that had ever existed. Certainly he was not going to be a neutral observer of a class of farmers he already regarded as a "hypocritical brotherhood." He already thought that their fidelity to the values of unfettered individualism and distrust of centralized planning clashed with the reality of massive infusions of state and federal money alongside gigantic engineering projects.

28. "Kids will be kids and you can't really pose or control them. They're not shy of the camera, so you grab what you can and hope for the best." Summer 1966.

Jon Lewis was not inclined to boost the San Joaquin Valley. He had in mind a still picture version of Edward R. Murrow's *Harvest of Shame* — something about interrogating the way deeply held agrarian ideals were contradicted by the sweat and human sinew required to bring in the harvest, and the way tons of chemicals were deployed to overcome what Joan Didion would label "the inconvenient features of California life." But while Murrow had underscored farmworker poverty, exploitation, humiliation, and powerlessness, Lewis was disinclined to take that view. Without glossing over problems, Lewis began to consider a different approach. Grassroots organizing in the face of overwhelming odds was an old story told and retold many times, he thought. But no one had fully recorded it on film.[4]

As the car droned on, Lewis wished he had packed his copies of John Steinbeck's books. He loved *The Grapes of Wrath* and regarded *In Dubious Battle* as the epitome of artistic engagement with farm labor problems, but above all that Steinbeck wrote, he most cherished the "The Harvest Gypsies," a lesser-known series of newspaper articles written for the *San Francisco News* in 1936 and later reprinted by the Simon J. Lubin Society as *Their Blood Is Strong*.

Lewis had encountered the series as an undergraduate. He liked one chapter in particular and could quote it verbatim. As Ganz sped along, Lewis closed his eyes and recalled Steinbeck's description:

> The houses, one-room shacks usually about 10 by 12 feet, have no rug, no water, no bed. In one corner there is a little iron wood stove. Water must be arrived from the faucet at the end of the street. Also at the head of the street there will be either a dug toilet or a toilet with a septic tank to serve 100 to 150 people. A fairly typical ranch in Kern County had one bathhouse with a single shower and no heated water for the use of the whole block of houses, which had a capacity of 400 people . . . The attitude of the employer on the large ranch is one of hatred and suspicion, his method is the threat of deputies' guns. The workers are herded about like animals. Every possible method is used to make them feel inferior and insecure. At the slightest suspicion that the men are organizing they are run from the ranch at points of guns. The large ranch owners know that if organization is ever effected [sic] there will be the expense of toilets, showers, decent living conditions, an a raise of wages.[5]

Interviewed about his Valley sojourn decades later, Lewis would take a break. Preparing for the next question, he liked to brew a pot of strong coffee. He would then flip through his dog-eared copies of Steinbeck's books remarking: "Same then, same now. César [Chávez] was fighting the same battles, with the same people, for the same things, in the same places."[6]

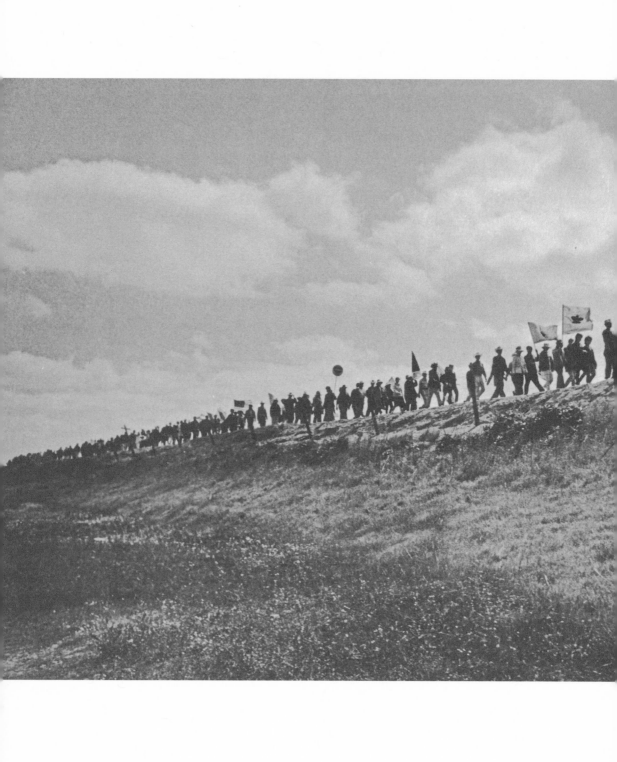

9. Power

Lewis photographed the Delano grape strike at a time when economists were struggling to coin a terminology capturing the unique dimensions of California agriculture. They often described it as a place where large-scale, specialized, intensively cultivated, irrigated crop production interlocked with a complex of animal feed manufacturers, hardware and equipment dealers, pesticide, fertilizer, chemical, power, insurance, and lumber companies, trucking operations, machinery manufacturers, banks, utilities, and universities. *San Francisco Chronicle* reporter Henry Schacht called this web of relationships "Agri-business."[1]

Agriculture employed one of nine people in California. Since 1900, it had been the state's most important industry, a cornerstone of growth and prosperity.[2]

By 1965, agribusiness was gigantic. Larger than the film, television, oil, and aerospace industries, it consisted of about fifty thousand farms (a drop of two-thirds since the end of World War II) that produced five times as much wealth in one year as was dug out of the Mother Lode during the entire Gold Rush. About 6 percent of those farms controlled 75 percent of the total acreage. About 15 percent, which accounted for three-quarters of all production, paid 80 percent of all farm wages. The top 2.4 percent hired 60 percent of the farm labor force.

Those farms were not like farms in the Midwest. Other than the cotton and tomato crops, California farmers could

29. "This is one of those shots that made it worth all the scurrying about in search of a vantage point. The march looms on the horizon, appearing unending and inevitable." March 1966.

not mechanize. People, not machines, worked the fields. Human hands, human sweat, and human sinew harvested and tended California crops.[3]

Around August 4, when the harvest was at full tilt, 190,000 farmworkers swarmed through the state. That was about the same number who had worked in the fields a generation earlier.

To block and thin lettuce, farmworkers crawled like bugs between the furrows. To pick carrots, they knelt like church penitents. To harvest fruit, they scurried up and down ladders. To irrigate fields, they rose hours before dawn, sometimes went about their business by lantern light, and spent the daylight hours irrigating crops beneath the broiling sun.

To pick watermelons, *meloneros* arranged themselves in a single-wing formation and marched forward, cutting and pitching thirty-pound oblong melons along a line that moved the fruit across the furrows and up into the bed of a slow-moving truck. They did this thousands of times each day, pitching the melons as much as ten feet to the next man without bruising or bursting them. The harvest lasted sixteen hours a day in summer temperatures above a hundred degrees. Often the crews were composed of football players getting in shape. Crew members commonly lost five to ten pounds per day while building up strong backs. Even in their sleep, meloneros found themselves thrashing about, with arms flailing, still throwing and receiving the big melons.

Because the cotton harvest was not yet fully mechanized, surrealistic scenes still played out on the Tulare Lake bottom, where field hands waiting for the thick December fog to lift shot craps, slept in their cotton sacks, or warmed themselves beside fires of kerosene-soaked tires. When the sun finally poked through, someone yelled "cotton ready," and harvesters waddled down the rows trailing their picking sacks.

It was a world few Californians knew. Full of exhausting, sweaty, dirty, low-paying labor, farm work extracted so much from mind and body and offered so little future that only those with no other alternative did it.[4]

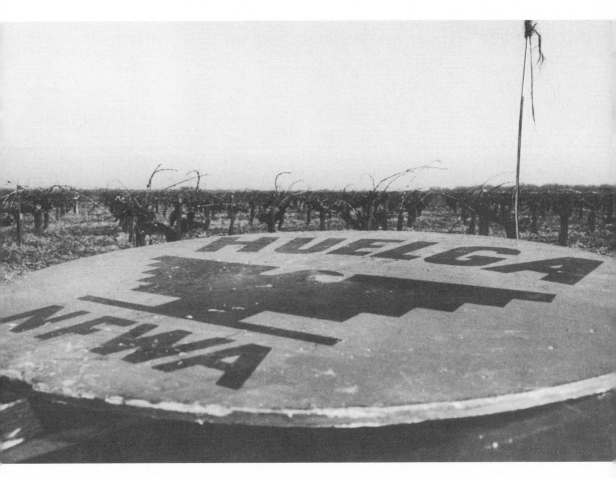

30. "Our picket sign didn't always have to be held vertically to convey our presence looming over the vineyard." Winter 1966.

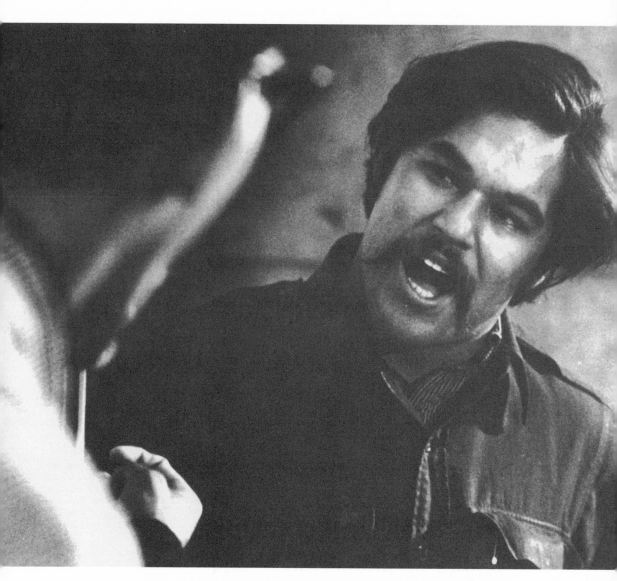

31. "Luís Valdéz had a commanding presence on the stage, and the actos they created left an audience pondering as well as in stitches with laughter." Winter 1966.

10. Fanatics

armworkers never accepted their lot passively. They wanted toilets in the fields so that they did not have to squat between the plant rows, retire to the eucalyptus grove, or stroll over to the irrigation ditch. They wanted a hiring hall. They wanted to eliminate labor contractors. They wanted fresh, cool, clean drinking water in the fields, the right to bargain collectively with their employers, a decent wage, and social and political equality.

To achieve these goals farmworkers launched hundreds of strikes, some involving no more than a single crew on a remote ranch, others that stretched out for years and united tens of thousands of men and women of all nationalities and ethnic backgrounds.[1]

A strike by hop pickers on the Durst Ranch in Wheatland on August 7, 1913, is often identified as the beginning of the farm labor movement. Conditions for the twenty-eight hundred men, women, and children who had gathered there were typical of those on scores of other big labor camps throughout the state. When the nine outdoor toilets became befouled and garbage piled up, the stench, low pay, and lack of clean drinking water drove workers to hold a protest meeting under the leadership of the Industrial Workers of the World, a radical labor organization also known as the Wobblies. Just as the demonstrators finished singing a Wobbly tune, the sheriff and local district attorney arrived. A deputy fired his revolver into the air to quiet the crowd. The shot provoked a riot that left the district attorney, a deputy, and two farmworkers dead. Four companies of National Guardsmen arrived to restore order. A statewide manhunt rounded up hundreds of Wobblies. Two strike leaders, Blackie Ford and Herman D. Suhr, were convicted of murder and sentenced to life in San Quentin prison.[2]

A subsequent investigation made California officially aware for the first time of the way migratory farmworkers lived but did little to alleviate their plight. Farm labor relations remained relatively placid during World War I and the 1920s. But as the Great Depression spread throughout the state, conditions in the fields worsened.

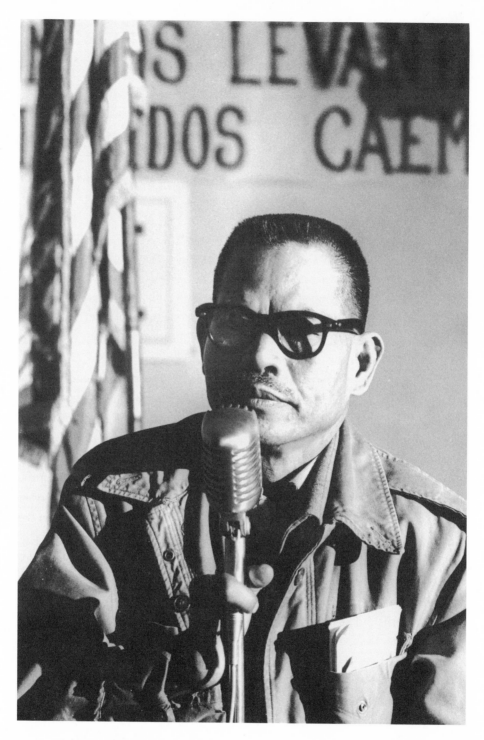

32. "Larry Itliong, head of AWOC, at a microphone in Filipino Hall. It looks like I used a strobe, but I would have held it up with my left hand, and here the lights are from the right side. What light there was in the Hall was poor and none of my available light negatives were this sharp. Beats me, but I'll take it." Winter 1966.

During 1933 strikes erupted in every agricultural district. Over forty-seven thousand farmworkers — nearly one-third of the entire farm labor force — walked out of the fields. The biggest and bloodiest strike occurred in October, when eighteen thousand cotton pickers, in three counties, stood up to the San Joaquin Valley growers.

Most of the strikers were Mexicans. In a report on the strike, University of California economist Paul S. Taylor and his student Clark Kerr described, "The excitement of the parades, the fiery talks, the hearing, appealed to the Mexicans particularly, and the race discrimination, poor housing, and low pay . . . were rallying cries which appealed to a class of workers with adequate personal experience to verify the charges hurled by Communist leaders and rendered exposition of the theories of Karl Marx superfluous."[3]

After twenty-four days a mediation commission imposed a settlement that brought an additional 15 cents per 100 pounds of cotton picked. To the average worker, this brought a meager raise of 45 cents per day — barely even enough for one square meal a day. The cost for this modest wage increase was 113 strikers arrested, thousands evicted from labor camps, 9 children dead of malnutrition, and 3 strikers dead and 42 wounded by vigilantes who opened fire on crowds in Pixley and Arvin.[4]

In the winter of 1934, Imperial Valley vigilantes, local police, and county deputy sheriffs firing tear gas raided a desert camp full of strikers, burned their shacks, and drove them into the desert, killing a baby in the raid. A former commander of the Imperial Valley American Legion Post told a reporter, "The veterans of the Valley, finding that the police agencies were unable to cope with the situation, took matters in their own hands and solved the situation in their own way. Now the Valley is free from all un-American influences."[5]

Continuing to crack down on farm labor organizers, state and local law enforcement authorities on July 20, 1934, raided the Sacramento offices of the Cannery and Agricultural Workers Industrial Union (CAWIU), the communist union held responsible for leading the strikes. Eighteen organizers were tried under the California Criminal Syndicalism Law. On April 1, 1935, eight were convicted. Seven men were sentenced to San Quentin Prison, one woman to Tehachapi Prison. Two years later their convictions were set aside on appeal. By then the CAWIU — and all other farm labor unions — had been destroyed.

The lesson seemed clear to an American Federation of Labor leader, who explained that "only fanatics are willing to live in shacks and tents and get their heads broken in the interests of migratory labor."[6]

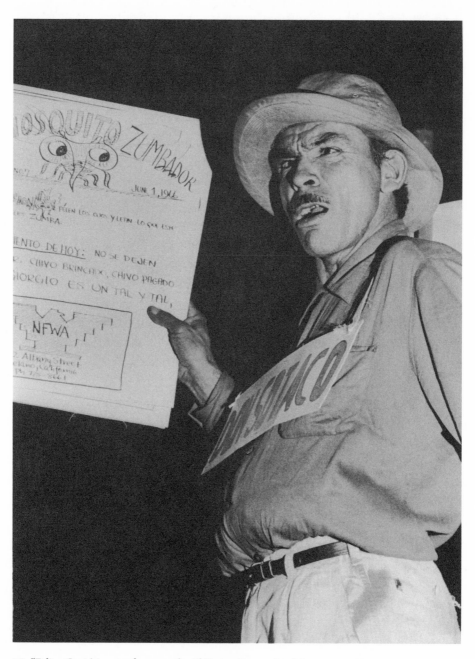

33. "Felipe Cantú in a performance by El Teatro Campesino." Summer 1966.

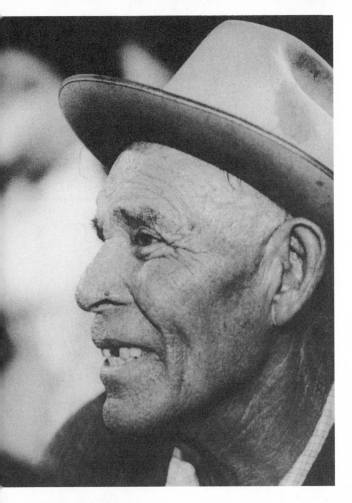

34. "Señor Campos sure stood out in any audience — a very gracious, soft-spoken man. The light in the Filipino Hall was always troublesome to me. I somehow managed to hand-hold a slower, moderate telephoto (135-millimeter) lens steady enough for this image. It was on the cover of *El Malcriado* and I hope is now a family heirloom." Spring 1966.

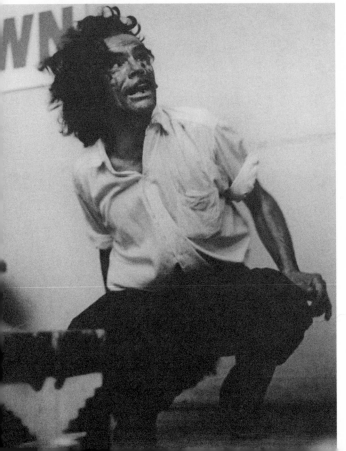

35. "Felipe Cantú at his best in another El Teatro Campesino performance." Summer 1966.

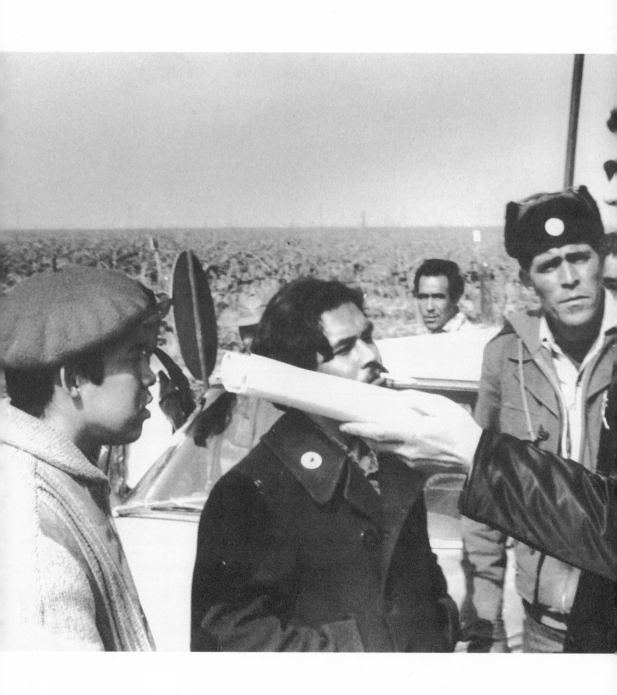

11. Flies

And so it went. Strike after strike, union after union, broken and scattered. To keep them on the run, growers banded together as the Associated Farmers, accused unions of being communist fronts, and formed flying squads of goons and thugs who cracked skulls with ax handles. Farmworker unions, after leading short, hectic, and spectacular lives, invariably died and were buried, leaving behind a graveyard of tombstone-like union acronyms — TUUL, AWIU, IWW, CAWIU, CUCOM — each condensing a unique and bitter chapter of farm labor history.[1]

So successful were growers in smashing farm labor unions that they often joked about their ability to thwart organization and collective bargaining. One famous Imperial Valley farmer put it this way: "Unions are just like flies to us. When they get too pesky, we sweep them away. When they buzz too close, we just swat them down."[2]

A University of California economist summarized the dismal state of farm labor relations even more succinctly. In agriculture, he wrote, "Effective collective bargaining is so exceptional as to scarcely challenge the proposition that it is non-existent."[3]

The dramatic farm labor relations scenario included innocent people falsely charged with murder and held incommunicado,

36. "I figured I'd better show the police presence on the picket line, but don't have much. Things had settled into a routine by the time I got there in the fourth month of the strike, so the violence and overt arrests had subsided. Here picket captains Tony Mendez, Luís Valdéz, and Manuel Vasquez are informed of something or another. Further south the Kern County sheriffs took over and I recall them as being a bit more confrontational." Winter 1966.

while murderers went free; law enforcement officers who turned out, in some cases, to be bandits with badges; and beatings, kidnappings, arson, sodomy, and mass murder.

At times farm labor strikes grew into miniature civil wars, a similarity that did not escape the attention of University of California Professor Paul S. Taylor. Testifying before the LaFollette Civil Liberties Committee in 1940, Taylor described the pattern of a typical strike in which "ardent organizers agitate and act, growers, officers and laborers each overstep the law, and citizens finally cry to the state authorities for peace, if necessary, at the hands of troops."[4]

Long after trade unions became entrenched in and accepted by the modern industrial enterprise, California's fertile valleys remained a bastion of the open shop. After many years of trying to organize in the fields, farm labor organizer and scholar Ernesto Galarza concluded that "the flame of unionism had been applied to the frozen structures of power, but it was like trying to melt an iceberg with a candle."[5]

What did this mean to farmworkers? It meant that growers, unencumbered by trade unions, dictated the various conditions of employment, basing their labor policy on the objective criteria of what minimized cost and maximized profit.

They often manipulated the wage structure and extended the workday and the work week as well. They could hire and fire at will, and they were free to engage in petty harassment. Some even withheld a portion of the paycheck, called it a "bonus," and paid it at the end of the harvest, ensuring that few people would quit before they finished picking the crop.[6]

Obtained at the flick of a finger and paid a pittance, California farmworkers were channeled through the fields like irrigation water. Farmworkers toiled under a labor relations system that one observer described as being "tantamount to a gilt-edged insurance policy against unionism in agriculture."[7]

Subject to the absolute rule of their employers, with no voice in setting the terms of their employment — employment that exerted a profound effect on their family life, their emotions, their community status, and their self-esteem — farmworkers all too often had but one bargaining right. If they did not like their job, they could quit.[8]

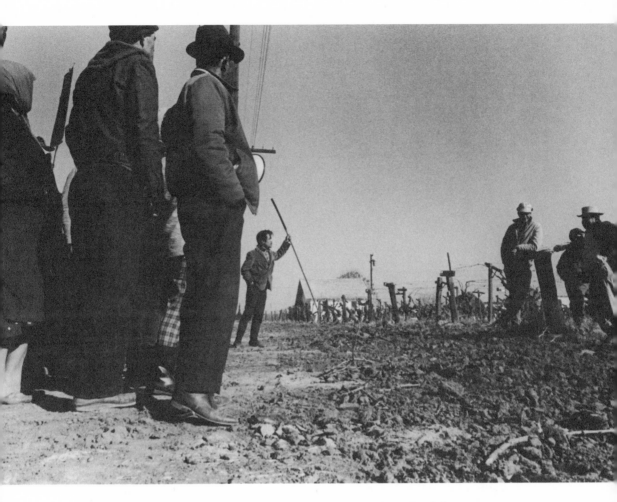

37. "That's Luís Valdéz shaking a Huelga sign at some workers taking a break from pruning grape-vines." Winter 1966.

12. Dispossessed

There were many reasons why farmworkers were exploited, oppressed, and taken for granted.

Farmworkers were a stunningly varied agglomeration of disadvantaged exiles, dispossessed Americans, immigrants, and colonized peoples. Farmworkers were poor, highly mobile people who lacked political power. They could not expect to receive fair and unbiased treatment by law enforcement authorities. They could not even legally bring growers to the bargaining table through collective action.

Farmworkers were dispersed through a sprawling industry. They lived in labor camps, *colonias*, barrios, and other out-of-the way places not easily reached or even found by union and community organizers using traditional approaches.

There was never a shortage of farmworkers. From the beginning, California growers benefitted from, and grew accustomed to, immunity from wage pressures that would eventually drive other industries overseas.[1]

California Indigenous Peoples, the first farmworkers, worked on the Spanish missions and were kept in the fields after the Gold Rush by a succession of peonage and indenture laws. As they died out, Chinese immigrants poured down the gangplanks and into the fields until the Exclusion Acts of 1882, 1892, and 1902 ended further immigration. Japanese people, forbidden since 1866 from leaving Japan, moved into the fields after 1900.[2]

More than thirty thousand Filipinos, who arrived in the 1920s, became essential in certain key crops like asparagus and table grapes. At the same time, Mexicans trekked into the Imperial Valley, the citrus districts around Los Angeles, and barrios new and old throughout the state. Mexicans came into California in such great numbers that the years after World War I became known in agricultural circles as the "Mexican Years."[3]

Beginning around 1932, hundreds of thousands of refugees migrated to California from Oklahoma, Arkansas, Texas, Missouri, and other states in the American Dust Bowl and Bible Belt. Rattling and clanking in their trucks and automobiles from

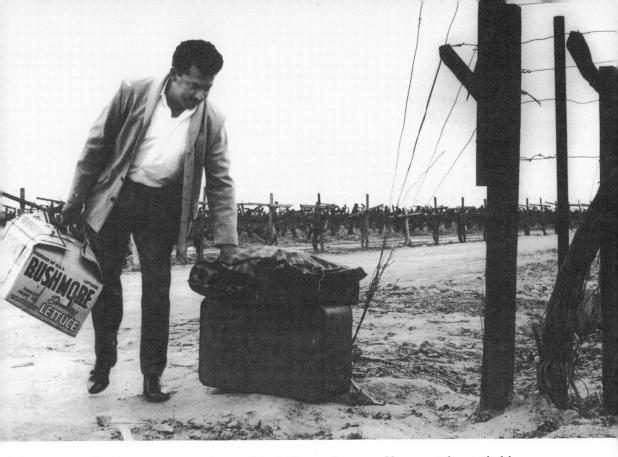

38. "When a man or crew came out of the fields on strike, we would transport them to the labor camp to gather their belongings and give them a lift to the Greyhound [bus station]. Seeing their tattered bags and great pride was instrumental in my decision to stick around and see how it all played out and what I could do to help La Causa." January 1966.

one field to another, shifting between ditch bank camps, tarpaper and cardboard shelters, and canvas tents, they bathed in and drank dirty water from irrigation canals and cooked over open campfires. Seen resting in the shade of billboard signs and beneath bridges, they provoked an ongoing debate that continues even today.[4]

At the heart of the debate over California farmworkers was the question of the merits and characteristics of each group. In his 1921 textbook *Farm Management*, University of California economist Richard L. Adams asserted that Mexicans were "childish, lazy, [and] unambitious." Japanese were "tricky and sexually lax." Negroes were "notorious prevaricators." The "best" workers — Indian Sikhs — were "lean, lanky, and enervated."[5]

13. Braceros

During World War II, as the U.S. military drafted millions of men into service, a farm labor shortage developed. On September 29, 1942, a small cabal of American bureaucrats intervened by contracting with the Mexican government to import five hundred workers. Under this arrangement, the federal government handled all of the responsibilities and costs for transporting, feeding, housing, and caring for the workers.

Word of the arrangement spread rapidly through the Mexican countryside. In a ritual followed annually over the next quarter of a century, men from the poorest, least-developed, and most remote regions of Mexico said goodbye to their families, packed their belongings in battered suitcases and cardboard boxes, departed from countless small villages across the Central Highlands, and flocked to recruitment and assembly centers.

Men camped in the streets that first year and rioted when food and money ran low and the lines of *aspirantes* (those hoping to go north) stretched through Mexico City for blocks. Police in riot gear used hoses and tear gas to keep order.

Eventually the aspirantes were fingerprinted, inoculated, handed contracts to sign (which few understood), and sent to Buena Vista railroad station. Photographers recorded them leaning out the car windows for one last handshake, then flashing V for victory signs as they disembarked near Stockton, California, paraded into labor camps, and arrived to work in the sugar beet fields around Woodland, Sacramento, and Salinas.[1] By the end of World War II, American taxpayers had forked out $21,615,767 to import 50,000 campesinos at a cost of about $450 per worker.[2]

Seven months later, Congress quietly authorized a unique work program specifically tailored to the needs of agricultural employers. For nearly a quarter of a century, the U.S. government recruited, distributed, and controlled five million men.

Brought north to toil on farms and railroads in California, Oregon, Washington, Idaho, Colorado, Arizona, New Mexico, Texas, and sixteen other states, these men soon became known as "braceros." They took their name from the Spanish word

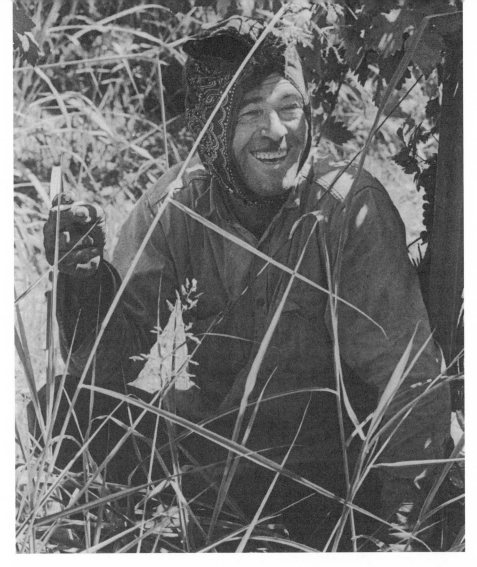

39. "If you were young and strong you could make fair money during the grape harvest, and even take a smoke break." Summer 1966.

abrazo (arm). They were literally "strong-armed men" or "men who worked with their arms," but they had other names as well: cabbage cutters, lettuce hands, ditch men (irrigators), and hoe-slingers (men who used the short-handled hoe to weed fields).[3]

Braceros lived in isolated labor camps, slept in cramped barracks, and earned minimum wages doing stoop labor. They sent home every dollar and penny they could save. They were disciplined, energetic, family- oriented, selfless men who maintained a sense of dignity and purpose that kept them going, despite their long journeys and grinding routine.

Braceros were not immigrants. They were men caught between two worlds — a nearly ideal, completely disposable, semicaptive class of laborers. Contracted to

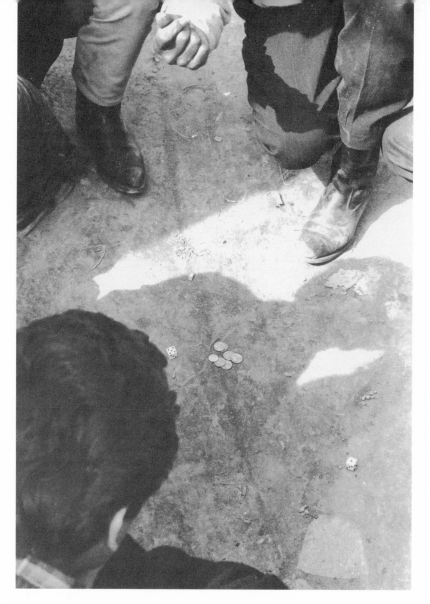

40. "Time passed slowly on the picket line, and with any luck a crap game could provide a beer at day's end — or fresh milk for the baby." Summer 1966.

labor in America, braceros left a life of poverty behind to seek an elusive fortune under conditions no better, and sometimes worse, than those back home. They originated in all parts of Mexico. The vast majority were under forty years of age.[4]

In many ways, the braceros were the same old story of farm labor in California, yet another wave of dispossessed people pouring into the fields, a rural proletariat at the heart of the heartland. They would sustain California's premier industry, solidify old traditions of labor migration, and through their remittances, rescue countless villages from abject poverty, which helped prevent Mexico from imploding.[5]

After World War II, when the farm labor shortage ended, Congress allowed the statutory basis for the bracero program to expire. Veterans and former prisoners of war who had worked in the fields returned home. Japanese Americans who had been interned in concentration camps were released. Convicts who had helped bring in the harvest went back to their cells, but the braceros remained in the fields.[6]

Over the next four years, growers contracted and recruited braceros, supposedly under the eye of the U.S. Immigration and Naturalization Service (INS) but in reality free of supervision and red tape, while the federal government provided financial support and administrative facilities. When growers complained that recruitment was too expensive and time consuming and that recruitment centers were too far away from the border, the U.S. Border Patrol in 1950 abandoned its responsibilities by "legalizing" and then "paroling" to growers ninety-six thousand undocumented workers who should have been deported.

Under the pressure of the farm labor shortages during the Korean War, Congress in 1951 ignored massive reports of abuse and deplorable living and working conditions and enacted Public Law 78, which placed the bracero program on a more permanent basis. Braceros never participated in the negotiations. They signed work contracts consisting of four pages of small print setting forth the ways in which they were separate but more equal than domestic workers. "Like the sprinkling systems of mechanized irrigation," wrote Ernesto Galarza, "braceros could be turned on and off."[7]

As the cornerstone of a labor force that could be expanded and contracted at will, braceros allowed growers to harvest crops that offered larger profits and diminish those threatened by overproduction. Braceros helped growers increase strawberry planting from 7,000 acres in 1951 to more than 20,000 in 1957. Braceros harvested 92 percent of the tomatoes in the San Joaquin Valley, 93 percent of the lettuce in Imperial County, and 94 percent of the celery in San Diego County.

Mincing no words, Ernesto Galarza compressed years of study into a succinct statement explaining how

> bracero wages fell so low that employers could pay contracting fees and graft to Mexican government officials without disturbing the margin of costs for braceros as compared with domestics. The artichoke producers of Castroville reduced picking costs by more than half. Beet growers who learned to combine braceros with machines harvested an acre at $13 instead of $32 . . . In addition, braceros were mulched in numerous and petty ways, through overcharges for merchandise in the camps, fees for cashing pay checks, and the perennial chiseling on the price and quality of meals.[8]

14. Pancho

The experiences of Francisco (Pancho) Repeso Fernandez, a thirty-five-year-old native of Oaxaca, in southern Mexico, illustrate the travail of a typical bracero in 1958. Only able to earn three pesos a day (about twenty-four cents) and with a wife and child to support, Fernandez had been visiting a small village about twenty miles from his home over mountain trails when he met several braceros who had just returned from El Norte (the United States). After listening to them, he asked them to notify him when they were going to return. After they contacted him a week later, Fernandez borrowed three hundred pesos from his father, gave a hundred pesos to his wife to live on until he returned, and took the rest to cover the cost of food, lodging, and transportation. Using a letter from the mayor of a nearby village stating that he was qualified to do farm work, Fernandez paid for a photograph that was affixed to the letter, and for no apparent reason was designated group leader and given a manifest with the names of the fifty men in his contingent.

Traveling by burro, bus, and train, Fernandez and his compadres embarked on a six-day journey to Monterey, Mexico, one of three migratory stations where braceros were examined and selected. Arriving late on a Friday, Fernandez found that the recruitment center was closed for the weekend. With the other Oaxacans, he located accommodations near the railroad tracks and passed the time wandering around town. On Monday morning Fernandez joined four thousand braceros, arranged according to their place of origin, who stood behind a tall fence before a gate leading into the recruitment center. At the request of an official, Fernandez handed in his manifest and led his contingent into a large hall that had been set aside by the Mexican Army. Loudspeakers explained the procedure for processing and began calling out names.

41. "Señor Campos whittles away the time as well as a stick." Spring 1966.

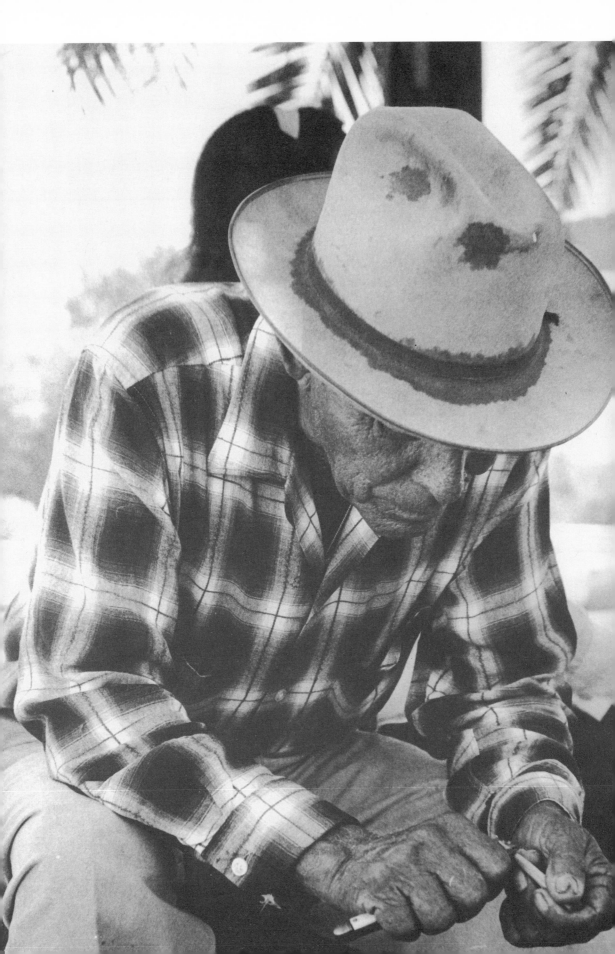

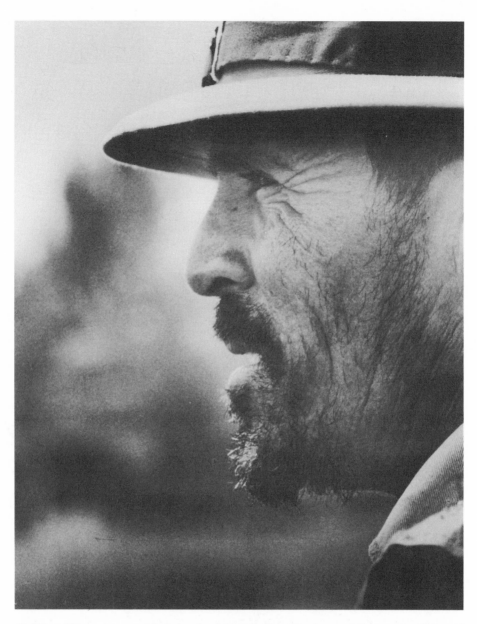

42. "Manuel Vasquez — one of the bulwarks of the picket lines. I've dozens of photographs of him and hope the strength and tenacity of the man is conveyed here. He was a huge presence." Spring 1966.

At the gate, an official inspected documents and initialed them. Veteran braceros told Fernandez that, if he was lucky, at the end of a typical harvest lasting six weeks he might return home with two thousand pesos — enough to pay off his debts, purchase a small chicken ranch, and set himself up in business.

Following a long line of men, Fernandez was first interviewed by a U.S. Department of Labor representative checking to make sure he understood farm work. He next passed an Immigration Service inspector looking to weed out "undesirables." With about fifty other men he stripped inside a large shower room and was inspected by Mexican doctors. He then stood in a long line of men moving through a plywood "delousing station," where he lowered his pants and was sprayed about the head and genitals with DDT.

At the end of his ordeal, Fernandez found himself standing before a typist who prepared his temporary entry permit. Along the way, seven men were rejected because they were not farmworkers, one as an immigration risk, and four others for medical reasons.

Directed to a mess hall, Fernandez received his first hot meal in nine days. He was then given a package of sandwiches, placed on a bus with seventy other men, and sent north to the border reception center at Hidalgo, Texas.

Arriving in the middle of the night, Fernandez slept in a bunk, showered and washed, and underwent a procedure similar to the one in Monterey, except at Hidalgo he was swiftly selected by an employer, handed a contract to sign, and placed on a bus for the ride north. He spent the next eight weeks in various labor camps, working from 8 a.m. to 6 p.m. for ten different growers. The camps were spartan places, with adequate food, indoor cooking, separate beds or cots, sanitary toilets and bathing facilities, and a store operated by a concession that sold food and clothing.

Fernandez earned $35 a week. He paid $11.25 for his meals and returned to Oaxaca with $180 in his pocket. He saved more than most. Out of his total earnings in the United States, the average bracero managed to keep about half. Ironically, any bracero meeting with misfortune on the job would have fared much better. A bracero who died, lost both hands or feet, or one hand and one foot, or was blinded while on the job was entitled to $1,000 in compensation. A bracero who lost one hand or foot received $500. A severed finger earned $50.[1]

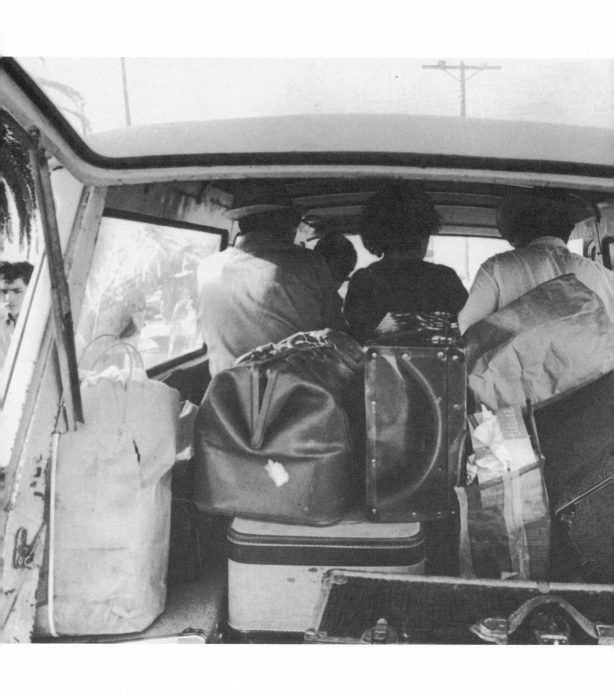

15. Mordida

Francisco (Pancho) Fernandez did well. Like most braceros who went into debt for the cost of travel and *mordidas* (bribes), he was an especially pliant worker. Regardless of the abuses he suffered, Fernandez was determined to repay his debts. After briefly returning home, he resolved to remain in the United States.

Braceros like Fernandez often sat idle for many hours each day, and sometimes for weeks when bad weather delayed harvest work or growers contracted for too much labor. Many braceros were charged room and board during these slack periods. They repaid their debts out of future wages, an arrangement often compared to debt peonage. Throughout the 1950s, one investigation after another concluded that braceros like Fernandez worked under an arrangement that effectively repealed the law of labor supply and demand and turned them into captive laborers.[1]

One field hand who had been picking cherries for a generation looked back on the changes that he had experienced and told a fact-finding committee, "I remember in 1948, when they didn't have any braceros, we got $1.10 a bucket. Then . . . after they ran the [Mexican] Nationals in, the price went down to 85 cents a bucket and even lower. Just the last couple of seasons, it finally got back up to where it was 14 years ago."[2]

43. "Possessions of a worker walking out of the labor camp." Winter 1966.

Of the chaotic conditions and indignities that braceros routinely endured at the Chihuahua recruiting center, Ernest Hover, chief of the examinations branch in El Paso, observed how on May 31, 1956,

> some 4,000–5,000 braceros gathered outside the head-high stone wall of the Compound where the processing is conducted. The outside area has several *loncherias*, sanitary accommodations, and in the town and nearby are dormitory facilities . . . The guardians of the gate to the Compound are the typical nondescript military of our sister republic. A general commotion among these braceros develops periodically during the day when the [Mexican] government announces by loud speaker the municipality whose registrants will be called. If the number is large, the gate is soon blocked, and the wall is surmounted by a line of braceros who race to the announcing booth. As the names are called, and checked against the list, each bracero is issued a numbered colored slip, 4 inches by 6 inches, known as the *ficha*. They then queue up before the Department of Labor screening team, presently three in number. Each by this time has extracted an array of documents of varying size which thereafter continually get out of hand, being dropped . . . waved, clutched, and crumpled at various stages in the process . . . A truly inventive character extracted his folded dossier from a Prince Albert tobacco can.[3]

As the numbers of braceros grew from 500 the first year to over 40,000 in 1952 and 65,000 in 1964, California growers succeeded in creating an agricultural proletariat that perfectly suited their needs. Whereas most farm labor had once been performed by Mexican families, Filipino American men, and "Okies" who had on occasion challenged the agricultural industry, now the new and more compliant braceros handled the work. With the Okies gone, the Mexicans and Filipinos were left to contend with braceros and growing numbers of non-English-speaking undocumented campesinos who lacked basic rights and could not engage in collective action.

Out of this came a self-fulfilling farm labor market prophesy. Like clockwork, growers asked for a certain number of workers for a certain period of time, then the U.S. Employment Service (USES) officials certified a labor shortage at prevailing wages and provided their Mexican counterparts with a three-day notice specifying the required number of workers. Aspiring braceros obtained permits from local Mexican officials, usually paying a bribe of $50 or more. Men with permits traveled to recruiting centers to compete for the same job with other workers. At the recruiting centers, aspiring braceros often paid a second bribe to get in line for an opening. Employed in the fields, braceros earned the prevailing wages paid by an industry that benefitted from an artificial oversupply of labor.[4]

Desperate and far from home, braceros were entirely dependent on growers, grower associations, and their agents. They had no cars and could not travel freely. Other than the occasional Sunday trip to town by bus or in the back of a truck, they remained on isolated labor camps. The general public never saw them. Braceros who grumbled or protested risked being sent south.

All but abandoned by federal agencies and Mexican consular officials, braceros toiled in the fields for the season and then returned home. Their reward for being disposable workers was to do it again the following year. Up to half of the braceros in some of the worst areas and most miserable camps walked away.[5]

At its apogee, the bracero program — which was in fact a sequence of programs born of administrative fiat, approved by Congress, and nurtured by executive agreements — propelled half a million men into the fields. One in five went to California.

As the braceros arrived, more and more domestic workers left. Because so many domestic workers left, growers appealed for more braceros.

Provided with a deep reservoir of cheap, docile bracero labor — and an even larger army of undocumented Mexican laborers — growers dictated working conditions, hours, wages, and living accommodations.

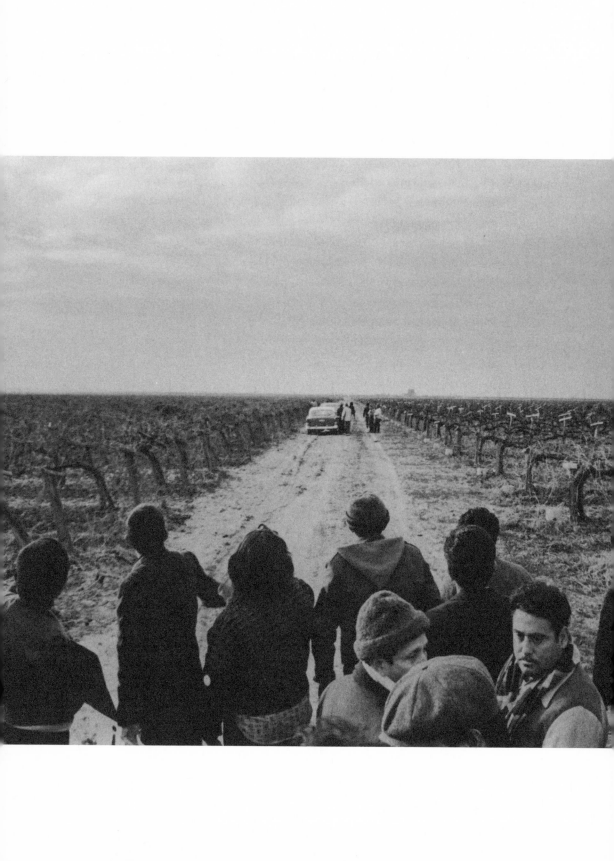

16. Unions

During the late 1940s and throughout the 1950s, a succession of unions attempted to revive the farm labor movement. None survived.

Their sad story began with the National Farm Labor Union (NFLU). A spinoff of the Southern Tenant Farmers Union (STFU), the NFLU obtained a charter from the American Federation of Labor to form a national union of farmworkers. It immediately set its sights on California's 5,939 farms that were over 1,000 acres in size.

On September 1, 1947, Local 218 of the NFLU called a strike at DiGiorgio Corporation's giant Bear Mountain Ranch near Arvin in the southern San Joaquin Valley. Annually producing 10 million boxes of fruit and 500,000 boxes of vegetables worth over $24 million, Bear Mountain Ranch was the largest farming enterprise and second-largest winemaker in the state.

With five hundred permanent employees and several thousand temporary harvest hands, the ranch, along with dozens of other DiGiorgio operations stretching from Borrego Springs in the south to Marysville in the north, appeared to offer a prime target. Succeed at DiGiorgio, thought NFLU organizers, and the rest of the farms would follow.[1]

In theory it seemed like a good plan. But in fact the NFLU failed to fully consider the character, background, paternalistic

44. "First time on the picket lines. All I remember is how cold and lonely it was out in those bare vineyards. In the distance you could hear the snip, snip, snip of the pruners as they worked their way down the vine rows. We'd yell at them when they got to the end." Winter 1966.

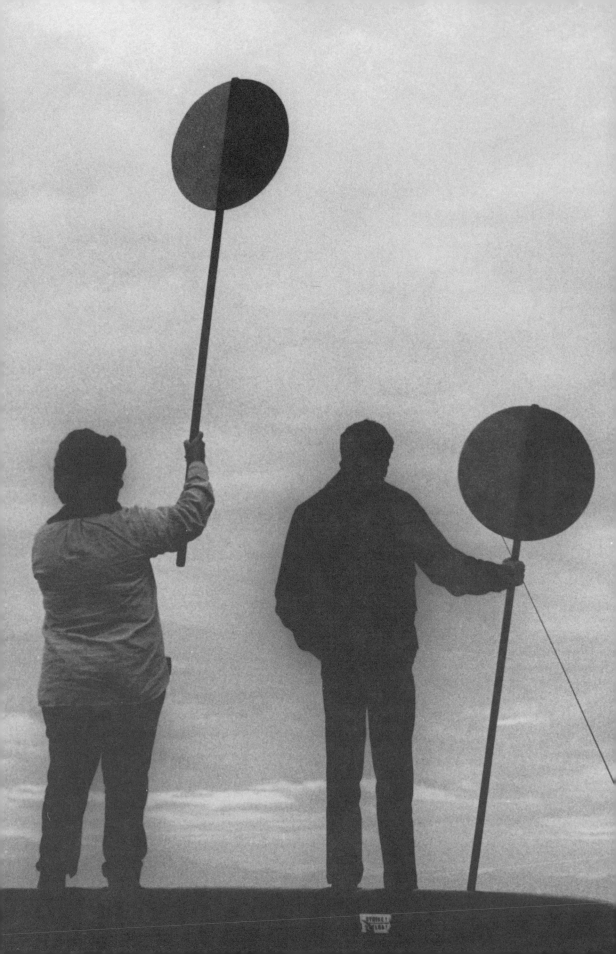

resolve, iron will, and above all, concern for public opinion of company president Joseph DiGiorgio. Variously described as "the Kublai Khan of Kern County" and a kind of mafioso "accustomed to controlling everything that was said, thought, and seen," DiGiorgio tenaciously defended his vertically integrated, family-run, $231 million agricultural empire.[2]

NFLU members were beaten, and Local 218 leader James Price was shot while conducting a meeting in his Arvin cottage. Under the watchful eye of deputy sheriffs, braceros harvested DiGiorgio fruit, even though their contracts prohibited them from acting as strikebreakers.

California Republican Richard Nixon's ruthless cross-examination of NFLU organizers before the House Education and Labor Committee tarred union leaders as "outside agitators" and "communist sympathizers." Remarks denouncing the NFLU as a sham and the strike as nonexistent were introduced into the Congressional Record by a politician friendly to DiGiorgio, then passed off as an official report.

Over two and a half years, DiGiorgio attorneys bled the NFLU dry. As part of a libel suit settlement ending the strike in May 1950, they forced the union to withdraw and destroy all copies of *Poverty in the Valley of Plenty*, a film documenting the plight of California farmworkers.[3]

45. "Pickets would often stay on the line as long as there were workers in the field." Winter 1966.

17. AWOC

The lessons seemed clear. Challenge agribusiness and you could expect to be slandered, shot, arrested, fired, hauled before a congressional committee, and driven into bankruptcy. Unions quickly absorbed the message. Galarza abandoned active organizing. He had little support from the AFL. He could not call strikes when he knew that workers would certainly lose their jobs to braceros.

Because farmworkers could not form a successful union or improve their conditions unless the bracero program was abolished, Galarza and the United Packinghouse Workers Union (UPWU), which had been trying to organize shed workers, spent most of the 1950s publically documenting the abuses of the bracero program. This brought few immediate results. By 1959 Galarza's union, now renamed the National Agricultural Workers Union (NAWU) held no contracts and had few members, no organizers, and no money.

After NAWU merged with the meat cutter's union and ceased to exist, the AFL-CIO executive council formed the Agricultural Workers Organizing Committee (AWOC). Jack Livingston, AFL-CIO director of organizing, and his right-hand man, Franz Daniel, headed west to create eight to ten small, independent unions, each with about two hundred members.[1]

Norman Smith, the stocky, cigar-chomping, sixty-one-year-old, 250-pound former supervisor at the Kaiser Steel mill in Fontana handled organizing. Smith wandered around the countryside, only to return empty-handed. As crew members piled into busses, vans, and cars and scattered in every direction at the end of the work day, AWOC organizers stood by with no idea how to organize such a distended, unstructured, and mobile labor force.[2]

Even if organizers had been able to make contact with farmworkers, AWOC would have fared poorly. It was a union of outsiders, mostly non-Spanish-speaking gringos, in a Hispanic work environment. Few came from the barrios and colonias where farmworkers lived.

Rather than establishing a grassroots organization, Smith and his lieutenants

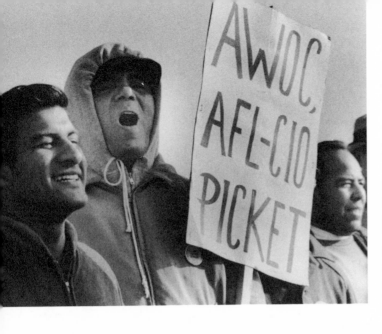

46. "One of the first days on the picket line. The men were yelling at a crew pruning vines. The workers were too far inside the vineyard, so I focused on the pickets. I made two shots, one horizontal, one vertical." Winter 1966.

did something bizarre. They abandoned the fields and the small farmworker communities and concentrated on the one place where farmworkers gathered — near the Farm Placement Service Offices, deep in the Skid Row section of Stockton.[3]

Every morning thousands of so-called "day-haul" laborers — winos, hoboes, transients, and other down-and-out single workers — poured out of the cheap rooming houses and lined up along the streets where labor contractors offered jobs to anyone who could climb the bus steps or make it into the back of a truck. For a dollar, the men were trucked to and from the fields, hence the term "day-haul."

Hardly receptive to labor organizing, the day haul laborers collected their paychecks and disappeared, leaving Smith with nothing to show for his efforts. AWOC took over spontaneous strikes by "ladder workers" in cherry, peach, plum, and olive orchards, and by Filipinos in the asparagus fields. Most of the strikes failed.

When it became clear that AWOC could not succeed as long as growers could use braceros to keep wages low and undermine organizing activity, Smith and the UPWU launched seventeen strikes designed to force the U.S. Department of Labor to invoke provisions against employing braceros in farm labor disputes. But it was too late.

The end came early in 1961, near El Centro, in the Imperial Valley, during a two-month lettuce strike, when hundreds of union members were arrested for picketing outside of the Danny Dannenberg labor camp. After the harvest, when crews moved north to the Salinas Valley, the threat of additional strikes caused one large lettuce grower, Bud Antle, Inc., to sign a contract with the International Brotherhood of Teamsters. The Teamsters loaned the company $1 million. Bud Antle then embarked on a massive campaign of expansion and modernization. This so angered the Salinas Valley Growers-Shippers Association that it booted Antle out of the group.[4]

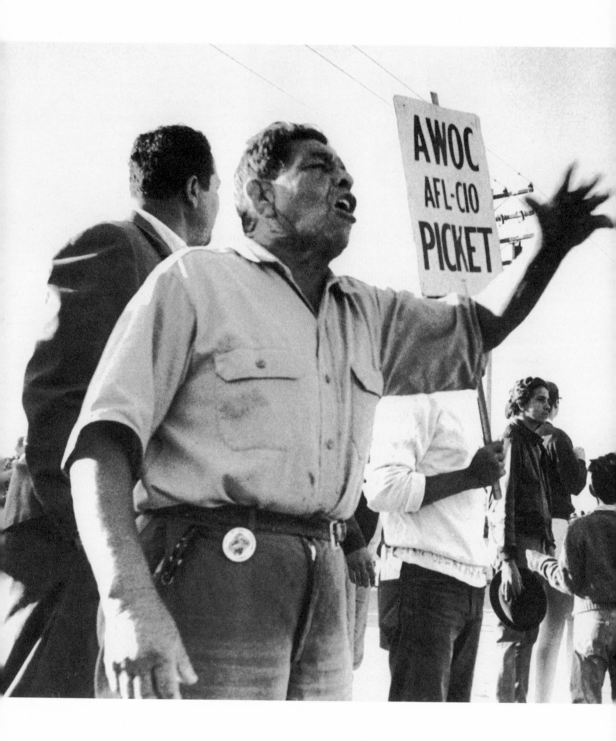

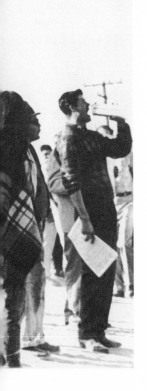

18. AFL-CIO

Convinced that AWOC was a lost cause, AFL-CIO President George Meany was about to pull the plug on the union when a bold cadre of tough Mexican American and Filipino American men stepped forward.

Along with a few members of the AWOC staff, they convened a conference in the small farm town of Strathmore. Assessing themselves $2 each, they dispatched a delegation to plead their case before the AFL-CIO midwinter convention in Miami Beach.

One of the four delegates sent east was Mrs. Maria Moreno, the mother of twelve children. In an impassioned speech to the full convention, Mrs. Moreno listed AWOC's accomplishments: a rise in farm wages of 25 percent over 1958 levels, a decreasing number of braceros, and a growing awareness of the problems faced by the state's farm laborers.[1]

In June 1963, Meany replaced Norman Smith with Al Green, a grizzled, cigar-stump chewing, Stanislaus County labor organizer for the plasterer's union. Armed with an infusion of $500,000 to assist his organizing efforts, Green immediately alienated everyone by dismissing Mrs. Moreno (for inadequate bookkeeping) and research director Henry Anderson. He then proceeded to organize not farmworkers but rather skid row labor contractors, who agreed to deduct AWOC dues from transients as they climbed into labor buses and trucks each morning.[2]

47. "Señor Huerta from Earlimart had center stage on the [picket] line one day and he ignored me for 10 to 12 frames, which I put to good use in my film *Nosotros Venceremos*, where the stills are intercut to his actual voice that day." Summer 1966.

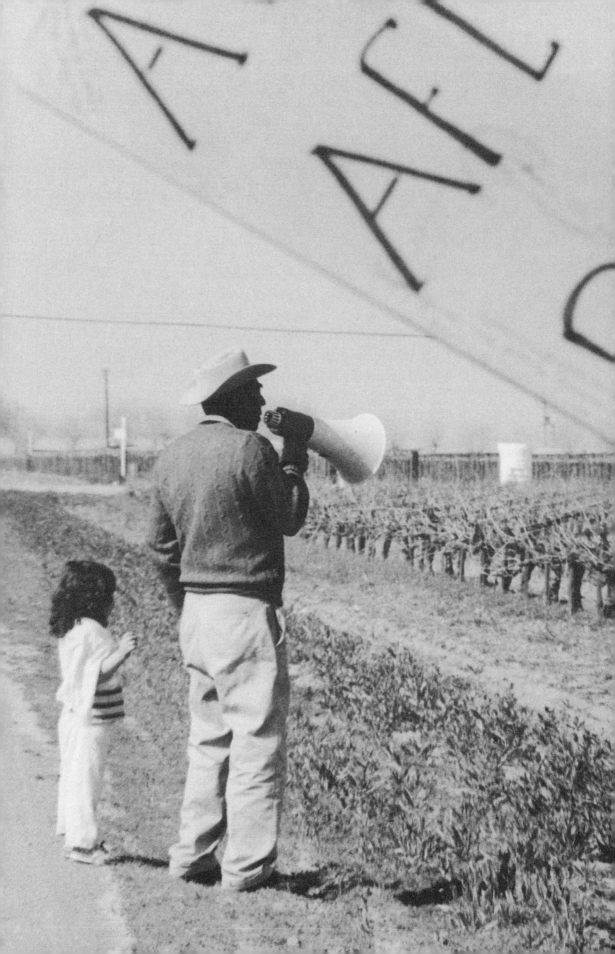

Less successful in establishing a viable farm labor union than his predecessors, Green helped to register thousands of farmworkers whose votes helped defeat Richard Nixon and elect Pat Brown as governor of California in 1962.[3]

Only the Filipino members of AWOC — led by Andy Imutan, Ben Guines, and Larry Itliong — remained as a viable and cohesive force. A tenacious bunch who lived and worked together, spoke little English, and depended on crew leaders to communicate with their employers and the outside world, the Filipinos were strong forces on farms around Delano and other Central Valley farm towns.[4]

While AWOC floundered, other forces were gathering strength. Bard McAllister, a community organizer supported by the American Friends Service Committee, established grassroots projects in a dozen small communities, where farmworkers first pushed for water and sewer districts, paved sidewalks, and then, after achieving specific local goals, expanded into larger regional projects.

At the same time the California Migrant Ministry (CMM) dispatched a team of migrant ministers. Led by Wayne Hartmire, CMM went far beyond the specific duties tending to the spiritual needs of migrants and attacked the social ills that kept workers impoverished, malnourished, and unorganized.

CMM soon linked up with Fred Ross and the Community Service Organization (CSO), an activist organization that specialized in mobilizing poor people on the grassroots roots level. CMM, CSO, and a small band of activist Catholic priests sponsored additional campaigns that improved city services in the barrios and colonias, exposed abuses of the bracero program, and forced the Farm Labor Placement Service to hire local workers first.

CSO efforts spilled over into labor organizing in 1962 when a thirty-eight-year-old farmworker named César Chávez resigned and began laying the foundation for a campaign that would finally bring countervailing power in the fields.[5]

48. "Sometimes it seemed so futile. There was nothing going on to the right other than those bare vineyards. You couldn't see the crew that the man and his daughter were yelling at. So I filled the frame with a union flag. Standard trick. I wonder if the little girl remembers that day." Winter 1966.

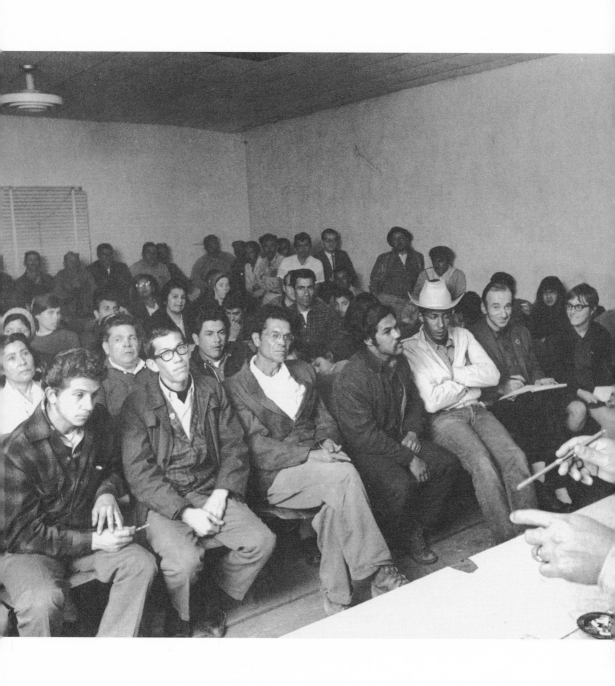

19. Chávez

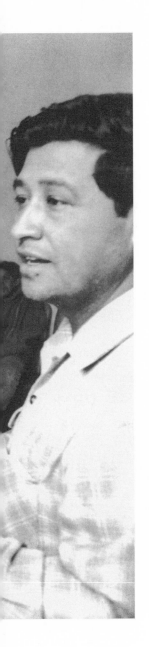

A deceptively small, soft-spoken man with tiny hands and jet-black hair, César Chávez did not look like a labor or civil rights leader. He was a boyish, sad-eyed, shy man. He wore plaid shirts open at the collar, favored dark work pants and scruffy shoes, and spoke in calm, measured tones. He could easily disappear in a crowd.

Born in San Luis, Arizona (a small community twenty miles north of Yuma), in 1927, Chávez was a child of the Great Depression. He had learned the lessons of farm labor the hard way, drifting with the seasons, living for a while in Brawley, then Delano, Mendota, and San Jose.[1]

By the time he dropped out of the eighth grade, Chávez had attended so many schools that he could not count them — somewhere between thirty and forty — mostly segregated. During the winter of 1939 the Chávez family had been stranded in a tent while picking peas in Oxnard.

Years spent weeding fields caused Chávez to hate the short-handled hoe, *el cortito*. He opposed open borders, watched how undocumented workers were used to drive down wages and undermine unions, hated the bracero program, and despised labor contractors with a special passion reserved for those whose

49. "The first union meeting hall was a rented storefront church for the Friday night gathering. It wasn't until that summer before the two unions merged that meetings shifted to the Filipino Hall. Much more spacious, but still on the west side of town. I was using the strobe." February 1966.

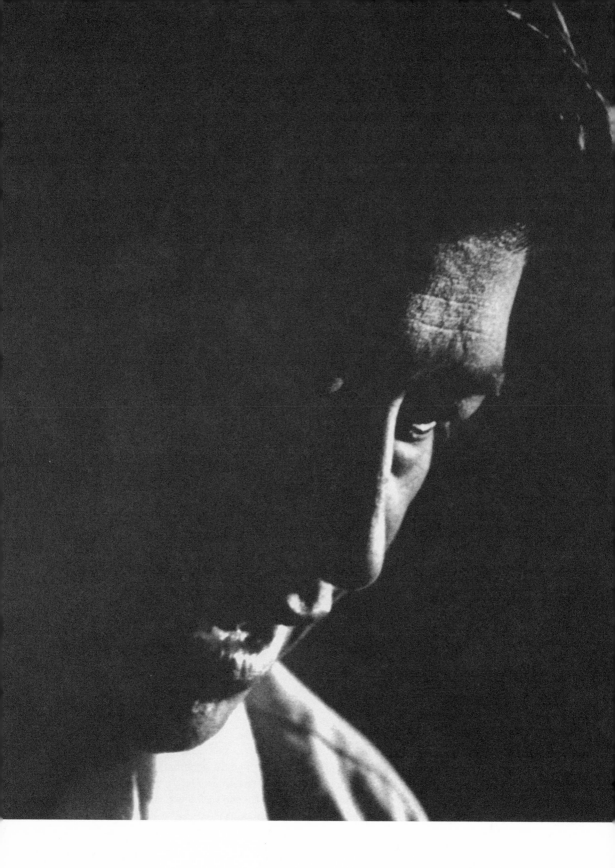

meanness one never forgot — in particular a Fresno contractor who skipped out after the Chávez family had spent seven weeks picking wine grapes.[2]

While living in the San Jose barrio called Sal Se Puedes, "Get Out If You Can," in 1950, Chávez met Fathers Thomas McCullough and Donald McDonald, the "bracero priests," the former at St. Gertrude's Parish in Stockton, the latter in the San Jose Mexican barrio. McCullough and McDonald educated Chávez about farm labor history and introduced him to Fred Ross, who was then organizing local CSO chapters. Chávez joined CSO in 1952 and was soon busy registering Mexican American voters and organizing CSO chapters all over the state.[3]

By 1958 Chávez was in charge of the entire CSO effort in the San Joaquin Valley. After adding three hundred thousand new Mexican American voters who cast their ballots mainly for the Democratic Party, Chávez began pressuring the CSO to concentrate on building a union of farmworkers.

In December 1962, when CSO officials refused to go along, he resigned as director. Chávez turned down an offer of $21,000 a year as a Peace Corps director of operations in four Latin American countries and moved to Delano, where he settled with his wife, Helen, and their eight children. That winter he earned $1.25 an hour pruning grapevines.

50. "I kept passing over this on the contact sheet as there's a big out-of-focus bar along the side of his head. Cropped and enlarged, it's my favorite pix of César." Summer 1966.

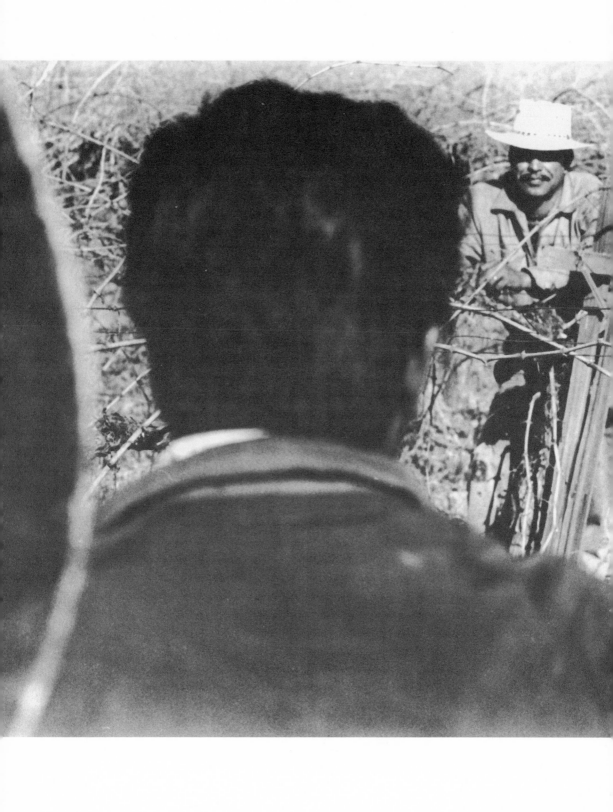

20. Organizing

During the spring of 1963, Chávez made a three-week tour of the Delano-area agricultural districts. Entering the fields under the pretext of asking a foreman for work, he would talk to field hands about the issues that mattered. Chávez later explained to an interviewer:

> People would put their heads down and they wouldn't answer. They'd just work harder. Some . . . didn't even know what the word "union" meant . . . they agreed it was a good thing, and I would take their names, if they would give them. I went from field to field during the day, and in the evening I would drive into the barrios and colonias and go around to the grocery stores and the bars, where the people usually were. I had some leaflets with me, which had a cutoff section on the bottom, where people could mark if they were interested and mail them.[1]

Fewer than one hundred people sent back the leaflets. They had limited aspirations — a dime an hour more, toilets in the fields, ice water, and a rest break. Only a few scribbled their names.

51. "I didn't care to describe a strikebreaker as a "scab" in the Jack London sense. By the time I got in the strike's fourth month, the growers were bringing in crews from outside the area, some from as far away as Texas and Mexico, without telling them a strike was in progress. They [replacement workers] were providing for their families and it is hard to vilify a man for that." January 1966.

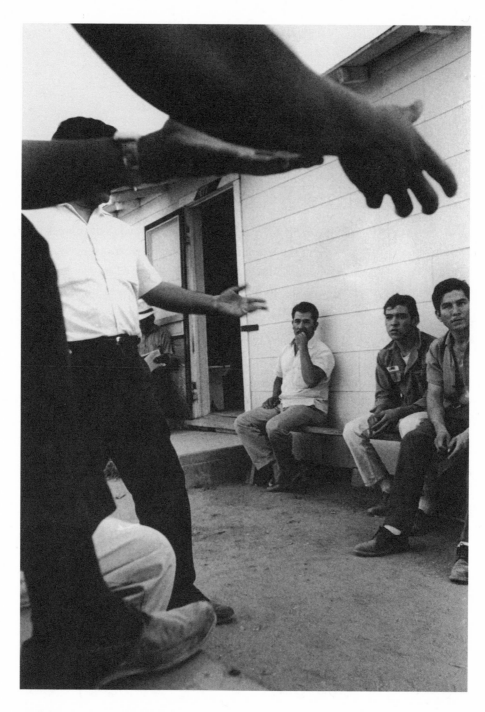

52. "Eliseo Medina and Eddie Perez organizing in a labor camp." Summer 1966.

From this core group, Chávez hoped to organize migrants into the Farm Workers Association (FWA), a quasi-union organization. He purposefully omitted the word "union" from the title, steered clear of strikes, and focused on local, specific, attainable bread-and-butter issues like fighting rent increases and decrepit housing in labor camps.

Chávez did not want to create a top-down effort. He believed that he could not succeed without complete support from the community.[2]

Because he could not do it all alone, Chávez enlisted the aid of Dolores Huerta, another CSO organizer, former AWOC member, and schoolteacher. Joining them as the core of FWA were Chávez's wife, Helen; his brother, Richard, and cousin Manuel; former bracero Antonio Orendain; jack-of-all-trades and former labor camp operator Julio Hernandez; CMM minister Wayne Hartmire; stern-looking Union Theological Seminary graduate James Drake; Citizens for Farm Labor volunteer Bill Esher; and student volunteer Eugene Nelson.

Operating out of the garage in the home that Chávez rented on Kensington Street, the small group fanned out through the Valley and initiated house meetings. For printing they had only an old mimeograph machine. On hot days, the ink would melt off the machine and form a huge black blob.

Chávez talked about creating a credit union, a gasoline station, and helping people with their immigration documents, developing services that met the immediate needs of the people. His real goal was building a sense of trust and unity and common purpose necessary for achieving a measure of political and economic power.

A lot of leaders had already come and gone. But Chávez was different from his predecessors. Unlike them, he was a farmworker. He had no other profession to fall back on. He intended to remain on the job until it was finished or until the job finished him.[3]

By September 30, 1962, when the FWA called its first convention of 250 members in Fresno, many of the people and organizations destined to play key roles in the farmworker movement were in place. FWA barely survived. By June 1963, only twelve families remained, half related to FWA officers. House meetings continued, and by 1964 FWA had a thousand families in seven counties.

Now self-supporting, Chávez and Huerta earned $50 a week. César's wife, who ran the credit union, earned $40. To underscore its broad goals, FWA became the National Farm Workers Association (NFWA).

21. Huelga!

All that was needed to ignite a farmworker movement was a dramatic event. This came on September 17, 1963, when the driver of a crudely converted truck packed with braceros collided with a speeding freight train at a crossing along the Southern Pacific tracks near Chualar, in the Salinas Valley. Thirty-two braceros died in a fiery crash, the latest in a long series of such bloody catastrophes.

On December 31, 1964, Congress allowed Public Law 78 to lapse into history. It had become indefensible to argue in favor of a program to import foreign labor at a time when African American activists were being clubbed, arrested, and murdered, and more than four million citizens were looking for jobs.[1]

The following May, when several hundred braceros were allowed to harvest table grapes in the Coachella Valley, Larry Itliong, Ben Guines, and the Filipino American members of AWOC stormed out of the vineyards. Because the Coachella Valley harvest season was short and frantic, growers could not afford any disruption and quickly agreed to pay $1.40 an hour and 25 cents a box — exactly what braceros had earned.[2]

Sporadic strikes erupted as the harvest moved north to Arvin, in the San Joaquin Valley, where growers offered $1.25 an hour and 10 cents per box. Filipino workers did not behave like mainstream unionists. Striking for wage hikes but not union recognition or contracts, their tactics resembled those of the Industrial Workers of the World, not the AFL-CIO.

Although they failed at Arvin, the Filipinos did not give up. When the harvest reached Delano on September 8 they demanded the same wages that they had received in the Coachella Valley.

Invisible for the past two years, Chávez believed that he was at least three years away from any strike action. He had exactly $25,000 of worker funds invested in his credit union, a few rented offices in neighboring towns, some service centers, and a $1,000 burial insurance program. Earlier in the year workers who grafted roses west of Delano had gone on strike, and Huerta had thrown herself into the

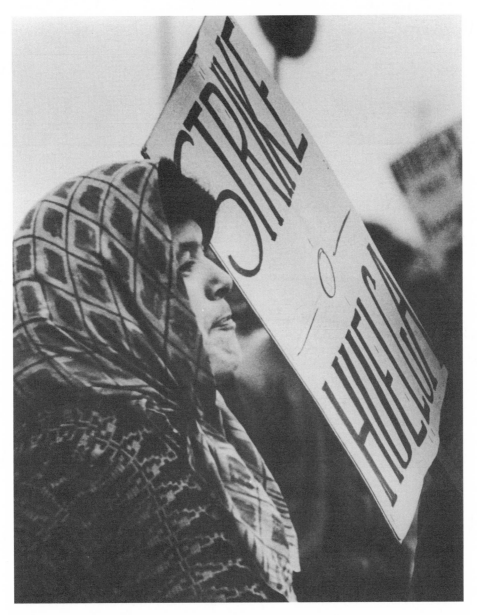

53. "How could I pass up that face. Such determination, out there in the cold, on the picket lines, in the winter." Winter 1966.

cause, only to be defeated when growers broke the strike by importing unskilled workers.

Chávez feared a repeat. He had no broad support in the community. His organization was far too small and weak to take on the table grape industry. As he pondered whether to jeopardize his young organization, Itliong called a sit-down

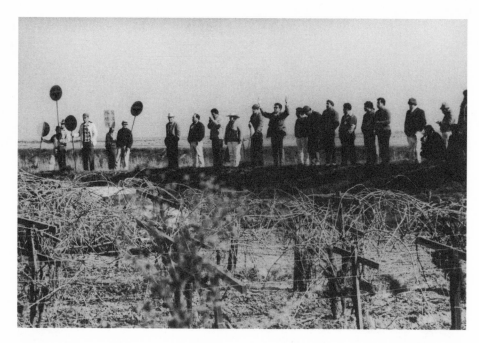

54. "You usually couldn't get a frontal shot of the picket line without trespassing. This was from a junction of the roads. I should have gone in and gotten closer, but the police were monitoring activities." Winter 1966.

strike in the Filipino camps. He had no support from the AWOC leadership, most of whom were away in the citrus groves trying to cut a deal with the Teamsters for a joint organizing drive. One day later, Chávez announced that he would ask NFWA members to join the strike.[3]

On Saturday, September 16, 1965, one thousand Filipino and Mexican grape pickers packed into the parish hall at Our Lady of Guadalupe Church in Delano. Gilbert Padilla and Antonio Orendain warmed up the crowd. Chávez took the stage. Surrounded by posters of Emiliano Zapata, the Mexican revolutionary hero, and huge red Huelga (Strike) banners with the NFWA black eagle in a white circle, Chávez spoke about the history of resistance to tyranny. Workers stepped forward to explain where they came from in Mexico and why they supported the strike. Chávez then asked for a strike vote. The hall erupted in pandemonium. Farmworkers chanted in unison "Huelga! Huelga! Huelga!"

No one realized that the Filipino grape workers, Mexican activists, and agglomeration of church activists and college volunteers had set in motion events that would envelop an entire industry, polarize rural communities, reverberate across the United States for generations, and emerge as the Chicano counterpart to the African American civil rights movement.[4]

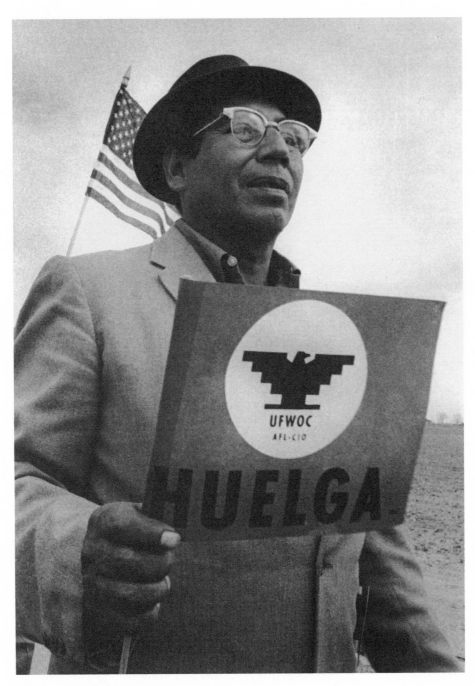

55. "A year after the march on Sacramento we had just a two-mile march to dedicate the Forty Acres facility. Here Felix Zapata carries the sign of the newly merged unions, now the United Farm Workers Organizing Committee." Spring 1967.

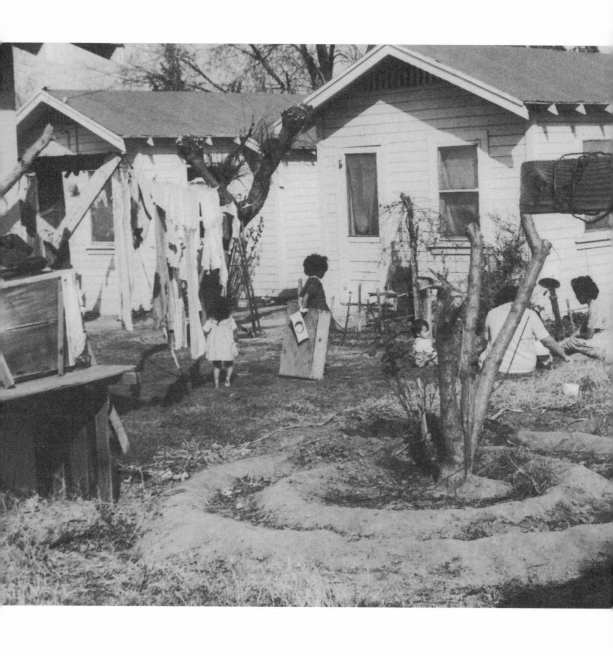

22. Delano

All of this seemed vague and unreal to Lewis as he sped across the Valley in the fall of 1965. An hour south of Westley, where the glow of suburban lights finally dimmed beneath a thickening tule fog, Lewis spotted a large WELCOME sign announcing the principal local crop in Patterson, self-proclaimed "Apricot Capital of the World." A half-dozen other illuminated signs along the road proclaimed this or that canal or crop.

Two hours south, the J. G. Boswell Company ran a 110,000-acre cotton farming operation that spread out over the dry Tulare Lake bed. Essentially a secret American empire, larger than some countries, Boswell epitomized the "factories in the field" that Carey McWilliams had skewered a quarter-century earlier. All around, hidden down the side roads and packed into labor camps, farmworkers existed behind what writers variously described as the "tar paper curtain" and the "tortilla wall."[1]

At Los Banos, Lewis and his buddies caught Highway 152. Fifteen minutes east of Los Banos, where incessant irrigation had created dead zones and nothing grew, fluffy tufts of white, salt-encrusted powder glowed in the moonlight. A few minutes later Lewis looked at the dormant grapevines and previsualized a picture that he would soon make. He would walk into a bare vineyard, crouch down, place the sun behind the vines and cross

56. "Farm labor housing was quite small if you had a big family, so activities often spilled over into the yard." Summer 1966.

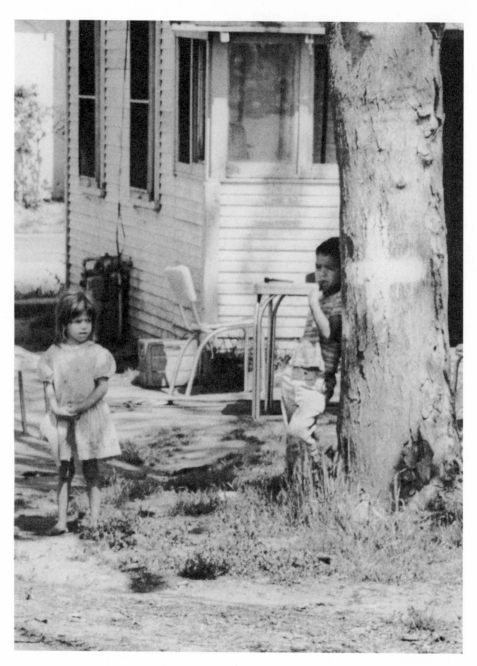

57. "Why they weren't scowling at the gringo photographer invading their backyard, I'll never know. But it was a long lens [135-millimeter portrait] and I didn't linger." Summer 1966.

arms, underexpose the picture, and create a menacing symbol of the farmworker spirit crucified and devoured on the cross of agriculture.

Barreling down Highway 99 south of Fresno, Lewis noticed more illuminated signs. Selma, "Home of the Peach." Kingsburg, "Raisin Capital of the World." And so it went for several hours.

Around 3 a.m., just after crossing the southern boundary of Tulare County, Lewis spotted another sign alongside the highway. "Hungry? Tired? Car Trouble? Need Gas? Stop in Delano" (the name is pronounced with an accent on the second syllable). Ganz took the off-ramp, slowed, and exited into what appeared to be a typical Valley town — flat, insular, but hardly boring.

Located 75 miles north of Bakersfield and 15 miles from Wasco on the Southern Pacific Railroad line, Delano was a community of about 14,000. It dated its beginning to July 14, 1873, when Central Pacific Railroad executives named the southern terminus of their San Joaquin Valley branch line after Secretary of the Interior Columbus Delano.

Until the turn of the twentieth century, the lonely station served as little more than a trading center for sheepherders, a shipping point for wheat and wool, and a stopover for threshers and farmhands looking for a Saturday night watering hole. As late as 1906, the town had fourteen bars and one grocery store.

Much of the surrounding countryside was a wasteland of saline flats studded with Russian thistle. With an annual rainfall of between six and seven inches in wet years, it was good for little other than cotton farming. During the fall, tumbleweed, dried jimson, burned sage, and cotton snagged on any obstruction to form huge grass and lint soccer balls kicked around by unseen giants.[2]

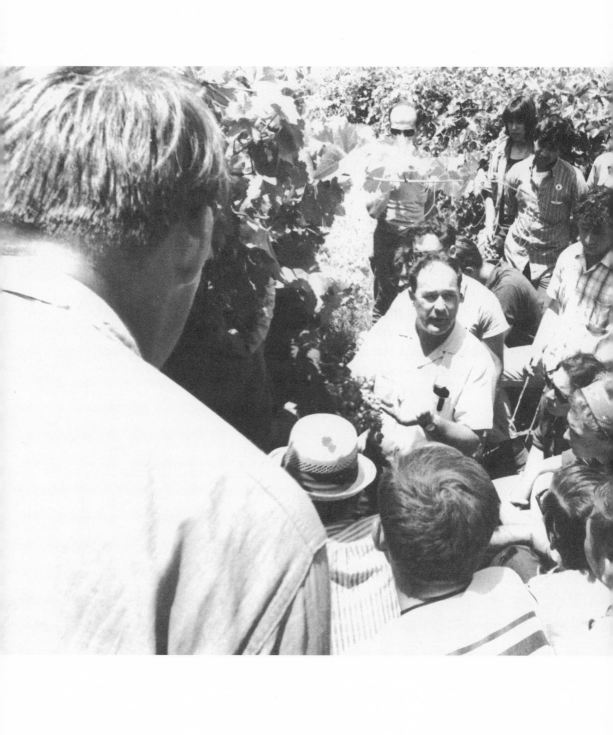

23. Growers

Delano emerged as a viticultural district in the 1920s and 1930s, when Croatian immigrants purchased farm land for $125 to $150 an acre — some of the last good farmland in the state. For years they ripped out scrub brush and sage, leveled the land, dug irrigation canals, and punched down wells.

The immigrant farmers worked hard and had big plans. By the late 1920s they had established on the east side of town a tight-knit Croatian enclave.

Within a generation Delano emerged as the vintage area for growing table grapes, where land and climate combined to produce the highest yields and the best-tasting fruit. "Grapes are what Delano is all about," wrote George Horowitz when he arrived there to report on the grape strike, "for wineries, canneries, fruit sands, mess halls, school children's lunch boxes, picnic baskets, and embassy banquets."[1]

In 1955, Highway 99 was extended through the town, and most of the honky-tonk district was demolished. When the deep wells started to run dry, water from the Central Valley Water Project via the Kern-Friant Canal allowed growers to expand their operations. Although water cost $700 per acre-foot, growers paid only $123. By 1965, the average grape farm in the area spread over 2,000 acres. At the center of each farm stood a packing plant, cold storage and box-making facilities, and sales and marketing offices.[2]

58. "Grower Jack Pandal was on the schedule of the summer student volunteer orientation. One of the few times they could set foot in a vineyard." Summer 1966.

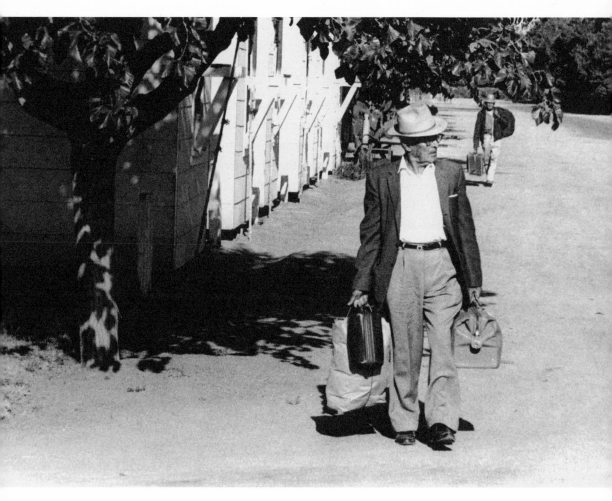

59. "A worker leaving DiGiorgio's Sierra Vista Ranch. Of a certain age with uncertain prospects, he walked with an immense dignity and commanded our respect." Summer 1966.

Croatian grape growers were proud and clannish. Their language and customs isolated them from the larger community. Their names were Pandol, Pavich, Duelich, Lucich, Caric, Divizich, Lucas, Radovich (Jack and Gene), Caratan (A. and M.), Dispoto, and Zaninovich (George, Marion, Marko, and Vincent).[3]

During the 1930s, sons of Dust Bowl refugees had started working for them as grape pickers; now they were foremen and supervisors. Labor contractors — lay preachers, tavern operators, storekeepers, and café owners — recruited, fed, and housed many of the vineyard workers. One farm labor contractor served on the school board. Another, Al Espinoza, was a police captain.

Too many contractors cheated both the farmer and worker. One charged 50 cents for a canned dog-food sandwich passed off as meat loaf. Another sold a 35-cent "pony" of wine for 41 cents. Others charged 75 cents for a pack of cigarettes and 35 cents for a soda.

Once farmworkers themselves, labor contractors seemed to have forgotten their roots. Squeezed by the growers, they squeezed the farmworkers. Several were notorious for collecting Social Security deductions and keeping the money. Contractors routinely failed to provide clean, cool water in the fields, sold bottled cold drinks at marked-up prices, and charged an arm and a leg to shuttle workers to and from the harvest in dilapidated vehicles.[4]

During the winter, contractors supervised hundreds of grapevine pruners in the fog-shrouded vineyards. Each spring, they watched over men who crawled under the vines to increase berry size by using a special knife to remove a narrow "girdle" of bark around the base of each vine trunk. Several months later they sent crews into the vineyards to remove grape clusters, thereby further increasing berry size.

Around August 5, contractors began supervising 3,000 to 5,000 grape pickers. Roughly one-third of them were Filipinos, the rest Mexicans. You could always identify older grape pickers. Crippled by a lifetime spent bending over and crawling about, they walked with a stiff-legged gait and shuffled along with a cane.

To make ends meet, grape pickers followed the ripening crops north. When the grape harvest slowed down, they supplemented their income by harvesting tree fruit. During the winter they drove tractors and replanted old vineyards and orchards.[5]

24. Poverty

Delano's Chamber of Commerce boasted that the town was the most racially mixed and harmonious city outside of Hawaii. Public schools were integrated. The local Cinco de Mayo celebration was covered fully by the town newspaper and received donations from many growers.

Like most Valley towns, Delano was hardly a model United Nations. "A Texan would be at ease in these shirt-sleeve towns like Delano," wrote Idwal Jones in *Vines in the Sun*. "They have no romantic air."[1]

Extremes of poverty and wealth, ethnicity and race, skill and bad luck bumped up against one another in Delano. Anglos lived east of the Highway 99 gulch and the railroad tracks bisecting the town. Here you found four banks; a string of automobile dealerships; upscale motels; supermarkets; the vast high school with huge playgrounds and well-kept basketball courts; an air-conditioned library; a city park; hospital; Lions, Elks, and Rotary Clubs; suburbs of low-slung air-conditioned homes — and not a single bookstore. The journalist George Horowitz saw little that was attractive. "Whatever doesn't look ten years old and already shabby," he wrote, "looks brand new, cheap as dust, and tacky . . . You have to look pretty hard to find something else."[2]

Filipinos clustered into boarding houses, dispersed throughout the vineyards in about sixty labor camps, or settled into a string of shacks hidden behind mountains of rusting automobiles arranged along a low ridge bordering the E. P. Acosta Wrecking Yards beside County Line Road.

Sprawling on the west side of town, where the vineyards gave way to cotton farms stretching clear to the horizon, cafes, poker parlors, worker hotels, a bakery, and bars demarcated the Mexican neighborhood. Residents complained about broken sewers and lack of sidewalks and gutters. City council members, who lived on the East Side, rarely visited or shopped on the West Side. They either did not know of the problems or did not care.[3]

For Mexican farmworkers, Delano might just as well have been the equivalent of Montgomery, Alabama. Recent arrivals, the poorest of the poor, along with

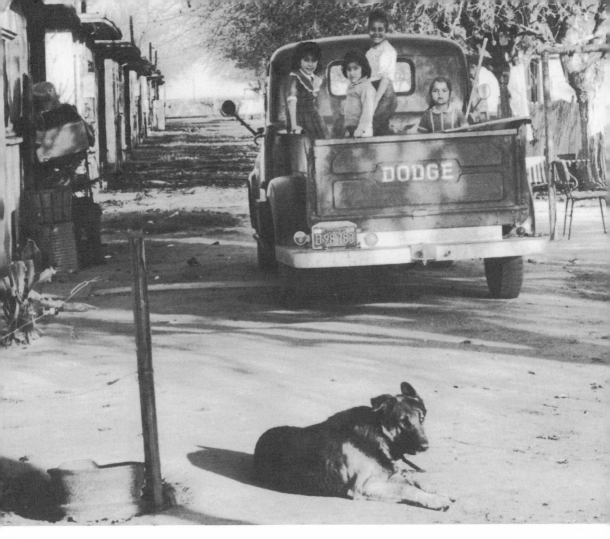

60. "A cluster of housing right by the roadside . . . The dog wasn't particularly menacing, but I didn't approach the truck full of kids as that would have been trespassing. As 'outside agitators' we had to tread lightly as we certainly stood out and were very much out of place." Summer 1966.

undocumented workers delivered by a fleet of rusty school busses and rattling trucks, clustered in run-down camps on the edge of town.

Delano labor camps all looked the same: a store, maybe a gas station, surrounded by houses, reached by way of deeply rutted dirt roads. Arroyo Camp on the west side of town sat astride Mettler Road across from the Delano city dump.

Under the eye of a contractor who often demanded bribes in return for work, field hands housed in camps paid *la mordida*. If you wanted to keep working or hoped for a better job driving a tractor or irrigating fields, you forked over a cut of your paycheck, a gift of groceries, beer, and if desperate enough, your wife.[4]

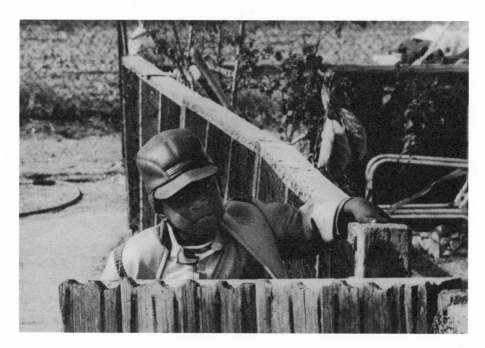

61. "I was prowling the back alleys of Delano looking for still life compositions of things discarded, when this young man appeared at the gate. One exposure and he was off, but I thank him for lingering for that frame." Winter 1966.

Survival required hard work and initiative. Undocumented workers carved out hollows in stacks of baled hay. They made overnight billets in irrigation drains. They crawled through loose floor planks into padlocked sheds.

Legal workers spent their spare moments hammering together shanties, excavating pit toilets, and hauling water for miles to irrigate small gardens in their remote, unincorporated villages. When they earned a little extra, they dug a well and added a room. When they had saved just enough to make a down payment, they found a small house on the West Side, put down roots, and tried to build a more permanent life.

One Delano grape picker, Rafael Vega, told an interviewer in 1966:

I was born in Zamora, Michoacán, Mexico, 47 years ago. In 1942 I came to work in the United States and my first boss was Giumarra. I remember he only used to pay us 75 cents an hour for picking grapes. My second boss was John Pagliarulo. In all the years I have worked in this Valley, I made the round of all the ranches, but this man Pagliarulo was the worst. He's still as greedy as ever, but in those years he only used to farm alfalfa and not grapes. He let me sleep in an old barn of his, without water and light, and in a second-hand bed he discounted from

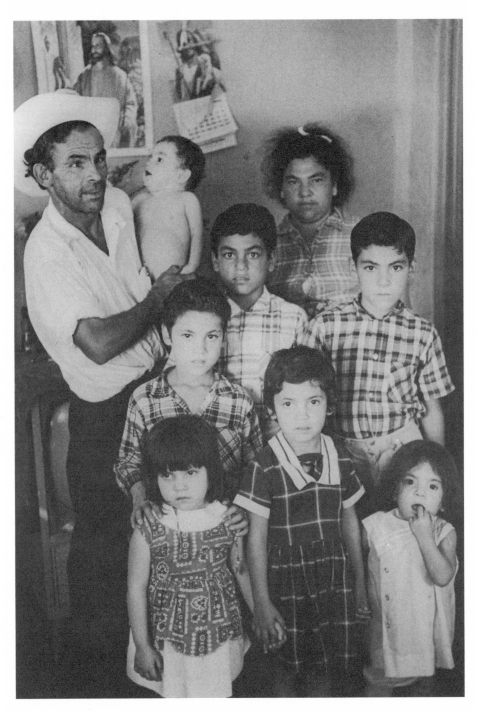

62. "La familia de Felipe Cantú. A mainstay of El Teatro Campesino, Cantú later played 'The Snakeman' in the movie *La Bamba*." Summer 1966.

63. "Cars were crucial and the volunteer auto mechanics invaluable. The state of the facility is indicated by the 'grease pit' below." Summer 1966.

my wages. Since he was such a mean boss I left his ranch one day, and when I came back to get my things, he had a lock on my door. He stole my bed, my clothes, and all that I had. His excuse was that he had lost a lot of things from that barn himself. From there I went to work with Orancio Lanza over at the California Ranch. I worked there for five years, and they fed us food that even a dog wouldn't eat. Because of the lousy food, they forced me to get married, and Rufegia Heredia became my wife. As soon as I got married, they ran me and my wife off the camp, because they didn't want any married couples. They wanted men that could pay room and board. From my marriage were born five children — three sons and two daughters. I had to struggle a lot to raise them because of poor wages. My children wanted food, clothes, money to cut their hair. I had to pay the rent and the payments on the car. My family would get angry with me because they thought I didn't want to give them anything.[5]

Recalling what Delano's farmworkers endured, César Chávez told a Senate Subcommittee on Migratory Labor:

Some people say, write off this generation of parents and hope my son gets out of farm work. Well, I'm not ready to be written off as a loss, and farm work could be a decent job for my son, with a union. But the point is that this generation of farm labor children will not get an adequate education until their parents earn enough to care for the child the way they want to and the way other children in school — the ones who succeeded — are cared for. The average farm worker in Delano has seven children, lives in a house which he rents for $55 a month, makes payments on a car, furniture, and to a finance company. Before the strike, he worked eight months of the year at $1.10 an hour, and his wife worked four months beside him. On weekends and in the summer, his children worked too. This average farm worker buys food at the same store at the same price as the rancher does. And he's not making it. So now these average workers are strikers; they've been willing to lose their cars, furniture, to live on bans and more beans, to work "on the line" seventy hours a week for the right to a living wage.[6]

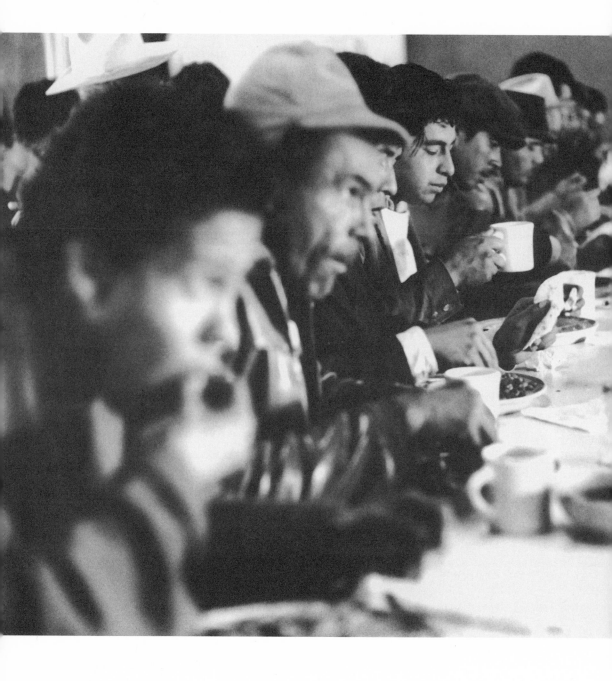

25. Welcome

Except for a few porch lights and yapping dogs, the west side of Delano in the fall of 1965 was dark and quiet as Ganz maneuvered his sports car toward NFWA headquarters, an otherwise nondescript, battered storefront at the corner of 102 Albany Street, in the extreme southwest corner of town. At various times it had served as a grocery store and a Jehovah's Witness hall.

Across the street, to the south, were vineyards, and to the west, the giant Voice of America relay transmission towers. The front of the building was a wreck, permanently patched with plywood after a truck had crashed through the wall. In front of the building, a jumble of dusty automobiles clogged the sidewalk.

Opening the car door, Lewis felt the Valley fog stinging his cheeks and infiltrating his clothes. He reached for his handkerchief, blew his nose, negotiated a maze of automobiles, shooed away several peacocks, and stepped inside an open lobby strewn with folding chairs and a long table covered with leaflets and cans full of cigarette butts. The room was barely lit by a single lamp. Not a soul stirred. A lived-in smell that was one part body odor, one part stale coffee, and two parts cigarette smoke reminded him of his Marine barracks.

64. "There wasn't enough counter space to accommodate the entire picket line, so we'd head in for lunch in staggered relays. The coffee pot was always on, but it could boil down and be quite bitter. As the summer of 1966 progressed and a merger of the two unions [NFWA and AWOC] was at hand, the strike kitchen moved to the Filipino Hall." Summer 1966.

The house was a nest of plywood partitions, mimeograph machines, old desks, door blanks on cinder blocks, typing and note paper scattered about, and empty soda bottles. Sleeping bags were tucked into corners. Well-marked maps lay wide on the floor. Every wall was papered with lists of pickets, picketing sites, telephone numbers, and posters of Ché Guevara, Emiliano Zapata, and Pancho Villa.

At the end of a dark, narrow hallway NFWA kept its offset press. Another room was used for editing its newspaper. Chávez maintained a small office nearby.

Presiding over the chaos was a statue of the Virgin of Guadalupe, patron saint of Mexican campesinos. Also prominent were posters and flags displaying the NFWA's black eagle inside a white circle on a red background. Lewis thought the eagle suggested a bad merger of the New Deal's National Recovery Administration emblem with an Aztec symbol. Growers, he soon learned, called it the "black buzzard."

Lewis could not find a place to flop. Exhausted and needing sleep, he headed to a stucco home known to all as the Pink House. Located behind NFWA headquarters on Asti Street, the Pink House served as a kind of bunkhouse for volunteers.

Stepping over volunteers and strikers sprawled about the floor, Lewis set down his sea bag, rolled out his sleeping gear, and passed a restless night. That morning, still wearing his rumpled clothes, he had the first of many meager breakfasts of strong coffee and tortillas slathered with butter. Soon he was pitching in, typing up forms for NFWA secretary Ester Uribe.

Later that day, Valdéz returned from visiting his parents. Chávez was nearby. Stocky, perhaps a bit underdressed for the biting cold of the Valley fog, he wore a checkered short-sleeved shirt. His eyes were bloodshot. He projected a quiet presence and seemed very much in charge.

Valdéz introduced Lewis to Chávez.

"Welcome," he said. "What do you know about farmworkers?"

"Nothing," replied Lewis.

Chávez asked if Lewis had come to work for the union.

"Oh hell, I don't know," he said.[1]

Even then, in those early days of the farmworker movement, Chávez shared with Martin Luther King and other leaders of the civil rights movement an understanding that photographers could further the cause. He knew how hard his opponents worked to keep the probing lens of photographers away from the fields and regarded photography as a spotlight that could expose what occurred outside public view. Chávez understood that the camera could capture shameful conditions and help demolish exploitation. He would later recall the safety provided by photographers and journalists — "a ring of security," he called it — and the dangers he sensed when they were absent. He also understood that photographers could be employed for

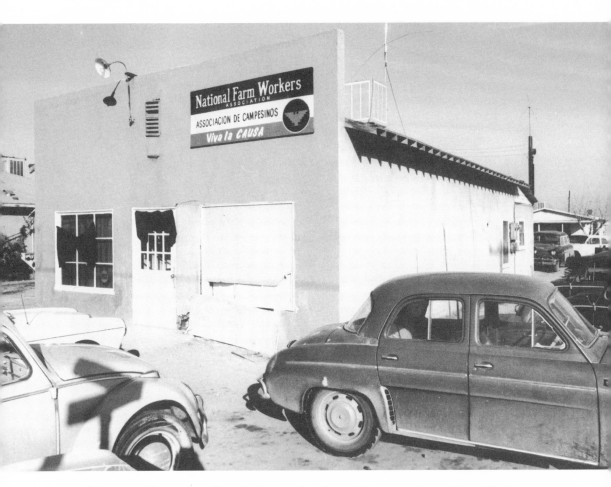

65. "The union office was literally at the farthest edge of town. There were vineyards immediately to the south and west of the building. The black banners on the windows mourned the passing in an accident that weekend of Rodrigo [Roger] Terronez. The clinic at the Forty Acres was later named for him. Terronez was one of the original two hundred NFWA members. Ninety days later, only twelve remained in the NFWA. Terronez was one of them." Winter 1966.

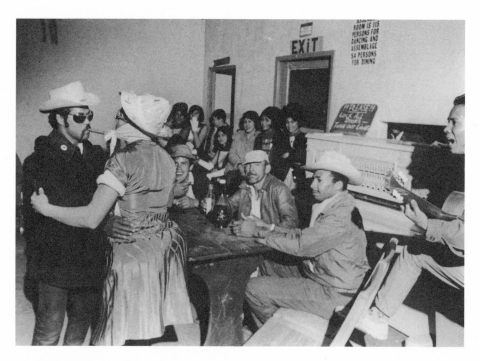

66. "Typical Teatro Campesino performance at the Friday evening meeting in the rented church storefront." Summer 1966.

political and tactical gain, that their images could serve as an important tool for documenting the cause, and that they provided undeniable evidence of the farm labor system's brutality and inequality. Already he was thinking of ways to stage scenes that would be spread across newspaper and magazine pages.[2]

Chávez said nothing about this to Lewis. He gave no directions, offered no advice, promised nothing. He simply faced Lewis.

"Well, check out our movement," he said quietly. "Everyone is welcome."[3]

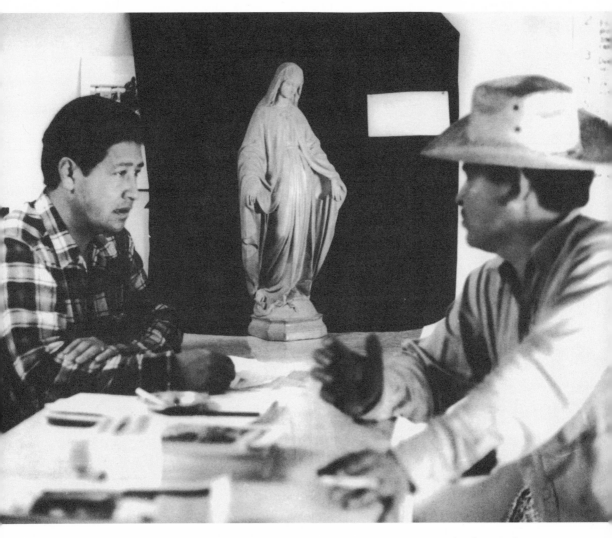

67. "César in his element — one-on-one — with a worker over the front counter at union headquarters." Winter 1966.

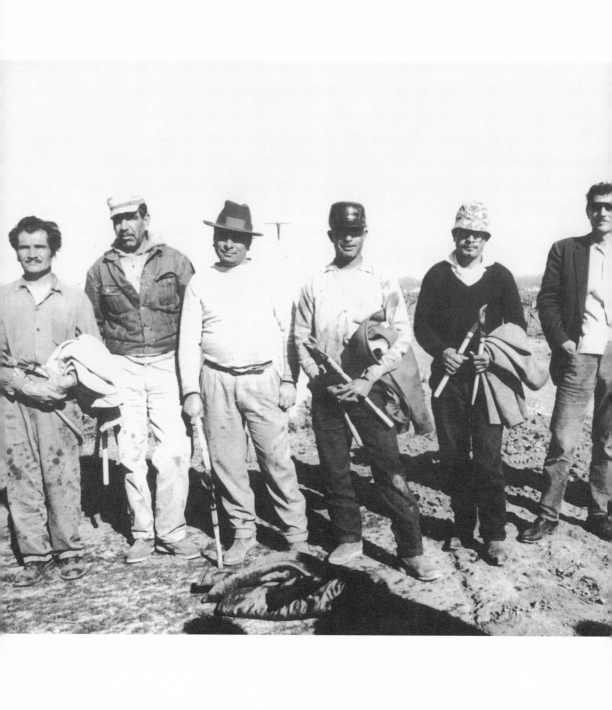

26. Slaves

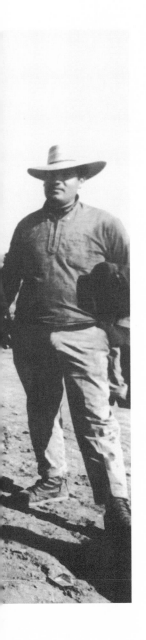

Over the next few days, Lewis got a crash course in farm labor. He learned that grape pickers followed a well-defined harvest circuit. They started picking lime-green early-ripening Perlette table grapes in late May around Thermal in the Coachella Valley. They ended the year harvesting Cabernet Sauvignon wine grapes in Mendocino County in November. None found steady employment. Between May and November they made ends meet by stringing together a succession of harvest jobs picking apricots, nectarines, and peaches. If they were lucky, they might get 250 days of work out of the year. If they were really lucky, they might find another two months of work pruning grapevines and thinning grape clusters.[1]

A typical grape picker earned $1.25 an hour — minimum wage for crouching under the vines and loading boxes of grapes in the hot sun. Older children and wives often helped. Eight of ten families in Delano earned an annual income below the federal poverty level of $3,100. Adults could expect to live to 46 years of age, compared with 69 to 75 for non–field workers.[2]

"We are like slaves," more than one farmworker would tell Lewis. Scholars described them as existing in a "structureless labor market" — meaning no unions, too many workers, unskilled labor, piece rate pay, and little protection under the law. Academic-speak for exploitation.[3]

68. "A crew that had just walked out of the Schenley field. About the only Spanish I could muster was: 'Lista, todos? Uno, dos, tres.' I hope I remembered to say 'Gracias, señores.'" Winter 1966.

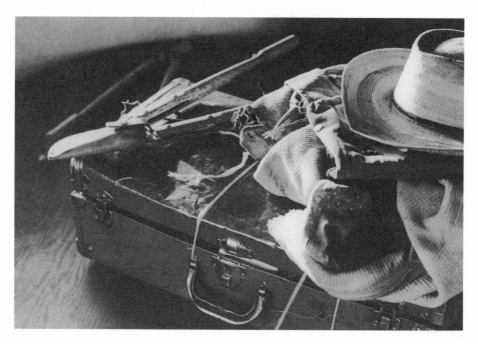

69. "All that a man took out of the labor camp with him as he walked out of the field in support of the strike." Winter 1966.

Lewis thought that joining the strike had certain advantages. He had no assignment, no connections to any news organizations, no car, and no family to support. If he decided to photograph the strike on his own, he would not be able to rent an apartment, purchase film, or feed himself.

Being a union member might allow him to overcome these obstacles, even turn them to his advantage. If he was willing to live on beans and tortillas and $5 a week picket's pay, then the union would let him sleep on the floor. Staying was either a foolish move that would consign him to poverty, expose him to danger, or force him to postpone well-laid plans. Or it was the opportunity of a lifetime.

Like most social moments — like Freedom Summer, the watershed summer of 1964 when hundreds of college students drove south to help register voters in Mississippi and work with local black activists and members of SNCC — what was happening at Delano seemed to cap a long period of struggle. Lewis saw that nonviolent direct action was on the rise. He saw that a movement overturning economic deprivation, routine exploitation, and pervasive racism was going to meet stiff opposition from entrenched powers. It was the equivalent of a revolution.

70. "They tell me this was a lettuce field, but being a city kid it could be a marijuana crop for all I knew. The bent back was what prompted me to trip the shutter. Short handled hoe work with *el cortito* (a.k.a., 'the Devil's tool')." Spring 1966.

27. Friendships

Delano was more exciting, foreign, and distant than any-
thing Lewis had ever experienced. Sensing the chance
of a lifetime, he talked it over with Valdéz.

"College is always there," Valdéz said. "La Huelga is now."[1]

By staying at Delano, Lewis was going to be part of history.
He would record it up close. Here was a chance to work to the
fullest of his ability in a significant way. He would not be using
his cameras for esthetic ends but rather as mechanisms for
cultural and economic justice and political liberation.

Although Lewis had been trained to use Graflex Speed Graphic
4-by-5-inch format cameras, the big press cameras were rapidly
being replaced by small, 35-millimeter cameras. Far more por-
table and much less intrusive, 35-millimeter cameras improved
mobility and allowed photographers to switch quickly back and
forth between different lenses, wide angle to telephoto.

At Delano, Lewis was going to have a chance to prove their
worth. He was going to exploit their portability and use them to
perfect his own style of unobtrusive documentary photography.
He was going to bring the viewer right into the middle of the
action and capture the closest thing attainable to the look and
feel of an actual event.[2]

71. "Phyllis, the Zapatas' granddaughter, was not yet in school, so she spent
much time on the picket lines and was used to me and the camera. As the
roving picket line was moving to another vineyard, I jumped into the back
seat of the nearest car. She was in the front seat checking me out, and I was
looking a gift in the face." Summer 1966.

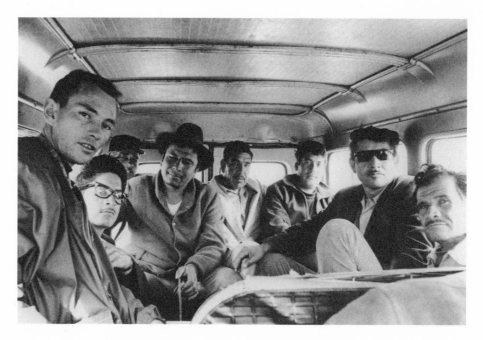

72. "Here's a Schenley crew that had just walked out of the fields in support of the strike. We would take them near the labor camp to get their baggage, take them to the strike kitchen for a meal, offer them sleeping space on the floor, transport them to the company's office to get that last paycheck the next day, then they were often on their own — as we hadn't the funds to buy them a bus ticket to Fresno. Both George Ballis and I [left] sported a crew cut in those days. John Kouns snapped the picture." Winter 1966.

Lewis would be the quintessential freelance photographer. No one was going to tell him what to photograph or how. He would control how he worked, write his own captions, assign his own stories, and frame his own pictures.

Lewis understood the overwhelming odds against success. He was aware of the violence, costs, challenges, and long hours that awaited him. He knew that dust would clog his camera lenses, that the killing heat would wear him down and ruin his film. And then there was the question of what would ever become of his work. Who would publish it?

Lewis had no contacts in the news industry. He did not know a single newspaper reporter. He had no idea how to pitch a story. He was going to learn it all on the job. He was going to have an opportunity to practice his magic twenty-four hours a day.

Lewis was not after one picture. THE PICTURE. Already he knew that a photographer rarely captured a single image that told everything. The elements of a story usually lay scattered about in time and space.

No standard plan applied. There was no formula. No script. He was not imitating anyone.

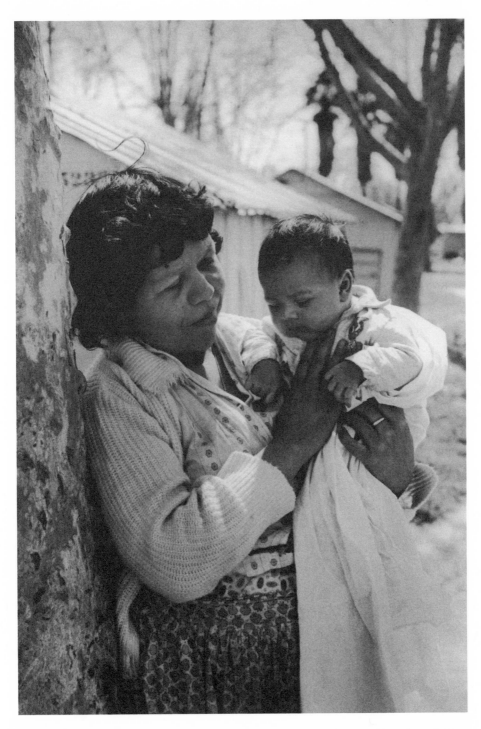

73. "Mother and child at the Linnell labor camp. Parents were proud to hold up their children for the camera. Had I been a more affluent photographer, I would have had a Polaroid along so I could give them a print." Winter 1966.

There would be no elbowing, no jostling for position. He was not going to be the aggressive photographer. He was not going to hit and run. He was going to stay beyond the immediate news event to document history. He was going to follow his own sense of what was important. He could not be impatient. Just an individual with a few rolls of film and a camera.

Lewis was going to create a visual diary. To do that, he would have to push his body. Days were going to pass without clicking the shutter. Long days. Boring days. Hungry days. He would hardly be in control. Then, in an instant, he would go through an entire roll of film, reload quickly, try not to drip sweat onto the film shutter, close the camera back, and catch the moment.

His technique would evolve as he achieved greater understanding. He would have to adapt. His exposures would become as automatic as putting on socks. His success would hinge on his relationship with the grape strikers. He could not have a false relationship with them. His vantage point would have to be that of the farmworkers themselves. If they were at all uneasy with him, he would fail.

Lewis later recalled, "Everyone seemed so much of the earth, so real, of such good will. All those proud faces, old and young, sunburned, weathered, fearless, determined. They were putting it all on the line. How could I turn my back on such people? How could I leave?"[3]

74. "Early Teatro Campesino performance at a Friday evening meeting in a rented storefront church." Spring 1966.

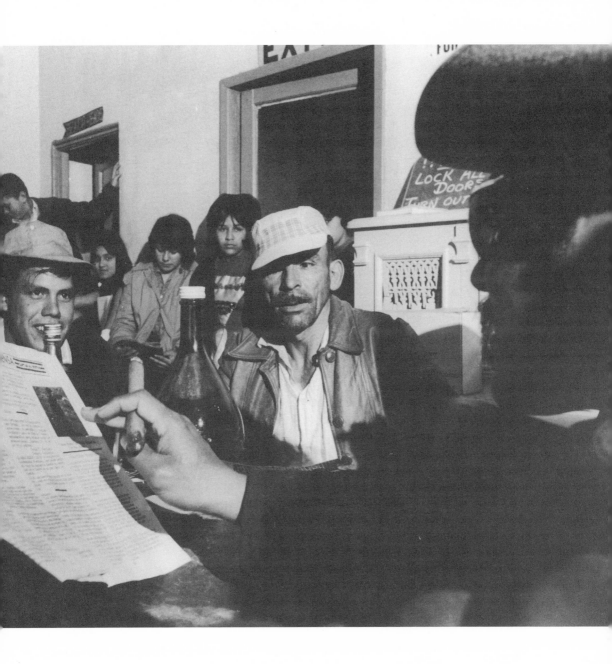

28. Photographers

Volunteers and activists using Brownie cameras and plastic Nikon knock-offs had already captured the first few days of the grape strike. Better-equipped and trained NFWA members did better. But many San Joaquin Valley newspaper photographers and their editors still dismissed Chávez as a crackpot Mexican and hardly bothered more than a cursory look. Even when picket line confrontations boiled over, photographers from the *Sacramento Bee*, *Modesto Bee*, and *Bakersfield Californian* failed to give the strike the attention that it demanded. Fitting Delano into their daily grind, they covered it sporadically, sandwiched between sports, business portraits, and other run-of-the mill assignments. As for photographers working for the *Delano Record*, a twice-weekly newspaper that could have won the Pulitzer Prize by blanketing a news event in its backyard, not one of them ever produced a single image of Chávez and the NFWA worthy of wide circulation.[1]

One exception to this pattern of photojournalistic neglect was *Fresno Bee* writer-photographer Ronald B. Taylor. His newspaper's biases were clear. The *Bee* was a rural newspaper whose Wednesday edition ran a farm page packed with advertisements for the agricultural industry. Yet Taylor's editors never balked at covering Delano. After receiving a standing assignment to follow events, Taylor began exploring an ever more complicated story that would shape his life for the next twenty-five years.

Taylor immediately perceived that the strike and NFWA were different from Al Green's AWOC and even the Filipino AWOC local. He saw Chávez as a radical departure from the past. From the very first moment he started covering the strike, Taylor understood that the NFWA was to be a totally independent, service-oriented worker movement, one built and directed by the farmworkers themselves. He later recalled that "the newspaper bent over backwards to report everything fairly. It could have mouthed the grower's side. A second-rate newspaper might have thought 'that rabble-rouser Chávez is getting too much attention. We should ignore the guy. He'll go the way of every other farmworker organizer.' But the *Bee* did not do that. The newspaper put me on the story and I stayed on it."[2]

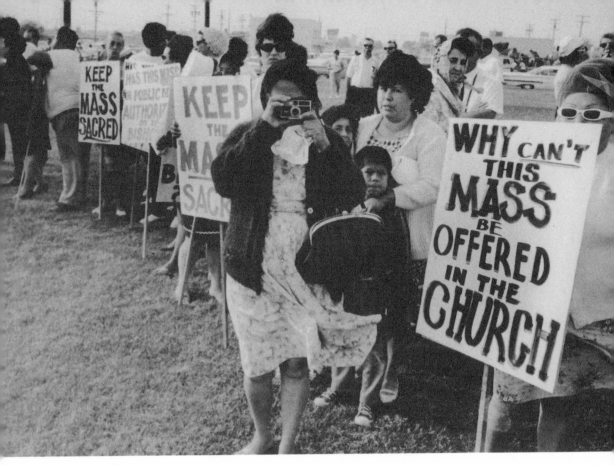

75. "Delano townspeople picketing and photographing a farmworker Mass in a park." Spring 1966.

During the early days of the strike, three extraordinary freelance photographers had stepped forward to get the picture — Ernest Lowe, a twenty-six-year-old public radio employee who had been covering farm labor since 1959; Harvey Richards, a forty-three-year-old former machinist and union activist who in 1960 had completed an essay on field sanitation and the predawn shape-up in the Stockton slave market; and George Ballis, the thirty-four-year-old editor of the *Valley Labor Citizen*, who had been covering farm labor since 1955.

Each had photographed the civil rights movement in the American South. Each was at ease among crowds and in dangerous confrontations. Each saw photography as a type of visual activism. Each was familiar with the Valley, understood agriculture, and had met all of the strike leaders.

They were not neutral or objective observers. They chose sides. They actively supported the strike. They aimed at producing visual documents that allowed the strike to continually renew itself.[3]

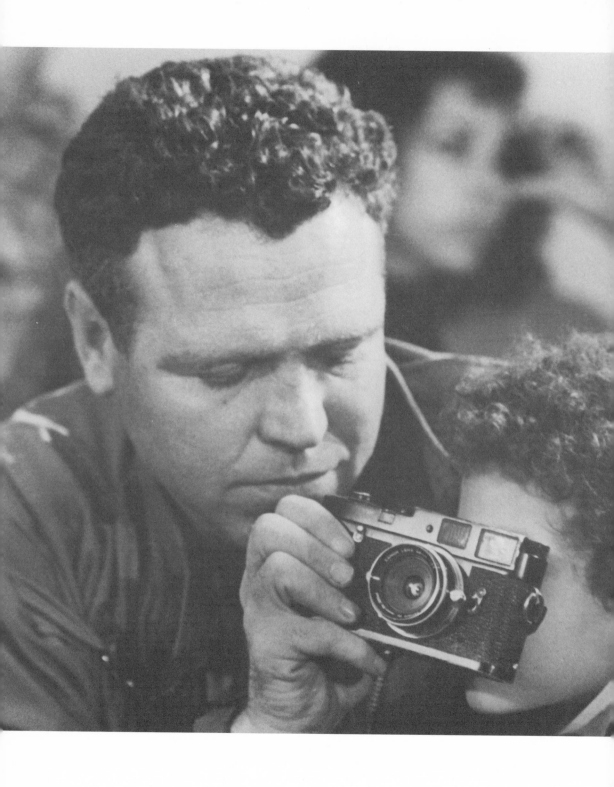

29. Witness

Taking great photographs did not guarantee that anyone saw them. Whereas civil rights photographers and African American photographers might place their images in *Jet*, *Ebony*, or one of several other black-owned magazines, as well as *Time*, *Life*, and *Newsweek*, freelancers covering the grape strike lacked similar outlets.

Largely unknown to the editors of national and regional publications, Lowe, Ballis, and Richards struggled to break into print. But no matter how strong, relevant, and newsworthy their images, they were largely ignored. The best they could do was to place their work in church-sponsored magazines, progressive publications, union periodicals like the *Valley Labor Citizen*, activist tracts like *The Movement* (the official publication of SNCC), and national publications like the *Christian Science Monitor*.[1]

A turning point in their coverage occurred on the morning of September 26, when Harvey Richards photographed NFWA organizer Dolores Huerta and two other strike leaders standing on top of an automobile roof while holding large Huelga signs. Published on the cover of the October 2 issue of *People's World* and subsequently republished in many other periodicals including the *San Francisco Examiner*, the dramatic photograph soon caught the attention of an FBI informant. Complaining to FBI Director J. Edgar Hoover, the anonymous informant labeled

76. "John Kouns wasn't a run and gun, shoot from the hip, rapid fire photographer. He would observe and ponder a bit before making a few select exposures. The eye was there and the work was prime." Spring 1966.

Richards a radical and used his photograph as an example of communist infiltration into the farmworker movement. On the basis of the informant's request, Hoover initiated a fifteen-year investigation of Richards and other allegedly subversive photographers and farmworker activists that turned up nothing.[2]

Midway through October 1965, photographic coverage had intensified. Photojournalists from the *Los Angeles Times*, *San Francisco Chronicle*, and *San Francisco Examiner* arrived in Delano and began sending back images. "The place was lousy with freelancer photographers," recalled Jack Pandol, the stocky, middle-aged grape grower who with his two brothers farmed two thousand acres on his Three Brothers Ranch between Delano and the Sierra Nevada foothills.[3]

Even though many photographers had experienced intimidation and harassment and had familiarized themselves with the Valley's social structure, they were nevertheless shocked by the racism, segregation, anger, and threats. Most believed that they were witnessing a unique historical moment, the opening phase of a dramatic struggle, perhaps even a fundamental shift in power. Growers hated them. "If Chávez scratched his ass or yawned," quipped Pandol, "one of these photographers would take five pictures as if he was some kind of saint."[4]

Suddenly, readers of urban newspapers saw the faces of Filipino American and Mexican American leaders, forlorn strikers locked out of their labor camps, people pitching together to feed and house volunteers and pickets, and Chávez and Huerta addressing meetings and speaking through a bullhorn. Photographers were now part of the organizing equation, indirectly supporting and shaping the movement in ways they did not understand.

Ballis refused to limit himself to taking pictures. Fed up by incessant police harassment, he wrote an angry editorial calling attention to the abuses he had witnessed. One article, "Justice, San Joaquin Style," described how

> the *Labor Citizen* photographer has been present on three occasions when grape growers Bruno and Charles Dispoto — in full view of police — have pushed, elbowed, kneed, tripped, and vilified grape strike pickets in the foulest language imaginable. The *Labor Citizen* has pictures of some of this pushing and shoving. Not once in the presence of the *Labor Citizen* photographer have the police said a word to either of the Dispotos until as noted in the paper last week, one of the pickets warned the police that another of the pickets might kill Bruno Dispoto if he continued the elbow routine. Contrast such casual acceptance by the police of the Dispoto violence with the scene last Monday night. The police arrested picket Jack Delarmente when they saw him strike Charles Dispoto. That's justice, San Joaquin Valley style.[5]

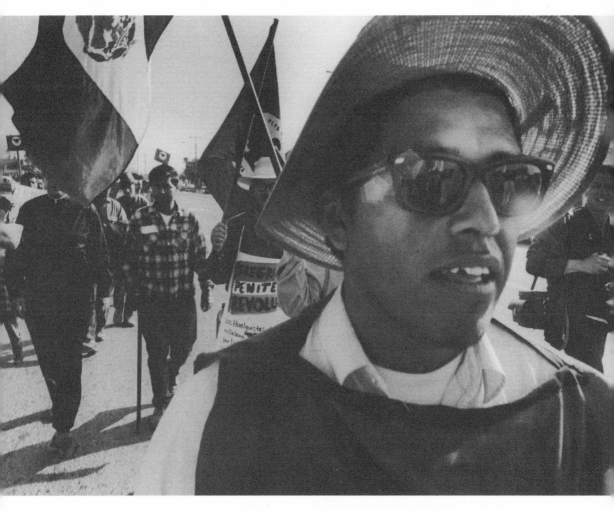

77. "Roberto Bustos was *el jefe* of the march on Sacramento and generally around the lead of the column. César Chávez [left] never did get up front and lead the march, but was always back with the less conspicuous. George Ballis [right] is photographing." Spring 1966.

30. Advocates

From the beginning of the strike, Chávez had carried a Nikon 35-millimeter camera that someone had donated to the union. But Chávez did more than photograph on the picket lines and at various confrontations and union events. He was blessed with an acute sense of history. He understood the value of media exposure. And he appreciated visual culture.[1]

Chávez and his cadre of volunteers designed and created the kind of images that appealed to the public. Religious symbols quickly became an important part of strike pageantry. Masses and blessings by priests inaugurated and authenticated every action. Union emblems added punch and assertiveness. Elaborately painted signs and banners injected color and symbolism into picket line scenes.

Arrests and harassment were also welcomed and often provoked, with some confrontations playing out like miniature battles. Violent behavior was condemned, but violence against the movement — especially if it was photographed — became a valuable tool in the struggle. "We took every photograph of violence and used it to publicize what they were doing to us," recalled Chávez. "We wanted those and other images to be seen by the public."[2]

Although Delano growers possessed a dramatic story, photographers completely ignored them. Such a story, involving the transfer of Old World viticultural skills to a new setting,

78. "Teatro Campesino performance featuring the grower [Luís Valdéz] on the backs of the workers, portrayed by Roy Valvéz and Carolina Franco." Summer 1966.

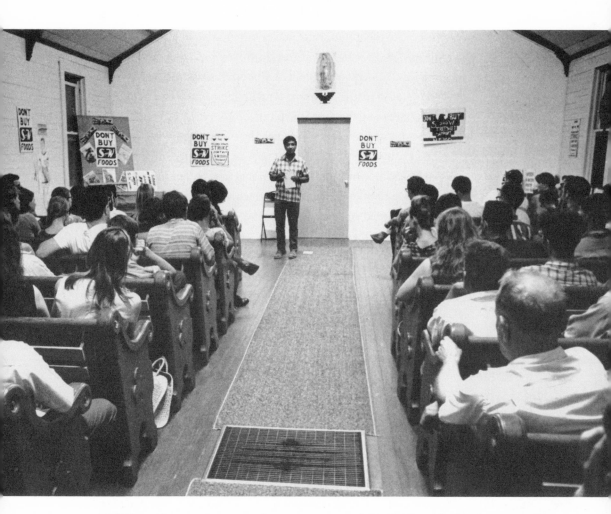

79. "César welcomes volunteers to the summer 1966 project in Del Rey. After less than two weeks orientation and very few days on the picket lines, they were shipped out on the boycott." Summer 1966.

never inspired a single pitch to *National Geographic* or any other magazine. This was caused in part by the prejudices and biases that photographers brought to their task, as well as their urban backgrounds and lack of patience. Also contributing to the skewed picture was the mundane nature of such images coupled with a news business eager for images of the "bleed and lead" type. "Unless a grower was screaming at someone," recalled Pandol, "he would never get his picture in a magazine or newspaper."[3]

Another reason photographers ignored grape growers was the hostility of most growers toward outsiders and photographers. Lagging behind the union, growers were slow to realize that their fate hinged on a battleground far from the vineyards. By the time they recognized this they had fallen so far behind the union that their clumsy public relations efforts looked silly. They would never catch up.

Absent any attempt at balance, photographers presented a dramatically skewed picture of the first few months of the strike. By documenting both the daily routine of volunteers and union members as well as the work of organizers and union leaders, photographers conveyed images of great passion that collectively forced the public to reflect on what it was like to be a farmworker in California.

They also indirectly supported the movement in ways that they did not understand. Defiant strikers confronting foremen and growers on picket lines always knew a photographer was watching. Volunteers preparing meals for picketers or collecting and distributing donations found themselves accompanied by photographers. NFWA members protesting along the highways, parading through Delano, and standing up to police, sheriff's deputies, and private guards no longer felt alone. "Any time something happened," recalled NFWA volunteer Eugene Nelson, "someone had a camera at the ready."[4]

Photographers continued to stream into Delano until late November, when cool, rainy weather shut down the harvest. Once the rains began, there would be no work and nothing to picket until pruning and vine tying operations began in January.

As growers began shipping grapes from their cold storage facilities, NFWA members wondered if they had lost the strike. Press photographers unable to get suitable images quickly left town. AWOC organizers shifted their attention to the citrus industry around Visalia and Orange Cove, where the harvest was just beginning.

Throughout the fall, the NFWA kept plugging away. Chávez knew that there was always something happening, or about to happen, if you only waited. The scene of action was shifting. Gilbert Padilla and cadres of the more aggressive Filipino NFWA members had been following grape shipments bound for the docks in in West Coast ports. On November 18 Padilla and four NFWA members established a picket line protesting the loading of grapes at Pier 50 in San Francisco.

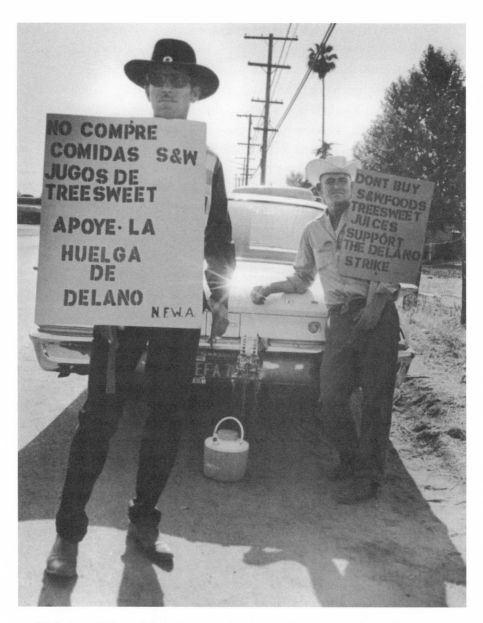

80. "Picketing at DiGiorgio's Sierra Vista Ranch going into the August 30 election." Summer 1966.

Chávez was not surprised by the massive press coverage. But when members of the International Longshoreman and Warehousemen's Union (ILWU) refused to load 1,250 cases of Pagliarulo table grapes, he realized that the strike was beginning to move in a new direction. Two weeks later, when another picket line stopped 2,500 cases of DiGiorgio grapes from being loaded on the Oakland docks, Chávez and everyone else in the NFWA realized they had a powerful tool for exerting pressure on the growers.[5]

Lawsuits by Pagliarulo and DiGiorgio claiming damages of nearly $100,000 forced the NFWA to obey a court-ordered injunction against any further picketing, but it did not cause the NFWA to stop its boycott. Under provisions of the National Labor Relations Act, longshoremen and other workers were prohibited from boycott activity. But because farmworkers were excluded from the National Labor Relations Act, the NFWA was free to conduct a secondary boycott directed at consumers.

What had long been considered a major obstacle suddenly became an asset. Through the secondary boycott, Chávez could extend the strike past the harvest. He could shift the battle away from the vineyards into the realm of public opinion. NFWA could bypass biased law enforcement authorities and racist local governments, nullify the stranglehold that growers exerted on the Valley power structure, and overcome tactical obstacles that had heretofore thwarted farmworker unions.[6]

Borrowing an SNCC tactic that targeted northern businesses for their connections to southern segregated institutions, the NFWA dropped its picketing activities at produce terminals, where workers could not legally refuse to handle Delano table grapes, and shifted to a consumer boycott of specific brands, a tactic that was perfectly legal.

From an atlas, Chávez chose thirteen major cities throughout the country. He then placed Rev. Jim Drake, a CMM member who had graduated from Union Theological Seminary and served as a driver for Chávez throughout the summer, in charge of coordinating the boycott.

On December 12, 1965 — the feast of Our Lady of Guadalupe — with the Christmas season approaching and the strike 100 days old Chávez dispatched a boycott staff comprised of strikers who had impressed him on the picket lines: young men and women, all under age twenty-five. Hitchhiking, riding the rails, and driving their old cars to various cities, they arrived at local unions, begged room and board, scrounged up telephones, and began picketing in liquor stores and supermarkets in Chicago, Detroit, Atlanta, Cleveland, New York, Boston, Philadelphia, Baltimore, New Orleans, Washington DC, Los Angeles, and San Francisco.[7]

Chávez at first concentrated on Schenley's Cutty Sark liquors and DiGiorgio Corporation's TreeSweet brand canned fruit. Schenley's five-thousand-acre ranch

was the largest in the Delano area, but there were other reasons why the company offered an enticing target. Schenley's vineyards were a subsidiary of a large liquor conglomerate with over three hundred million dollars in income. Schenley had multiple contracts with other labor unions. Its labels were highly visible. Although the NFWA could not ask workers to refuse to handle Schenley products, it could launch a consumer boycott of Schenley products in stores. Not only would this avoid injunctions, it would be a way of tapping into support among student volunteers and civil rights groups, specially members of SNCC, at a time when there was little work in the vineyards around Delano.[8]

Within months the boycott teams had ten thousand people passing out leaflets and setting up picket lines in front of supermarkets and liquor stores. Sustained by local labor unions and sympathetic churches, the boycott teams leafleted, picketed, and harassed grocery and liquor stores, often with help from CORE, SNCC, and Students for Democratic Society (SDS), always with a press photographer present.

At the same time, Chávez launched some diversionary tactics in the Delano rail yards. Appearing with a cadre of volunteers, he would pretend to photograph them creating a big scene that diverted police attention while small groups climbed aboard freight cars to monitor shipments of table grapes and jump off along the way to set up picket lines wherever the grapes were being unloaded. Countless union posters, leaflets, and public relations packets conveyed the picture to urban audiences unfamiliar with agriculture and farm labor, while images taken by photographers closely aligned with the NFWA appeared in the pages of sympathetic union publications and in editorials and reports appearing in newspapers and magazines across the United States.[9]

What had started as a geographically limited strike over wages in the vineyards around Delano had suddenly exploded into a national crusade for social justice.

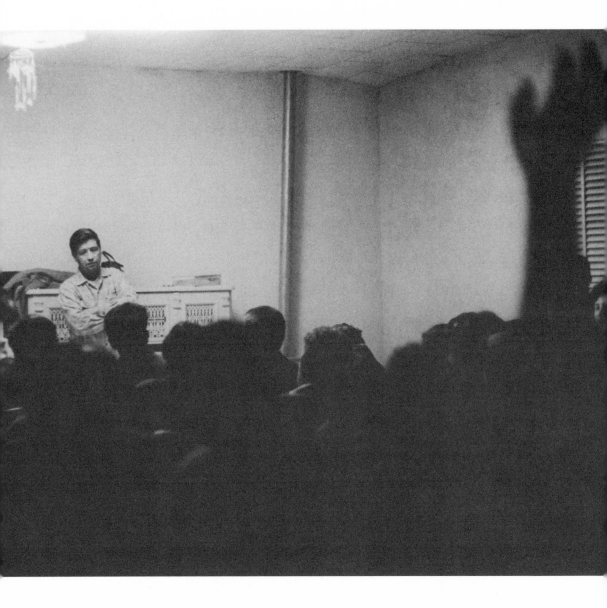

81. "César Chávez takes a question from the audience during a NFWA meeting." Winter 1966.

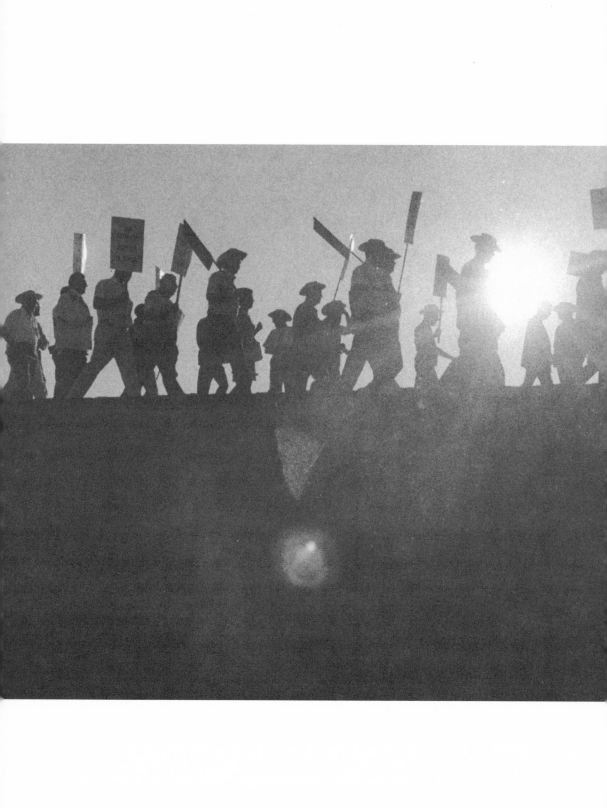

31. Boycott

Four days after launching the boycott, Chávez asked United Auto Workers Union (UAW) President Walter Reuther to visit Delano. When AFL President George Meany denounced the visit as "press agentry," Chávez got exactly the response that he wanted. On December 16, Chávez and AWOC leaders defied a police ban on marches and carried plywood NFWA signs to the Delano airport to greet Reuther. Hurrying to the picket lines along the cold storage sheds near the railroad tracks, the labor leaders paraded with a column of supporters through the streets of Delano.

All along the way, farmworkers shouted "Viva Reuther! Viva Chávez! Viva la Huelga!" On a street corner, Reuther halted the march and gave an impromptu speech. At one point, the chief of police had to stop his car for the march as the strikers passed by shouting, "Arrest us! Come on, take us to jail now!" At city hall, Reuther spoke in support of the strike. Around 6:30 p.m., Reuther addressed a crowd of five hundred cheering farmworkers at Filipino Hall. With strikers jammed into every nook and corner, packed into the kitchen, and hanging on the porches and windows, Reuther announced that the AFL-CIO was pledging $5,000 a month in support of the strike, along with a $5,000 Christmas bonus, and that the UAW would support the grape boycott.[1]

82. "A UAW delegation complete with Walter Reuther came by one day, all identically attired in identically printed hats, jackets, and picket signs. Such a spontaneous gathering was best rendered in silhouette." Winter 1966.

A clot of television cameras recorded the speech. Dozens of photographers followed the march through town, so many that they fell and tripped over one another and occasionally pushed, shoved, and fought in order to get the best shots. Chávez credited Reuther's support that day with generating images that gave the faltering strike its first national exposure. Photographers from *Time* and *Newsweek* who had never seen Chávez got their first extended look at him parading with the UAW president. Without exception, they found him perplexing, enigmatic, and highly photogenic — a small man whose weathered face could instantly transform from its usual expression of mischief to one of mesmerizing rage.

Through their lenses, Chávez emerged as a Gandhi-like figure. Chávez always made for interesting pictures. He was certainly at the center of everything, and he seemed to be turning the tables on growers with a brilliant, unconventional campaign. With his quiet manner and kind eyes, he was different from most other labor leaders, different from anyone in California. Photographers who had not seen a Mexican American leader could not get enough of him. It soon became photographic shorthand to refer to "the Chávez movement."[2]

Walter Reuther's visit was the first substantial support by organized labor. Not only did it draw attention to the grape strike, it also helped publicize the national boycott. Within one month, liquor stores in San Francisco removed Schenley products, a CORE-sponsored march cleaned Schenley products off the shelves of forty-nine Harlem liquor stores, and Secretary of Labor Willard Wirtz announced the official end of the bracero program.

And then, just as developments seemed encouraging, a thick, pea-soup December fog enveloped the town, casting a cold chill over the Valley. Penetrating deep into muscles and joints, it sent everyone into dark depression.

Short, cold days yielded nothing exciting. Schenley remained silent. DiGiorgio would not budge. Growers raised wages and easily rounded up workers and began their winter pruning. Picketing dragged on.

Chávez launched an organizing drive in the Salinas Valley, where the NFWA had few followers. He opened NFWA offices in Bakersfield, McFarland, and Earlimart. And he led three hundred workers in a march protesting a Monterey County Welfare Department requirement that welfare recipients work for twenty-five cents an hour

83. "By the time I arrived, César wasn't on the picket line that often, as he was the chief fund-raiser to keep things afloat. So you had to grab what you could when you could. I never did catch him shouting at strikebreakers." Winter 1966.

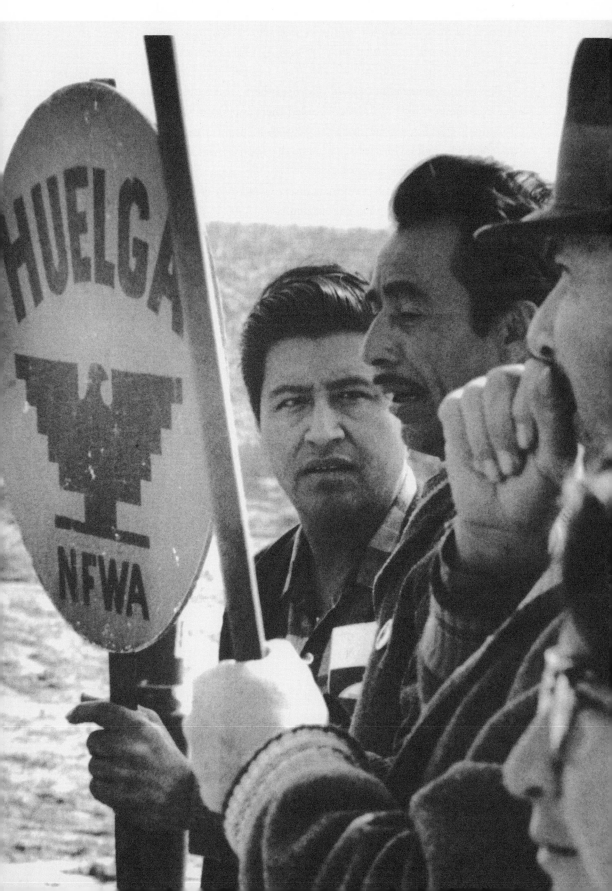

or forfeit benefits. He also welcomed in a new member of his team, LeRoy Chatfield, a Catholic priest who had served as a high school vice-principal before being released from his vows to work for the NFWA.[3]

Barely able to see a half block, photographers who had stuck it out over the past four months concluded there was nothing left to document. Packing up, they said good-bye to volunteers and union members who had taken care of them and departed for warmer environments and the next crisis.

When Jon Lewis arrived in mid-January he found only *El Malcriado* editor Bill Esher, volunteer Eugene Nelson, *Valley Labor Citizen* editor George Ballis, and *Fresno Bee* writer Ronald B. Taylor sporadically photographing the faltering strike.[4]

84. "Eugene Nelson was finishing his book *Huelga* in January 1966, and he had left for Texas by the time I returned in February. This is the only shot I have of him, and we never did have a conversation or share a beer or two." Winter 1966.

32. Zoo

Within a few days, Lewis developed a deep affection and respect for the NFWA, its members, and for what it was trying to do. He liked its leaders. He liked the outsiders and CORE volunteers who had come to Delano in response to urgent appeals for help. He found the atmosphere electric and exciting. He believed in the cause. He got to know the strikers, especially Augi Lira and Felipe Cantú.[1]

Lewis was too broke to finance even a short stay. Although a job photographing theatrical productions awaited him at San Francisco State University, where there was also some possibility of obtaining a student loan and financial aid to supplement his GI benefits, Lewis decided to postpone plans to obtain an MA in the graduate photojournalism program. Hitching a ride back to San Francisco, he withdrew from the winter semester, borrowed $150 from one friend and $50 from another, and used the money to purchase a Durst 606 enlarger. Paul Sequeira, soon to become a *Chicago Sun Times* photographer, gave him an enlarging lens. Lewis packed it all in a box, loaded it on a Greyhound bus, and returned to Delano. He told Chávez, "I'm with you." Lewis thought he might last a few months.[2]

Chávez offered help with supplies. In exchange, Lewis would provide images for the boycott and *El Malcriado*, the NFW's pesky, devilish, clever, irreverent newspaper. But he would have to buy his own film.

As he started work that day, Lewis thought:

It really was a David vs. Goliath struggle. Here was this small band with nothing, taking on a powerful industry. They were completely fearless. It seemed like they had everything stacked against them. They were just scraping by, making it up day by day. They wouldn't quit. There were so many vivid characters. So many faces, young and old. Goofy people. Crazy people. Creative people. Actors. Organizers. Very dedicated people. A lot of former priests. Jews. Catholics. Protestants. Even if you didn't agree with them, you could not be there long without seeing

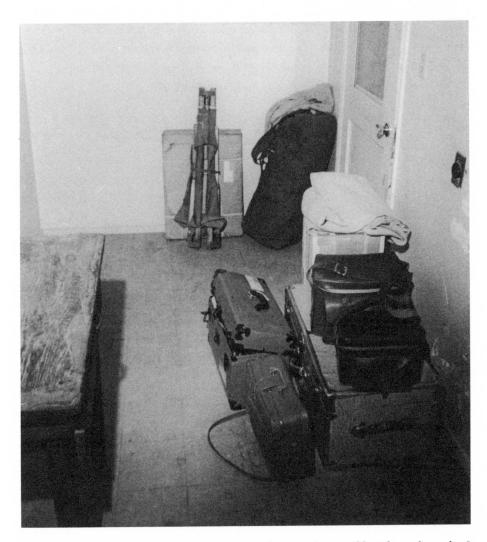

85. "All this on the Greyhound bus without any excess baggage charge, unlike airline policy today. I could never have gotten it down there [Delano] had there been such a charge. Maybe I would have graduated with the MA sooner, and have retired from a college teaching job by now." Winter 1966.

an incredibly photogenic situation. You had to be a pretty bad photographer not to find something worth documenting. The images were there in front of you wherever you went. Technique and artistry had little to do with it. You operated on instinct. It was definitely an f.8 and be there situation.[3]

After settling in, Lewis constructed a darkroom in an alcove-washroom near the garage of the NWFA's Gray House, as it was known. He wedged his bed along one side, installed a clothes rack at one end, constructed a developing sink along the opposite wall, and placed an enlarger and drying rack at the far end between

the door and his bed. The only luxuries were a small portable radio, a reading light, and a tiny desk where he spotted prints. He filed his prints in empty Luminos photographic paper boxes.

Upon settling into the Pink House, Lewis discovered that

it was so crowded. Just packed. The house was stacked floor to ceiling with canned food, eggs, sacks of rice and beans, and secondhand clothing. We were always cramped for room. People were coming and going all of the time. Priests. Writers. Activists. Actors. Volunteers from Berkeley, San Francisco State University, Mills College, Stanford University. They would be tossing bedrolls everywhere, in the yard, on the floor, on the lawn, and on couches in all of the rooms. You'd rub elbows with students studying for law degrees, MAs, and PhDs. It was never quiet. The phones were always ringing. Every day was a crisis. A car would break down and need parts. People would be there trying to find money to feed strikers and a place for volunteers to crash. Donations would be arriving. Julio Hernandez would be supervising everything, stockpiling supplies. There was nonstop laughter, constant banter in English and Spanish. People would be up all night stuffing envelopes. People would go from auto repair to mimeographing. Typewriters would be clanking away. *El Malcriado* was coming out weekly. People were literally running into one another. There was activity 24 hours a day. The place was just a zoo.[4]

A few days later Lewis was at NFWA headquarters. Chávez walked in and sat down. On one occasion he had been passing by the darkroom and stopped to tell Lewis that he had some personal photographs that he wanted developed — landscapes mostly. But he never followed up. Chávez was seldom on the picket lines. Lewis had hardly seen him since arriving. He desperately wanted to make a good portrait. But the light in César's office was very bad. Lewis never tried to photograph there. But the light in the union front room that day was soft and diffused. There were hundreds of Huelga signs lying about, apparently just delivered. Lewis looked at them and got an idea. He asked Chávez for a few minutes of his time, posed him with one of the signs, and quickly made three verticals and six horizontals.

The six-image sequence would soon become a stylistic pattern at Delano. No six-image sequence would ever be without at least one turned on vertical.

Just as he finished, Luís Valdéz walked in and Lewis put him through the same drill. It was the only time during the strike that Lewis asked anyone to pose.[5]

86. "The only posed shot I took of César. I don't know what the picket signs were doing around the office unused but they saved my act once again." Winter 1966.

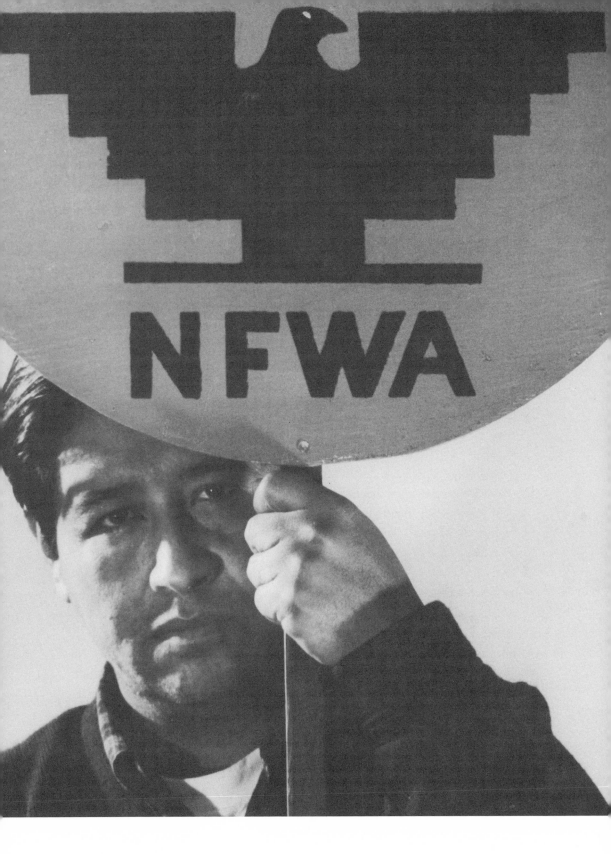

33. Darkroom

Shortly after moving in during January 1966, union volunteer Laurie Olman took a break from running the mimeograph machine. She stood in the doorway to the darkroom-bedroom and snapped a picture of Lewis reclining on his bed, legs kicked up, looking back at the photographer. Thin and crew cut, he was very much the fit ex-Marine. Except for the developing trays and enlarger, the photograph might have been mistaken for an image of a college student in his dormitory room, not an activist photographer just back from dawn patrol during a labor strike.

To help Lewis with supplies, NFWA volunteers scrounged up lumber and materials. Because no one trusted the Delano photo shop, Lewis established a credit account of sorts with a photography store in Bakersfield. Then he typed up a press pass and pasted in a self-portrait from his days at San Jose State University. With that he became the first official NFWA photographer.

In People's Bar that night Lewis bumped into Augi Lira, who complained that he had not eaten all day and had no money. Lewis gave Lira $1 so that he could purchase a burrito and heat it up in a small oven. On $5 a week picket's wages, the loan represented 20 percent of his income and left him little money for his principal vice, Pall Mall cigarettes. A few days later Lewis shot a group picture of Lira and others, and later sold six 8-by-10-inch enlargements for $1 each.

Recalling that initial sale of images, Lewis underscored how important it was to him, as well as the sacrifices required for such a small transaction, because "The guys who bought pictures were making $5 a week as pickets. They had no other jobs. They were out of work. After buying a beer or two and maybe a pack of cigarettes, they were in the same financial straits as me — completely broke. None of us ever had more than a few dollars in our pockets. I felt bad about taking their money. But that money allowed me to buy enough film to keep shooting for another week."[1]

From his crude bedroom-darkroom base of operations, Lewis became a one-man photo agency. His principal outlet was *El Malcriado*. Editors gave different translations of *el malcriado*. To some it referred to the "ill bred" or the "lowly born."

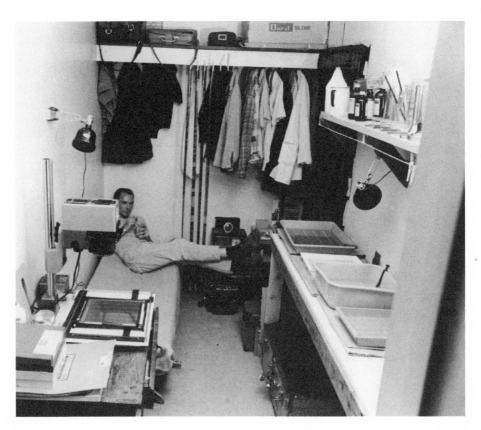

87. "The Greyhound bus line was pretty generous in its baggage allowance. I appropriated the washroom off the garage of the "Gray House." It was only six feet wide but had running water and electricity — if no air conditioning. I had to use it for processing nights, as days were sweltering. NFWA volunteer Laurie Olman made this snapshot." Winter 1966.

One NFWA member simply said it meant "we shall inherit the earth, and along the way we'll have a lot more fun than they will." Most agreed that "the bad boy" came close to capturing its meaning, and that *El Malcriado* carried on a tradition of ribald political harassment that had been popularized in *La Cotorra*, a well-known Mexican magazine specializing in irreverent political satire.

Edited by Bill Esher, who had also edited *Farm Labor* before becoming the NFWA's "publicity genius," *El Malcriado* was written by four volunteers and published with little more than a typesetting machine and a homemade layout table. *El Malcriado* had first appeared about five months before Lewis arrived. It was saucy, disrespectful, at times poetic, and always free-swinging, unlike any other newspaper published lately in the United States, with perhaps the exception of the Industrial Workers of the World newspapers like *Solidarity*, the *Industrial Worker*, and *Industrial Union Bulletin*. It caused an uproar.

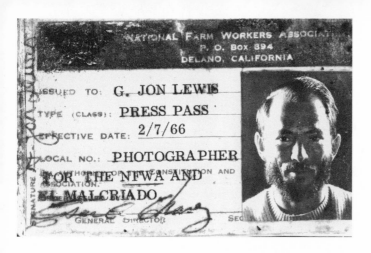

88. "NFWA press pass, typed by myself and signed by César. The photo is from previous year at San Jose State University." [Original in color.] Winter 1966.

Devoted to "challenging the elaborate power structure of California's Central Valley" with stories that could "tell the truth," *El Malcriado* published cartoons, drawings, and investigations, some written with an utter disregard for the facts, most combining editorials with reporting. Farmworkers loved it. Jokes, invective, and bilingual slander made it a hilarious and entertaining read and also led to a series of libel suits. Photographs considerably enhanced the paper.[2]

Once Lewis became established, *El Malcriado* relied on his work almost exclusively, although his byline rarely appeared. Lewis recalled:

We were really shameless. Revolutionary anonymity or something like that. The editors were bold and cheeky. To hell with objectivity. It was like photographing for a really brave, radically goofy, fearless college newspaper that liked to poke fingers in people's eyes. Probably like in the early days of *Rolling Stone*, the *Berkeley Barb*, and *Village Voice*. We had one view, and that was our view. We figured the growers had all kinds of magazines and publications. This was one chance to even the score. We saw Delano as two towns — a white Delano, and Mexican and Filipino Delano. We saw this as symptomatic of every other Valley town. We thought the Delano town council was completely in the pockets of the growers. Same for the courts, the Tulare County Housing Authority, and the high school. The police were like the Gestapo of Nazi Germany. We saw Delano as a sick town in sick Valley. Everyone in power was in cahoots against us. We were ruthlessly attacking that sickness with a newspaper by farmworkers and for farmworkers that addressed things that mattered to people who worked in the fields. We hated the growers, especially Charles Dispoto, and never hid our disgust. We thought the Citizens for Facts were the Delano counterpart for the White Citizens Councils of Mississippi and Alabama. Our photo reproductions were really terrible. They were grainy and over-inked, and tended to blotch up. The bad reproductions never bothered me. It was the first time that I ever had a regular outlet for my work. I was just happy to see my photographs in print.[3]

When not busy supplying *El Malcriado* with images, Lewis sent complete photo essays, often with extensive typed captions, to news organizations in cities around the country. Not one of his essays was ever published. He also looked after freelance photographers who could not afford lodging. He would find them a corner where they could flop, introduce them to NFWA leaders, get them the $5 a week picket's wage, and counsel them on how to go about their work.[4]

On January 22, 1966, Lewis published his first image on the cover of *El Malcriado*. His photograph showed Augi Lira playing Governor Pat Brown in one of Teatro Campesino's ribald skits. The caption read:

> Like a pile of mashed potatoes, the Governor has proved spineless in resisting the insatiable greed of the growers for special privileges and favors. Governor Brown has done nothing to help the strike and the struggle of farmworkers for justice, while his Department of Employment and Attorney General's Office have either deliberately helped the growers or shut their eyes to discrimination and grower violations of the law. The Governor brought in thousands of braceros for the growers this year, even though Congress had outlawed the Bracero program. Does Governor Brown know that he is hurting the people or is he just plain dumb?[5]

The same issue of *El Malcriado* carried photographs that Lewis had made of Schenley Industries payroll checks. One image revealed a worker netting $63.49 for 63 hours pruning and documented a mysterious deduction of $40.64 for "temporary insurance." Another showed a grapevine pruner earning $5.35 for 18 hours of work, about 30 cents an hour.

Beneath each one of Lewis's images, *El Malcriado* printed hard-hitting captions. An especially vitriolic one read:

> Lewis S. Rosenstiel is a little old wine (and whiskey) maker who is President of Schenley Industries. He sometimes pays his workers only 30 cents an hour. He's just a little family farmer, so he can't afford to pay more. He sometimes makes only $1,100,000 a year (that was back in 1958), but his income has been improving since 1961, when he made $2,600,000. He only owns $30,128,760.000 worth of Schenley stock (as of February 10, 1966). He lives in a modest $400,000 home in New York, though he has a little bungalow in Miami valued at $113,000. And a tiny little farm in Connecticut priced at $139,000. Plus a lot here and there in New York valued at another $1,400,000. His wife spent $50,000 on clothes at *one* store, reports the *Wall Street Journal*. But that's just his personal fortune. His corporation, SCHENLEY INDUSTRIES, did make $17,700,000 in *profits* in 1965.[6]

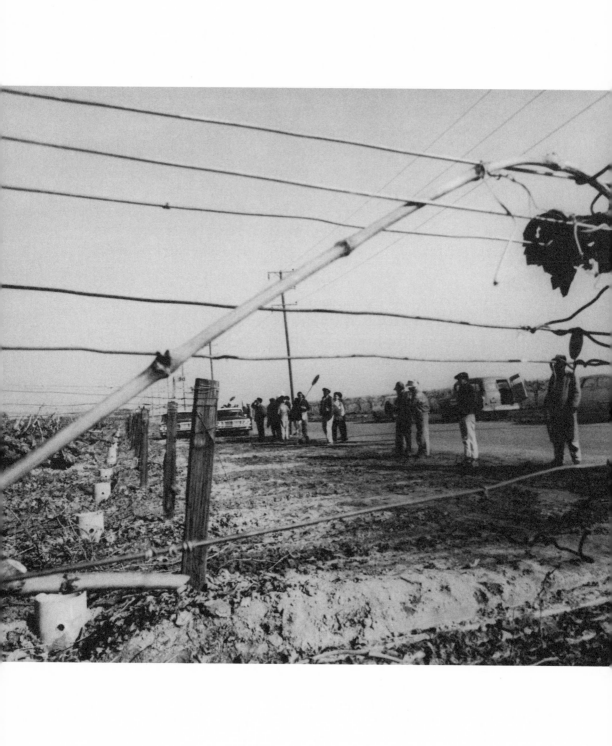

34. Routine

Working conditions in his darkroom were uncomfortable at best. Freezing cold or boiling hot, depending on the weather, it had only one small window and could not be properly ventilated. Chemical fumes built up, permeating his clothes and bedding. Outside his door, people slept on the concrete floor. Opposite his room, El Teatro Campesino rehearsed in the garage.

To obtain glossy prints, Lewis used four 16-by-20-inch polished ferrotype tin plates. He would squeegee the prints onto the plates and then place them on the lawn in the hot sun. This yielded six to eight glossy prints each day.

On hot days, when his darkrooms become a chemical sauna, Lewis did all of his printing and developing during the coolest part of the night, from 1 a.m. to 5 a.m. Often he went straight from an all-night printing marathon out into the fields.

Describing his regimen, Lewis recalled:

As vineyard pruning began, we started patrolling the back roads. We would meet in the strike kitchen, a mile west of town, where the pickets assembled for a breakfast varying from toast and coffee to eggs and bacon, depending on the donations coming in. There would usually be two caravans — the "Zapatistas" and the "Villaistas." You had to pay attention

89. "Here I did trespass, as the police were at the far end of the picket line. I did have a press pass from *Ramparts* magazine in San Francisco, but I was obviously a union supporter and hardly objective, so they could have hauled me off to the slammer. But it . . . was too much to resist." Winter 1966.

which car you jumped into because it would be cold in the morning, and later in the day, when it got warm, we would all strip off our jackets and shirts and throw them in the car. If you put your jacket in a Zapatista car and you were riding with the Villaistas, that might be the last you would see of your clothing. The Villastas might take off to picket another vineyard and you would not see them again for days. We would load up four or five to a car then form a caravan behind our picket captain and head for a location scouted the previous day. At the first ranch we had scouted we would set up at the entrance and wait for the workers to arrive and greet them. Sometimes crews turned away in support of the strike or because they did not want any trouble, but many drove right through the picket lines. By mid-morning we had done about as much as we could do, so we would load up and look for another vineyard to picket. When we saw cars parked along a road we knew a crew was at work and we would set up a picket line and begin the chant: "Huelga. Huelga. Huelga." Sometimes we would add "Esquirol afuera" [Scab, stand aside]. We would often return to the kitchen for lunch, and then we would go back out to the fields again. Most days it was just a lot of sweat. You didn't shoot a hell of a lot of film. Some days you didn't take a single picture. When it got warm, you'd get sleepy. Then there would be moments when things broke open and the adrenalin would flow. Foremen would see us and begin driving their trucks up and down the roads, kicking up dust and sending us diving. Occasionally the photography was like combat.[1]

Lewis never knew who would be on the picket lines. Busy with other matters, Chávez was seldom there. But whenever he was present, the pickets were always more serious. Dolores Huerta was often on the picket line at daybreak. Already well-known for her acid tongue and willingness to mix it up with the growers, she often went at it with Jack Pandol. Huerta would grab a bullhorn and shout in Spanish. At times, Pandol and Huerta would engage in dueling megaphones. Lewis shot several rolls just documenting Huerta early one morning. "You don't even have to caption the images," he explained. "You can see a powerful woman projecting her voice."[2]

On slow afternoons and in the evenings, Lewis often hung out with Luís Valdéz and Augi Lira. He called them the "golden boys," the stars of El Teatro Campesino — Valdéz with his wildly hilarious actos, and Lira with his wonderful songs. Watching them compose actos on pieces of butcher paper — on anything that could hold ink or pencil marks — Lewis recorded men going about the process of creating the scenes and characters they would portray at the Friday evening meetings, on the picket lines, and eventually in a kind of traveling guerilla theater.

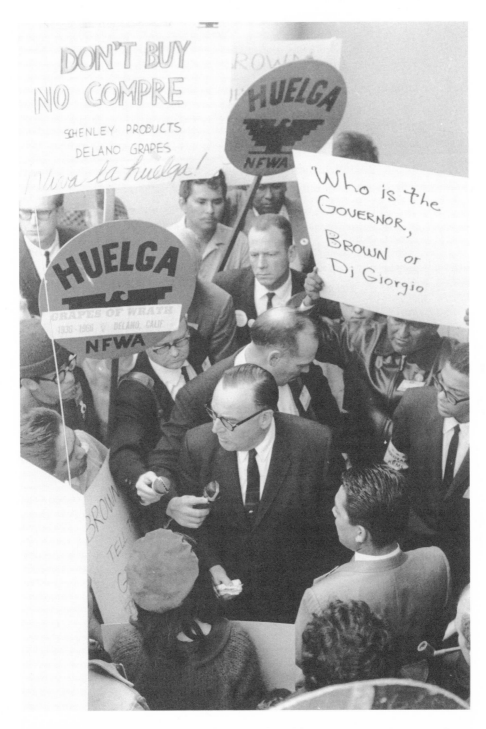

90. "Picketing Governor Pat Brown in Bakersfield at the California Democratic Convention. It was February 1966 and I had just come back from putting affairs on hold at San Francisco State University. It was a welcome break from the picket lines, with the day-after-day sameness." Winter 1966.

A typical day began at 6 a.m., when Lewis met with pickets at strike headquarters. Looking for strikebreakers somewhere within the thirty-eight thousand acres of vineyards around Delano, Lewis and the six or seven pickets would spend hours crammed into an automobile. Whenever they found pruning crews, they radioed the locations back to headquarters.

To get his shots, Lewis scrambled on top of cars and water towers and moved in and out of the picket lines, photographing from every possible angle. He photographed confrontations when pickets caught scabs passing through the picket lines and when deputies declared the picket line an unlawful assembly and ordered everyone to disperse. Soon he began to exhaust the compositional possibilities. Strike leaders shouting through bullhorns at midday made for undramatic images, so Lewis began composing images at daybreak and reducing the pictures to silhouettes against the sky. He did the same with picket lines.

Whenever NFWA pickets began shouting through the bullhorns, growers would drag their crews into the middle of the vineyard and set up megaphones and try to drown out the pickets by playing loud music as the pickets screamed and screamed. Often these confrontations would escalate out of control. Ever alert for angry growers, as well as guns, weapons, and sheriff's deputies, Lewis developed a sense for danger and learned how to avoid it.[3]

Following the same routine day after day, Lewis was often reminded of his stint in the Marines:

> You got up early, wolfed down a breakfast, hurried out to the cars, piled in sometimes ten to a car, even more, to save money on gasoline. You headed out to a vineyard, and then you stood around. You were half asleep. Tired. Still hungry. Dreading the heat. Hoping for some action. Any action. Mostly it was just boring. You put in the hours. It reminded me of the old "hurry-up and wait" of military life. Meals, such as they were, became the big reward of the day. It wasn't all that unfamiliar to me.[4]

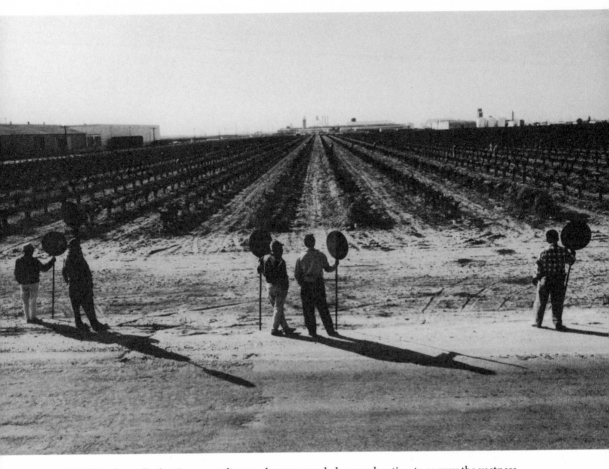

91. "I don't recall what I was standing on, but you needed some elevation to convey the vastness of those vineyards." Winter 1966.

35. Lessons

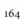

Within a few weeks, Lewis found that his images were becoming redundant. There were only so many ways to document a picket line in February 1966. At this point he became very grateful to NFWA volunteer Jim Holland. A carpenter, Holland made several hundred circular Huelga signs. Each was painted red, with the black eagle, and attached to a long pole. NFWA hauled them out to the fields by the hundreds in a van known as the "green weenie."

The symbol in the middle of Holland's Huelga signs — soon to become world famous — had a strange and unimpressive pedigree. Delegates to the NFWA convention in 1962 had gasped when Manuel Chávez first unveiled the 16-by-22-foot black eagle banner on the stage of a meeting. According to one story, the design had been dreamed up by Manuel Chávez and Gilbert Padilla because Manuel had difficulty drawing anything else and could reproduce it using the capital x's on a typewriter. Chávez also wanted "to get some color into the movement, to give people something they could identify with." He had turned to ancient history for a color combination the Egyptians had used "to crash into your eyes like nothing else." Later versions would have "Huelga" printed above and below the black eagle. Some NFWA members bitterly complained that the eagle suggested a Nazi symbol or the flag of some Communist country.[1]

Lewis made good use of the signs. To fill open space in his images, he often stationed himself in such a way that the big sign took up the foreground of his wide-angle lens, and then composed a scene in the

92. "I like the way the faces are stacked in the center of the photo and don't know why I didn't grab the telephoto lens and go for it." Winter 1966.

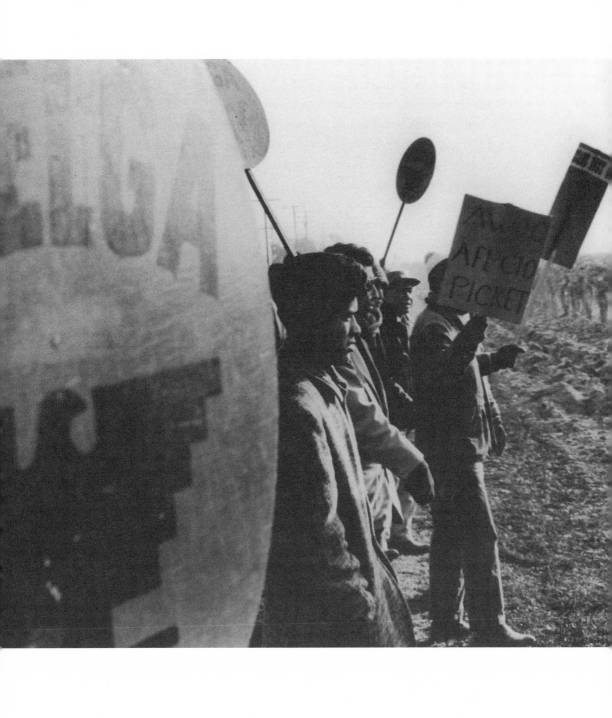

remainder of his viewfinder. Decades later, Lewis would observe that those round Huelga signs with their black eagles appeared in virtually every one of his picket line pictures. The signs were much appreciated not only by him but by other photographers searching for ways to turn ordinary photographs into much stronger images. "That sign and the bullhorns were our props," Lewis recalled. "They were everywhere."[2]

Growers were never happy to see Lewis or anyone else with a camera. Early in the strike one of them beat AWOC organizer Hector Abeytia after he raised his camera. Another strangled Eugene Nelson on his own camera strap. Growers would skid their trucks to a stop, jump out, and confront photographers. The most truculent growers would stand together, arms folded across their chests, eyes hidden behind sunglasses. One or two were verbally abusive.

While a few pickets felt intimidated, most remained defiant. They shouted back insults: "Pinche puto," fucking faggot. "Pendejo," asshole. "Cabron," son of a bitch. And "culero," coward. Pickets frequently punctuated their insults with an upraised middle finger. Several got into fistfights.

Watching these dramas play out, Lewis quickly assimilated a lesson known to previous generations of farmworker activists and studied in detail by countless labor relations specialists. In the distended agricultural environment, tactics that worked in industrial plants failed in the vineyards. Picketing had little effect. Because there were so many farms so widely spread out, a union might succeed in shutting down operations in one vineyard while work continued elsewhere.

The logistics of agricultural labor strikes were impossible. You could not tie up operations the same way the United Auto Workers clogged the entrance to an auto assembly plant or the way the United Mine Workers tied up a mine entrance as tight as a wet knot. One journalist compared picketing the vineyards around Delano to trying to cover a factory with a thousand entrance gates spread over forty square miles or a factory that changed its location daily so you had no idea where the entrance gates were located.

Early in the strike, Lewis decided he would not explore living conditions at Delano, although he had ample opportunity to do so. The subject had already been probed by his predecessors. He felt he would add little to the picture. While not averse to recording poverty, he was basically a shy man repulsed by the idea of intruding. But he was also unknowingly ahead of his time.

Decades before critics began to question photography's traffic in pain, Lewis had already taken an ethical stand against exploitation and sensationalism. Yes, he was in Delano to mobilize useful action. Yes, he was going to gain intimate knowledge and deep access. Yes, he was going to bear witness. No, he was not there to benumb and exacerbate suffering through exploitative voyeurism generated according to a

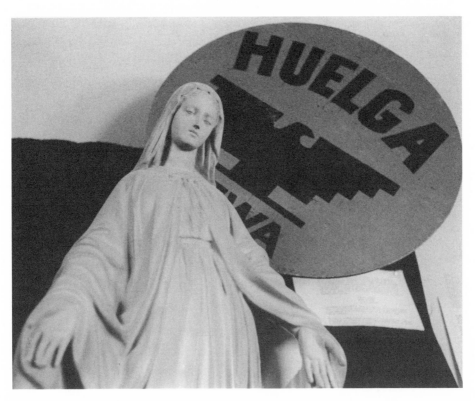

93. "The grape strikers were very religious and never hesitated to invoke God and Church in the name of their cause. Here the Huelga is watched over by the Virgin Mary inside the NFWA headquarters." Winter 1966.

mass media timetable. He was not going to violate privacy, add insult to injury, or compound affliction. He was not out to mistreat farmworkers. He was not going to engage in a politically reactionary type of photography that invited passive consumption. He was not there to provide spectatorial gratification. He was going to do positive photography.

Lewis knew it was tricky, this business of visual strategies and aesthetic choices, the challenge of somehow bringing aid to the exploited, hacking away at the complacency of people enjoying the luxury of seeing but not enduring, holding the relevant parties accountable, passing judgment, doing politically useful work. He knew it was not at all simple. He could never actually talk about it except in fragments.

Decades later, he tried to explain his approach by admitting:

I found it hard to photograph poverty. I was sometimes ashamed to see what other photographers did. When some of them began poking around, I saw a lot of the farmworkers just placing their hands in front of their faces and motioning

for the photographers to stop. I always felt I was intruding. Even on the picket lines. I was not a Filipino or Mexican American. I had not worked in the fields. I did not live in Delano. I was an outsider. I had not known hunger and privation. I felt that I had certain responsibilities. I was always photographing strength, strong men and women standing. I did not want to do degradation, although that was what the boycotters wanted. I was not a dispassionate observer. I was not cool. I was not indifferent. I was not trying to be artless. I was not doing photojournalism. I was not neutral. I wanted my work to be a catalyst. I was always thinking of Walker Evans, how he seemed to photograph with tact, delicacy, complete awareness, perfect respect. I felt that in some way I was exploiting people. But I could not do some things. "Give us starving kids," they would say. Well, the kids didn't know they were that poor. I never tried to document living conditions. I could not go into people's homes to show how bad off they were. Any number of people lost homes and cars because they went on strike. That's a powerful commitment. But I could not photograph their grief.[3]

In February 1966, NFWA gathered together some of the best strike photographs and began issuing "a series of picture books giving the feeling of what it is like to live and work in twentieth century America under feudal labor conditions." *Huelga: The First Hundred Days of the Great Delano Grape Strike* was the first. Written by Eugene Nelson, the tract featured pictures of angry pickets, the early morning shape-up for work, and children working in the vineyards. In one of his early images, Lewis had photographed Nelson pounding away on his typewriter, either writing a story for *El Malcriado* or finishing *Huelga*. It is the only known image of Nelson at Delano.

Quickly selling out within a month, *Huelga* went into a second printing and inspired other photographic accounts. The most important of these was titled *The Grape Strike*. Published by the National Advisory Committee on Farm Labor (NACFL), a New York City–based nonprofit organization that had been supporting the farmworker cause for a decade, *The Grape Strike* was packed with pictures of sheriff's deputies and private guards protecting strikebreakers, lines of pickets holding up large Huelga signs, farmworkers at union meetings, and the labels and vineyards of grape growers being struck. A George Ballis photograph of a Kern County deputy sheriff carrying a camera at the Giumarra ranch underscored the way law enforcement authorities employed photography against the farmworker movement. "All deputies carried Instamatic cameras," the book explained. "Some had cameras and tape recorders. They took repeated photographs of all pickets, particularly close-up shots."[4]

94. "Paul Chávez and Emilio Huerta hitching a ride on the Porta-Potty truck." Spring 1966.

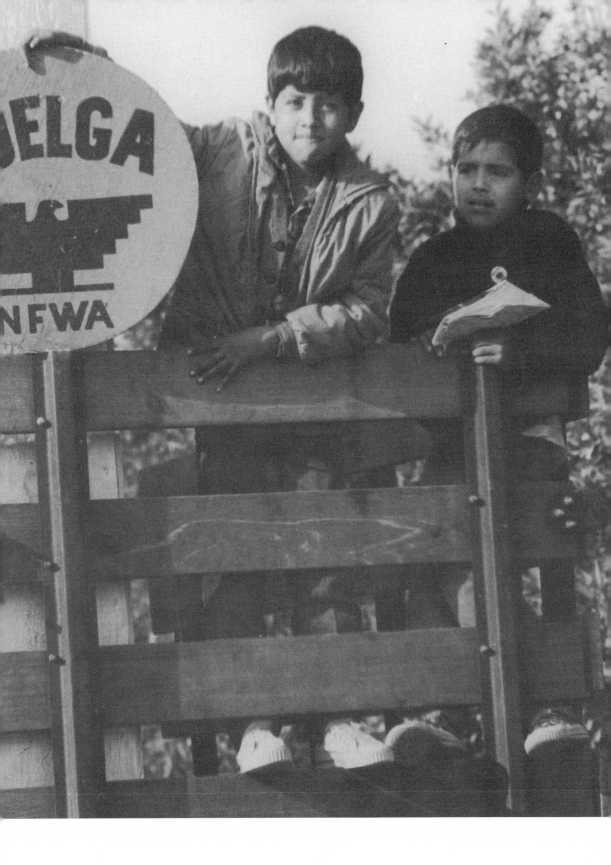

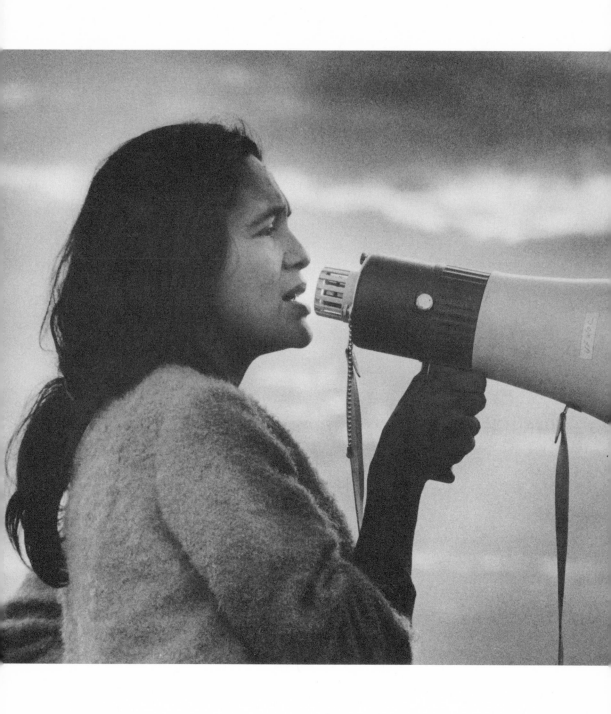

36. Doubts

Afew days after *The Grape Strike* came out, Lewis was looking through the open front door of the Pink House thinking that his photography seemed futile. "All this work, the long hours," he asked himself, "was it worth the effort? Was I having any effect?"

Lewis was depressed and worn out. He had been photographing nonstop. "Get up early, patrol, develop film, print, and about a hundred other things, like typing up union fliers and addressing envelopes," he recalled. "Endless work. I just wanted to take a long hot shower and lay down on a clean bed. I did not think I could continue much longer."[1]

Lewis was not alone in his doubts. Union members were broke. Volunteers missed their families and wanted to go home. Other photographers and news crews were a rare sight. Schenley Industries and DiGiorgio Fruit Corporation appeared unharmed by the boycott. Delano seemed isolated and forgotten. Gasoline bills ran $4,000 a month. Telephone bills

95. "During the Perelli-Minetti strikes and boycott, there was an inclined approach to the freeway overpass with a great vantage point overlooking the grape harvest that I'd never had before or since. But I saw Dolores [Huerta] and a few others at the base of the hill holding forth at the edge of the vineyard, and for some reason I decided to abandon that viewpoint and descend. One of the best decisions I've ever made, as the gods were smiling monumentally." Summer 1967.

averaged $1,600. Just to keep going, NFWA needed $25,000 a month. Expenses for rent and car payments for the hundreds of strikers on picket duty kept mounting. Food donations from urban groups were tailing off. Julio Hernandez, in charge of the "Strike Store," began issuing distress calls for lard, oats, salt, sugar coffee, rice, dry beans, and flour.

People were hungry. In the strike kitchen, cooks were reaching the last of the rice that had been donated to the union that Christmas. A sense of doom permeated union headquarters. "It is very sad and quiet here," NFWA Vice President Dolores Huerta confessed in a letter to AFL-CIO Assistant Regional Director Irwin DeShetler.[2]

Every so often, when the union succeeded in pulling a crew out of the fields, Lewis would photograph them and then agonize over their future. Many of the men had no place to go, having been kicked out of their labor camps for supporting the strike. They would flop on the floor with the volunteers in the Pink or Gray House. The next day they would be gone. Lewis photographed them leaving their camps and loading their belongings along with their beat-up luggage into the trunks of their automobiles. He wished them the best of luck and wondered if he could be so brave.[3]

As the sense of doom deepened, Eugene Nelson discovered that Tulare and Kern County deputy sheriffs had launched a massive program of surreptitious photographic surveillance. After Nelson protested to local police and federal authorities, the surveillance continued. Pulling over entire caravans of strikers on their way to picketing duties, deputies forced picketers out of their cars, questioned them, and detained them for as much as an hour and a half. Pickets filled out field reports and then stood to be photographed. Lewis found it a strange form of photography, almost mindless. "When I asked a deputy what reason he had for photographing," Lewis explained to Nelson, "he just muttered something about traffic hazards."[4]

So frequent and widespread was the surveillance that Lewis and other volunteers were detained and photographed on a half-dozen separate occasions. But law enforcement authorities did not end their photographic surveillance in the fields. The Delano police department photographed license plates of vehicles outside NFWA headquarters and forwarded the information to federal and state authorities, while the Kern County sheriff's office compiled a card file of five thousand suspected strike supporters. Each card showed the supporter's name, criminal record (if there was one), association with groups (if known), and a mug shot from the dossier of picket line pictures (if the name and photo could be matched). At the same time, an FBI informant posing as a photographer began conducting an extensive photographic surveillance of Lewis and other "outsiders" in an attempt "to identify some of these people when the strike is over."[5]

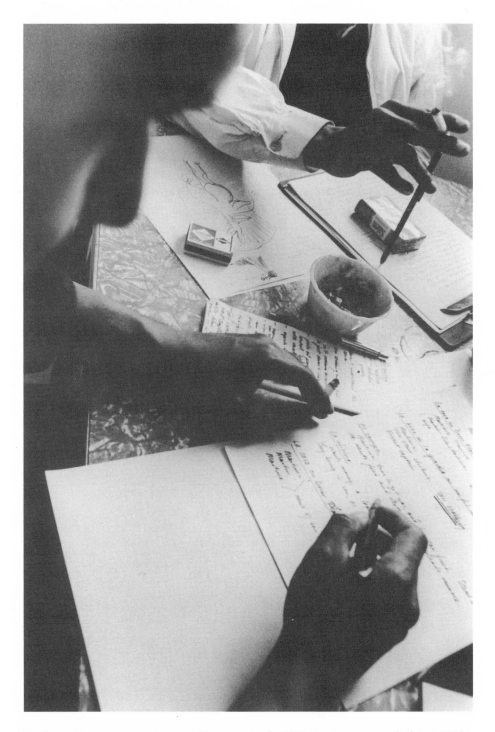

96. "A working session coming up with new actos for El Teatro Campesino. That's Luís Valdéz and Augi Lira as they script another production. It was nice to encounter them seated, instead of hopping around the stage as they usually were doing." Spring 1966.

Lewis and other pickets at first pretended to cooperate with deputies. Adopting a variation on "shuck and jive," they examined the cards that they were asked to fill out, turned them over, read them upside down, corrected spelling, dropped the cards, added and deleted information, and took as much time as possible. When asked to pose for mug shots, they sneezed, picked their noses, frowned, closed their eyes, opened their mouths wide just at the moment when the shutter snapped, and forced deputies to reshoot pictures again and again. Some strikers went further.

Of these confrontations, Lewis recalled that "Chávez got it down to a science. He would politely examine a card, correct spelling, and engage in friendly conversation. This would go on and on. Chávez would just drag it out. He would tie an officer up for an hour or more."[6]

97. "I couldn't have posed this much better, so usually shot-from-the-hip grab shots are better than anything I could have imagined or pre-envisioned." Spring 1966.

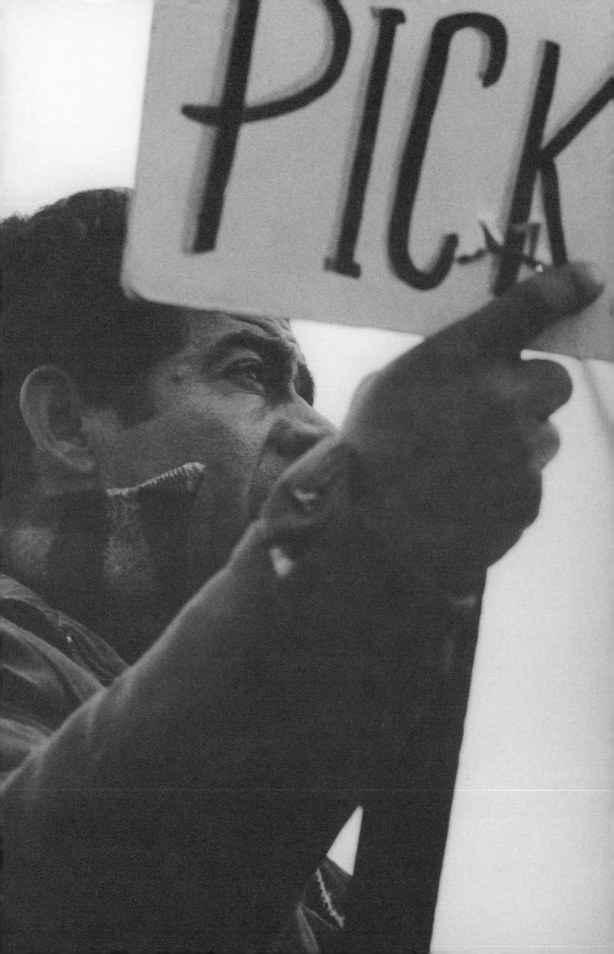

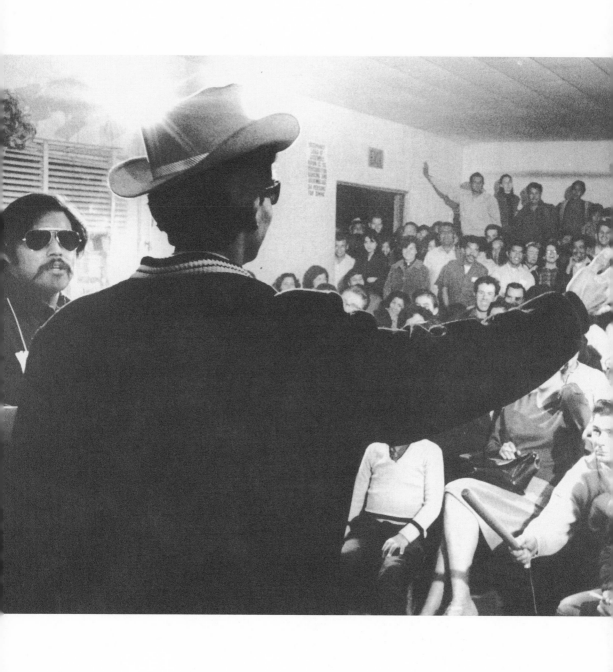

37. Exhaustion

Besides being photographed by the police and FBI, Lewis was scrutinized and tailed by professional photographers and public relations agencies. Grower associations had hired them to play up Communist Party involvement and lack of support for the strike among field hands.

With his beard and Marine combat jacket, Lewis seemed to epitomize the unkempt, long-haired outside agitator. Also scrutinizing Lewis and the volunteers were vehement anti-Chávez photographers, among them Gary Allen, a Los Angeles–based Stanford University graduate who wrote and shot photographs for a John Birch Society pamphlet, *The Grapes: Communist Wrath in Delano*. Allen was out to tarnish the reputations of Chávez and his followers. His photographs drove home the theme of communist involvement with captions that read "Communist Larry Itliong," "Cuban-trained Luis Valdez," "Revolutionaries Dolores Huerta and Wendy Gopel," [Goepel] and "Marxist attorney Alex Hoffman."[1]

Shortly after Allen published his hatchet job, documentary filmmaker Mark Harris arrived unexpectedly from Portland, Oregon, where he was employed at KGW-TV, a local NBC television network affiliate. A history buff who had graduated from Harvard University two years earlier, Harris had been working on a film about Industrial Workers of the World (IWW) founder Big Bill Haywood when he read about the grape strike

98. "Early Teatro Campesino performance before the Friday night meeting moved to the Filipino Hall. I considered cropping out César Chávez's hand with a cigarette, but what the hell — tell it like it was." Winter 1966.

in Edgar Z. Friedenberg's *New York Review of Books* essay "Another America." Friedenberg had predicted that the impact of the grape strike on labor relations and American democracy "is likely to be out of all proportions to the number of people, strategic import of the industry, or bread-and-butter issues involved." Harris had to see it for himself.[2]

Harris, like Lewis, was anxious to document history as it happened. After convincing the head of the small documentary division at KGW-TV to pay for his plane ticket to California, he flew to Bakersfield, rented a car, and drove straight to Delano.

Forty years later, Harris recalled how

> I had never been in the Central Valley. The sight of all those vineyards and so much farmland really fascinated me. After I reached Delano, I asked a few questions, got some directions, and headed over to union headquarters. Except for Jon Lewis, I did not see any other photographers. This surprised me and made me even more determined. The place should have been swarming with cameramen. It was only a few minutes before I was shaking hands with César Chávez. I said that I want to make a documentary about the strike. As I remember, he agreed at once, although we did discuss the matter more over dinner that night at a Chinese restaurant in Delano. At that point I had little experience as a filmmaker—only a few documentaries about local issues in Portland—but César didn't hesitate to open the doors of his new union to me. At the time, I wanted to believe it was my youthful idealism that persuaded him to trust me. But looking back, I'm sure it was more his own faith in the justice of his cause. He was confident that if any reasonable person hung around the NFWA with a camera long enough, he couldn't fail to record the truth about the farmworkers' struggle and the union battle for recognition.[3]

Six weeks would pass before Harris was able to round up funds, put together a crew, and return to Delano. Of those six weeks, Lewis recalled:

> They were a low point in the strike. I was photographing the same thing for the tenth time, and not very well. It was cold and lonely work. So fucking dreary. We were all exhausted. Out of ideas. Going nowhere. Depressed. I really could not photograph in the fog. I know some photographers used it to advantage. If you stood back, placed your camera on a tripod, and shot a scene with a long lens you could compress all that fog in front of the subject and be very artistic. I never saw a shot worth the effort. To me, the fog created a feeling of being lost and wandering and forgotten. We all hated those foggy winter days. We were at

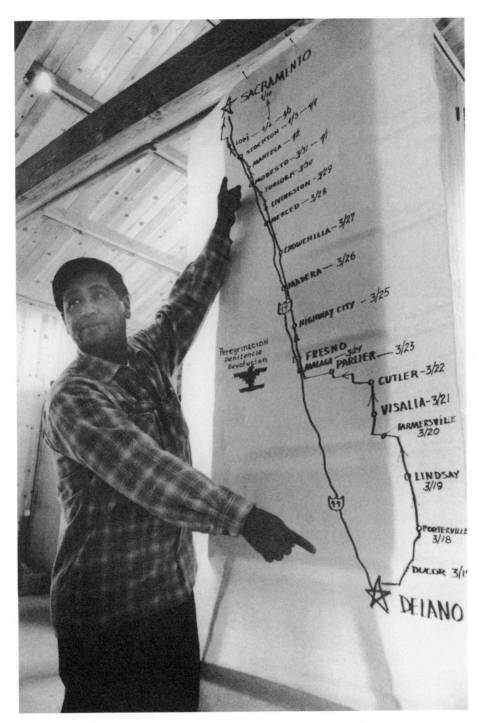

99. "I made this on March 9, 1966. This is the moment when César Chávez first displayed a map of the march on Sacramento. We were at first aghast before we all realized how brilliant it was." Spring 1966.

a loss for ideas. Everyone was trying to come up with another gimmick, some tactic. Was there some way to buy time. How could we build support? We needed to lift spirits. We needed to generate favorable images. We needed to expand awareness of the strike and win public support. We were desperate.[4]

And then, as he would do so often, Chávez stepped forward with a highly photogenic plan. Lewis recalled a NFWA weekly meeting on February 22, 1966, when

Chávez found inspiration from field hands who had been sprayed with sulfur dust while picketing the Schenley ranch the previous year. Many had vowed to protest by undertaking a cross-country pilgrimage to Schenley's corporate headquarters in New York. They were going to walk all the way across the country. Imagine that. In winter. They would have died. Chávez rejected the plan as too dangerous and expensive, although he had once used the march as an organizing tactic while working for CSO in Oxnard. But he liked the concept, especially after seeing the publicity generated by the Freedom March on Selma, Alabama. People don't understand how attuned he was to the civil rights movement. And he had read all about Gandhi and knew that he had used similar tactics. He thought that he could rekindle interest, generate new imagery, and create what amounted to a massive photo opportunity that projected the kind of picture that he wanted the public to see.[5]

A day later, Lewis accompanied Chávez and a small group of NFWA leaders to a retreat in the Sierra Nevada east of Visalia. Lewis had no idea what was going on until NFWA members taped a huge piece of butcher paper on a wall inside one cabin. Late in the afternoon, Chávez convened everyone at a meeting to announce that seventy-five farmworkers would begin a long march. There was considerable discussion about the route. All agreed that it had to start in Delano. Some said it should head south to Mexico to protest illegal recruitment of strikebreakers. Others advocated marching to San Francisco, to the West Coast headquarters of Schenley and DiGiorgio, and to the longshoremen who had refused to load grapes. But because Sacramento seemed to be the root of the problem, the NFWA decided to walk 280 miles north from Delano to Sacramento. They would begin on March 17, St. Patrick's Day. They would cover approximately the same distance Gandhi had covered on his famous Salt March to the Sea in 1933.[6]

Lewis photographed Chávez as he identified towns along the way and drew the route of the march in red ink. East from Delano to Richgrove. Cut north to Highway 65. Pass through Ducor, Terra Bella, Porterville, Strathmore, Lindsay, Exeter, Farmersville, Visalia, Cutler, Orosi, and Parlier. Pick up Highway 99 at Malaga,

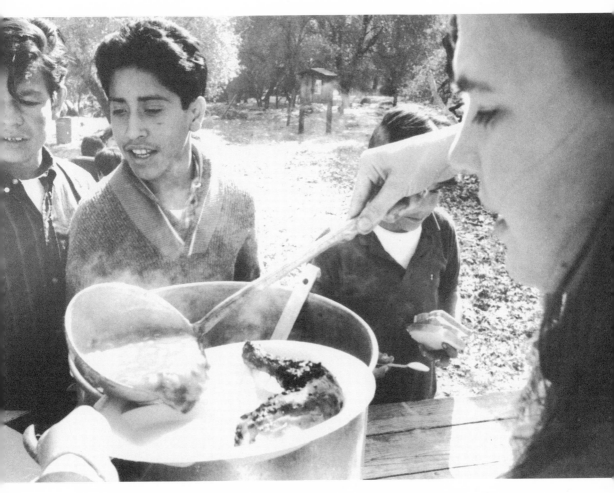

100. "For so impoverished a union, the group feeds were amazing. 'Special of the day' was a drumstick slathered with beans at the mountain retreat planning session prior to the march. The NFWA showed the movie *Salt of the Earth* one evening to immense applause. Wendy Goepel is serving the meal." Spring 1966.

just south of Fresno. On to Sacramento by way of Madera, Chowchilla, Merced, Modesto, Stockton, Manteca, and Lodi.

The marchers would average ten miles each day. Each night marchers would stop in one of the small farmworker towns along the way. A truck carrying supplies, a makeshift ambulance, and a mobile first-aid station would tend to their needs. On Easter Sunday, April 24, they would arrive on the steps of the state capitol and join thousands of other farmworkers and supporters in a huge rally.[7]

Chávez referred to the march as *La Peregrinación* (the pilgrimage). Modeled on the Lenten *peregrinaciónes* of Mexico, it would supposedly underscore the theme of "Penitence, Pilgrimage, and Revolution." In fact, it aimed at much more. The march would pressure Schenley, enhance support for legislative proposals to extend collective bargaining rights to agriculture, and shame Governor Pat Brown into action. With ten thousand people massed on the steps of the state capitol, how could he not intervene in the grape strike and force a settlement?

Although Brown was viewed as not hostile to the farmworker movement, he had done little to help. After being elected in 1958, he had presided over the great spurt of growth after World War II. Other than to fund ten migrant service centers throughout California, the governor had remained aloof from the farm labor movement. His support for the State Water Project had earned him wide popularity among growers, who irrigated their crops with water from the plumbing system that Brown had pushed forward. Brown did not want to alienate that base. Ronald Reagan, who was going to challenge (and defeat) Brown in the fall campaign, had been openly critical of farm labor strikes and was calling for a new bracero program. Brown was maneuvering for reelection and was going to have to choose sides. If the farmworker movement was ever going to enlist his support, now was the moment.[8]

Although the march seemed a radical departure, it was not. Lewis recalled that

Chávez had to shift his focus away from local organizing. He had to develop a statewide organization. He had lost contact with the small cadres that he had set up around the Valley. Now he was going to rebuild his base. The march was going to be a kind of mobile house meeting on a grand scale. It would allow Chávez to build support for the strike and boycott. He would address farmworkers in barrios and colonias along the way. By relying on the locals for food and shelter, the NFWA would involve farmworkers in the event, whether they realized it or not.[9]

Nothing of this scale had ever been attempted by a labor organization in California. Remembering how NFWA members reacted to the plan, Lewis stressed that

it took us all by surprise. We were so down. It injected new life into the strike. It certainly got me excited. I had been in the Marines when the big civil rights marches had occurred in the south. Now I was going to see the California version here in the Central Valley. You can't imagine how energizing it was. There was a sense that what was about to happen went far beyond a protest by Delano farmworkers, that it stood for the larger needs of a whole class of people who had been robbed of their dignity. I photographed Chávez unveiling the map and later addressing NFWA members. That night we all watched *Salt of the Earth*. We were really inspired. We were ready to go."[10]

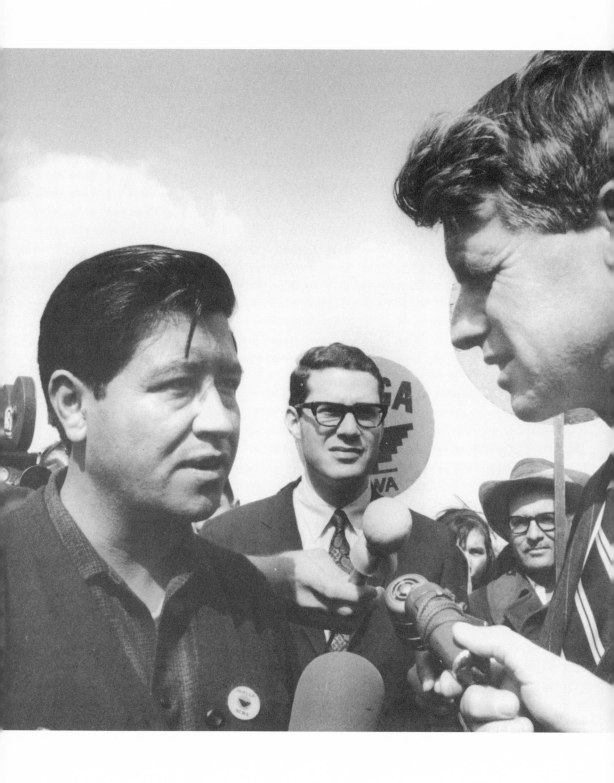

38. Kennedy

As NFWA prepared for the march, Lewis photographed hearings conducted by the Senate Subcommittee on Migratory Labor. United States Senator Harrison (Pete) Williams Jr., chairman of the Senate Subcommittee, had long been a champion of farmworker rights. Over the years he had introduced bills to extend minimum wage protections, collective bargaining rights, and child labor laws to agriculture.

As the drama at Delano began to attract national attention, Chávez asked Williams to help. Williams convened hearings on March 14 in Sacramento, and on the following day moved them to Visalia. Most of the testimony was a repeat of other hearings. But the Delano hearings, scheduled for March 16, promised considerable excitement because Senator Robert F. Kennedy was going to be present.

Kennedy was the most famous of many famous public figures making the pilgrimage to Delano. Following the assassination of his brother he had undergone a metamorphosis. No longer the aggressive individualist of his Justice Department and Rackets Committee days, Kennedy during his first year as a newly elected senator from Massachusetts traveled through the rural areas, meeting with the poor and using his personality to direct press attention to the problems of economic and social injustice, poverty, and hunger. But when the grape strike erupted, he had not immediately connected it to the Southern voting-rights struggle

101. "Much hoopla and a media circus surrounding RFK's [Robert F. Kennedy] visit on March 16, 1966, of which I was part. He did shake hands with actual workers later." Spring 1966.

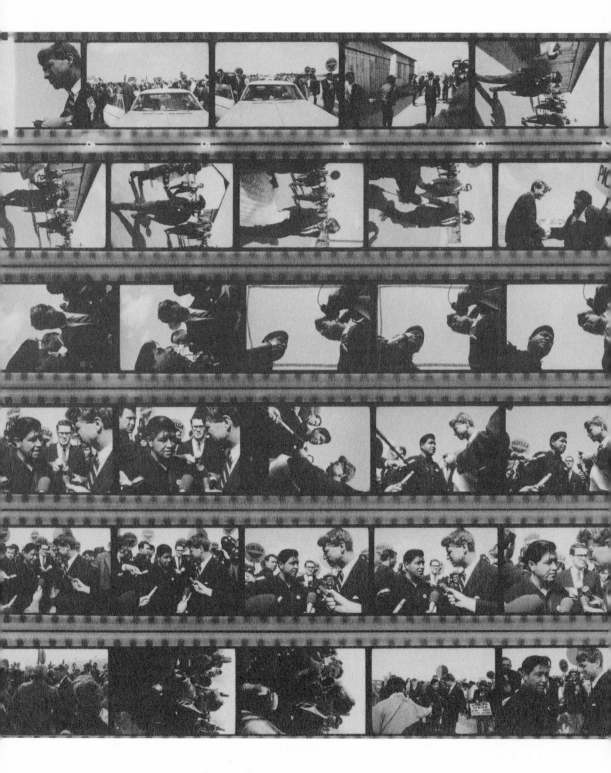

102. Jon Lewis contact sheet number 62, Robert F. Kennedy visit to the picket lines, March 16, 1966.

or the civil rights movement. As late as the cross-country flight to California, Kennedy was still asking staff members "Why am I going?"[1]

Kennedy feared taking on another issue at a time when he was leading opposition to the war in Vietnam. When he finally arrived at the hearings a day late, he had a galvanizing effect on those present. The Delano hearing would be a perfect amalgamation of divergent personalities. Here was Kennedy — ruthless, arrogant, articulate, a power broker. And Chávez — mystical, full of moral certitude, nonviolent, uncomfortable before audiences.

Arriving early at the hearings, Lewis discovered

about one thousand farmworkers packed into the Delano high school auditorium. The place was a sweat box, hot and uncomfortable. Everyone was very excited. Farmworkers held hand-lettered signs and waved banners. Many of them did not quite know who Kennedy was, except that he was a famous government official, brother of the slain president. I spent some time in the audience shooting pictures but I could not get outside. Several hundred people unable to enter the building were waiting for Kennedy. Some of them tried to crawl in through open windows. Seats had to be cleared for the growers. They arrived in a gruff and very hostile mood. I made few interesting images of the actual hearings. What can one do with men sitting behind long tables speaking into microphones? I snapped some cover-your-ass shots of the Senate Subcommittee and of union members reacting to testimony. Like everyone else, I was waiting for Senator Robert Kennedy to speak. When he appeared on stage, I caught a picture of him surrounded by farmworkers, including two young children who were just in awe of him.[2]

A day before Kennedy arrived, Chávez had again complained that Kern County sheriff's deputies were photographing individual pickets and interrogating them as they marched peacefully along public roadways. Conservative Republican California Senator George Murphy, who a year earlier had introduced a bill to revive the bracero program, was so shocked by the accusations that he asked Kern County Sheriff LeRoy Gaylen

to attend the Delano hearings and address the issue. As a highway patrol captain, Gaylen had policed the 1933 cotton strike. Subsequently he had policed most major farm labor struggles in the San Joaquin Valley. Unaware that he was attracting rapt attention, Gaylen went into great detail explaining his department's photographic activities.

Kennedy grew perplexed as the sheriff related one detail after another. Lewis kept his camera trained on Kennedy as he interrogated Gaylen. After Kennedy discovered that the sheriff maintained a file of five thousand photographs, Lewis began snapping images as the two engaged in an especially heated exchange that went:

KENNEDY: Have you taken pictures of the people that were picketing — Sheriff, have you been taking pictures?

GAYLEN: Well, you have people who come in from other places that we don't know, and we keep in touch, find out who they are, why they're here.

LEWIS: Click!

KENNEDY: What are you taking their pictures for?

GAYLEN: Just in our files so we will know who they are in case anything happens.

LEWIS: Click!

KENNEDY: I can understand [why] you want to take pictures if there's a riot going on, but I don't understand why if someone is walking along with a sign you want to take pictures of them. I don't see how that helps.

GAYLEN: Well, they might take pictures of us, too.

LEWIS: Click! Click!

KENNEDY: It's not a question of them wanting to take pictures of you. You're a law-enforcement official. It is in some way an act of intimidation to go around and be taking their pictures.

GAYLEN: I've got to identify those people.

KENNEDY: We're talking about your taking pictures of somebody walking along with a picket sign.

GAYLEN: Well, he's a potential [sic], isn't he?

KENNEDY: Well, I mean, so am I . . . Do you take pictures of everybody in the city?

GAYLEN: Well, if he's on strike or something like that.

LEWIS: Click!

103. "TV lights again enabled some freedom and mobility at the U.S. Senate Subcommittee on Farm Labor hearings, of which RFK was the star. After questioning the Kern County sheriff on his preemptive arrest policy, he suggested that during the lunch break the sheriff read the U.S. Constitution — to loud cheers and laughter. This is my favorite photograph of RFK." Spring 1966.

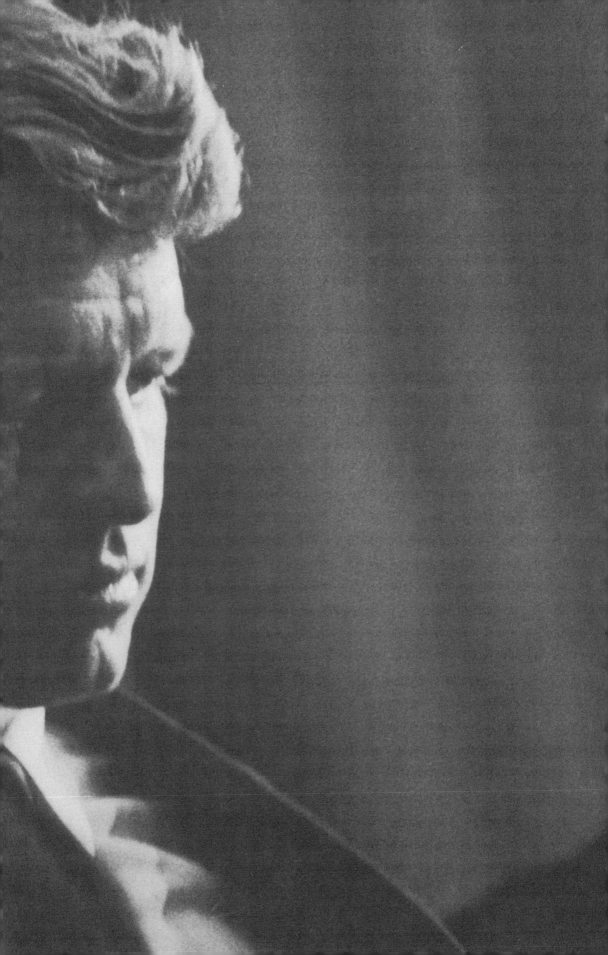

Kennedy then asked Gaylen why he had arrested forty-four strikers and several priests the previous October.

GAYLEN: I had news there was going to be some cutting, if they didn't stop saying certain things. The workers in the vineyards didn't like it — they were arrested because they were going to be hurt.

KENNEDY: How can you arrest someone if they don't violate the law? You can't arrest a person in America until he has broken the law. You can't say, well, I thought he might break the law, so I arrested him.

LEWIS: Click!

KENNEDY: I suggest the sheriff and district attorney read the Constitution of the United States.[3]

At the conclusion of the hearing, Lewis followed Kennedy and Chávez through Delano and out to the picket lines at DiGiorgio's Sierra Vista Ranch. Kennedy plunged into the picket line, showing a genuine concern for the strikers. Lewis shot another roll of film as Kennedy shook hands with pickets and visited with NFWA members.[4]

That evening, as he watched Kennedy's images appear on the contact sheets, Lewis reflected on his brief sojourn at Delano. It had been a strange six weeks, alternating between tedium and exhaustion. Now Lewis wondered about the pilgrimage. He had seen pictures of civil rights marchers being beaten, arrested, and harassed in Mississippi. He wondered how Californians would react. Would his cameras be smashed and his film ripped out?

He had already exposed sixty-five rolls of film. Whatever was about to happen, he was not going to miss the march. But he would do more than record the event.

Following a journalism that says in order to understand something you have to witness it over a long period of time, Lewis became a participant-observer. Instead of a notebook, he would pack a camera. He would lend his body to the event. As he settled into his bed that night, he felt a stirring of excitement. This was why he had come to Delano. This was the essence of the type of photography he most cherished — up close, in the middle of a historic moment.[5]

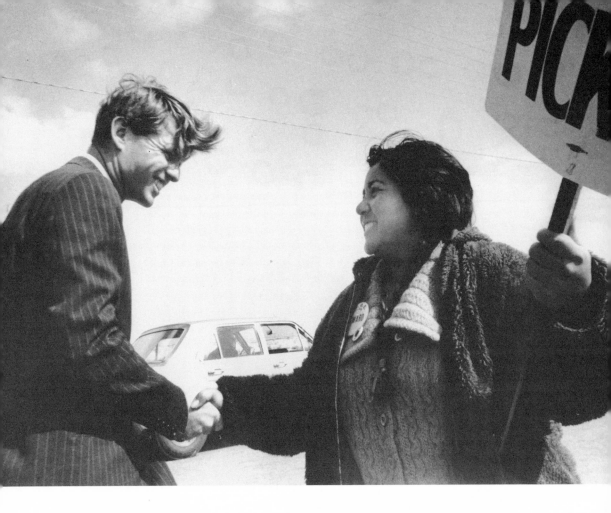

104. "César and RFK paused for the media a number of times during his visit. I have some half-dozen frames with the background cluttered with reporters in suits, with not a farmworker in sight. I was often next to George Ballis for the RFK sequences, and we got almost identical shots. I often kneeled down to isolate them for a much stronger shot. In this frame, Carolina Franco grasps RFK's hand. Not bad for a seat-of-the-pants grab shot. There was a bond between the well-dressed, well-pressed Ivy League elitist and our welcoming line of strikers — many dressed in their best. This must have been RFK's first encounter with the Chicano community, which would support him strongly in his presidential bid. The bonds formed here in 1966 and when Kennedy came at the end of César's fast in 1968 resulted in solid union and Chicano support in the California primary during his presidential bid." Spring 1966.

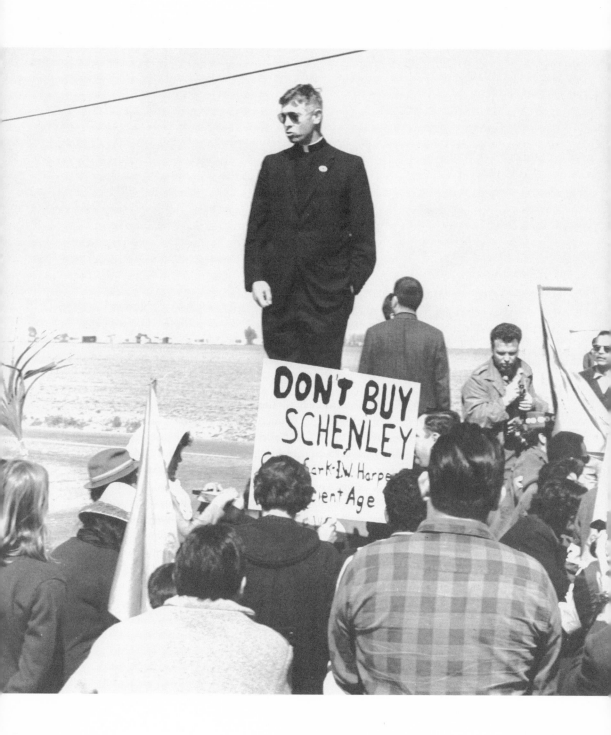

39. The March

A round midnight, several new photographers arrived at the Pink House. One was Gerhard Gscheidle. A twenty-three-year-old German with a strong interest in photography and a degree in steel fabrication, Gscheidle had been deeply touched by news of the murder of three civil rights workers in the South. On his own, he had traveled by bus to Mississippi, where he photographed for *The Movement*, an SNCC publication. He had been exhibiting his work in the student union building at the University of California, Berkeley, when *The Movement* editor Terry Cannon invited him to Delano to photograph the march.

Like Lewis, Gscheidle had limited resources and would depend on the NFWA for food and lodging. Other than what he would earn from his photographs, he received no compensation, not even picket's wages, although the NFWA did pay for film, paper, and transportation.[1]

A second photographer who arrived for the march was Blair Stapp, a San Fran-cisco–based instructor at the Art Institute. Besides photographing and making sound recordings of the pilgrimage, Stapp also opened his Bay Area darkroom to Gscheidle and other farmworker movement photographers. Two other photogra-phers also present from the beginning of the march were Sam Kushner, draped in cameras, perpetually puffing on his pipe, often toting a tape recorder and notebook, who was covering the farmworker strike for the communist *People's World*; and John Kouns, a former United Press International (UPI) photographer specializing in social issues, especially the civil rights struggle and the antiwar movement.[2]

During the summer of 1965, Kouns had camped out in a metal Quonset hut and set up a darkroom thirty miles northeast of Delano at the Linnell Farm Labor Camp. Maintained by the Tulare County Housing Authority, the Linnell Farm Labor Camp consisted of sheet metal shacks, eight by fourteen feet, that sheltered

105. "That's John Kouns [right] photographing on the picket lines." Spring 1966.

a family of five or six people. The shacks had no heat except from propane tanks and no running water. In the winter they were refrigerators, and in the summer, ovens, habitable only after sundown. Constructed in 1938, the shacks had long been condemned.

That fall Kouns had completed a story on cotton picking. He had already spent two months on and off at Delano. Sleeping on the floor of the Pink and Gray Houses and taking his meals at the Arroyo camp with Lewis and other volunteers, he "did some picket duty and some photography, sometimes topping off the day with a few beers at People's Bar." He had deep friendships in the farmworker movement and had remained just one telephone call away. Kouns was in the midst of developing something he would later describe as "guerilla camera" when he returned to Delano to cover events through the winter and sporadically over the next two years.[3]

Like Lewis, these photographers never considered themselves to be aloof and detached observers. Some even rejected the label "photojournalist." Much like Lewis, they were going to throw themselves into the movement, trading job security for an opportunity to photograph in depth. Lacking the funds and backing of newspaper and magazine photographers, they had one thing that their competitors lacked — time — and they intended to turn it to their advantage. If deadline pressures prevented daily news photographers from studying anything at length, lack of such pressures could provide an opportunity to go beyond the kind of hit-and-run images that they detested.[4]

All of these photographers supported the NFWA. They crossed the line demarcating participant and observer. Many allowed the NFWA to make their best images into posters. Becoming an extension of the union, they echoed the sentiments of many other photographers when they explained that they hated with a passion known only to those who had been through the wringer photographers who came and went once they got a shot or two. Asked if he was neutral, San Francisco freelancer Mike Bry, who had also begun photographing at Delano, explained to an interviewer that every photographer he met during the strike sided with the union. "This business of hiding behind the camera was a crock," he said. "You couldn't go out on the picket lines every morning and put up with everything you had to put up with and remain neutral very long."[5]

Lewis and other freelancers openly admired Chávez. They admired the way he refused to play it safe. They thought him shrewd and credited him with completely understanding the role that photographers were playing.

Over the years, Lewis often thought about the way Chávez played to the cameras. He believed that

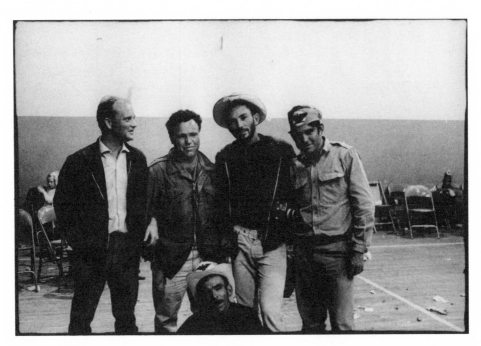

106. "That's Gerhard Gscheidle on the left, John Kouns next to him, myself, a NFWA member whose name I can't recall, and Augi Lira in the front center. I can't remember who made this shot. Spring 1966.

César Chávez was very different from other leaders in the way he thought visually, although he never talked about it. I don't think anyone realized how many of the NFWA's tactics aimed at shaping a picture that appealed to the public. We sensed that cameras were going to play a pivotal role. At times it seemed like everyone had cameras. Volunteers knew that when they returned home they could better tell the story of the strike by referring to images. Photography shaped a lot of what happened. Growers just hated to see anyone with cameras.[6]

Lewis was certain that Chávez would provoke an incident on the day of the march, that he would do something dramatic, that he would create scenes that would embed themselves in the popular imagination. The chief of police was warning the NFWA about where it could and could not walk, and Lewis was certain that Chávez would bait authorities and make them arrest him.

As ever-larger numbers of farmworkers arrived in town, Lewis kept busy photographing them unfolding banners of the Virgin of Guadalupe and of Emiliano Zapata, along with banners of various support organizations and unions. Lewis knew that the banners would be prominently displayed at the head of the procession, along with the American flag and the NFWA red eagle. He thought that they would serve as vivid English and Spanish captions inside his photographs.

40. Participating

Up before dawn on the morning of March 17, 1966, Lewis packed his old Marine sea bag and carried it to the NFWA truck. Over the past few months he had found that his camera gadget bag weighed him down. Not only did it prevent him from moving about, it wore grooves in his shoulders no matter how many times he switched the strap from one side to the other.

To increase his mobility, Lewis stuffed his camera lenses into a war surplus backpack and headed over to photograph the marchers, eighteen of of them women, gathering at the Gray House and the Pink House. Inside the backpack he could feel the lenses banging against one another and worried about scratching the lens elements. To prevent damage he placed a filter on the front of each lens and a cap over the back, then wedged in some extra pairs of socks, a shirt, his hat, bandages, and plenty of Tri-x black and white film.

Lewis was going to march all the way to Sacramento. He was going to cover the whole event, from beginning to end, not as an outsider, but as one of the marchers. He began by photographing the youngest marcher, Augustine Hernández, age seventeen, from McFarland, and the oldest, William King, age sixty-three, from Fontana. Next came Alicia Jimenez, age twenty-two, of Sacramento, who carried the banner of Our Lady of Guadalupe.

Although AWOC had been invited to join the march, its top leaders refused, stating that they were engaged in "a trade union dispute, not a civil rights movement or religious crusade." Larry Itliong was among those AWOC leaders who ignored instructions not to march with the bearded campus and civil rights activists, ILWU warehousemen, and Chicano activists. While AWOC did not officially participate, its members had selected Manuel Vasquez as their captain. Lewis photographed him and thought that the march was shaping up to be a big, dramatic event, without parallel in California history. If he never did anything else in his life, covering this event would make his journey to Delano worth the sacrifices.[1]

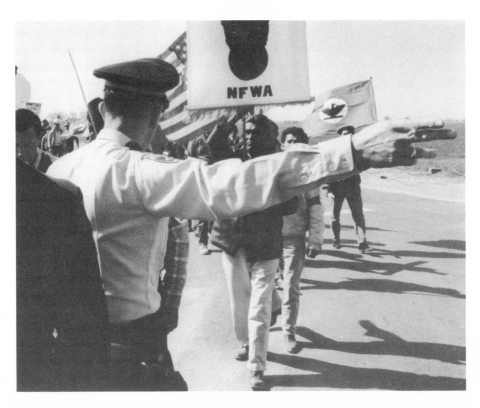

107. "After going all of one block from the NFWA office, the Delano police attempted to route us around the outskirts of town, when we wanted to hang a right and proceed through the center of Delano. There were a number of news media types and TV cameras recording the conversation between the police and our lawyers, so the cops relented. [George] Ballis was more enterprising than I and got that great shot of César pointing a finger at the police chief. I didn't get much of our passing through downtown Delano either. I guess it took a while for me to get the feel of things, but I shot 102 rolls of 36-exposure black and white, so I eventually got something through sheer volume." Spring 1966.

At the February 22 meeting, NFWA members had decided that about seventy-five people would march. But over the following three weeks, the number dropped. Lewis recalled how

> César and Dolores did not want to deplete all of the pickets from Delano. They still needed people to run the nursery school, clinic, store, soup kitchen, and the NFWA office. The women had a lot to say. Some offered to picket so that their husbands could go on La Peregrinación. There were still about one hundred people who wanted to march all the way to Sacramento. [Nurse] Peggy McGivern explained the risks. Anyone with high blood pressure, bad feet, diabetes, sick families, or ill children had to stay in Delano. That narrowed it down to about seventy-five people. Some had to drive the trucks. Chris Sanchez was assigned to the portable

toilets. Gustavo Espinosa and Henry Uranday were designated mechanics. DeWitt Tannehill was put in charge of the chuck wagon. Mario Rubio, Marshall Ganz, Antony Mendez, Manuel Uranday, and Charles Gardinier were designated as monitors. Their job was to point us in the right direction, work with the Highway Patrol, keep us from getting run over as we walked along the highways, visit towns ahead of us, set up meetings, arrange for food, and find out where we could sleep.[2]

As they headed out, television crews filmed police lines blocking the street. All of the major newspapers had photographers and stringers on the scene. Their images of helmeted police preparing to block the way called to mind scenes of state troopers confronting Martin Luther King in Selma, Alabama, one year earlier. But while the big, urban California newspapers and national press clotted along main street, only Lewis — along with Kouns, Gscheidle, and Ballis — captured scenes leading up to the dramatic moment when the march moved through Delano.[3]

Shortly after photographing a Catholic Mass in the backyard of the Pink House, Lewis had to scramble when Chávez changed plans and, without obtaining a permit, led everyone along Albany Street through the middle of the Delano business district. Twenty-five Delano policemen in full riot gear lined up across Garces Highway, determined to prevent the march from passing through town. So many photographers and television crews were present that the Delano city manager, already wary of unfavorable images, decided to avoid an incident and allowed the march to proceed. "They wanted us to arrest them," Police Chief James Ailes explained to writer John Gregory Dunne a few months later. "They were all down on their knees with their priests saying all their words and what not. It would make them look good if we arrested them with all that press and T v there."[4]

Decades later, Lewis remembered how, at the beginning of the march,

wherever you turned there was something interesting — an old union member, a family, the flags, the march, the cops, some detail. People were holding up portraits of the Virgin of Guadalupe. Some had large crosses. Someone had a Star of David. There were Mexican flags, American flags, AWOC cloth banners, and a big Schenley boycott balloon. Old World War II veterans even had their service caps. Valdéz had a manifesto that he had been working on, and was going to read it to us each evening. He called it the "Plan of Delano," but it was really modeled on Zapata's "Plan de Ayala," a radical demand for basic human rights. It was an environment rich in photographic material. You could just focus your lens on infinity, hold it up, mindlessly snap away, and get good pictures. I thought the confrontation lasted only a few minutes, but later everyone present said we were held up for hours. That's how quickly time passed.[5]

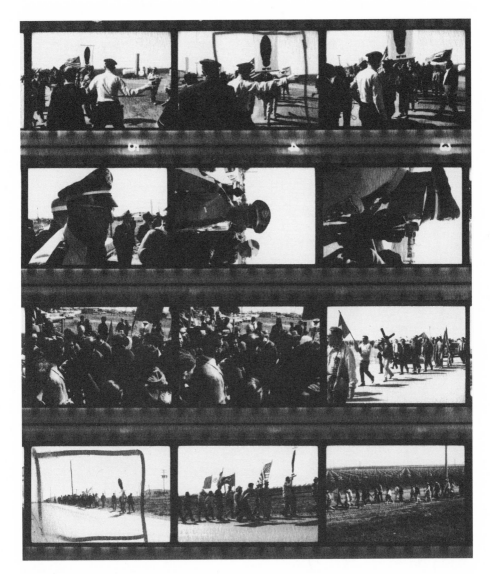

108. "Contact sheet from the first day of the march to Sacramento, passing through Delano. Our asses were dragging at day's end getting to Ducor after dark. Many blisters and much wondering if we could complete the march. It took several days to get into the rhythm of things and take enough breaks during the day so everyone could keep up." Spring 1966.

As the march moved out and settled into a steady three miles per hour, Lewis realized that there was a down side to participating. He was not going to be able to see the larger picture. Without a car, he could not explore the environment that he was passing through. Nor was he going to have the energy required to work the situation. By committing to the march, he was lending an extra body to the union, but he realized that it was not the best way to cover the event. There was no way to

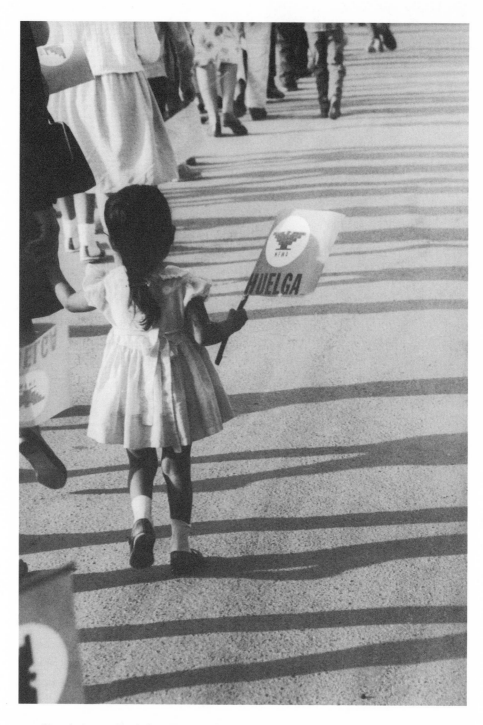

109. "A grab shot you're glad you got. I might have followed her a short distance and shot eight to ten frames, but I pretty much knew it wouldn't get much better than this." Spring 1966.

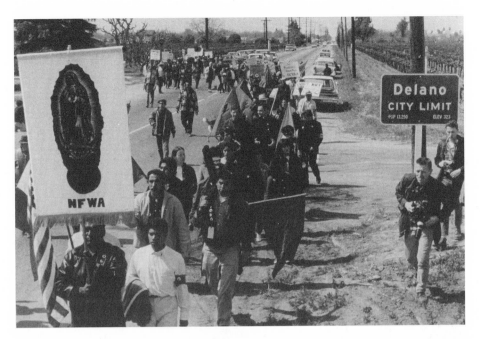

110. "That's George Ballis on the right, with crew cut. Ballis shot with two cameras—one with a wide angle lens, the other with a 135-millimeter telephoto lens. I made the photograph on top of a car just as La Peregrinación left the Delano city limits on the way to Richgrove." Spring 1966.

do both. Lewis chose to walk. He would be a participant first and a photographer second. That was the kind of man he was.

Carrying several cameras along with his photographic gear ten miles east along County Line Road and then north on Highway 65 on the first day wore him out. Passing through the midway point at Richgrove, Lewis thought it hardly qualified as a town—a few small markets, a bar and café, a fire station, and a grammar school seemed to be surrounding a sprawling labor camp and very old, small houses collapsing into themselves. Their destination at the end of the day was Ducor, a small, forgettable place, once known as Dutch Flat, founded—like many other Valley towns—as a Southern Pacific station.

Lewis remembered:

Hardly anyone in Ducor greeted us. The place was creepy. We were really hurting. We could have used some help. A few people on the scruffy-looking main street were either puzzled or outright hostile. No one waved to us. The town seemed to consist of a lot of junkyards and billboards. We didn't see any police. There was no Mexican American greeting committee. Nothing. We had to sleep in the park, except for a small group taken in by a single lady in a two-bedroom cabin. It was a bad start. We wondered if it was a portent of things to come.[6]

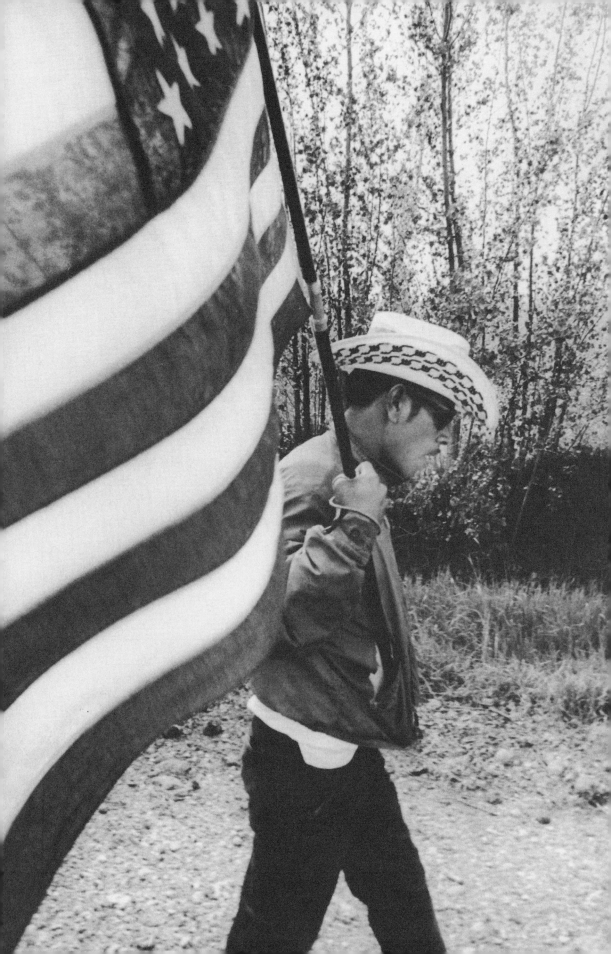

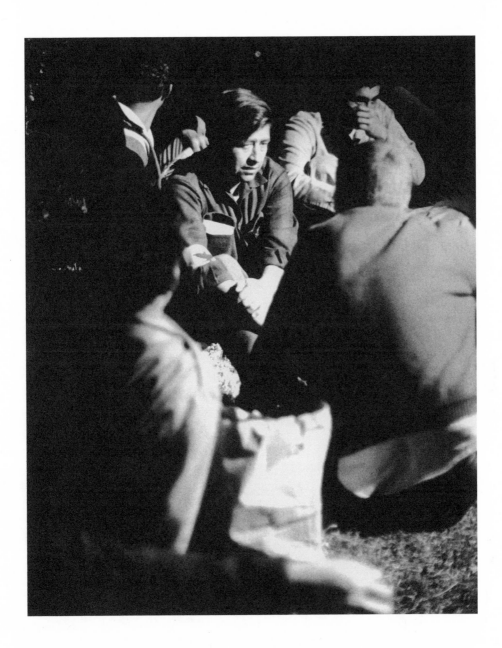

111. (*Left*) "Pete Cardenas, one of the 'young Turks' of the movement, was often at the head of the march carrying one of the three flags or banners that lead the procession. The flag was billowing pretty unpredictably, so I shot some 10 to 12 frames hoping something would fall into place. A couple of them did." Spring 1966.

112. (*Above*) "Around the campfire at the conclusion of the first day of the march to Sacramento when we stopped in Ducor. No rally that night, but an evening of our nurse lancing blisters — César's and mine." Spring 1966.

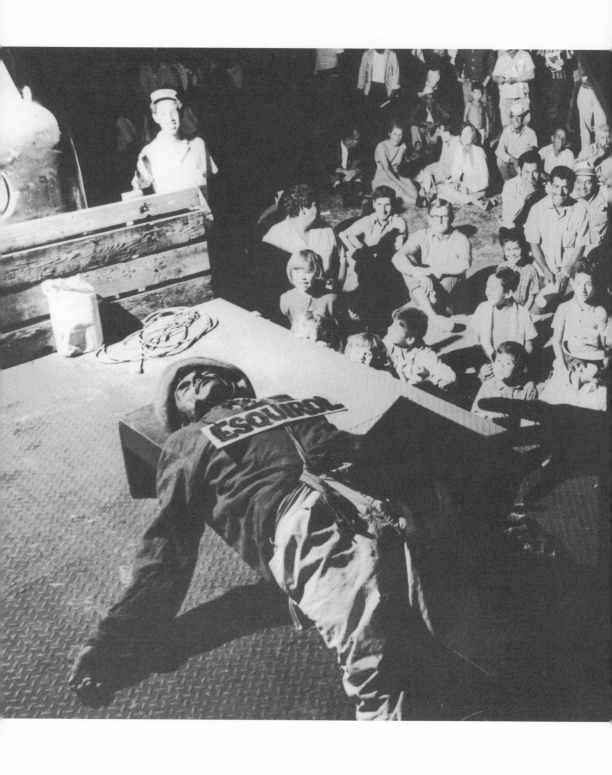

41. La Causa

Like all photographers working in the flat agricultural landscape, Jon Lewis quickly discovered that ground-level images did not convey the necessary perspective. To overcome that handicap on the second day of the march he began prospecting vantage points that provided an elevated view. On the outskirts of Porterville he and John Kouns climbed a highway overpass. With the sun low on the western horizon, Lewis took advantage of the soft evening light to compose shots of the procession snaking its way into town.

Framed by his normal perspective lens, the marchers looked like a forlorn little band. Lewis next switched to his 135-millimeter portrait lens and began picking out scenes as the marchers passed below. *Click!* A family, a father holding his son's hand. *Click!* Roberto Roman, age thirty, of Delano, bent under the weight of a large cross, straggling far behind the procession. *Click Click Click!*. Vivid and colorful signs attached to wooden stakes. *Click!* Children skipping school. *Click!* Young and old. *Click!* Bobbing baseball caps. *Click!* A sea of sombreros. *Click!* Women in print blouses. *Click!* Men in jeans and work shorts. *Click!* Groups and individuals looking up and waving their

113. "The evening rallies on the march were a special coming together of the Chicano community and a splendid organizing opportunity. There were songs, bilingual speeches, theater performances, and a reading of the 'Plan of Delano,' which set forth the union's aspirations. This photograph captures a Teatro Campesino performance on a flatbed truck on the second night of the march to Sacramento." Spring 1966.

arms. *Click!* Hundreds of faces, mostly brown, wrinkled from years under the sun, some blondes and redheads with ivory complexions, beginning to sunburn. *Click!* Henry Uranday carrying a huge Peregrinación sign.

Lewis later remembered how quiet it was, how the steady tramp of boots and sneakers mingled with the occasional "Viva!" and "Huelga!" He wished he had color film to record the gold-embroidered Our Lady of Guadalupe banner, red pennants, black eagles, and American, Mexican, California, and NFWA flags. At one point he and Kouns made the same shot of the marchers seen from directly overhead as they crossed a RIGHT TURN mark painted on the black asphalt. It was as close to abstract symbolism and political irony as either would ever get — or tolerate.

With the light all but gone, the streetlamps and neon signs along the main boulevard gave Porterville a warm and eerie glow. It was a walkable city, enticing to a photographer afoot. But all that Lewis could think about was finding a comfortable place to rest.

Of his entry into Porterville, Lewis remembered that

> several hundred farmworkers were waiting for us just outside of town. It was a big change from Ducor. Someone had gotten things organized. We felt welcome. They were strumming guitars and playing accordions and singing. Outside a small house, the family had placed a silver punchbowl full of cold fruit juice. I remember making a picture of the marchers passing by and dipping their cups. By the time we reached the city park, I was in no condition to photograph. I developed blisters on both feet the first day. My feet were red and raw and sore. We did not know where we would stay or who would feed us. We headed to the NFWA truck and grabbed our gear. I remember being in a big meeting hall and making a picture of the marchers discussing the next day's strategy beneath a picture of "Justice." That second night in the park, union supporters took a couple of us into their homes, fed us some tortillas and coffee, and then dropped us off at the start-up point in the morning. That was the routine over the next few weeks.[1]

Moving north, Lewis passed through thousands of acres of vineyards. A smoky haze polluted the otherwise clear and crisp air. Busy replacing old, underproductive vineyards with new ones, growers had been ripping out vines, bulldozing them into piles, and burning them. Several vineyards had already plowed the still-smoldering ashes underground and were full of crews scurrying about digging holes and replanting bare rootstock.

Elsewhere, crews were at work pruning vines, tying canes to trellises, and raking and collecting canes they had pruned over the winter months. Each crew had a transistor radio hanging from a trellis wire. Even a half-mile away, Lewis could

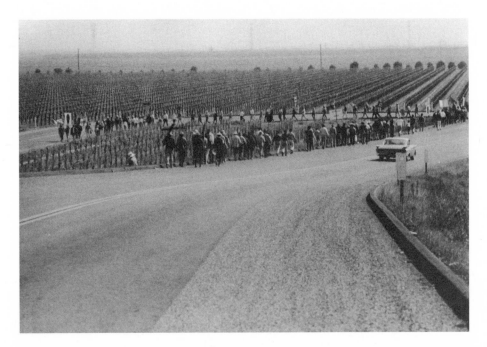

114. "Moments later, from the left side of the road, I got a splendid panoramic shot of the march passing through endless vineyards. Sometimes it was better to be out in front of the march, while things could work out if you lagged behind." Spring 1966.

hear the odd cacophony of Mexican music from a Spanish-speaking radio station blending with the snipping sound of pruning shears cutting through grapevine canes.

Every mile or so Lewis passed a farmhouse, identified by clumps of trees that provided the only shade in the otherwise treeless landscape. Beside the railroad tracks running parallel to the highway were vast cold storage complexes, box-making factories, pallet-making factories, parking lots full of trucks, loading docks, and cooling machinery. Inside the cooling sheds, tens of thousands of boxes of grapes harvested seven months earlier and stacked floor to ceiling were held in a kind of suspended animation. They would be sold in April and May, until the first fresh grapes from the Coachella Valley hit the market.

On Sunday morning, the marchers reached a golf course on the outskirts of Farmersville. Lewis passed on the obvious opportunity to contrast poor field hands marching by rich golfers, but Kouns could not resist. He ambled over to the eighteenth hole, faced the marchers, and composed a photograph with a man putting a golf ball in the foreground. "He didn't lift his head," Kouns recalled. "He didn't acknowledge me one bit. He kept on with his game. I think, in a sense, that's what the Valley has been doing to the farmworkers. The farmworkers can shout and yell and sing and they aren't heard until they go out on strike."[2]

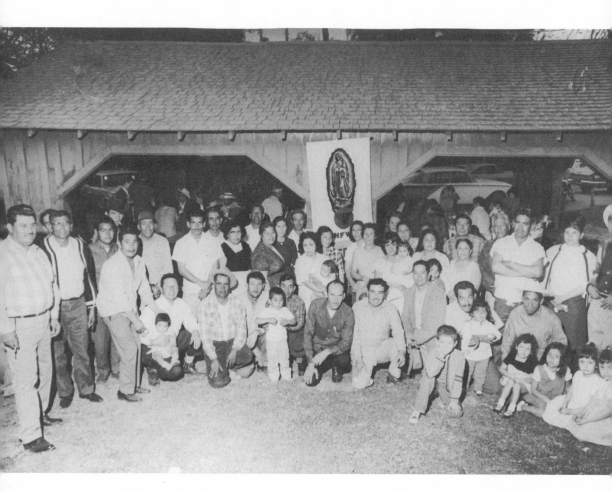

115. "The second night of the march, where there was a most welcome communal meal with Earlimart supporters." Spring 1966.

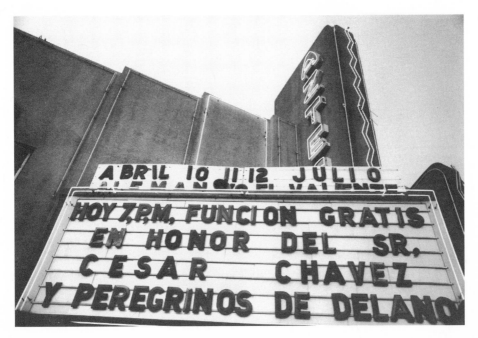

116. "A big welcome as we arrived in Fresno on March 24. Instead of roughing it in a park for the evening rally, we held it indoors in a theater with padded seats and air conditioning." Spring 1966.

Reaching Cutler two days later, the marchers were surprised by the cool reception by local shopkeepers and barrio leaders, who refused to allow them to sleep in the Latin American Club's large hall. Local growers who supported the Club's annual Tomato Harvest Festival had issued an ultimatum: help the NFWA and they would no longer cooperate. With so many charities depending on funds from the festival, Latin American Club leaders told Chávez to find his own quarters. Still, over four hundred farmworkers and supporters participated in a candlelight parade through town, the first of many such candlelight parades. Entering Orosi the next afternoon, the marchers were greeted by hundreds of local supporters who met them a mile outside of town and accompanied them to the town's park.

At dawn the following morning, dozens of families left with the marchers, taking them halfway to Parlier. They did not reach town until after dark.

Of their reception after walking twenty miles from Orosi to Parlier, Lewis recalled:

I had never been to Parlier before. It was just a big barrio. The streets weren't even paved. No gutters. Dusty. Mexican. Just like West Delano. It seemed like everyone in town had turned out to greet us. The roads were lined with cheering people for a mile outside of town. Apparently the NFWA had used its subscription list for *El Malcriado* to find people who would take us in and feed us. There was

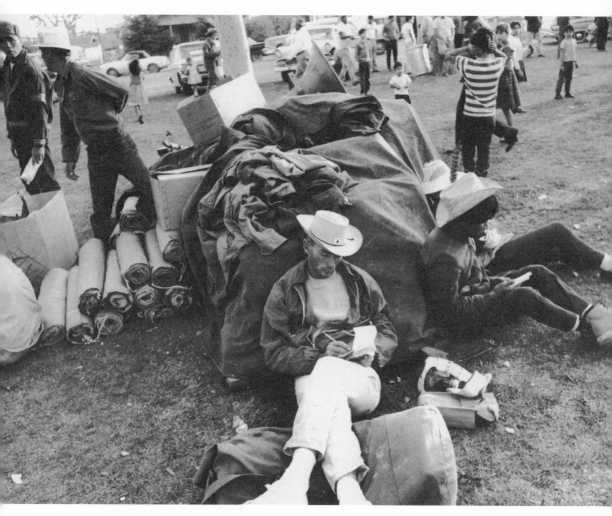

117. "A truck would deliver our baggage and bedding at the site of each evening's rally. Initially supporters would take a few marchers into their homes for the night, give them breakfast, and transport them to the day's starting point. Towards the end such was our momentum and numbers that we'd take over the town's main park, bed down, and piss on the petunias in the morning. I've no idea what became of the notes I was taking. John Kouns made this snap." Spring 1966.

a huge feast that had been prepared by the women over at the Catholic church. After that, there was another candlelight parade through town. Then we returned to the church and Luís read his "Plan of Delano" and put on one of his actos. The place was jammed full. It was so dramatic, all the singing. I remember how Valdéz would begin, that low and slow voice saying, "We are sons of the Mexican revolution." And then he would read to us like children sitting at his feet. And we listened like children. It ended with chants of "Viva la Causa!" The next morning a priest from Mexicali served Mass and walked with us. Along the way we passed through Del Rey. Farmworkers gave us lunch. Growers parked their tractors and automobiles and congregated around and didn't say a word. We had a huge rally and César made a great speech thanking the people for their generosity. Then we moved on to Malaga, a small town south of Fresno. Hundreds of farmworkers turned out to greet us. We piled into their cars and went to the Aztec Theater in Fresno, where César spoke to the largest crowd ever seen in that theater. There must have been a thousand people waiting outside the theater. Luís read "The Plan of Delano" again. El Teatro performed three actos — "Governor Brown," "The Drunk Esquirol" [Scab], and "The Mink Bikini." The people just roared and could not get enough. The next day we marched through Fresno with the mayor and had a feast in Roeding Park. I remember the chants: "Abajo los contratistas" [Down with the contractors], "Arriba nuestros huelgistas" [Up with the strikers], "Viva la Causa en la Historia" [Long live the story of the cause], "La Raza Llena de Gloria" [The Mexican people are filled with glory].[3]

And so it went. Contract photographers for *Time*, *Life*, and *Newsweek* hired a small truck and driver, jumped in the truck bed, spent a day leap-frogging around the marchers, retired to a clean motel room and hot shower, edited their work, transmitted their "snaps" or shipped the film out by courier, and departed for the next assignment.

Lewis did not have much regard for the magazine photographers. Gerhard Gscheidle, who could scarcely contain his contempt, recalled:

We watched them speeding around for an hour or two up and down the line of marchers. This got a sorry nod from us three [Gscheidle, Lewis, and Kouns]. These image makers who joined the march for a couple of hours or even a day on assignment, well, the difference of covering the pilgrimage on assignment and the plain conviction to document the fight of the Mexican American farmworkers for better working conditions made a big difference in my mind.[4]

Older photographers could not walk the entire distance. But that did not keep one of them from covering the event. Remembering Harvey Richards, a veteran

of the civil rights and antiwar movements, who was the most senior photographer at Delano, Lewis explained that

> Kouns and Gscheidle would be along the road somewhere and there up in front of us parked and waiting we would spot Harvey Richards. He would tag along in his station wagon with that platform on the roof. All of a sudden he would stop, climb up on top, haul out his tripod, hook up a movie camera, drag out his still camera, snap on a telephoto lens, and start shooting. When he got what he wanted he would jump back in and shift his location a few miles north, maybe find a nice vantage point on an overpass or nearby hill. Richards was much older than anyone else. No one expected him to walk with us. We really admired his organization and discipline. Every morning when we left a park and every evening when we arrived we would see him there, stationed in the best spot. He really worked it. Flags waving in the breeze. César out front. Strikers stretched out behind him. He was always in position to record an incident when it happened. Richards probably took the best pictures of the massed marchers moving through the countryside.[5]

Only impending deadlines and concern for the large amount of film they were shooting caused Lewis to rest. When the entire march paused for a day, Lewis accompanied Kouns back to the Pink House. He recalled:

> Kouns and I were ahead of schedule. But we got to stinking pretty good by the second week. Our socks especially were putrid. Back at Delano we showered, washed our socks and T-shirts and underclothes, then stayed up all night developing film and printing photographs . . . We were really grubby and just needed to clean up. By the next morning we were back trudging north. We only missed a couple of hours covering that entire march.[6]

118. "That's John Kouns on the left, me on the right, doing our laundry, photographed by Gerhard Gscheidle during a break midway through the march to Sacramento." Spring 1966.

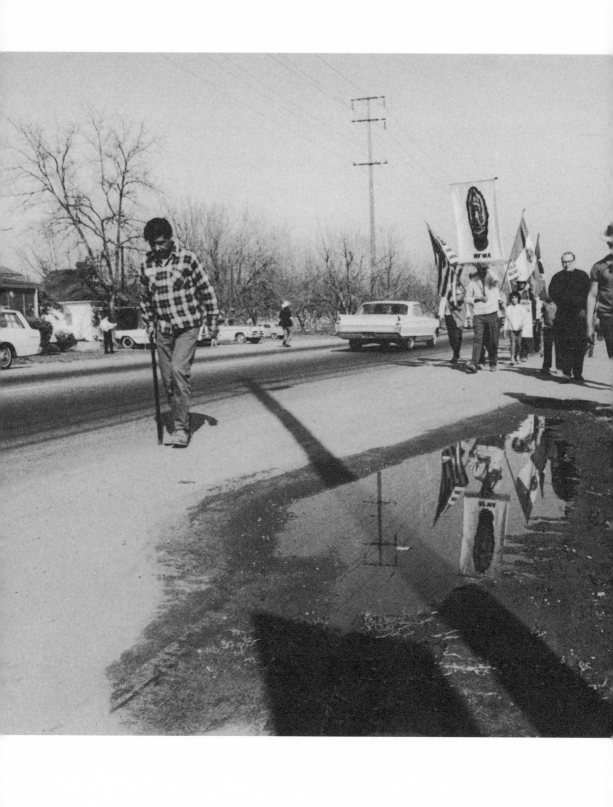

42. Blisters

By the time he passed through Fresno, Lewis had developed a photographic rhythm centered on variations of essentially the same scene. One category of images focused on pageantry. Seeing union members in the countryside carrying statues, flags, and banners, Lewis produced images that could easily have been mistaken for photographs of civil rights marchers moving through the American South. Another category of images placed the march within the larger agricultural environment. By shooting into the sun and dramatically silhouetting the marchers early and late in the day, Lewis created a number of images that captured universal themes of solidarity and mass protest. A third category focused on the spectators along the way. While passing through the barrios and colonias, Lewis found a rich reservoir of images in the faces and gestures of people cheering the marchers on and feeding and caring for them. A fourth category centered on the reaction of foremen and growers in the vineyards. Pausing from pruning or driving their tractors, some watched with obvious disdain, if not outright hostility. A few carried large posts. One or two foremen made obscene gestures.

Occasionally Lewis and the marchers would arrive in town early. Everyone would head to the park and lay down on the grass or sleep in a high school gymnasium before the evening meal. Chávez would usually speak from a stage rigged on the back

119. "One of the few times César was out in front of the march. Luckily, I was too." Spring 1966.

of a flatbed truck or a bandstand in a city park. Valdéz and El Teatro Campesino would follow with hilarious and bizarre performances that amalgamated commedia dell'arte and Bertolt Brecht. El Teatro Campesino actors ridiculed growers, labor contractors, and undocumented workers. They often improvised on the spot. Their boldly satirical skits underscored the need to unionize against abuses and exploitation.[1]

No matter how hot or exhausted, Lewis found that El Teatro Campesino made good filler and welcome diversion. Vividly goofy characters with printed signs hanging from their necks like *esquirol* (scab or strikebreaker), *contratista* (contractor, who earns a living buying and selling the labor of others), *patroncito* (a well-fed boss, probably fat, in sunglasses, unable to speak Spanish, not very brave), *huelgista* (striker), *gobernador* (the man elected to represent all of the people) provided Lewis with an ever-changing cast of characters. Some characters tried to drive home key ideas unfamiliar to farmworkers, like an organizer dressed in a union contract who defended workers under attack by wielding a long, thick pencil as if it were a lance. His favorite character was a DiGiorgio Corporation foreman. Wearing huge boots, a military cap, and dark sunglasses, the character resembled a cross between a Nazi concentration camp officer and a plantation owner in the American antebellum South. At intermission, Augi Lira would sing "De Colores," a Spanish religious hymn that emerged as the NFWA anthem. As the crowds joined Lira, Lewis turned his camera toward them and recorded expressions on the faces of exhausted farmworkers signaling their support.[2]

A favorite skit emerged from an encounter that Valdéz had on the picket lines. Someone shouting through the bullhorn had used the word *dignidad* (dignity). A few minutes later a field hand approached Valdéz and asked him "What's *dignidad*?" Valdéz thought about it, and used it as the basis for a skit about farmworkers learning lessons about their value as human beings. Lewis photographed that skit so many times he eventually stopped and actually began watching the scene, which seemed to change each time it was performed.[3]

Another favorite subject was Peggy McGivern, the quiet NFWA nurse. After leaving Stanford University Medical Center on what she thought would be a brief stay in Delano, McGivern had become a fixture. By the second day of the march she had lanced so many blisters that she would have a recurring nightmare about a giant blister bursting and drowning her in an avalanche of pus. Each night she could be seen bandaging feet. Lewis simply followed her around, recording the pluck and determination of farmworkers and the devotion of a gringo nurse.

More than anything else, Lewis focused on Chávez. Too busy to buy proper boots, Chávez walked in an old pair of shoes. His back was already bothering him.

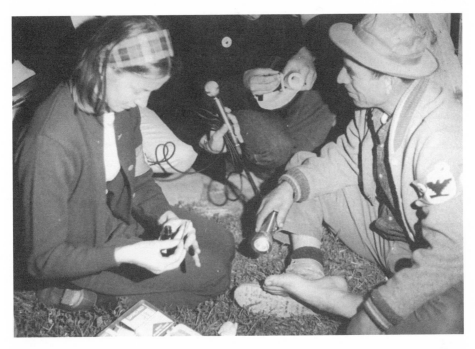

120. "At the end of the first day of the march in Ducor, nurse Peggy McGivern spent several hours lancing blisters. I had to get in line myself." Spring 1966.

Soon his right ankle puffed up to the size of a small melon and the bottom of his left foot turned into a huge blister. His tortured journey, every grimace along the way, evenings as he sat by the roadside removing his shoes and massaging his aching feet, formed a continuing theme.[4]

Somewhere along the way, a union volunteer — Hy Robinson — arrived on a motorcycle. Lewis asked him to help with his photography by giving him a lift. For a long stretch, Robinson put Lewis on the back of the bike and the two scouted for bridges and overpasses. Lewis waited there to get a precious elevated perspective on the march. Robinson soon left. Lewis never saw him again but he would always acknowledge the role that Robinson played in this phase of his photography.[5]

A few days later Lewis made a self-portrait. He included his own reflection in the wing mirror of an automobile as he composed an image of the march. It was about as artsy as Lewis would get, a radical perspective, absent any depth of field, existing in two dimensions rather than three, in which the act of looking is incorporated into a documentary image. Drawing a viewer into the process of seeing, it underscores the way photographic art reorders reality to make the familiar unfamiliar and reveal some unseen, subjective reality.

As a photo event, the march succeeded on its own merits and required little advance publicity. In every town, the numbers of marchers grew as farmworkers from local communities joined La Peregrinación, sometimes for a mile or a few hours, often for a day or more. Many signed up with the NFWA and donated food, fruit, rosaries, and Bibles. "News got around the San Joaquin Valley and certainly in the Mexican American communities, which actually was one of the biggest goals of the pilgrimage — to spread the word about the strike," recalled Gscheidle decades later. "I remember how jubilant Terry Cannon [editor of *The Movement*] was when the *Los Angeles Times* ran a story after the march was well underway." In this way the march took the strike to workers far from Delano, some of whom were confused about the issues and often had not even heard of NFWA.[6]

Unlike the civil rights movement, which was covered by a contingent of African American photographers employed by *Ebony* and *Jet* magazines and their competitors, there were no Mexican American photographers on the march. With few Hispanic media outlets and no editors from ethnic journals who might sponsor them and publish their pictures, Mexican American photographers were so few and far between that Gscheidle later recalled that he "didn't know or meet a single Mexican American [professional freelance] photographer during my time in Delano."[7]

The one exception was union volunteer Manuel Chris Sanchez. A huggable, diabetic, teddy-bear of a union activist who hung out at the People's Bar and was known to everyone as "Fats," Sanchez became interested in photography while tending the Porta-Potty on La Peregrinación. After the march he purchased an inexpensive camera and learned how to shoot by speaking with Lewis and Kouns and watching them work. "It seemed he was always relaxed, a wry sense of humor carrying him through the stressful times," recalled *El Malcriado* editor Doug Adair many years later. "But he really did not become fluent and productive for several years."[8]

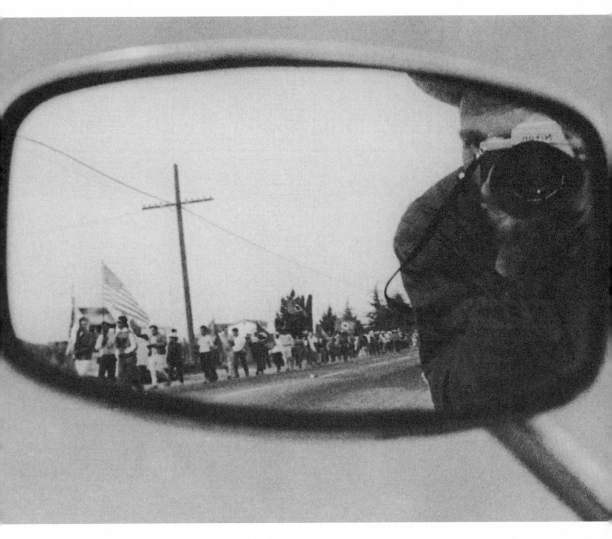

121. "The hot-shot-to-trot Tri-X kid-chronicler gets artsy-fartsy circa March 30, 1966." Spring 1966.

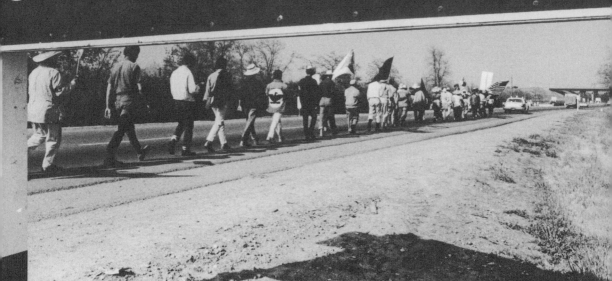

43. Sacrifice

Seven days north of Fresno, Lewis got his first glimpse of Modesto, the second-largest city along the path of the march. He was surprised at the greeting he received as the marchers exited from alongside Highway 99. Entering town early on the evening of April 2, Lewis saw that

> the streets were lined with union members holding big signs and banners. "Asbestos Workers Local 1215, Viva la Huelga!" "Glaziers Workers Union Local 79, Viva la Causa!" On and on. Hundreds of union members turned out. Bricklayers. Carpenters. Painters. Butchers. Bakers. I couldn't believe it. What a sight! We had no idea how much attention we were attracting. Sometime we would grab a newspaper along the way, but several of the towns did not even have a newspaper so it was hard to get an idea of how the march was being covered.[1]

That evening Lewis discovered that on the previous day AFL-CIO representative William Kircher had met with AWOC leader Al Green. Kircher was a protégé of Jon Livingston and an opponent of Walter Reuther. George Meany had sent him to California to dispatch AWOC, which Meany regarded as a thorn in his side. He could not have foreseen that Kircher, one of eleven children in a German-Irish Catholic family, would not exactly go along with the program.

Kircher occupied a unique position somewhere between the bread-and-butter unionism of the AFL and the industrial unionism of the CIO. He had an independent streak and was much loved by rank and file union members. To better understand the farmworker movement, Kircher put on some old clothes and joined the march. After a week on the road, he became convinced that AWOC was irrelevant and that its leadership was jealous of Chávez and actively sabotaging the NFWA.

122. "If your photos don't convey the tremendous distance we traveled, use the road signs to make the point. I regret not seeing any at the outset reading '300 miles to go,' so this is about the best I could do between Fresno and Modesto." Spring 1966.

123. "A midday break by the roadside on the march to Sacramento showing a cross-section of participants. César's daughter, Linda, is alongside him, left. There was generally a water truck close at hand and a larger truck carrying Porta-Potties." Spring 1966.

Near Modesto, Kircher read in the newspaper that the local AFL-CIO was boycotting the march. The next day, he summoned Green to a meeting in Stockton. Kircher told Green that since Modesto was Green's territory, he was going to judge Green's competence by the nature and enthusiasm of the reception he organized.[2] Lewis soon learned that as a result of that meeting the organizing environment changed because

Kircher laid down the line. Green had always been uneasy about the march. His method for organizing farmworkers was to sign up labor contractors. Green was in cahoots with the Teamsters, and they were trying to organize in the citrus packing plants. Kircher didn't like Green. He didn't like the Teamsters. In fact, he hated the Teamsters. He accused Green of sabotaging the march and undermining the strike. He said show the colors or else heads will roll. Boy those union guys turned out in force. It really had an effect on the march. It gave me plenty to photograph. And of course local newspapers played it up without ever getting the real story. After that, Kircher was a big supporter of the NFWA. He told Green to take a hike. He shut down AWOC in Stockton and transferred everything to Delano. Then he placed Larry Itliong in charge. It was clear that Kircher intended to shift AWOC into NFWA. That was the end of Green. We never saw him again.[3]

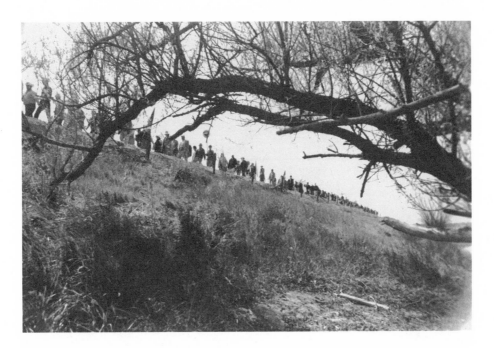

124. "A gully provided the chance to show the march without that vast open sky on April 9. Maybe the arc of that tree branch propels the line of march forward." Spring 1966.

Near Tracy on April 2, Lewis noticed that NFWA organizer Jim Drake had made an important tactical decision. Acutely aware that television camera crews were now closely following events, Drake induced marchers to carry boycott signs. Lewis noticed the signs and began featuring them in his compositions. He liked the way "those quickly assembled signs exclaiming Boycott I. W. Harper, Boycott s&w, and Boycott TreeSweet provided focus to a lot of our photography over the next few days. We'd grab a newspaper the next day and see how the press photographers were zeroing in on them, placing the Virgin of Guadalupe alongside the NFWA eagle and the American flag, with those 'Boycott Schenley' signs big and bold. So we knew the message was getting through."[4]

Just outside of Stockton the following day, television reporters began doing stand-up reports along the path of the march. A half-dozen San Francisco newspaper photographers also arrived. Among them was Fran Ortiz, a staff photographer for the *San Francisco Examiner*, who walked the last fifty miles to Sacramento. Ortiz made a lasting impression on Lewis, who described how

> Ortiz would eat meals with us and sleep in the parks. If there was a café or cantina near the camp, he would treat us to a good meal and shots of tequila.

125. "We didn't have an ambulance on the march, but station wagons had an empty seat when the blisters got too bad about March 30." Spring 1966.

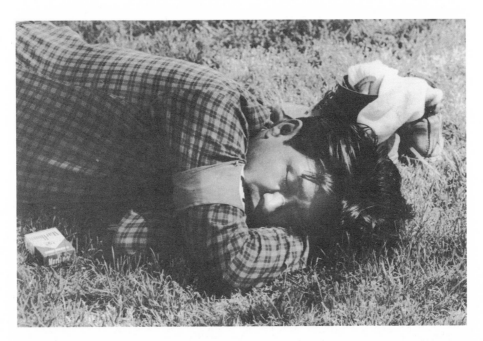

126. "César removed his boots, had a smoke, then a nap during a noon break on the march." Spring 1966.

Ortiz was really affected by the march. He completely altered his approach. He arrived with zoom lenses and motor driven cameras dangling all over the place. But he soon realized that the march required a more intimate approach. By the time we reached Stockton he had packed his big lenses and motor drives in his gear bag and was using two quiet Leicas with normal and wide angle lenses. We liked that because it was so different from the way the big magazine and photo agency photographers behaved. We felt he was one of us.[5]

Entering Stockton on April 3, the marchers received their biggest reception. Lewis remembered it as a moving fiesta, with mariachi bands leading the way and people standing in their front yards waving flags and offering cold drinks to them as they passed by.

Of events later that day, Lewis stressed that "We headed for St. Mary's Park [Square]. There was a local CSO office there, and a lot of sympathetic AWOC members. The reception thrilled us. By then we needed it. We thought we might actually accomplish something. We were going to make it. Newspapers said that five thousand people had joined the march. Considering the few we started out with, it was difficult to fathom."[6]

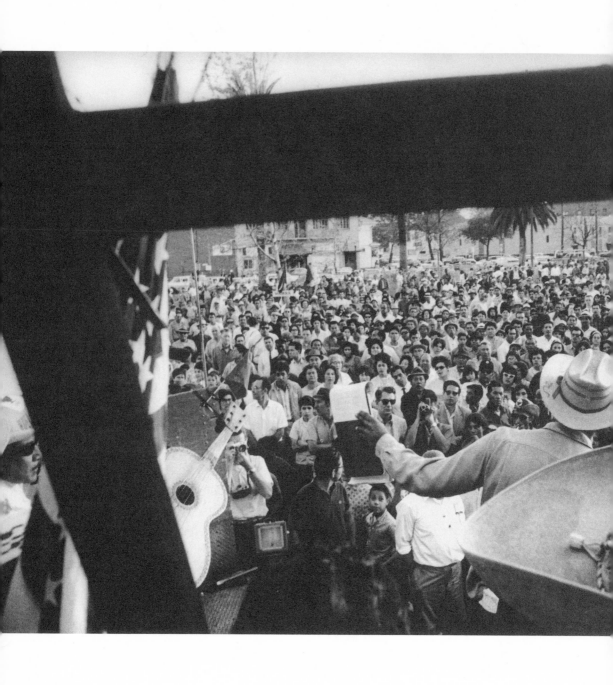

44. St. Mary's

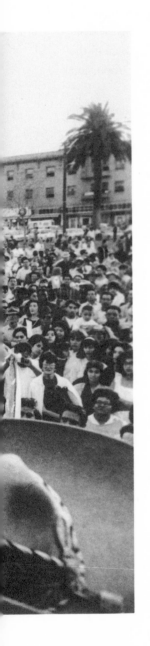

Inside St. Mary's Catholic Church, Lewis attended a Mass in honor of the marchers. Between prayers, he watched Fran Ortiz employ his Leicas to great advantage. Noticing a field hand in the pew behind him, Ortiz turned around just as the congregation rose and the field hand held up a small cross with a crucifix of Christ. As the field hand looked toward the altar, Ortiz slowly raised his Leica to photograph him deep in prayer. The photograph — infused with a sense of honesty and dignity and embodying the theme of penitence that epitomized the march — ran in the *Examiner* and later in *Time* magazine. "It became a pretty emotional image," Ortiz later observed. "I could not have made it if the people had not come to trust me. They seemed to understand photography and were not at all shy."[1]

Outside of the church, Lewis concentrated on the crowd. Since the beginning of the march he had framed and reframed pictures of one particular group of farmworkers led by Roberto Roman, the Mexican field hand who had carried the ten-foot-high, two-by-four-inch wooden cross, draped in black cloth. Roman had walked all the way from Delano barefoot. As the crowd thickened for an afternoon rally, Lewis tucked in behind Roman and used a wide-angle lens to incorporate the cross into the foreground of his composition. The image is basically a crowd shot, an archetypal proletarian picture, but the strong

127. "The evening's rally in Stockton's central square on April 10, 1966. I was perched precariously on the back rail of the flatbed truck and got some strong images without falling off — including the sea of faces used effectively in my film *Nosotros Venceremos*. Spring 1966.

framing with the cross in the foreground and the marchers following suggested death, penitence, faith, and resurrection.

On April 5, just north of Stockton, Ballis also noticed Roman and began following him. Sticking close as Roman fell behind and became separated from the march, Ballis photographed Roman alone on the road struggling to carry his burden north to Sacramento. Roman so obviously emulated Christ on the way to his crucifixion that the image was attacked as sacrilegious. But his image dramatically drew attention to the sacrifices that farmworkers were making as they fasted and limped along the road, further confirming César Chávez and his followers as the Mexican American counterparts to Martin Luther King and the Freedom Marchers in the South. Many farmworkers would regard that image as the single most important and memorable photograph of La Peregrinación.[2]

Unknown to Lewis, Ballis, and all but a few members of the NFWA leadership, the march had become a major worry for Schenley. When the march neared Stockton on April 3, Schenley CEO Lewis Rosentiel contacted Sidney Korchak, a Los Angeles labor lawyer and fixer. Korchak convinced Rosenstiel to recognize the NFWA and reap the good publicity to follow. With no stake in the Delano grape-growing community, Rosentiel on April 5 agreed to sign a recognition agreement with the NFWA. Schenley would provide an immediate 35 cents an hour raise in wages to $1.75, a union hiring hall, and a check-off arrangement for the NFWA credit union.[3]

Lewis learned of the Schenley agreement early the next morning. He recalled:

We were out in the Tokay grape vineyards around Lodi. It was beautiful country. A sunny day. I saw a commotion over by the old Volkswagen van that served as a control center for the march. Here's SNCC organizer Terry Cannon, who was acting as a press secretary, up on top of the damn thing standing on the roof. He's got a bullhorn and he's telling everyone to be quiet. He's got some news. I'm wondering, "Has César been shot?" We had not seen him for several days. Was he in a hospital, dead of a heart attack? We didn't know what to think. Everybody was rushing over to the van. I just got there in time to hear that NFWA had signed an agreement with Schenley. Cannon gave all the details. The contract would cover five hundred Delano workers. Negotiations would start soon. Most of the farmworkers did not at first understand what Cannon said. It took a while to translate it all into Spanish. Then it was joyous pandemonium. Someone

128. "Emilio Huerta, Dolores Huerta's son, helped ease the load of the cross bearer on the march. They would fall behind at times, and George Ballis got that splendid shot of them in silhouette on April 10. I even bought a T-shirt with that on front." Spring 1966.

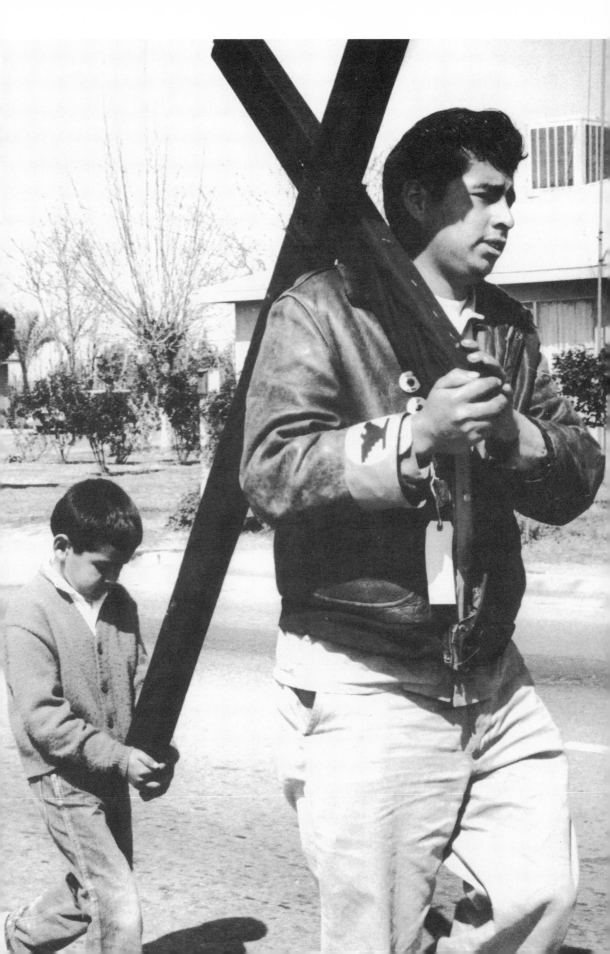

produced some black paint and some brushes. Everyone got out their signs and laid them down on the ground and just started crossing out "Schenley" and writing in "S&W," "TreeSweet," and "DiGiorgio."[4]

Predicting a bright future, *El Malcriado* crowed, "This agreement destroyed, once and for all, the lies of the other growers about the strike. Schenley had been badly hurt by the strike and the boycott, and was eager to sign a contract . . . Now other growers, especially DiGiorgio, the biggest of all, are squirming like snakes, trying to escape the FWS eagle . . . For the first time in history, we Mexican American farm workers have demanded that we be treated with dignity and respect, and our demands have been met."[5]

On April 7, Robert DiGiorgio, the Yale-educated, fifty-five-year-old head of DiGiorgio Fruit Corporation, seized the public relations initiative, split with the other Delano growers, and requested the California State Conciliation service to hold secret ballot elections on his farms. A clever marketing strategist who hobnobbed with the power elite of San Francisco and served on the boards of a half-dozen major corporations, DiGiorgio also announced that it too would recognize the NFWA and accept an election if the union ended its boycott and agreed to binding arbitration. Workers were to choose between NFWA, AWOC, and the Kern-Tulare Independent Farm Workers, a company union led by labor contractors.

Lewis and everybody else in the NFWA immediately smelled a trap. DiGiorgio was going to try to split the workers, kill the boycott, play the good guy, and reap the benefits. Even before the election, DiGiorgio would escape from the boycott, which represented the only real pressure the NFWA could exert on the company.[6]

Lewis believed that if the NFWA lost the DiGiorgio election, even if it was rigged, the strike was finished. With the stakes

129. "Any number of musical groups or individuals would show up and serenade us. It provided some variety to our singing of 'De Colores,' which accompanied us up the Valley. Music certainly helped pass the time and lifted spirits. Is that Paul Espinoza out of focus in the background?" Spring 1966.

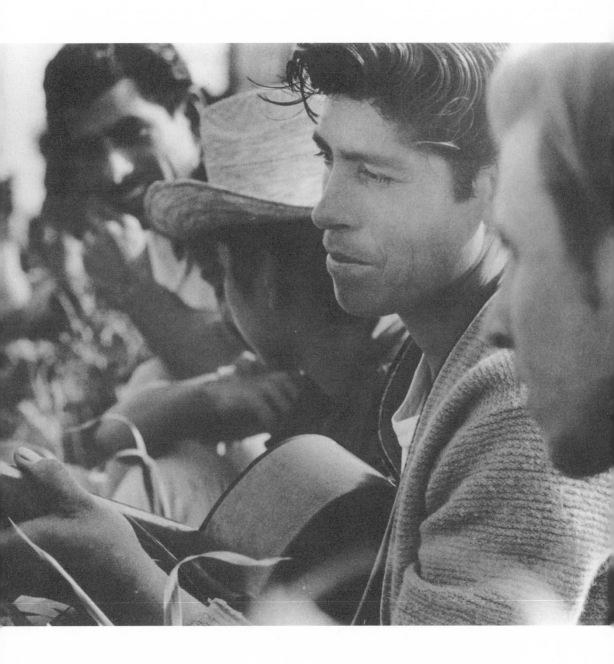

so great, Lewis talked it over with Terry Cannon. Both feared that the DiGiorgio election was dangerous. Lewis thought,

> We might lose everything. There were so many questions. Who could vote? DiGiorgio employed workers on a dozen ranches all over the state. Were they all eligible? We had little contact with many of them. We could not even gain access to ranches outside of Delano. Most of the workers at Sierra Vista Ranch were gone. Some were in Texas. Some would never be found. Would scabs be able to vote? Would the election be limited to full-time employees? Just seasonal workers? Who was going to guarantee a fair election? Farmworkers were excluded from the NLRB. DiGiorgio could retaliate against union activists, fire them, and buy off and bribe others. Who could stop that? What penalties would be imposed? As for secret ballot elections, field hands knew that in Mexico all elections were rigged. How could they be convinced otherwise? If you really scrutinized that election offer you could see it provided DiGiorgio a dozen different ways to beat us.[7]

Kircher, Itliong, and Chávez saw it the same way. Itliong immediately pulled the AWOC out of the election. Chávez maintained the boycott. He denounced any election involving a company union. He would agree to elections only if workers were protected from unfair labor practices as defined by NLRB rules. All of this was going to be worked out even as the march went forward and the NFWA negotiated its Schenley contract, affiliated with the AFL-CIO, and continued to picket and boycott.[8]

For Lewis, Kouns, Gscheidle, and other weary marchers, the news supplied a jolt of energy that would carry them through the next three days. They knew that they were not only making history, they were living and recording it at the same time.

130. "Luís Valdéz mocking DiGiorgio during a Teatro Campesino performance on the march." Spring 1966.

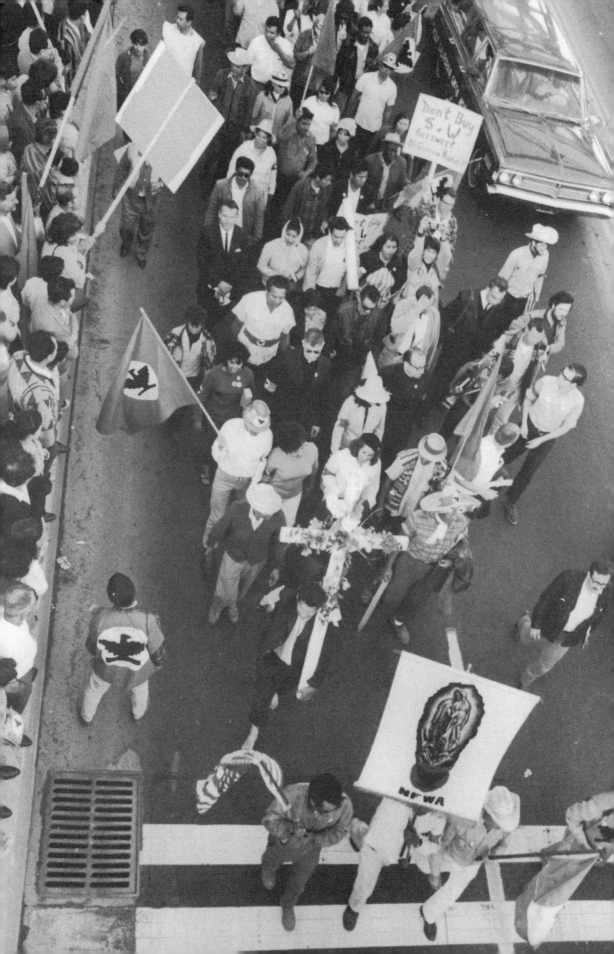

45. Sacramento

Lewis hardly slept on the two days before Easter. On Good Friday, April 8, he was up at dawn. After photographing a morning blessing, he followed the marchers as they stopped fourteen times to kneel and pray along the narrow levee road from Courtland to Freeport, each stop symbolizing stations of the cross. Lewis ended his day after dark, when everyone assembled at the Freeport Sportsman's Club for a rally and passion play. Early on Saturday morning, Lewis documented a joint Catholic, Protestant, and Jewish prayer service, then followed the march from Freeport to West Sacramento. When several thousand newcomers joined a 6:30 p.m. rally in Our Lady of Grace school, Lewis tried to capture the size of the march. He then stayed up all night visiting with friends.

Too excited to sleep, he recalled that

> my ass was really dragging. I was wearing my last change of clothes. I was ripe. But I didn't care. I knew it was all coming to a head. I had been dreaming about this moment for weeks. I could see we had arrived but could not quite believe it. We had been on this journey toward something. Now we were there. I just wanted to visit and hang out. Take it all on. I felt energized. I could hardly eat. I just kept thinking, "We have arrived. We are really in Sacramento." I did not want to miss a shot.[1]

Under lowering skies on Easter morning Lewis photographed a huge Mass at Grace School, then scrambled to record three to four thousand marchers crossing the Tower Bridge on their way to the steps of the California State Capitol. His first image caught NFWA organizer Marshall Ganz, clipboard in hand. To gain perspective, Lewis scrambled onto truck beds and any elevated spot. During the hour it

131. "Last morning of the march entering Sacramento. They had wrapped the cross, which had been with us all the way, in white crepe paper with flowers for the Easter Sunday finale." Spring 1966.

took for the procession to cross the bridge, Lewis worked the crowd, singled out individuals and groups, and greeted old friends from Delano as they passed by.

Present were many people who had never participated in the movement, walking side by side with people who had been active in the farmworker cause for decades. As he prepared to follow the fifty-one *origináles* (farmworkers who had walked from Delano, some having dropped out) to a 4 p.m. rally on the steps of the capitol, Lewis shifted his attention to Chávez.[2]

So great was the interest and so without parallel in California was the march that Lewis suddenly found himself competing for position with many other photographers, most of whom did not realize that Lewis was also one of the *origináles*. It seemed to him that every capable activist photographer in the state was present — old veterans who had first photographed in the fields during the Great Depression alongside press photographers, magazine photographers, and hotshot photographers working for famous New York–based photo agencies like Black Star and Magnum, and even photographers associated with the counterculture and rock music scene.[3]

Jim Marshall was one of the hotshot "rock photographers" (a label he dismissed by saying that Edward Weston and Ansel Adams were rock photographers, while he photographed musicians who played rock music). Also present was Hansel Mieth Hagel, the German immigrant photographer who with her husband, Otto, had worked as a migrant field hand before moving on to *Life* magazine and a career as a chicken farmer and freelance photographer. Now in her fourth decade photographing farmworkers, Hansel had just finished a photo essay on the Head Start program in Sonoma County, where she had met many farmworker families living along the banks of the Russian River. Lewis did not know Hansel Mieth Hagel, already a legendary figure among those who knew the photographic medium, but noticed her and watched her work.[4]

When thousands of cheering supporters joined the march on the downtown side of the bridge, Lewis wheeled around and framed them with the capitol building in the background, then moved into the crowd.

Of his work that day Lewis emphasized that

it was so noisy and chaotic. People were playing guitars. Several farmworkers had trumpets and were blowing on them. There were women pushing baby strollers, people on stilts, people with Mexican flags, California flags, American flags,

132. "On Easter Sunday at the state capitol where some ten thousand turned out. After all the speeches and a brief shower, we returned the banner to the church of the Virgin of Guadalupe, from where she was loaned to us." Easter 1966.

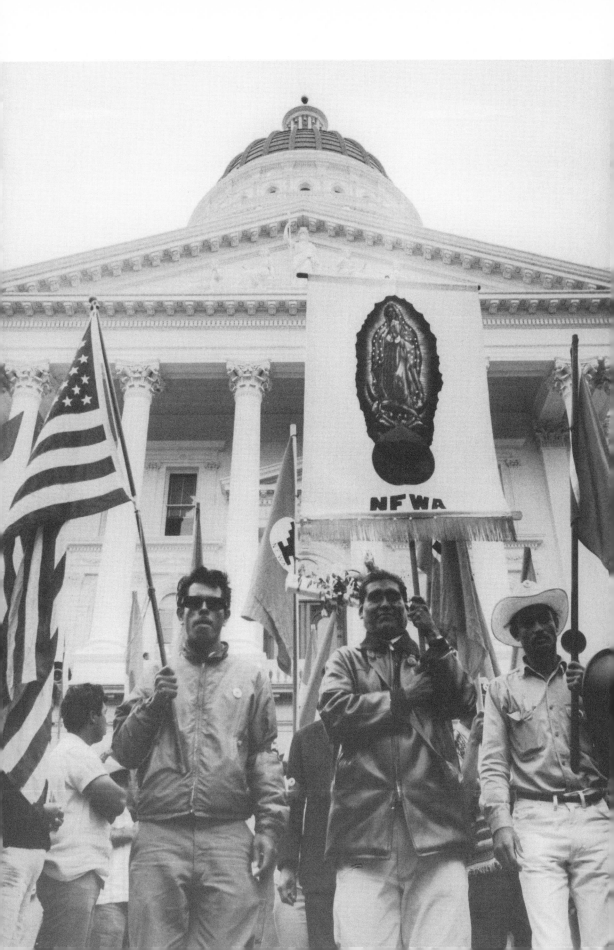

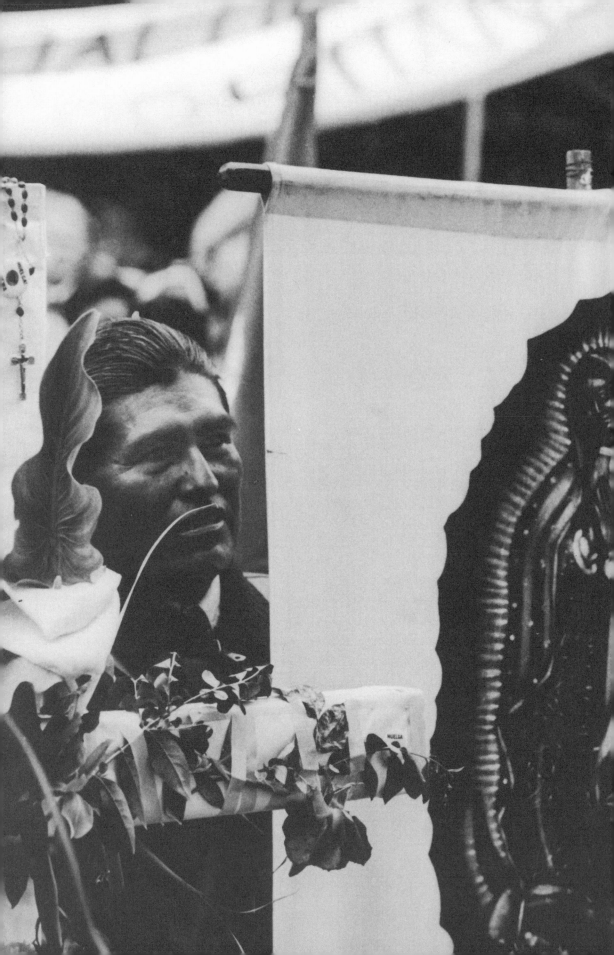

NFWA flags. An easterly breeze kept the flags unfurled. A Mexican dressed in full regalia rode a tan horse at the front of the march. News helicopters were hovering overhead. Police walkie-talkies cracked and hissed. Automobiles stopped on the bridge and people got out to make pictures. You could not find a sour face. People were singing. People were shouting "Viva Schenley. Viva la Victoria. Abajo, DiGiorgio" [Hooray for Schenley. Hooray for the victory. Down with DiGiorgio]. Everyone was smiling, cheering, and clapping. The dark and cold winter and our deep depression lifted. Now we had hope. We had shown the whole world. We knew what we could accomplish. We had beaten a giant corporation. If you read history, you knew that farmworkers had never been able to do anything like this. A farmworker association that had entered the strike with only $85 in the bank and two paid employees had beaten a giant corporation and had another on the run. Everything just seemed to come together.[5]

On the steps of the state capitol, Lewis photographed a ceremony in which marchers returned the Our Lady of Guadalupe banner that had been loaned to NFWA by Our Lady of Guadalupe church in Sacramento. Recording the situation through a classic sequence of long and wide shots, Lewis photographed all of the marchers many times. Absent from the picture was Governor Brown, who had opted to "spend the day with his family" at the invitation of Frank Sinatra in Palm Springs. Tired and dehydrated, Lewis did not have the energy required to properly zero in on Dolores Huerta, who gave a rousing, defiant speech about workers being on the rise and Delano starting a revolution, then ended by threatening a general strike if Governor Brown did not convene a special session of the legislature to extend the rights of collective bargaining to farmworkers.

Lewis completely missed Chávez, who delivered a stirring speech saying that NFWA was not going to settle for raising wages from $1.24 to $1.75 an hour, that it wanted what other workers already had, including sick leave. Foremen would no longer be able to insult women, no workers would be fired without just cause, and NFWA members would now be able to elect their own leaders to sit down as equals with the Schenley bosses to negotiate wages and working conditions. "As for labor contractors," Chávez continued, "they are out. In the future there is going to be no room for them. The profession of labor contractor is a dead one."[6]

Concentrating on wide shots of the crowd and overwhelmed by the moment, Lewis recalled others who remained detached and did the best work. Among those

133. "Luís Valdéz often carried the Virgin of Guadalupe banner at the head of the march. Here he has gone the last mile after the march on Sacramento." Spring 1966.

he most admired was Jim Marshall. Full of admiration for the way Marshall concentrated and got his pictures, Lewis remembered that Marshall

> was just a 30 year-old music photographer who had left a career as an insurance adjuster and found his calling documenting the rock music scene. He liked his drugs and was considered a curmudgeon and a bit arrogant, but he could really shoot candid pictures. I watched him follow Chávez through the crowd up to the speaker's podium. He stayed focused. Never looked at the crowd. He was after Chávez. He got the shots I missed. *Click!* Chávez marching arm in arm with other NFWA leaders. *Click!* Chávez beneath a banner of the Virgin of Guadalupe. *Click!* A close up of Chávez listening to the speakers. *Click!* Chávez addressing the crowd. Marshall kept his focus and I didn't. He probably got the best stuff, even though his specialty was rock music. He never again covered farm labor.[7]

Attentive to the relationship between the crowd and speakers, Lewis stationed himself near the speaker's podium. He swung around and used his 135-millimeter portrait lens to capture key moments of excitement. *Click!* Strikers shouting and cheering. *Click!* Union members waving banners and signs. *Click!* children perched on the shoulders of their fathers. *Click!* César's father, Librado, the tall patriarch. *Click!* The crowd parting to receive and greet the "originals," many limping with bloody feet, as they completed their walk and reached the steps of the capitol.

For the first time since arriving at Delano, Lewis found it difficult to concentrate. Remembering his photographic work that day, he stressed many years later that

> the whole event was monumental. You just wanted to enjoy it, file it away in your memory. Governor Brown emerged as the real stinker. NFWA leaders took great delight announcing that he had skipped town and was playing golf. After a while, it began to drizzle, and the excitement died down. I began to lose interest after the speeches went on and on, hour after hour, in English and Spanish. Overall, it was a great moment. I kept thinking about those photographers who had been present for the great triumphant moments in history — V-E Day in New York City, the liberation of Paris in 1944. I knew this was like that, on a much smaller scale, but really a historic moment in California, certainly a moment that we would refer back to again and again. We had done it. We had lived on donations and a pittance. We were fanatics or zealots, college dropouts, student activists, ministers, union members, mostly young and idealistic, maybe naïve. Some of us could not even read or write. But we had overcome. We were in the public eye. We had finally arrived at our destination. Sacramento was our Selma or Birmingham. Now we were going after the Governor. We were taking on DiGiorgio.

134. Jon Lewis contact sheet documenting the conclusion of the Sacramento march. Easter 1966.

We were not merely another union. We had become a social movement with growing support. We had won the first contract with a grower. We thought for the first time that farmworkers could actually unionize. To stand on the steps of the state capitol surrounded by thousands of people and all those political leaders and famous people from everywhere while trying to take this all in was exhilarating. Maybe if I had not been so tired I would have documented it better. Maybe if I had not been so happy I would have predicted the counterattack by the growers and DiGiorgio and the next big battle.[8]

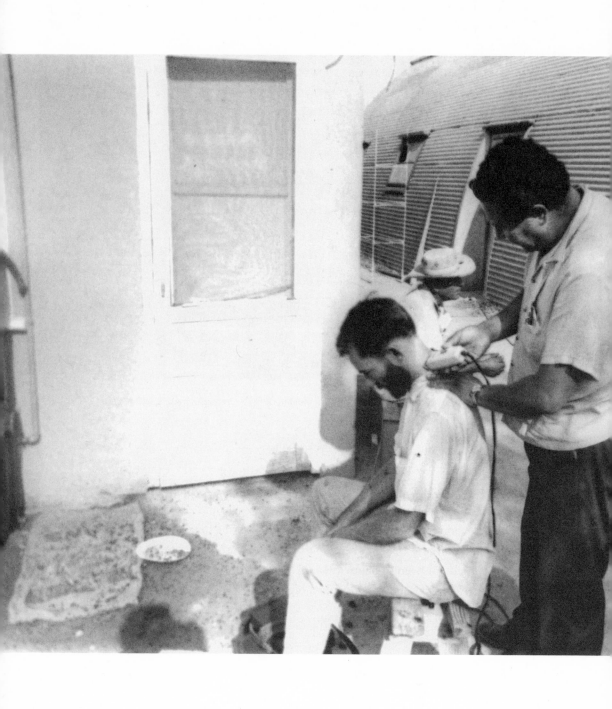

46. Alone

A few days after the march ended, Gerhard Gscheidle returned to San Francisco to edit his color photographs. He sent the layout to John Poppy at the San Francisco office of *Look* magazine. Poppy poured over the images, forwarded them to editors in New York City, and proposed an article. Gscheidle's photographs never appeared in the magazine because, in his view, management feared losing advertising revenues from DiGiorgio Corporation. Not until that fall did Gscheidle place two pages of his color photographs, including a full-page portrait of Chávez and a half-page shot of the Sacramento marchers in, of all places, *Farm Quarterly*.[1]

Back at Delano, Lewis finished developing the last of the 102 rolls of Tri-x that he had shot, and then quickly made prints. Although he had a complete if not definitive record of the largest civil rights demonstration that the state had ever seen, Lewis could not place his images in magazines and newspapers. Eventually a few shots ran in progressive publications and church-oriented journals along with *El Malcriado* — scant reward for the sacrifices, effort, and quality of his work.

Looking back over La Peregrinación, Lewis remembered scurrying up telephone poles, crouching down in gullies, climbing anything remotely resembling a hill, and shooting from motorcycles, truck beds, benches, trash cans, and the porches of homes in order to vary his perspective. In many ways it had been a fishing expedition.

135. "The union's nonunion barber, Julio Hernandez, gives a trim to the union's scruffy photographer." Summer 1966. Photograph by Jeff Kouns.

Describing the type of photography he did during those dramatic weeks, Lewis stressed, "You cast a wide net. You see what you get. You scoop up the keepers. And you toss out the small fry. You keep trolling and think about all that got away, escaped your net, the missed shots at the end of a roll of film, just when you were reloading the camera. I didn't go on the march with the idea of getting any particular shots. I just hoped to catch something each day and assumed that the images would add up to something."[2]

By mid-April 1966 Lewis was exhausted. Taking time off to do his laundry, he spent a few days tidying up. His fingernails were dirty and needed to be trimmed. His cameras were filthy and required cleaning. He had not cut his hair in months.

Too poor to visit a barber, Lewis asked NFWA vice president Julio Hernandez to make him look more presentable. When not locked in conferences with Chávez or negotiations with DiGiorgio, Gilbert Padilla, and Antonio Orendain or trying to figure out how to feed and house strikers or repair the latest car to break down, Hernandez served as a kind of jack-of-all-trades-union-barber.

Lewis recalled, "Hernandez was everyone's friend. A big, round guy. Always doing something. Always there. He was a cog in the whole operation. He knew everybody. He seemed to be involved in everything, but never rushed. He would always have time to visit with you. I just sat in a chair on a warm spring afternoon and we talked while he cut my hair outside of the Gray House. [John] Kouns snapped my picture."[3]

On April 14, Lewis was again out on the DiGiorgio picket lines. It was a different kind of picketing. He recalled:

Chávez was not trying to persuade workers to stop pruning and tying grape-vines. Rather he was trying to communicate to field hands living in camps at Sierra Vista Ranch. The workers were far away from us. DiGiorgio really had them under control. The NFWA had no chance of winning any election if it could not reach those workers and communicate its message. DiGiorgio was not going to let me or any other NFWA member anywhere near those workers. Foremen began working on field hands. DiGiorgio himself even sent letters to employees. DiGiorgio had guards all over the place. Mean guards. They beat up a farmworker, Manual Rosas, and a volunteer, Ida Cousino. After that, NFWA filed a huge lawsuit [$640,000] and César refused to even speak with DiGiorgio representatives. It was getting very ugly and dangerous.[4]

A few days into the DiGiorgio confrontation, Lewis met Jim Lorenz, a young lawyer who had just received a grant to start the California Rural Legal Assistance. Lewis mentioned in passing that he might better crack into the national market

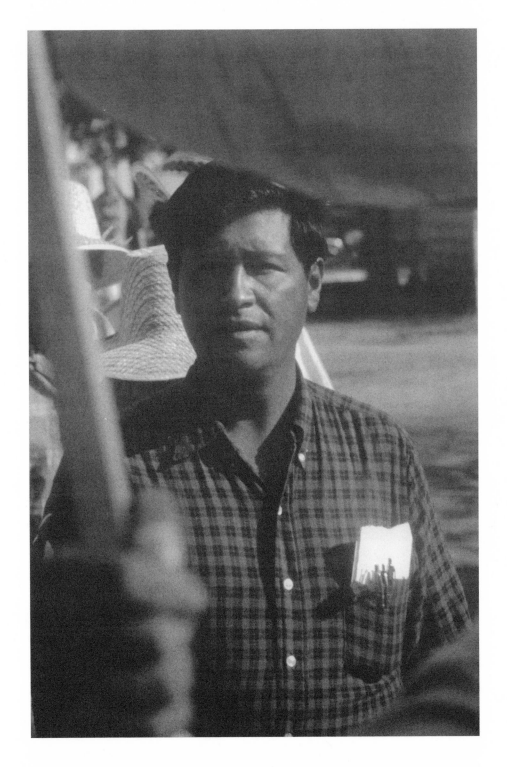

136. "Made from bulk-loaded color film, later became a postcard." Summer 1966.

by photographing in color. Lorenz decided to help him. In exchange for prints to decorate his new office, Lorenz gave Lewis enough money to buy one hundred feet of surplus 35-millimeter color film. Lewis bulk-loaded eighteen rolls of the film into used film canisters that he had saved while developing his film. After shooting some of his color film, Lewis took the bus to San Jose, where he borrowed chemicals to develop several batches of film in a friend's bathroom.

Lewis recalled:

I spent all night in that bathroom developing the film. In the morning, when the sun came up, I put a blanket over the window and kept going. The first few rolls in effect were lost. I had to experiment and play with different exposures and make a lot of adjustments before I could use the stuff. I had never heard of anyone doing this. But I was desperate enough to try. It was all to save money. I couldn't just take the color film to a lab and say "bill me." We had no funds at all. We scrounged. And we did not trust any of the camera stores in the Valley. The movie film worked just like regular film.[5]

By early May, Lewis was the only photographer around. Gscheidle was gone. Kouns announced that he was heading home but would periodically return. Most nonstrikers had headed south to the Coachella Valley for the early table grape harvest. Key volunteers had left to launch the DiGiorgio boycotts at major chain stores in various cities. After the NFWA printed and distributed two million leaflets explaining the boycott and the Farm Bureau tried to mount a counter boycott, retailers throughout California began pulling s&w products.[6]

What had started six months before as a spontaneous strike over wages in a backwater of the San Joaquin Valley was now developing into *La Causa*, a movement to radically reorganize the power relationships of California agribusiness. At each challenge, NFWA had developed new and innovative tactics for raising money, attracting volunteers, reassuring strikers, preventing the movement from fragmenting, minimizing expenses, maximizing resources, getting the word out to the general public, and developing what NFWA organizer Ganz later identified as a "charismatic community." Farmworkers referred to themselves as *Chavistas*. Supporters and volunteers became *voluntaries*. The grape strike was La Huelga. The NFWA was synonymous with La Causa. And César Chávez emerged as a charismatic farm labor leader.[7]

Lewis had recorded much more than he realized. Through his lens one sees the NFWA turning short-term power into structural changes that had escaped all previous farmworker unions. He had documented a movement crossing a new threshold that used urban support to pressure agricultural employers.

Having passed through his initial trial by fire and documented a march that produced the first contract with a grape grower, Lewis and the NFWA now faced a series of daunting challenges and responsibilities. A half-dozen wineries, including Christian Brothers and Novitiate, held union representation elections that the NFWA easily won. In addition to everything else, the NFWA suddenly had contracts to administer, grievance procedures to process, and worker representation elections to win. After a half-century of struggle, Lewis had captured that pivotal moment when farmworkers began to believe that they might organize and develop countervailing power. As he would soon learn, the fight had only just begun.[8]

47. Participant

Every day brought another crisis. Lewis was adapting and reacting in an exhilarating and ultimately exhausting and ever-changing crisis-driven adventure. He never had enough film. He was constantly scrounging about. He was always hungry. Always grungy. He seldom had more than pocket change. He lived as a stoic. But his passion and loyalty to the farmworker cause never wavered.

Reflecting on his motivation many years later, Lewis recalled:

> I was absolutely committed to the union. I made the same shots everyone else made. I had a union card. I hung out with everyone at the Pink House. After springtime it was often so hot that you just pulled a sheet over you at night. It was the same for all of us. We were like robots. Up before sunrise. Monotonous meals. Tortillas, beans, and coffee. Out to the vineyards. It was important just to get our bodies out there on the picket line. I crossed the line from objective observer to participant. I carried picket signs and painted them. If we had a few dollars, all of the photographers would gather at People's Bar for a beer. We had chosen sides. We were comrades in a cause. We were fighting a battle. But we also felt like we were part of something much bigger than the grape strike. We were against a society that seemed stacked in favor of the rich. As much as we were fighting for farmworker justice, we were also fighting for the little guy in general.[1]

For freelancers like Lewis, the daily mantra became "obtain more film, stay another day." Focusing not so much on the hard news of confrontation as on the soft news of everyday activities, Lewis was present whenever people gathered together. Occasionally he interrupted the mundane work of making posters, stapling fliers, and addressing mailings by breaking the boredom by shooting photographs.

When union members cooked meals for picketers or held workshops, Lewis was there. When visiting dignitaries came through, he joined them on their dog and pony shows. When food donations arrived, he photographed volunteers unloading boxes of beans and canned fruit.

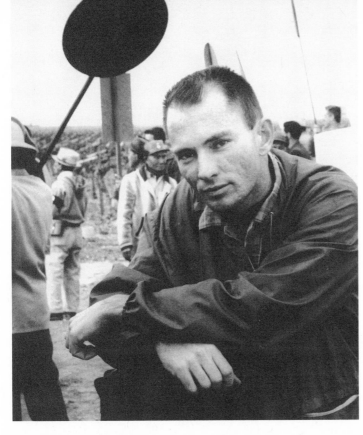

137. "Among the first few days on the picket line, I don't recall at what point during what was to be a week-and-a-half sojourn that it dawned on me that I should stay on. What was preposterous one day became inevitable the next. John Kouns caught me here when I was still in my Marine haircut." Winter 1966.

By operating on the edges of everyday union activities, Lewis was able to capture both the day-to-day grind and the charged spirit of the movement. And because he was not working on a deadline and had an insider's view of what was important, he could document quiet moments as well as hot ones. Even though he made no pretense of objectivity, his cumulative effect was to produce a broader and more accurate picture of the grape strike than the one captured by the photojournalists who were constantly arriving and departing.[2]

Early in May, Mark Harris injected some excitement into the strike when he returned to Delano with a documentary film crew. By then La Causa — the farm-worker movement — had been profiled on the nightly news shows of all three major television networks. Delano was again awash in reporters and volunteers, all clamoring for some spectacular shot of Chávez. None of this affected Lewis, who continued to follow the same routine that every other picket followed — up with the pickets before dawn, meals in the strike kitchen, photograph on the picket lines, photograph strike meetings at night, develop film, print photographs, grab some precious sleep.[3]

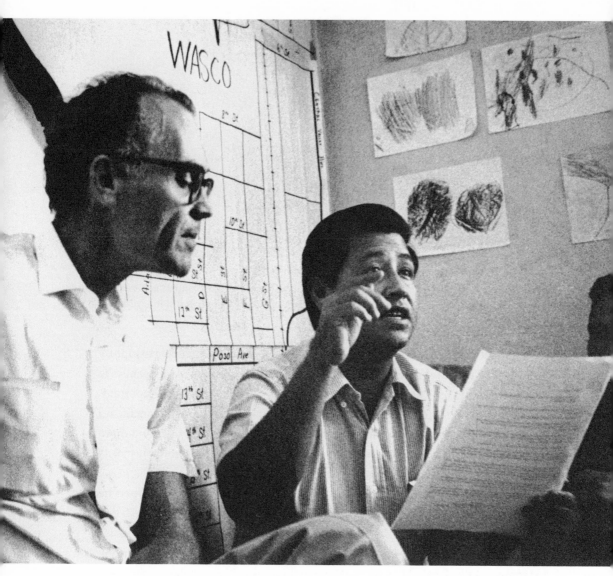

138. "After having access to DiGiorgio's labor camp during the lunch break, organizers would gather at the Pink House. Fred Ross had recently come aboard to direct the campaign, and César was usually in the background. Here we have artwork by farmworker children on the wall, beside maps of adjacent towns." Fall 1966.

48. DiGiorgio

Lewis spent the first two weeks in May 1966 documenting the NFWA's campaign to represent workers at DiGiorgio Farming Corporation. Because organizers could not reach workers inside the labor camps, NFWA concentrated on field hands living in Delano. After workers had returned home and had a chance to relax, organizers began visiting them. In order to gain access to the camps and build a following, the NFWA asked workers to sign cards authorizing them to act as their bargaining agent.

Lewis remembered that

it all went well at first. We were building a following and developing a cadre of leaders. We were beginning to train them. We had a whole bunch of fellows who were challenging the foremen and bosses. On Friday, May 13, we began hearing that the Teamsters were also distributing authorization cards. At first we didn't understand what was happening. We thought, "Oh, they're going after the packinghouse workers. Good. We'll have the whole workforce under union contract lickety-split." We didn't suspect a thing. After all, the Teamsters [Joint Council] President George Mock] had proclaimed his support for the NFWA, and the Teamsters in Los Angeles [Joint Council 42] were strongly backing the DiGiorgio boycott. Boy, were we wrong. Dolores Huerta got ahold of some Teamster contacts the next day and discovered that the Teamsters were going to offer themselves as an alternative to the NFWA. They were billing themselves as a proven and dependable union, as if we were some kind of long-haired, radical, flame-throwing revolutionaries who couldn't walk and talk at the same time. What they were really doing was organizing the employers and then rounding up workers. They were getting in bed with DiGiorgio. Their strategy was to gain access that was denied to the NFWA. They were going to buddy up to foremen and bosses and use them to pressure workers into signing authorization cards. We should have known better. Never trust the Teamsters. That's the big lesson

I learned. They had been doing this since the 1930s, trying to gain membership by presenting themselves as alternatives to other unions. It was the same crowd who had worked with AWOC and Al Green in the citrus industry in 1965. William Grami, an Italian who directed the Western Conference of Teamsters (WCT), and his sidekick, Pete Andrade, who ran the cannery workers operation. [Teamster's Union President James] Hoffa was in the background trying to stay out of prison for jury tampering. He did not want another headache. Hoffa loathed the civil rights movement. He hated Martin Luther King. He hated people like Chávez. He had never met a farmworker. He had even supported the bracero program. Whenever he had seen a budget for a farm labor organizing drive, he had hit the roof. Einar Mohn, the director of the WCT, was an old rival, if not an enemy. Rumor was that he intended to use farmworker unionization as a base for challenging Hoffa. We didn't know what to think about that. They were such a slimy bunch. Old farts. All administrators. Fat cats. Ambitious. None had ever organized in the fields. None had any contact with farmworkers. Except for Andrade, they couldn't speak a word of Spanish. It was the same tactic they had used to sign a contract with Bud Antle lettuce in 1961. Those guys were clever and devious. DiGiorgio and other growers turned to them when their stupid Independent Farm Workers was exposed as a company union and flopped. For the Teamsters, the move made good sense from a bread and butter point of view, especially if it removed a union that was overtly hostile to the Teamsters and all they represented. They already had a base among the cannery, packing shed, and cold storage plant workers. The Teamsters represented over a hundred thousand California workers who were directly connected to agriculture, including truck drivers. If they got the farmworkers they would have had a stranglehold on agricultural work and more dues revenue. It would have been a big feather in the cap of Mohn and others bucking to move up and displace older leaders of the International Union. It was really all about them and not farmworkers. They could have cared less about farmworkers.[1]

At dawn on Monday morning, May 16, Lewis and NFWA organizers stationed themselves at the entrances to the fields and began leafleting activity.

Lewis recalled that a few hours after they started picketing,

Ophelia Diaz, a DiGiorgio crew boss who had worked for the company since 1944, told us that her supervisor had ordered her to have her entire crew sign Teamster authorization cards. Other crew bosses were being asked to do the same thing. They were supposed to hand over the cards to Dick Myers, the guy who ran DiGiorgio's farming operations at Sierra Vista. Diaz's bosses had also

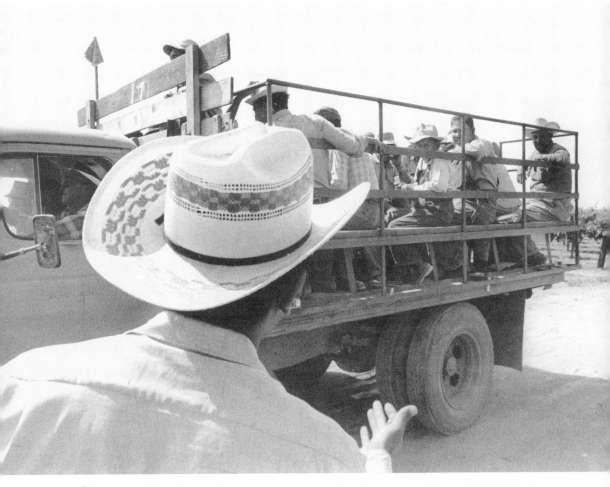

139. "You couldn't communicate too well with a crew in the middle of a field and the grower's bull-horn atop the pickup truck blowing music at high volume to drown us out. You could shout a few words and distribute a few leaflets when they brought a crew into or out of a field." Summer 1966.

asked her to lie about what she saw when DiGiorgio's security guards beat up Rosas and Cousino three weeks earlier. When she refused, they fired her on the grounds that after seventeen years as a crew boss her work had suddenly become unsatisfactory. A week later her husband, Henry Diaz, who had worked for many years as a foreman on another Delano grape ranch, was also fired. That very day DiGiorgio bused in two hundred field hands from its Borrego Springs Ranch. We could see what the company was doing. DiGiorgio was getting rid of anyone sympathetic to the NFWA and then replacing the work force with outsiders. By housing them in DiGiorgio camps, the company kept them under control. Those workers had no idea what was happening.[2]

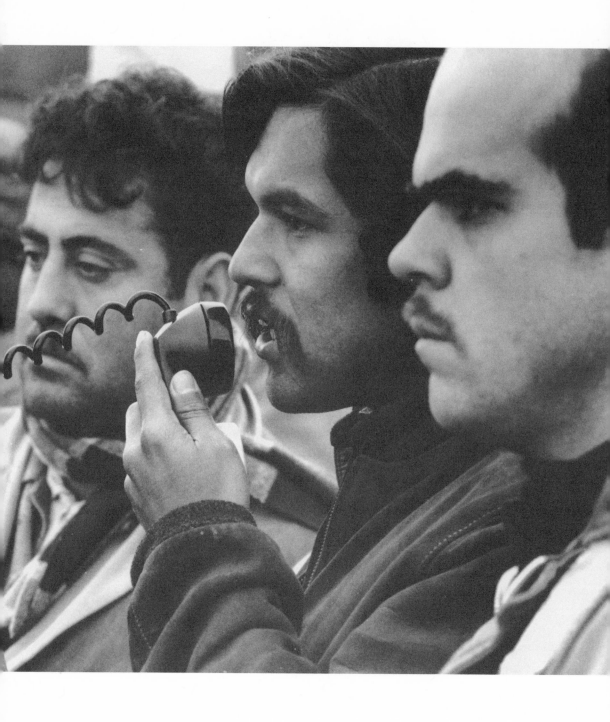

49. Sweetheart

Four days after DiGiorgio began its purging and busing operations, company attorneys obtained an injunction that restricted picketing to the main entrance at Sierra Vista Ranch. Barred from contacting workers in the camps or from picketing public roads, the NFWA was unable to communicate its message. Except for what they heard over bullhorns and loudspeakers, DiGiorgio's workers were sealed off from the outside world.[1]

In his strike diary, Lewis wrote, "It is a sweetheart agreement if ever there was one. The Teamsters Union . . . is in the camps to talk to the workers where we couldn't. Even the bosses are talking for the Teamsters. Here is one of the strongest unions, and it had helped us before. Now it is going through our picket lines to make a deal with the company? We are angry as hell. The strikers are ready to fight. To hell with non-violence. What now?"[2]

A few days later, Lewis attended a meeting in the Delano American Legion Hall. Chávez had already dispatched organizers to all of the DiGiorgio ranches. But when it came to additional action, he was out of ideas. Everyone agreed that the NFWA was losing.

Even though Chávez had adamantly opposed any form of violence, he led a discussion in which the workers expressed their frustrations. It was always the same, they said. Growers could get away with murder. They could break any law they liked. Every institution was against them.

On and on the meeting went. Strikers vowed revenge. Anyone who was still employed was going to get fired. Relatives were going to be

140. "Luís Valdéz's voice carried much authority on the picket lines. He had been a theater major in college, plus had worked with the San Francisco Mime Troupe prior to coming to Delano, so he knew how to use that voice." Winter 1966.

fired. The growers were purging every person associated with the strike, anyone friendly to the NFWA. So what if you were a loyal employee all your life? Growers did not care. Time to make them pay. Burn the sheds. Cut down the grapevines. Take revenge for all they had done and all they were doing.

An obviously distressed Chávez listened and listened, and then he called for a vote. Strikers would not endorse violence of any kind.

What next happened deeply impressed Lewis. He watched three women, obviously worried, who asked to see Chávez and entered his office.

Lewis thought, "This is it. The end. They want to give up." But the women had an idea. Lewis recalled:

Those women were geniuses. They hated that injunction and could not understand it. They asked Chávez what would happen if they picketed. He told them that they would be arrested and jailed. The NFWA would be fined and it might not have enough money to pay the fine or bail them out of jail. So they asked him what would happen if they prayed and said a Mass outside of the DiGiorgio gates? All of a sudden, Richard Chávez is there. César is talking to him, giving him directions. Richard went to work on César's old station wagon. He constructed a small chapel in back. Under a pitched wooden roof. When they opened the tailgate, it looked like a shrine. Pictures. Crosses. A big cross. Rosary beads. Candles. Flowers. Our Lady of Guadalupe. Strike signs. Flag. Someone parked it across the street from the DiGiorgio gate. Early the following day the NFWA began leafleting. The Spanish radio station began broadcasting a message, "Come to the vigil. Come to the DiGiorgio gate to pray for the strikers." It was a miracle. Hundreds of people showed up. The NFWA used loudspeakers to send the vigil to the strikebreakers in the camps. They came out to the fence and watched. I think it was the first time that they realized what was happening. We were able to speak to them and educate them about the strike. When the DiGiorgio trucks brought crews in from the vineyards to the mess hall on the following afternoon, eight women attempted to join the vigil. Company foremen parked trucks to block them. So they just walked through the vineyards to the shrine and knelt down and prayed. Then they went back to work. That evening a huge crowd of women showed up and prayed. On the following day, half of the DiGiorgio camp came to pray. Ministers said Mass there. People sang. Workers signed cards authorizing the NFWA as their bargaining agent. Day after day, it went on for several months. Twenty-four hours a day there were at last three people there. I photographed that shrine and the services from every angle, at every time of the day and night.[3]

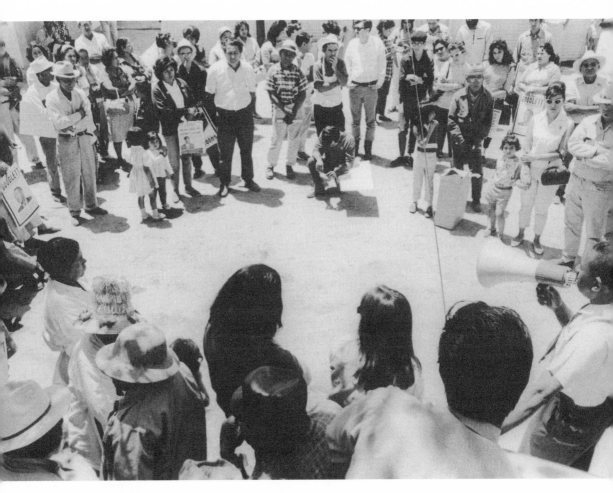

141. "On lunch break at the Arroyo Camp, Oakland newspaper publisher Carlton Goodlet addresses union members." Summer 1966.

50. Harvest

Since arriving in the fall of 1965, Lewis had photographed winter pruning but not grape picking. He knew next to nothing about harvest work. Out on the DiGiorgio picket lines, he soon discovered that foremen and supervisors would not let him near any of the crews harvesting early-ripening Perlette table grapes.

To obtain his images, Lewis waited until pickers reached the end of a vine row, where he could work without risking arrest. Whenever foremen and supervisors were not looking, he would slip into a vineyard, crouch under the vines, and visit and photograph the workers. In the thick vine cover, it was impossible to see him as he sat there and spoke to the workers and composed his pictures. When it became difficult to photograph surreptitiously, Lewis began following Roberto Roman's NFWA crews in the Schenley vineyards.

Lewis quickly discovered that picking table grapes was slower and involved far more skill and decision-making than he realized. Men and women, with a few children beside them, worked under the vines, women wearing bandanas pulled over their faces just under their eyes to protect them from the sun. Sulfur dust, leafhoppers, various other bugs, and spider webs made the work less than pleasant. Tiny black gnats flew into their eyes and were frequently inhaled. Mosquitoes were everywhere. And workers always had to be careful not to run into a trellis crossarm.

142. "This man had reached a certain age but could still shoulder a box of table grapes and hump it down the row for stacking. This had to be done many times to make a livable wage." Summer 1966.

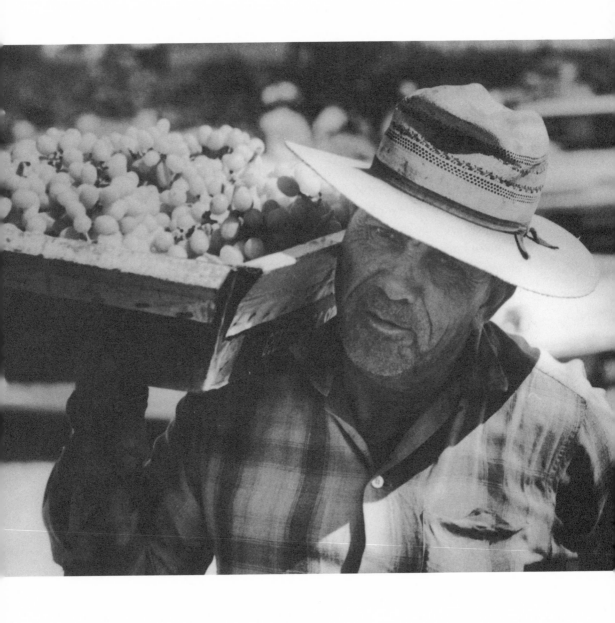

Most workers knelt on the ground or waddled sideways like ducks. They used clippers to cut grape bunches free from canes. The clippers had sharp, pointed ends. Pickers inserted them between shriveled, undersized, and discolored berries, snipped off the berries, then carefully turned over the bunches with a free hand, inspected them, snipped out any protruding berries and raisins, then placed the now perfectly shaped grape bunches in tubs.

Every half hour, men loaded the tubs onto hand trucks and wheeled them to the end of a vine row. Here women working in the shade of portable packing platforms further trimmed and inspected the bunches, then carefully packed them in wooden, twenty-three-pound grape "lugs" with the grower's label affixed to both ends. A variant system had the pickers also doing the trimming and packing under the grapevines. Loaders then took the packed lugs to the end of the vine row, where a crew loaded them onto a bobtail truck for transportation to the cooling shed.

There was no way to mechanize the work. Foremen tallied the production of each crew. An average field hand cut and packed about 2.5 boxes per hour. Paid $1.20 an hour, plus 25 cents per box, grape pickers averaged about $1.83 an hour.

Not all of DiGiorgio table grapes were used as fresh fruit. A large portion of its crop was made into wine. Documenting the work, Lewis discovered that it was very different from harvesting table grapes. Whereas table grape pickers were methodical, wine grape pickers worked at a frenzied pace. Whereas table grape pickers used clippers to carefully snip and then trim the grape clusters, wine grape pickers used a hooked knife to cut the grape clusters at maximum speed. Whereas table grape pickers carefully placed the fruit in wooden lug boxes, wine grape pickers tossed them into tubs, and when the tubs were full, they dumped the contents in huge bins.

Within a few hours, wine grape pickers were covered in dirt, grime, and sweet, sticky grape juice. To catch the sweat and filter the dust and debris, many of the workers wore handkerchiefs knotted around their heads and covering their noses and mouths. Lewis thought that they looked like a cross between Appalachian coal miners and Bedouin camel herders.

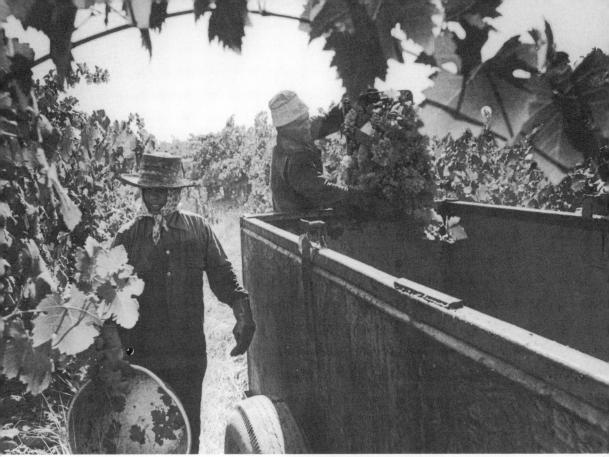

143. (*Above*) "It takes a lot of wine grapes to fill the gondola." Summer 1966.

144. (*Right*) "I didn't get much closer than this that often." Summer 1966.

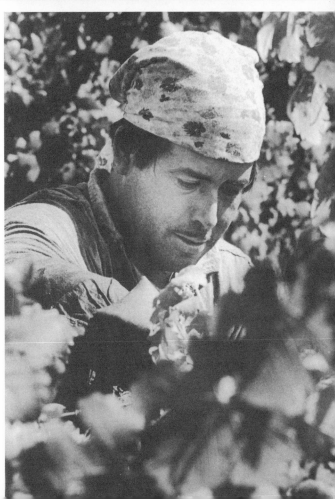

51. Altar

When not photographing harvest operations, Lewis focused on foremen and supervisors escorting Teamster organizers into the fields. Throughout May and well into June, the Teamsters at various times withdrew from the DiGiorgio elections, then reentered the fray, then stalled and engaged in double-talk. Lewis photographed company personnel helping Teamster organizers pass out petitions, dues authorization cards, and literature attacking the NFWA as a collection of "beatniks, out-of-town agitators and do-gooders."

In the evenings, Lewis accompanied NFWA organizers into the labor camps and into worker's homes. One evening he was visiting workers as they milled about under a few palm trees on the edge of the company's property. Four Tulare County deputy sheriffs and a DiGiorgio employee with a movie camera stood nearby.

Tired and sporting a small beard, Chávez climbed atop an old station wagon. As he prepared to speak to the men, the DiGiorgio employee began filming. Chávez noticed him and turned to Lewis. "Take some pictures of the guy taking pictures of me," he said. Lewis exposed a few frames, then turned to Chávez, who now had a bullhorn and was waving it about, asking for quiet.

For the next few minutes Lewis documented Chávez begging the men to remain in Delano and promising them food and lodging. Lewis knew better. The union was broke.

Across the street, beside the Sierra Vista railroad siding, Lewis spotted a group of women wearing mantillas (scarves). They were kneeling on cardboard in the dust. Beside them was the battered the Mercury station wagon that Richard Chávez had turned into a shrine. Now enveloped in flowers, crepe paper, old wall paper, Huelga posters, American and Mexican flags, and candles, it was a vivid picture that made Lewis wish that he had not exposed all of his color film.

Looking inside the back hatch, Lewis spotted a statue of the Virgin of Guadalupe. The handcrafted altar had been painted and adorned with prayer cards. Dried flowers lay scattered about. As one of the woman knelt on some cardboard, Lewis

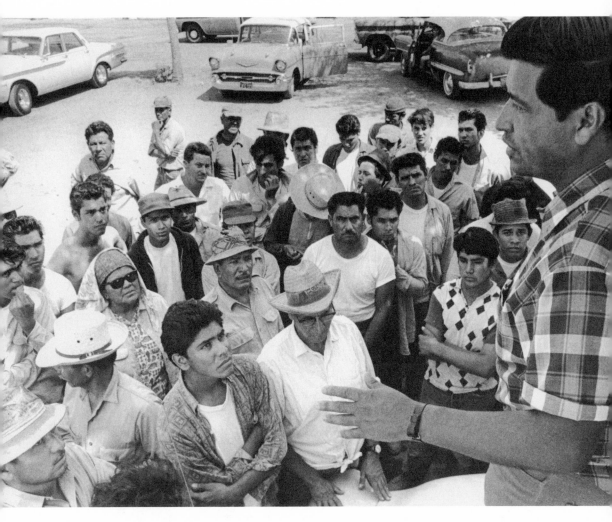

145. "I was always on the lookout for photographing César with the workers. He was in his element, and they and their lives were what it was all about. There was a walkout of Schenley workers in summer of 1966, shortly after our first contract was in place. César urged the workers to be patient (like all labor bosses?) while Dolores Huerta met with Schenley ranch committee to formulate their demands." Summer 1966.

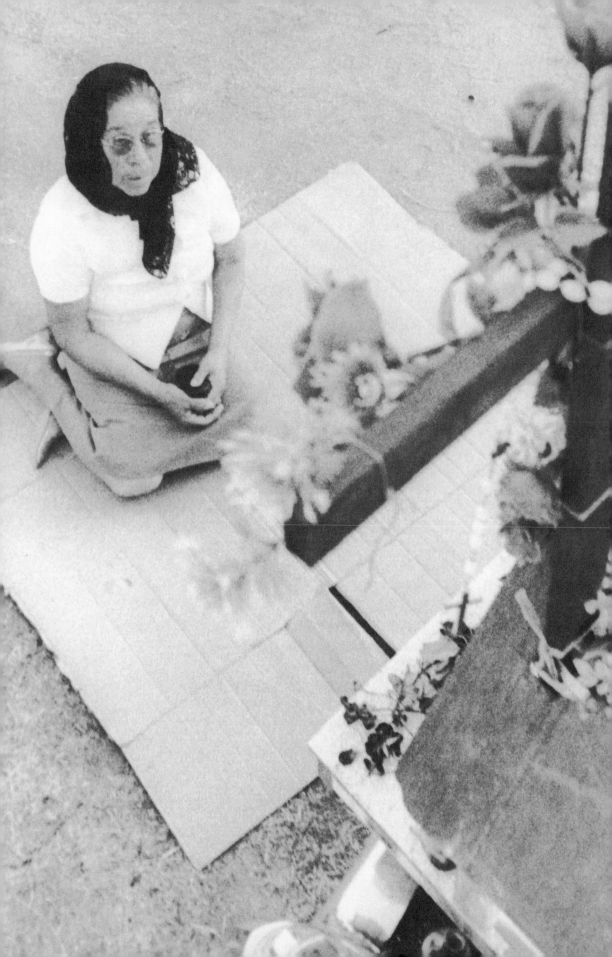

began photographing. His last image recorded a string of rosary beads hanging from a cross on the makeshift altar.

A few days later, after spending the lunch break being harassed by Teamsters in one labor camp, Lewis wrote in his diary, "The Teamsters had their muscle men to work us over. They could break a nose or a camera, but they couldn't break our spirit. One of us [Luís Valdéz] sitting and talking to a group of workers was suddenly hit in the face with a beer can. He didn't fight back and was attacked. When we pulled the Teamster goon off of him, he [Valdéz] said, 'Is this the kind of union you want?' The workers heard, and were not fooled."[1]

Not long after the Teamster smashed Valdéz in the face, Lewis retaliated. Going through his film, he found various shots that included clear images of a half-dozen of the most vicious Teamster organizers. Lewis then enlarged the prints to obtain ping-pong ball–sized head shots. He then carefully cut out the heads of each Teamster.

Recalling his actions that day, Lewis stressed that "the Teamsters were turds. That's what we all thought of them. Turds and goons. To get the point across, I took a picture inside one of the toilets over at Sierra Vista. Then I pasted those Teamster heads all around that toilet picture. Some were floating and some were on the floor. Crap all over the place was what it said. I tacked the shot up inside one of the toilets."[2]

And so it went. Day after day Lewis made good pictures because the motive that impelled him to place finger on shutter was strong. He was telling a story, recording it in sequence. He was doing reportage. His old Nikon F had become an extension of his eyes. He had discovered that his photography was a kind of joint operation of his brain, eyes, and heart. His goal was to capture an unfolding drama. Sometimes he found his images quickly, in a matter of seconds. Most of the time it was a matter of hours, days, and weeks.

Lewis had discovered that there was no standard approach. He remained alert in body and mind, and he kept on the move. That was most of it. But he had also learned to be specific. He was after one thing. He was not going to be distracted. When he felt that he had

146. "One of those resolute farmworker women praying on cardboard at the makeshift altar." Summer 1966.

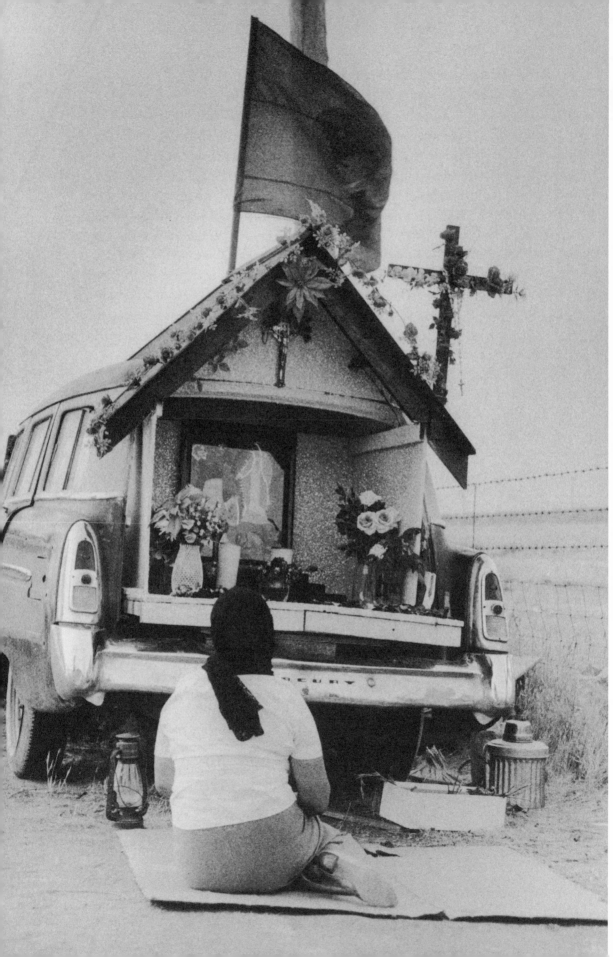

taken the best shot, he kept shooting because he had learned that he could never be certain how events unfolded. He called this "staying on scene." But he had also learned to shoot with economy because he had to. He did not have the luxury of unlimited amounts of film, chemicals, and paper, and he did not want to clutter himself with useless images that only spoiled the sharpness of his focus.

He tried to bridge gaps in his reportage. He was not going to be able to go back and rewind a scene. He kept thinking of Henri Cartier-Bresson's 1952 essay about "the decisive moment." Bresson had emphasized the need to "perceive reality" while simultaneously recording it and of the need to "count the points and rounds, rather like a boxing referee." Lewis had read and reread the well-thumbed and creased essay, highlighting and underlining important points. "Remember what you have done and how the images fit together," Lewis had written in the margin. Above all, he had underlined Bresson's advice to shoot "on tip toe," no jostling or elbowing, "with a velvet hand, a hawks' eye." Violate those guidelines, and you became a paparazzo — what Bresson called "an intolerably aggressive character."[3]

Lewis understood that his success as a photographer did not rest so much on technique and technology as on maintaining a good relationship with the people he was photographing. A deceptive relationship, one false word, or attitude, would ruin it all. If the farmworkers were at all self-conscious or uneasy with him, the picture would recede to a place that the camera could not reach. The trick was to remain at once unobtrusive and at close range. If he ever made himself obvious, even if by taking out a light meter, he would be better off forgetting photography for the moment and listening to the music or joining in the harangue or cheers.

147. Shrine at DiGiorgio's Sierra Vista Ranch. Summer 1966.

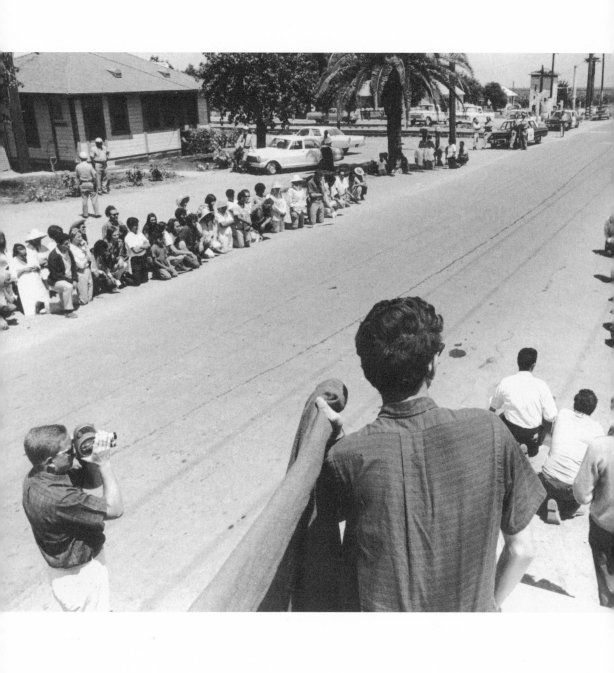

52. Fraud

On Wednesday, June 22, Lewis learned that DiGiorgio would hold elections at Sierra Vista and its Borrego Springs Ranch on Friday, June 24. No state or federal agency would oversee the elections. No guideless had been negotiated. Strikers would not be allowed to vote. A private accounting firm would tally the ballots. Two clergymen — one opposed to the NFWA, the other an ally — would act as observers.

Lewis recalled:

> Everything had been done unilaterally and was completely under DiGiorgio's control. The Teamsters waited on the sidelines. If company supervisors delivered workers into the union, they would return to DiGiorgio. It was the very personification of what labor organizers called a "sweetheart deal" [a contract delivered to a union by an employer to keep out another union regardless of what employees wanted]. Chavez denounced the election as "phony." He thought it was a lost cause, completely rigged in favor of the Teamsters. With only two days to campaign, the NFWA could not reach strikers in DiGiorgio camps, and NFWA strikers would not be allowed to vote. We were caught between withdrawing from the election and participating. NFWA asked DiGiorgio workers to boycott the election and discredit it.[1]

148. "That's the shrine [right edge] built into the back of a station wagon outside of DiGiorgio's Sierra Vista Ranch, during the "phony" election of June 1966. It remained there until the August 30 election, with people maintaining an around-the-clock vigil. DiGiorgio workers would come by after hours, and some solid organizing was done." Summer 1966.

One day later, Dolores Huerta and Kircher crashed a DiGiorgio press conference in San Francisco. They called DiGiorgio a liar and created a confrontation that was broadcast on the evening television news. NFWA lawyers then petitioned the court to prevent DiGiorgio from using either AWOC or NFWA on the ballot. When the NFWA learned that workers were to be bused to vote crew by crew, NFWA organizer Fred Ross, who had arrived to direct the organizing campaign, got many of them to remain on the bus and not vote at all.

On election day Lewis joined four hundred NFWA members along both sides of the road at Sierra Vista. He photographed Dolores Huerta talking to workers through a bullhorn and DiGiorgio field hands being threatened by foreman demanding that they get out and vote for the Teamsters or risk being fired.[2]

Writing in his diary, Lewis observed how "with our own eyes we saw most of the workers stay on the trucks and heard their foremen threaten them if they didn't get out and vote. We stood there for twelve hours as they brought some of the crews back two and three times to try and get them to vote. But the workers were with us, and most of the people that voted were maintenance men and office helpers and not farmworkers."[3]

Although the Teamsters won as expected [281 for the Teamsters, 60 for no union, 17 who wrote in AWOC or NFWA, and 41 casting blank ballots], it was a pyrrhic victory. Almost half of DiGiorgio's employees refused to vote.

A dejected Lewis asked, "Was that it? Did it end this way? We went up against two of the strongest opponents there could be and didn't even get a fair fight. Now all they had to do was announce their sweetheart contract. It would be just a matter of time for us. Whenever we put pressure on a grower, he could make a deal with the Teamsters, and our union would waste away . . . Our prayers went into the heavens that night."[4]

149. "There was a 'boycott DiGiorgio' march down San Francisco's Market Street at the start of that hectic summer [1966]. Here César bums a light from Julio Hernandez while Larry Itliong lights his stogie. There appears to be a typo in the banner, as 'SVERZA' should read 'FUERZA' ['The union is our force']." Summer 1966.

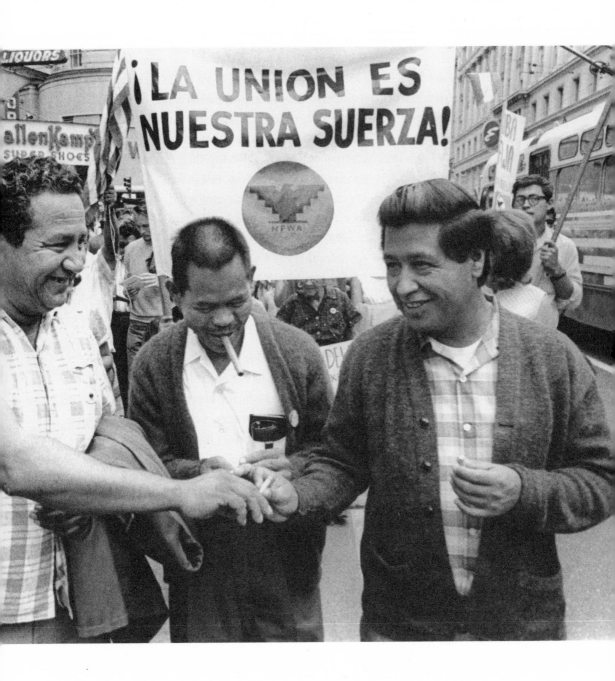

When DiGiorgio invited the Teamsters to negotiate a contract, Chávez denounced the election as a fraud and announced that the NFWA was expanding its boycott of DiGiorgio. Targets would also include companies like Bank of America and anyone else close to DiGiorgio.

Over the next week, NFWA mobilized all of its resources. Through contacts with U.S. Senators Harrison Williams and Edward Kennedy, California senator Alan Cranston, friends in the AFL-CIO, and the Mexican American Political Association (MAPA), Chávez succeeded in pressuring Governor Brown to ask for an investigation of the election and to suggest remedial action if it had not been fair.

On Monday, June 27, NFWA organizers called a strike at the Borrego Springs Ranch. The next day, Chávez, Chris Hartmire, and Father Vincent Salandini, a Roman Catholic priest from San Diego, accompanied the strikers back to their camp to retrieve their possessions. DiGiorgio guards immediately arrested them. All three were strip-searched, handcuffed, shackled together, loaded in a sheriff's department van, and driven to jail in San Diego, 150 miles away.

On June 29, a band of eighty students who had just completed a summer training project sponsored by SNCC, SDS, and several national student associations removed DiGiorgio products from four hundred stores in Cleveland and five hundred in New York. The next day, following news that the California Council of Churches had endorsed the boycott and that the San Francisco Board of Supervisors was going to designate a Huelga Day, the American Arbitration Association announced that Wayne State University labor arbitrator Ronald Haughton had been appointed to investigate the election. Under pressure from all flanks, DiGiorgio and the Teamsters, along with the NFWA agreed to abide by his findings.

Two weeks later, Haughton concluded the last of over two hundred interviews and reported that the elections were indeed fraudulent. He proposed new elections at Sierra Vista on August 30. Strikers and strikebreakers would be allowed to vote. Packinghouse workers would vote as a separate unit. Eligible workers were those who had been employed at DiGiorgio between September 19, 1965, just before the grape strike began, and August 15, 1966, about two weeks before the election. If DiGiorgio's workers voted for a union, everyone would have forty-five days to sign a contract. Wage, benefit, and contract issues that remained in dispute would be handled by Houghton and Sam Kagel, a San Francisco waterfront arbitrator familiar to all. Decisions would date back to the date on which the election had been certified. Unions that lost the election would be banned from organizing for one year. Election procedures would be established by the American Arbitration Association. After the NFWA, the Teamsters, and DiGiorgio all agreed to the terms, Chávez ceased all strike and boycott activity.[5]

Although the NFWA did not gain a complete victory, it had managed to undo the phony election and establish the basis for a fair process. About 2,000 workers were eligible to vote, 700 of them at that moment employed at Sierra Vista. Considering the task ahead, Chávez confessed to reporter and confidant Jacques Levy that if the NFWA lost at DiGiorgio it would not survive. He immediately pulled fifty-three full-time boycott organizers home from twelve cities and reassigned them to the DiGiorgio election. It was going to be a do-or-die effort. Meanwhile, the Teamsters thought they were sitting pretty. All of the growers were scared to death of the NFWA. William Grami thought that the Teamsters were a shoo-in. The growers would just deliver the workers, and that would be the end of Chávez and his farmworker movement.[6]

Recalling those two hectic weeks, Lewis jotted this note in his diary: "With the dawn new life was there. Churchmen came from all over the state to investigate the election. They talked to the workers and heard all the ways DiGiorgio tried to force them to vote for the Teamsters. Now someone besides us knew what DiGiorgio meant when he talked about 'free elections' in full-page newspaper ads . . . We had heard from DiGiorgio what his workers wanted all these months. Now they would speak for themselves."[7]

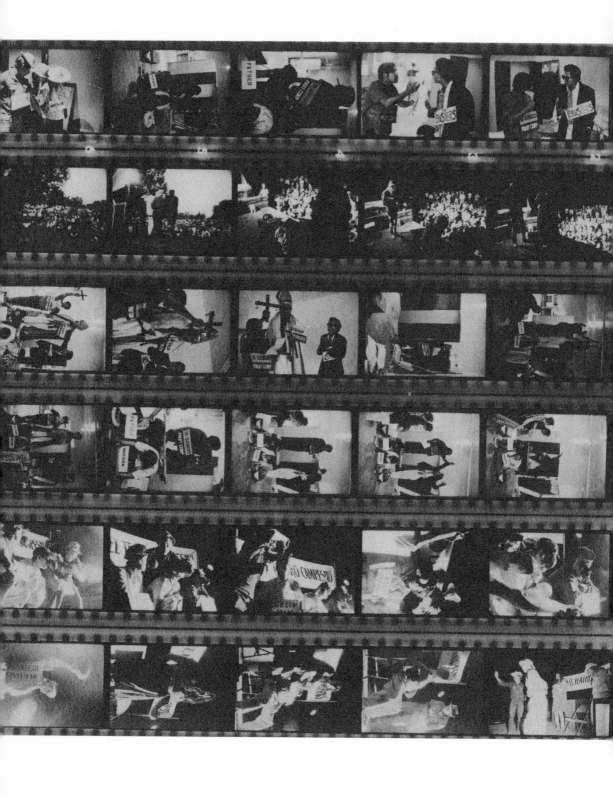

53. Prints

Swamped by requests for photographs, Lewis disappeared into the darkroom. He was not the sort to make fifty prints of the same scene just to get one that might be exhibition quality. Even if he had been so inclined, he could not have done it. Printing paper and chemicals were scarce.

Lewis took no position one way or another on the issue of straight versus manipulated prints. He also had his standards to uphold, as well as certain technical problems. His greatest technical problem was the extreme contrast between highlight and shadows caused by the harsh San Joaquin Valley sun. To get a decent print of a picture made under the midday sun Lewis had to "dodge and burn" his images the same way a conductor learns to move his hands and arms to direct a symphony. This meant standing hunched over his enlarging easel, fingers moving here and there, blocking light to one section, shading another, and adding more elsewhere. He was rarely happy with his output, although most of the recipients of his work were quite satisfied.[1]

Lewis loved the darkroom. The ritual was always the same. In total darkness, guided by the tips of his fingers, he threaded his exposed film around the stainless steel developing coils, carefully fitted it into the wire channels, then loaded four rolls into his tank. He then poured the developing chemicals inside, clamped one hand over the top, and inverted it to insure that the chemicals reached every nook and cranny inside the film

150. Jon Lewis contact sheet number 221 documenting El Teatro Campesino's acto ridiculing DiGiorgio. Summer 1966.

reels. Now he was on automatic. Every thirty seconds he agitated the tank so that the light-activated silver bromide crystals clustered, formed strands, and finally merged into living images of pure silver. The process took about seven minutes under "normal" conditions and required the utmost concentration.

With only the whir of a small vent fan, his mind wandered through the day's activities then settled on tomorrow's work. After the proper time, Lewis opened his developing tank, emptied the developer, and poured in fixer. Four minutes later the timer bell rang. Lewis dumped out the fixer, removed the top of the developing tank, injected some hypo eliminator, and thoroughly washed the film. Ten minutes later, he turned on the yellow safe light, carefully unwound the film from the wire reel, grabbed one end by the thumb and forefinger of his left hand, and removed any excess water by pulling it between the forefinger and index finger of his right hand. Most photographers had a special tool for this purpose. But supplies had always been tight. Lewis just used his fingers.

The roll of film was filled with scenes and faces from Sierra Vista. Holding it up to the light, Lewis concluded it was satisfactory—although he would not really know until he printed the full frames. With a wooden clothesline clip he attached the film to one of several overhead wires, added another clip to the bottom so that the film did not curl, washed his hands, tidied up, and flopped onto his bed. The film would not be dry for several hours. In an emergency when the union needed images ASAP, he might slap the damp film in the enlarger and make a print. But the procedure risked scratching the still-soft emulsion.[2]

On excessively hot days during the Sierra Vista election campaign, the film developer would often reach a temperature of ninety degrees. Normally a photographer would chill it down to sixty-eight degrees, since all of the various photographic processes hinged on calculations based on that temperature. But Lewis sometimes exploited the situation to quickly produce prints that the union required. He would load a single-reel developer tank with one roll of film, pour in the hot developer, and then stop development after one minute. Because this might cause problems with the film emulsion, Lewis never developed more than one roll of film, and sometimes portions of a roll, using this method.[3]

Now it was time to rest. Lewis was fast asleep within seconds. A few hours later his internal timer went off and he began printing. Normally he would make contact prints, examine them under a loupe or magnifying glass, and select certain frames for enlarging. But often he did not have time to make the contact prints, then wash, fix, and dry them before selecting an image for printing.

Lewis followed a procedure employed by daily news photographers operating under deadline pressures. Holding the raw negatives up to the yellow safelight, he

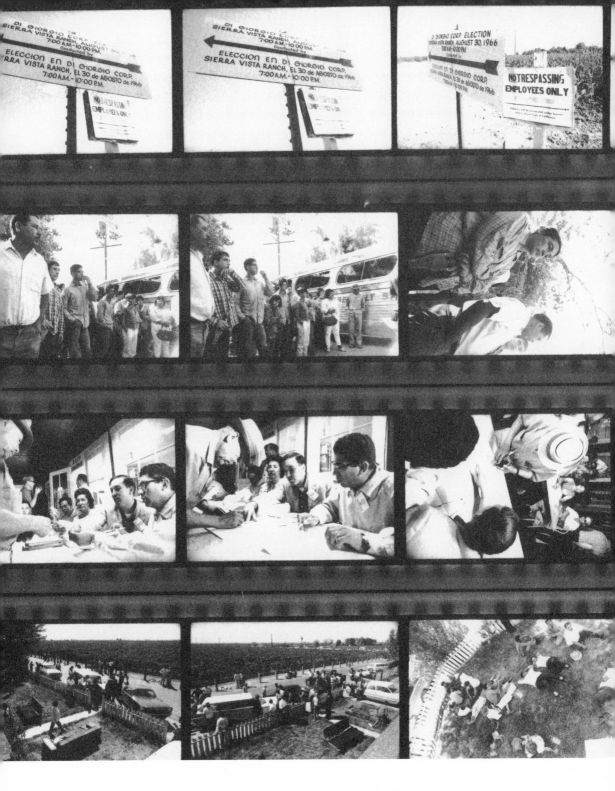

151. Twelve frames from Jon Lewis contact sheet number 252 documenting the August DiGiorgio election campaign. Summer 1966.

selected one, slapped it into the negative carrier, held the carrier at an angle under the enlarger lens, and used a bulb with a soft brush on the end to blow away any dust. He then placed the negative carrier in the lamp housing, set the aperture on the enlarging lens, switched off the darkroom lights, placed a piece of white paper on his enlarging easel, focused the image, and decided whether to crop it or print it full frame.

Lewis had carefully cut up many of his 8-by-10-inch pieces of printing paper into 1-by-8-inch test strips. Under the yellow glow of the safelight, he placed one test strip on his easel and centered it on a key part of the image. Setting the enlarging light timer on 30 seconds, he turned it on and pulled a piece of cardboard across the test strip, uncovering another section every 3 seconds. This yielded ten bands of exposures ranging from 30 seconds to 3 seconds.

Watching the test strip "come up" in the developing tray, Lewis looked for the area that best represented a full range of tones from bright gray to deep black. It was standard darkroom procedure, and sometimes it required a second test strip as Lewis dialed in and fine-tuned his exposure, then decided which areas of the image required burning (additional exposure) and dodging (holding back the light by placing fingers, cardboard, and various other devices between the enlarging lens and print paper).

Because he was operating on such a tight budget, Lewis seldom made more than two test prints. To save further on paper, he sometimes made 5-by-7-inch prints but preferred 8-by-10s. Remembering the information from his test strip, he darkened the lights, placed a full sheet of paper in his easel, tripped the timer, and made a final print. Lewis seldom altered his images. He was after only the best representation of sky, skin tones, and shadows. If the facts were accurate and the image was of consequence, the underlying emotional truth would emerge.

Early-morning shots sometimes benefitted from additional burning in order to darken the shadows. Lewis also spent considerable time burning in overexposed skies and cursing himself for not darkening them "in camera" by using a yellow filter on his camera lens. "Frankenstein shadows" that turned eye sockets into dark blobs under the midday sun also required considerable dodging, as did faces and skin tones, which Lewis achieved by means of an oval or round piece of cardboard held at the end of a long wire that he danced across the area in question in order to lighten the exposure. That was the extent of the manipulation he deemed permissible.

When the timer bell sounded, Lewis removed the paper from the easel and slid it into the developing tray, gently tipping one corner of the tray up and down to send fresh developer across the print. The black tones appeared first, then the mid-tones, and finally the whites of the eyes. Two minutes later, the image was ready. Lewis

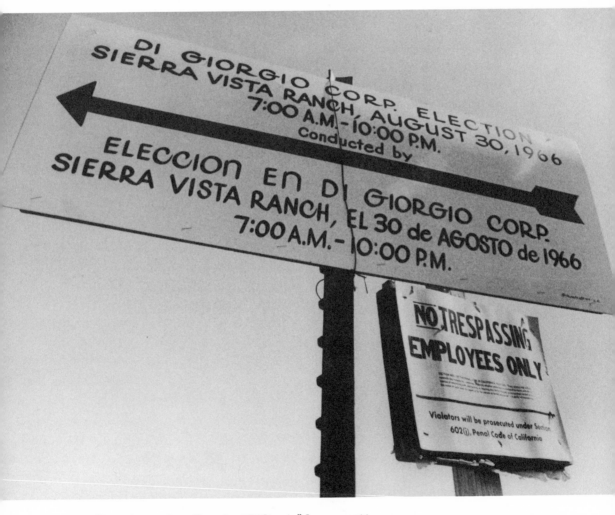

152. "Directions to the polling site at DiGiorgio." Summer 1966.

slid it into a tray of fixer, waited a minute, again agitating the tray to send fresh chemicals cross the print, then turned on the lights. After a quick evaluation he made a second print, if necessary, and placed the prints in a wash tray. After he had finished, he slipped the dry negatives into numbered glassine sleeves and walked the finished prints over to union headquarters. By then it was three or four in the morning. No one was around.

Output for the month of June was prodigious. In a memo "PRINTS SENT OUT — JUNE '66," Lewis gave the following account of one Sierra Vista printing marathon:

48 8×10s Alex Hoffman — injunction
100 8×10s boycott mailing
50 assorted prints 10° display panel
10 8×10s Denver
3 8×10s Los Angeles
17 8×10s Wash., DC
8 8×10s movement filmstrip
10–15 8×10s El Malcriado

REQUESTS PENDING
150 8×10s boycott mailing
10 8×10s Nat. Students Assoc.
6 8×10s ACLU Berkeley
20 11×14s L.A. Boycott[4]

In the quiet early-morning hours Lewis sat down at a spare typewriter and composed captions. He was usually too tired to do much more than a who, what, where, when, and why identification. If he was lucky, he might grab an hour or two of sleep. Then it was out into the stinging heat of another blistering day.

153. "DiGiorgio strikebreakers would often retreat into the vineyard to get away from the picket line. Here one approached us to accept a strike leaflet." Summer 1966.

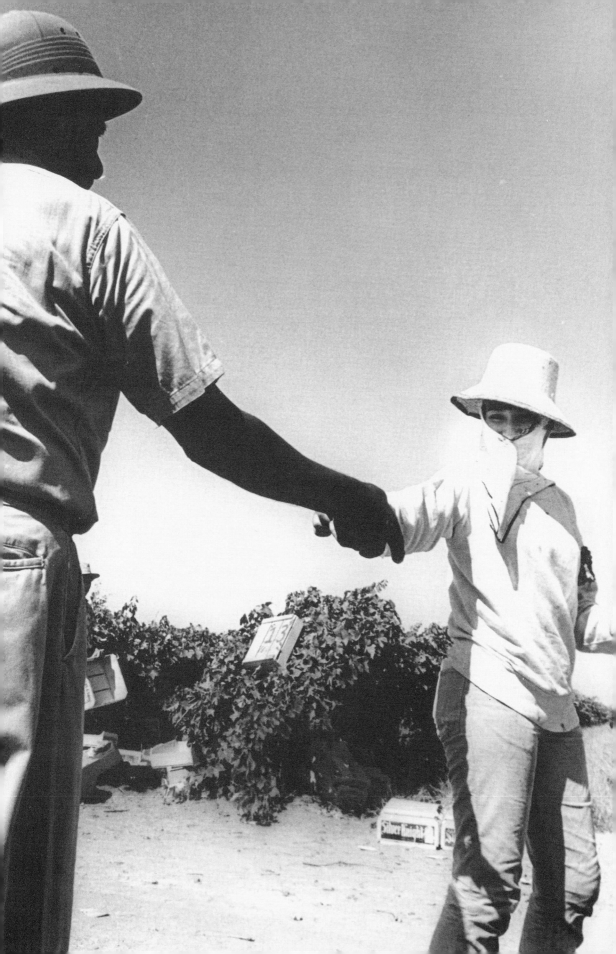

54. Violence

From July 18 until August 30, Lewis concentrated on the struggle at Sierra Vista. He spent most of his time with Fred Ross and team of twenty-five farmworkers, five Anglo volunteers, and two former DiGiorgio employees, Joe Serda and Ophelia Diaz. Within less than six weeks, the NFWA team had to identify, recruit, and develop leaders among the seven hundred employees currently eligible to vote at DiGiorgio.

It was no easy task, given the authority that DiGiorgio exerted over Sierra Vista Ranch employees eight hours of every day. This task became even more difficult after July 18, when DiGiorgio violated pre-election rules and laid off 190 workers, among them a group of 20 "submarines" whom the NFWA had planted among the field hands. Company personnel manager Dick Myer claimed it was a routine layoff, but Lewis saw it as just a way to stack the vote.[1]

To accomplish its goal, the NFWA team met three times a day to plan strategy, train volunteers, and evaluate progress. Lewis was there every morning when Ross and his volunteers swarmed around the Sierra Vista Ranch gates to hand out *El Mosquito Zumbador* (The Buzzing Mosquito). Featuring hilarious Andy Zermeño cartoons that transformed DiGiorgio into an ugly, voracious, farmworker-devouring octopus and Teamsters into slobbering, gap-toothed monsters, *El Mosquito Zumbador* also presented high-paying Schenley pay stubs (noting that the contract also included a hiring hall, medical plan, grievance procedure, and seniority system) side by side with those of workers earning less under a Teamster contract at Bud Antle lettuce. After the leafleting at the DiGiorgio gate, Lewis tagged along for the 8 a.m. meeting in the Pink House, where tactics were discussed and organizers departed for their daily assignments.[2]

At noon, Lewis followed NFWA organizers into the six DiGiorgio farm labor camps. Workers commonly referred to them as the Mexican, Filipino, Anglo, Puerto Rican, Black, and Women's camps. Organizers worked the camps for an hour during the lunch break and returned again for an hour in the evening. The noon visits

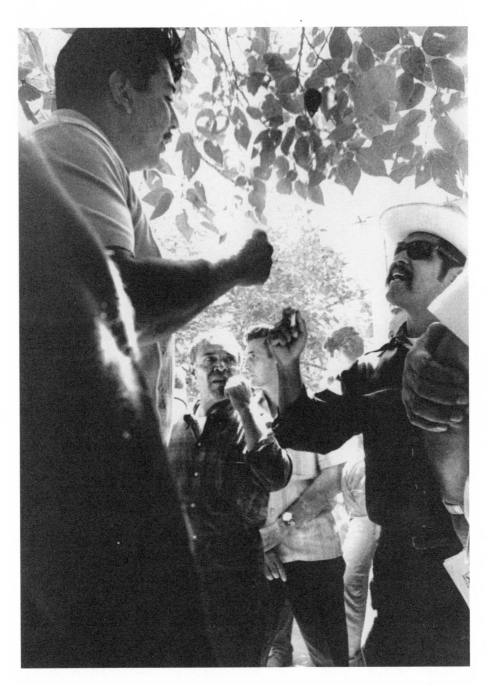

154. "Luís Valdéz standing toe to toe with Art Chavarria, head Teamster organizer for the election campaign at DiGiorgio. Later, a Teamster goon walked up and with no warning, hit Valdéz in the face with a beer can, shouting 'Communista,' as Luís had traveled to Cuba. His response was 'Is this the kind of union you want?" Later he wrote the song: 'Chavarria, el perico, hijo del patron ['Chavarria the parrot, the boss's little boy']. Revenge is much sweeter served cold and before a meeting of union members." Summer 1966.

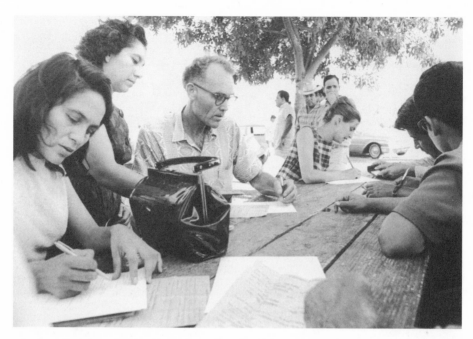

155. "I never did get much of Dolores with Fred Ross. Here they compile voter eligibility lists for the DiGiorgio election. Assisting at the table is Jane Brown, summer student volunteer, who stayed some three years." Summer 1966.

soon escalated into verbal confrontations that frequently led to shoving matches and fistfights.

Both the Teamsters and NFWA saturated the camps with organizers. Ross sometimes sent as many as twenty-five NFWA members into the camps, even though election rules permitted no more than seven organizers during lunch and five in the evening. Lewis hung back and became inconspicuous while photographing the organizing activities. He had to get the shots without scaring workers already suspicious of everyone.

Most of the action occurred around the bullring at the Mexican camp, where everyone gathered for meals. At the center of the bullring action was Art Chavarria. Stout and smelling heavily of shaving lotion, Chavarria sported a thin mustache and a crow's nest of black hair topping an almond-shaped cranium. He had a deeply obscene laugh and an ability to talk nonstop and ridicule anyone. All of the NFWA organizers detested him.

Chavarria maintained a barrage of taunts and insults. He yelled into a hand-held microphone that transmitted to a loudspeaker mounted on top of his Teamster van. Luís Valdéz would take a bullhorn in hand and counter Chavarria's taunts with clever banter. Chavarria would accuse the NFWA of being "commies." Valdez would respond

with carefully enunciated words to the effect that Chavarria was an ape, and by holding up copies of *The Enemy Within*, Robert Kennedy's exposé of Teamster corruption.[3]

Following the noon confrontations, Lewis returned to the Pink House to record debriefings and gulp down a meal. While organizers rested, he went into the darkroom to develop film and make prints. At the same time he had to follow the day's events, whatever famous person was passing through, and any occasion when César gave a speech or talked to a group of volunteers.

Around 5 p.m. Lewis emerged from the darkroom just in time to photograph Ross planning the evening's strategy. His images record Ross developing a voter eligibility precinct list consisting of 3-by-5-inch cards holding relevant information on each person on the list. Ross was tracking down every single person on the list. NFWA organizers had to locate and interview every one of them, and then record whether or not they intended to vote for or against the NFWA. Every afternoon, an organizer reviewed this information, tallied a preliminary vote, and offered advice on whom to speak with again.

On alternate days, Lewis followed Huerta, Padilla, Valdéz, and other organizers back to the camps and accompanied Mario Bustos, Pete Cardenas, Eliseo Medina, Ruth Trujillo, and Alice Tapia as they visited local workers who lived in Delano.[4]

Lewis was especially impressed by Fred Ross. He recalled that

Ross had it down to a science. He would review everything before the organizers left. No one ever left the Pink House without those index cards. Boy, you had better not lose one. Then they would return and Ross would analyze the results. When I went to bed, they would still be there writing reports and developing strategy. "This guy is soft, visit him again. This guy won't budge, no use. These people are solid with the NFWA. This guy is Teamster. And so on." It was inspiring. Ross was counting the votes. Medina and those organizers were real good. They knew that supporting the NFWA subjected people to reprisals and that it was far easier to go with the Teamsters. They were patient. They sold the NFWA as a way to express anger over years of mistreatment and as a way to make lasting changes.[5]

Lewis thought the Teamsters were gangsters. Unlike the NFWA, which was out in the community pounding the pavement, driving to neighboring towns, and actually meeting people and talking to them, the Teamsters did little more than shout and threaten. Lewis seldom saw them in the community. He thought they were lazy. He recalled how

[William] Grami had a suite of rooms over at the Stardust Motel, the only decent place in town. The Teamsters had an office downtown on Main Street. But nothing

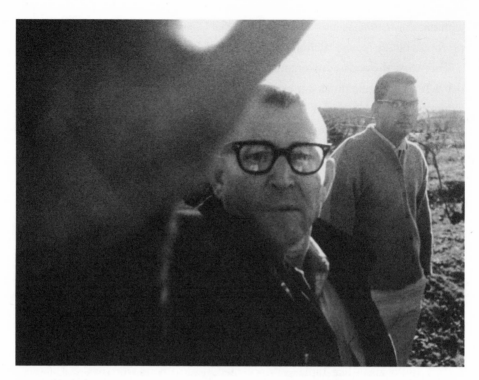

156. "DiGiorgio security guard Hershel Nuñez slaps the camera. Of course I was trespassing and attempting to take a picture in his face as he ordered me off the property. No combat wounds but the reflexes functioned under fire." Summer 1966.

ever happened there. There were between six and ten of them. They had come to Delano from all over the place, some as far away as Texas. They all drove new cars. I remember a Cadillac and a T-bird. They liked to hang out at the pool and drink beer. When you saw them there you just broke out laughing. They were all pink and red where they had not been covered by a shirt. The rest of their bodies were bright white. It was as if you had splashed their heads and dipped their arms up to their shoulders in pink paint. They had a secretary who answered the telephone in their Main Street office, but I don't think she ever had much work. The place was mostly a mail drop and for show. Their organizing—such as it was—consisted of waiting for DiGiorgio's supervisors to intimidate workers into voting for the Teamsters. Their pitch was that a vote for the Teamsters was a vote that pleased the company. They seemed to think that their big boots and nice clothes and Teamster jackets and big cars would somehow impress the poor farmworkers. They tried to buy votes with trinkets and boxes of canned fruit. I found them repugnant.[6]

As he rotated between harvest work and the picket lines, Lewis encountered increasingly angry and violent company foremen. The election had entered a phase which

the writer John Gregory Dunne compared to the trench warfare of World War I — full of feints, charges, counterattacks, and retreats — with neither side making headway.

Often caught in the middle of these confrontations, Lewis recorded strikebreakers running the gauntlet and company security guards racing up and down access roads, kicking up dust clouds that sent everyone sprawling, all within clear view of police and deputy sheriffs, who seldom intervened. Fistfights and shoving matches became so common that Lewis inevitably became a target.

One day Lewis was trespassing at Sierra Vista when security guard Herschel Nuñez began shouting orders to stop and leave the property. When Lewis ignored him, Nuñez slapped at Lewis's camera, and then attempted to rip his camera away.

Of the incident Lewis recalled:

> Nuñez never got to me. I was too quick. But I got a picture of him trying to block my way. I never really got my ass kicked like some other photographers before and after me. I was scared some of the time. There were some mean SOB's out there. There were some rednecks. Working with the union and packing a camera, you're a visible target. Plus you're a college student, or an outside agitator, someone who's suspicious. You did not look like the strikers. You stood out and were immediately recognized. You stayed on the other side of town, on the other side of the tracks. You had to be careful. You didn't want to be caught in a dark alley with some of those guys around Delano.[7]

By being ever-present, Lewis amassed a large and dramatic portfolio — which no one saw. He photographed all of the leaders of the grape strike, the famous and the less known, and created an inside view of activities at NFWA headquarters and at the Pink House and Gray House. He photographed in the bars and on the picket lines and on La Peregrinación. He studied labor in the fields and recorded men kicked out of labor camps for union activity. He photographed violent and nonviolent protest. Never in the annals of American photography had someone burrowed so deeply into a farm labor strike.

But as a freelancer who lacked connections and backing, Lewis continued to suffer the fate of so many others before and after. Largely shut out of the major news outlets, he was pushed aside in favor of photo agency and newspaper staff photographers. Fellow union members continued to use his images to energize volunteers, illustrate brochures, and make more vivid the articles appearing in *El Malcriado*. But to mainstream news outlets, as well as newspaper and magazine editors, Lewis was just a scruffy radical. As an outsider, the best that he could do was keep the radical, labor, and church publications supplied with images. "We considered ourselves lucky every time our work was published," he recalled.[8]

55. Chavarria

Nothing more clearly illustrated how far Lewis had moved away from the journalistic mainstream than what happened when *The Saturday Evening Post* decided to illustrate John Gregory Dunne's essay on the grape strike. Rather than contacting Lewis or another Delano freelancer familiar with the NFWA, the editors chose Berkeley photographer Ted Streshinsky.

A man of boundless energy and endless curiosity, the one-time U.C. Berkeley doctoral candidate in history had completed many assignments on agriculture and seemed a logical choice. *Post* editors sent him to Delano the day after he married his wife, Shirley, in a San Francisco City Hall ceremony.

Never jealous of others or protective of his own work, Lewis took Streshinsky under his wing. He taught Streshinsky how to deal with increasingly nasty police and sheriff's deputies, accompanied him to the picket lines, introduced him to union members, and in the evenings, emptied his pockets to share a beer and a game of pool with Streshinsky and his wife at People's Bar.[1]

Out on the picket lines at Sierra Vista one day, Lewis and Streshinsky tailed a van full of Teamsters to the edge of an orchard. The intense and bitter campaign at DiGiorgio had by now escalated and included massive amounts of visual and written material, including Teamster Union leaflets asserting that the NFWA was a "communist front." To counter that image, the Communications Workers of America (CWA) issued a pamphlet, *A Family Portrait*, which contained portraits of Teamster union organizers and their alleged links to gangsters. And the seafarers union sent in a few enforcers to watch over the Teamsters.[2]

Lewis was wary and careful. When Dunne introduced himself and extended a hand, Lewis thought Dunne was a Teamster and jammed his hand in his pocket.

"Are you a Teamster?" Lewis snarled.

"I don't have enough handshakes to pass any out to Teamsters."[3]

One sweltering hot day late in mid-August a large group of strikebreakers was reclining under the shade of some peach trees near the bullpen at the Sierra Vista

157. "My 'buddy' Art Chavarria, head Teamster organizer for the DiGiorgio election in summer 1966. I was a pretty easy target for verbal abuse, and we had some jocular exchanges. I was carrying a baseball bat around evenings. Especially after giving him a set of fangs in the darkroom. Valdéz ridiculed him in many actos." Summer 1966.

158. "'Teamsters are turds' photograph, version with organizers placed in a trash can 'where we belong on election day.'" Summer 1966.

Mexican camp. Chavarria was doing his usual tricks. Lewis had already tangled with Chavarria and photographed him several times. That evening while developing film in his darkroom, Lewis found a picture of Chavarria and went to work manipulating it. He bent the photographic paper in such a way that Chavarria's smile was distorted to look like a snarling mouth full of fangs. After making dozens of small prints, he scattered them around a befouled toilet on the picket line. Lewis then photographed the scene, made several sets of prints, and distributed them out on the picket line. Fred Ross did his best to further provoke Chavarria by walking over to his van and showing him the picture. If Chavarria was offended, he never admitted it.[4]

A few days later, Chavarria continued his obnoxious ways. One day he spotted a college girl speaking with a union organizer standing beside Lewis and launched into an intimidating harangue.

"Hey, honey," he yelled into a microphone. "What do you want to talk to the Vietcong for?"[5]

It was common form of attack linking union members to subversive organizations and enemies. Label the NFWA as inferior or disloyal or somehow defective, and you could justify just about anything from violence to verbal insults.

Chavarria spent most the time accusing anyone associated with NFWA of being a disloyal or subversive radical in league with Fidel Castro and the Communist Party. Holding a Citizens for Facts pamphlet, he accused CMM Reverend Wayne Hartmire of being a "former convict" because he had once been arrested during a civil rights demonstration. Luís Valdéz, he often said, was "Castro's emissary to Chávez."[6]

Shortly after ridiculing the college girl, Chavarria spotted Lewis snapping pictures. "I'm easygoing, baby," he said, "but I just hope you try to take a picture of me the day after tomorrow [when the Teamsters would supposedly win the election at DiGiorgio]. I'm much better looking than those ugly Chavistas."[7]

Lewis intensely disliked Chavarria. Although quiet by nature, he could not resist the urge to give Chavarria an earful.

"That's right, Art, you just keep talking. You take a good picture. I like to photograph ugly men. You are the ugliest man I have ever seen, and I'm not just talking about your face."[8]

"We're going to win tomorrow," Chavarria replied. "And we're going to celebrate. Have some beer. You like beer? I know you like beer. That's the nice part of being with the Teamsters. We're not going to cuss you. We're going to say, 'Good morning, ladies. Good morning, gents.'"

"You just go on believing that, Art," shot back Lewis, taking another picture.

"Fat chance."[9]

"I notice you're the only one here with a Japanese camera," Chavarria replied. "You're not even a good American."

"And you are?" asked Lewis.[10]

Chavarria narrowed his eyes. His face contorted into a sneer. Lewis had seen that sneer many times before, usually just preceding a riot. All of the Teamsters sneered and scowled. They seemed contemptuous of dialogue and did not like people talking back. They were used to getting their way. Lewis had never encountered a more obnoxious bunch.

Launching into one of his insulting monologues, Chavarria fixed on Lewis's six-month-old beard. The Teamsters seemed to hate anyone with a beard.

"Hey, baby, I was a barber once," he said. "You need a shave. I'll give it to you. Real close. But you never know. The blade might slip around your neck. Then, oh, oh, one less commie."[11]

159. "Fred Ross irks a Teamster organizer replete with gold neck chains during the organizing drive for the election at DiGiorgio." Summer 1966.

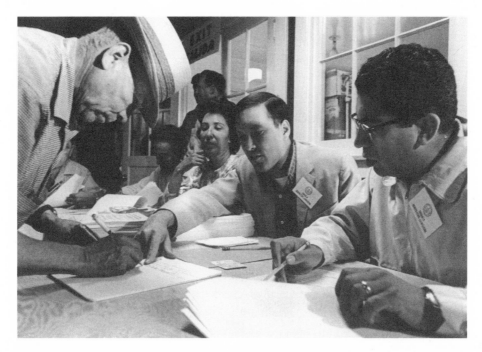

160. "A worker establishes his right to vote in the August 30 DiGiorgio election. They would truck in field crews working that day, plus there were people who came from as far as Texas to vote. Our first Schenley contract was handed us in a backroom deal with lawyers. The DiGiorgio contract was earned." Summer 1966.

With that, Chavarria pinched off his nose with his thumb and index finger.

"Baby, I don't mind you taking my picture," he added. "But you smell. You stink to high heaven. You take my picture; you stand down wind, where I can't smell you. I'll tell you what. You go stand downwind and I'll get you some of that stuff you squeeze under your arm. It's called deodorant. De-Ode-Dore-Ent. It's pretty good stuff. Ever hear of it? It gives one-day protection. You need it. You need it bad."[12]

Lewis brushed off the insults. They did not have suitable bathing and washing facilities, and, as Lewis recalled, "we probably did start to stink around noon in that heat."[13] He was used to the insults.

Two Teamster organizers standing nearby began eying him.

"Why don't you just bust him in the chops with that mic, Chavarria," said one.

"That's right," added the other Teamster.

"Jam it right in his mush. Make him choke on it."[14]

Lewis took it in stride. Insults and threats were all in a day's work. They came with the territory. He had heard worse, much worse.

56. Rallies

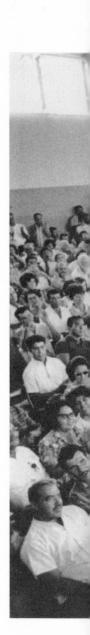

Many nights Lewis returned to the West Side of Delano for rallies at the Filipino Hall. By now he knew the Hall well. He recalled:

> I would have my breakfast and other meals there most days. AWOC had plenty of money and they put a lot of it into feeding the pickets. You might get a buttered taco over at the NFWA kitchen, where the food varied with contributions. But at Filipino Hall they served up platters of *lumpia* and delicious *adobo* dishes and plenty of rice. There were always steaming cauldrons of rice and hot coffee ready for anyone who walked in. That's where I met the Filipinos. Before the strike the Filipinos and Mexicans didn't really mix. There was even some hostility between them. They worked on different crews and lived in separate camps. We got to know one another at the Hall.[1]

Hot, humid, and uncomfortable, the Hall crackled with excitement and anticipation. Farmworkers spilled out the front doors onto the sidewalk. Barely able to move and sweating bullets, Lewis found the poorly lit Hall a difficult place to photograph.

Although Lewis had a strobe, he seldom used it. He hated the direct light and harsh shadows of photographs lit by an on-camera flash. Lewis often photographed indoors by holding his strobe with one hand, off to the side, while shooting his old Nikon F camera with the free hand, or occasionally resting it on a tripod. Because it was so awkward, Lewis shot most Filipino Hall events with available light.

161. "The Sunday rally at Delano's National Guard armory prior to the DiGiorgio election. A huge crowd, much enthusiasm, and the expectation of victory in the week ahead." Summer 1966.

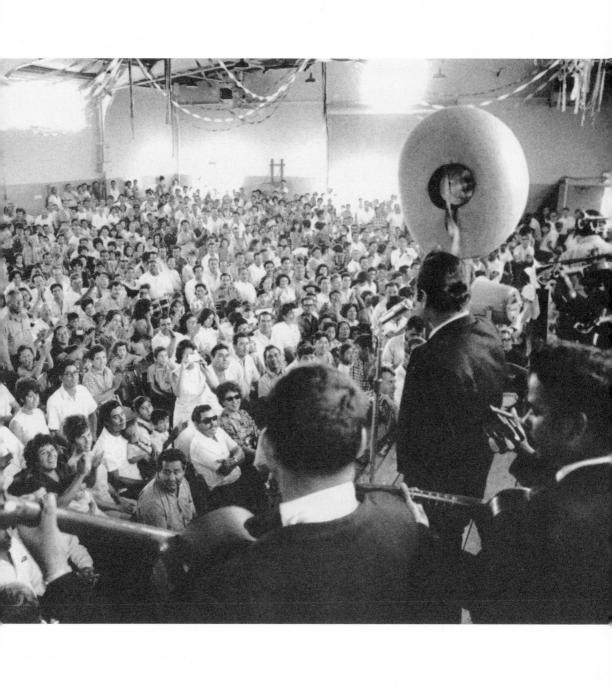

Of his photography inside the Hall, Lewis recalled:

My old Nikon F did not have through-the-lens light metering. It was always a crapshoot. I had a little hand-held meter that I used sometimes, but it was no help indoors. By then I had done enough photography inside that hall to know the lighting and exposures. I would just slow the shutter speed way down and open the lens up and hope for the best. It was the old "f.8 and be there at a sixtieth of a second" technique. I could do it in the dark, make the setting with my eyes closed. Any photographer worth his salt could. Sometimes my negatives were a bit thin and I had to compensate for it in the darkroom. But my photography did not depend on tonal qualities. I was always trying to take good pictures. My work was about content.[2]

Lewis missed few shots that evening or any other evening at Filipino Hall. He photographed the smiling faces of farmworkers cracking up at a bawdy Teatro Campesino skit in which a DiGiorgio character — wearing a sign, dark sunglasses, and smoking an oversized cigar — leaped on the stage to be booed and hooted down by the audience as he blustered and guffawed and threatened everyone until an actor dressed as Governor Brown arrived and began shouting "strike, strike" in Spanish, only to be dragged off the stage by horrified DiGiorgio employees. Lewis continued to record the faces of children watching a dramatic 1930s-era film on migratory farmworkers. Then he stopped.

For the next fifteen minutes, Lewis put down his camera and watched a remark-able film made by his predecessors thirty years earlier — one frame after another of farm labor camps, Okies in overloaded "flivvers" heading west from the Dust Bowl states, emaciated children, gaunt women, defeated men seated at soup kitchens, and families packed into torn and tattered tents. Shots of happy, well-fed people attending the 1933 World's Fair celebrating a "Century of Progress" were especially powerful. One scene in particular lodged in his mind. Toward the end of the docu-mentary the camera cut away from hoboes in a jungle camp and fixed on a famous billboard of the times that proclaimed: "There's no way like the American way."

The images did not seem that far from what he encountered around Delano. Lewis had no way of knowing that the film had been made by Hansel Mieth Hagel and her husband Otto. Lewis had encountered Hansel while photographing La Peregrinación on the steps of the state capitol.

Lewis was not the first photographer to cover farm labor, and he would not be the last. For generations, farmworkers had been struggling to form a union. For at least three decades photographers had been part of the story. Leaving Filipino Hall that evening, Lewis understood his place in history.[3]

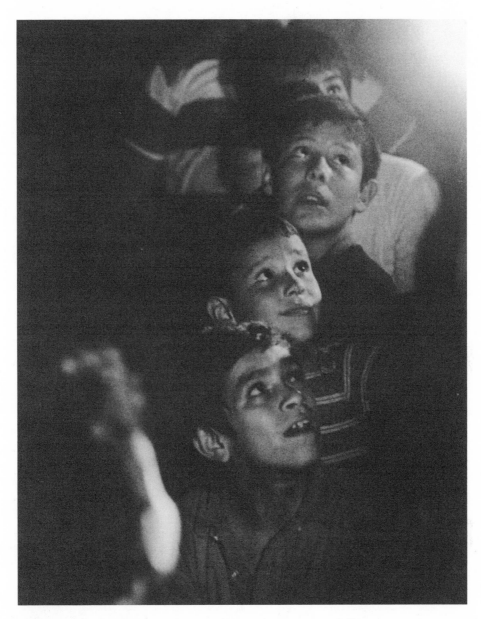

162. "Sons of farmworkers in rapt attention during the DiGiorgio rally." Summer 1966.

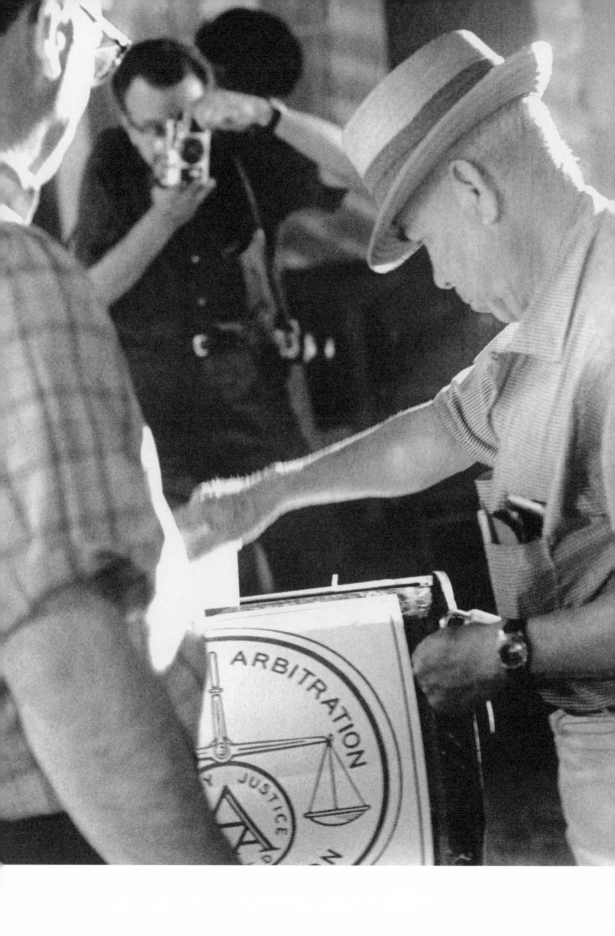

57. Voting

Lewis did not sleep the night before the election. There was just too much to worry about.

Voting at Sierra Vista was scheduled to begin at 7 a.m. on August 30. Two elections were going to be held, one for the shed workers, another for field hands. Radio announcements explained the importance of the election. A food caravan delivered ten tons of supplies from Sacramento for all the voters who would be arriving in Delano. A huge NFWA-AWOC unity fiesta drew 2,500 people and over $5,000 in contributions from supporters around the state. More importantly, it announced the merger of AWOC and the NFWA into the United Farm Workers Organizing Committee, an AFL-CIO affiliated union.[1]

Robert DiGiorgio was jumping into the fray with both feet. He told reporters that he would sell Sierra Vista if Chávez won the election. Then he wrote a public letter urging farmworkers not to vote for "no union," which would only help the NFWA, and to vote for the Teamsters. A California Senate Agriculture Committee hearing in Delano had tarred Saul Alinsky as the radical behind the strike and had summoned Mickey Lima, head of the California Communist Party, in an effort to further link farmworker organizing to communist tactics. On August 21 the Teamsters, now calling themselves "La Union de Agricultura," held their own rally and invited DiGiorgio workers for a Sunday full of "food, fun, and fellowship." Jimmy the Greek, a well-known odds-maker, was betting three to one against the NFWA. Even Saul Alinsky had his doubts.[2]

Lewis was equally unsure how all of this would play out. The stakes were monumental. The election was going to make or break the farmworker movement. The repercussions were going to reverberate for decades. Lewis was going to be there both to record the outcome and to assure that everything went fairly.

163. "Casting a ballot in the August 30 DiGiorgio election. That's Ted Streshinsky out of focus in the background, shooting available light as well. Hope his negatives were sharper than mine." Summer 1966.

When the first picket car left the Pink House at 5 a.m., Lewis was ready and grabbed a ride. He recalled how Sierra Vista that morning reminded him of a scene along Main Street in a small village awaiting the arrival of a circus:

All of the polling booths were decked out in red and white and blue curtains. There were workers all over the place, just waiting to vote. It was not a tense atmosphere. Everyone was excited. We all knew that we were witnessing a turning point in history. Nothing like this — a union representation election — had ever occurred anywhere in agriculture. I was not going to miss anything. One of my first shots was a wide view of the Sierra Vista complex, with hundreds of farmworkers lined up, cameramen in the street, the Virgin of Guadalupe shrine in the center.[3]

About eighteen hundred farmworkers were going to vote. Half of them were at that very moment employed picking grapes in DiGiorgio's vineyards. The others were eligible to vote because at some point during the year they had worked at Sierra Vista. Photographers — anyone with a camera, anyone calling themselves a reporter — could not mix with the voters. Lewis had to remain about a hundred feet away in a roped-off section. Nearby was Harry Bernstein, the veteran *Los Angeles Times* reporter. Even though Bernstein was reporting that the NFWA would probably lose, his dispatches had so infuriated DiGiorgio's attorneys that upon seeing him they accused him of being a NFWA member.[4]

Lewis was sure that most of the harvest workers would vote for a union. Organizers had been talking to them. Recalling how NFWA members went about their task, Lewis stressed that

they knew them on a first-name basis. When I left for Sierra Vista that morning, the streets around union headquarters and the other NFWA buildings were already clogged with cars. NFWA had urged all of its members to report before voting. César and the other leaders pretty much knew how many votes they had among the workers employed at that time. They were checking each man on a list and then putting him in a car and driving them to Sierra Vista. The question on everyone's mind was what the other workers would do. NFWA needed a good portion of the votes of workers who were no longer employed at Sierra Vista. Inside the Albany Street office, NFWA had a huge map of Wasco, Earlimart, Pixley, and Porterville. There were tacks and marks for street addresses of voters in every one of those towns. A lot of NFWA members were assigned to meet, feed, lodge, and help workers arriving from far and wide, some even from Mexico. Fred Ross and his team had created a dragnet. That's what Ross called

it. A dragnet. They knew that almost all of the one thousand DiGiorgio workers who were eligible to vote had left Delano. A lot of them had signed cards with NFWA. They tracked down and contacted every single worker who had ever been employed at DiGiorgio. People with addresses in Texas and Juarez, Mexico. They persuaded them to return.[5]

As Lewis went to work, several women from Citizens for Facts snapped his picture and asked writer John Gregory Dunne for his name. Lewis ignored them. He watched reporter Terry Drinkwater telling viewers of the CBS Evening News that all signs pointed to a Teamster victory. As Drinkwater finished, someone shouted that he ought to spend more time researching his reports because he had really flubbed this one.

Voting began at 6 a.m. With lawyers and reporters milling about, Lewis switched back and forth between using a medium telephoto lens to explore the voting area and a wide-angle lens to record the larger scene. When much of the press tired and wilted in the sun, then began to dissipate, Lewis stayed put. He watched Streshinsky and Dunne leave for Teamsters headquarters. He would later learn that the trip had been a bust. They encountered a lone secretary who was filing her nails.[6]

Lewis spent the rest of the day at Sierra Vista. He refused to leave until 8 p.m., when officials from the American Arbitration Association collected and sealed the ballot boxes, loaded them into waiting California Highway Patrol cruisers, and transported them along with NFWA, Teamster, and DiGiorgio observers to San Francisco, where the votes would be tabulated under state supervision.

After a quick nap, Lewis rose early to develop his film and make prints. The next day no one was on the picket lines. Everyone congregated at the Albany Street headquarters, awaiting the election results.

As expected, the Teamsters won the vote of the shed workers, 97 to 45, with 12 ballots choosing "no union." But in the first certified election for a union among field workers, NFWA won 60 percent of the vote — 530 to 331, with 7 votes for "no union."

When the American Arbitration Association analyzed the ballots it discovered that 513 votes for the NFWA came from workers no longer employed at DiGiorgio. Ross and his crew had saved the union. Businesses in Delano closed for "a day of mourning."[7]

Lewis would never forget the scene at Filipino Hall. He recalled:

It was pure joy. People were yelling and shouting. People were tossing their hands in the air, yelling in English and Spanish. People were singing, dancing around. Even the most stoic NFWA members were throwing paper into the air, hugging

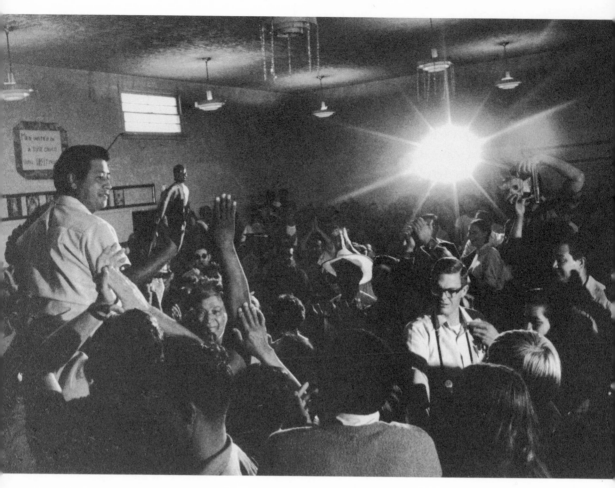

164. "The day after the DiGiorgio election [August 30] the ballots were counted in San Francisco, while union members assembled in the Filipino Hall to await the result. When the results came in, pandemonium broke out. Here the workers have lifted Chávez onto their shoulders. It was a great moment. I don't know who has raised the camera in a vertical composition [right center]. The photographer lower right missed the shot." Summer 1966.

one another, just delirious. That night, when everyone gathered at Filipino Hall, it was complete pandemonium. It was nothing but "Viva la Huelga." "Viva la Causa." "Viva César Chávez." We were delirious with joy. No one had the foggiest idea what to do next. But everyone knew that something had radically changed.[8]

At the end of the evening, Lewis photographed Chávez addressing the audience. *Click!* Chávez with his hands in his pockets and a wry smile on his face. *Click!* Chávez waiting for the applause to stop. *Click!* Chávez promising more victories to come.

What Lewis most cherished was not the sequence on Chávez, but rather the portraits he made of workers speaking about the victory — an old woman with no teeth, men with wrinkled faces and dirt under their fingernails. They spoke from the heart — slowly and powerfully. Lewis caught their pride and sense of accomplishment. Those pictures captured La Causa.

As he put down his camera, Lewis wondered what the future held. He thought,

Chávez just squeezed by. He and his staff had been clever. They had beaten the Teamsters and the growers. It had been a miracle, but they did it. It was really hard to believe. Now the NFWA had a whole new cadre of leaders. If this Huelga thing survived, it would not be by mimicking the building trades unions. It would be something different, a movement that picked up momentum by registering voters, wielding political power, tapping into the power of the tens of thousands of disenfranchised farmworkers who still had no idea who Chávez was or what had happened at Delano. The fight had only just begun.[9]

58. August

What Lewis did during his first seven months in Delano was in many ways comparable to what photographers accomplished during the darkest moments of the civil rights movement. He had lived through the cold winter, the hot days of summer, into the fall victories. He had participated in the greatest protest in California history. He had recorded the first union election won by farmworkers. He had observed and documented a Mexican American march that paralleled the great civil rights marches. He had been there when the NFWA affiliated with the AFL-CIO as the UFWOC. He had been in the middle of it all, seen it up close, not as an outsider but as part of the movement.[1]

Throughout his Delano sojourn, Lewis had kept his eye on the action, emphasizing strength, not squalor. He had lived in a town full of paranoia, suspicious of outsiders, unable to understand strike demands that went beyond dollars and cents, a town so angry with the role that priests were playing in the movement that it was threatening to boycott the Catholic Church. He had lent his body to the cause — as a picket and a photographer, and at other times as a construction worker and writer. He believed that farmworkers were challenging a way of life in the same way that African Americans were challenging what many southerners regarded as God-given rights under the Jim Crow system. How any of this would turn out was anybody's guess. Many were saying everybody would lose, that Delano had been permanently damaged, that you could not organize farmworkers, that the strike was an aberration.

Out on the picket lines following the victory at DiGiorgio, Lewis found the routine becoming immutable and deadening. He had ridden in every one of the fifteen or twenty late-1950s automobiles that transported NFWA members to the vineyards. He knew all of the pickets, the old men in ragged straw hats, the younger picket captains, the teenagers, and the college girls in white blouses and pigtails. He had pushed stalled cars, washed windshields plastered in dust, and covered thousands of miles of the surrounding countryside. He knew many Kern and Tulare County

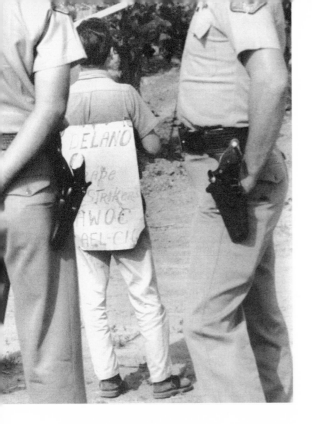

165. "The police were a constant presence on the picket line, but by the time I got there in the fourth month of the strike the harassment had abated. I never did witness an arrest or altercation, and some officers were sometimes friendly." Summer 1966.

deputy sheriffs by their first names. He had met John Gregory Dunne, then writing the magazine article that would become *Delano*, and his wife, Joan Didion, a Valley native herself. Lewis recalled her wearing a red dress to the picket lines and "looking like she was going to melt."[2]

Lewis especially loathed a huge, black Tulare county deputy sheriff, J. O. Webb. The deputy despised all strikers, especially the volunteers, and Lewis in particular. Webb carried a little plastic instamatic camera and was always trying to photograph Lewis. When Streshinsky accompanied Dunne out to the picket lines, Webb summoned Streshinsky to his side.

"You see that guy with the beard and camera," he said referring to Lewis.

"How about getting a picture of him for me. Every time I try, he turns his head."

Streshinsky refused.

Webb eventually got his picture, which he filed along with thousands of others in the huge database of images pasted to file cards maintained by the Tulare and Kern County sheriff's departments.[3]

Lewis stuck it out through early September. When NFWA set up a camp across from the county dump on the far western edge of Delano, Lewis was there documenting strikers repairing their battered automobiles. To reach the undercarriage they would descend into a pit dug into the ground, no fun on a hot day when they had to change the oil or lube an old car.

59. People's

Between stints on the picket line, Lewis photographed Chávez speaking to volunteers seated on an old grandstand at what had once been a cock-fighting ring, and Peggy McGivern and other volunteer nurses and doctors dispensing medical care to strikers and their families in a nearby trailer. On one occasion, he trained his camera on a weathered and sagging fence on which two slogans were whitewashed in bold letters: "Viva Pancho Villa!" shouted one slogan. "Juarez, Zapata, and Chávez," asserted another. It would become an icon of the strike.

Each day, Lewis scrutinized the union mess hall. A stark building that John Gregory Dunne described as resembling a "hash house on some sweltering, godforsaken back road," the mess hall was often filled with families, bachelor strikers, old men, and other volunteers. Seated at stools at the long mess hall counter they received eggs and beans shoveled onto plates by overworked volunteers.[1]

Lewis was especially attentive to chronicling the incessant work of volunteers unloading cars and trucks full of donations and the lengths to which union members went to stretch every piece of food as far as it would go. On spare afternoons,

166. "All volunteers recall fondly People's Bar on Friday evening after the meeting where we got our $5 [picket's pay]. That's Ann [unknown] behind the bar. I recognize Alex Hoffman, Donna Childs, Chris Sanchez, and Ida Casino. A small draft beer was 25 cents. I never could afford to get bombed in People's Bar, but I sure could nurse a 25-cent glass of beer. The effervescence was long gone before the last sip." Winter 1966.

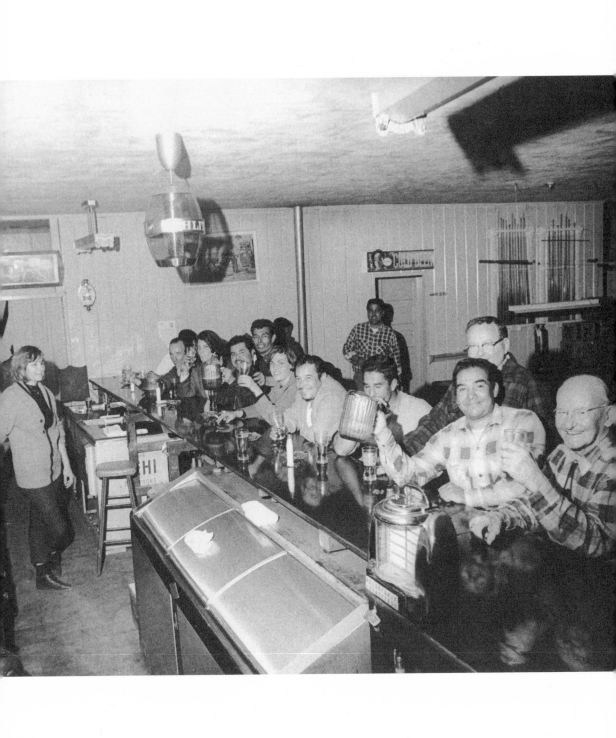

Lewis photographed the wives of strikers lining up outside the union storehouse to receive provisions. His contact sheets capture the monotony of the strike diet: eggs, eggs, and more eggs, plenty of dried and canned fruit, and milk. One of his images records hundreds of cases of canned pork and beans stacked floor to ceiling. Others record the sequence of visitors to the medical trailer: pregnant women in labor, sick babies, and men injured working on automobiles, too afraid and too poor to visit the local hospital emergency room. Photographers passing through for a few hours or a day on assignment completely missed this aspect of the strike.

Of all the work that Lewis did that summer, probably the most odious and exhausting centered on Forty Acres, the union headquarters complex. To make the most of the $50,000 that the UAW had contributed toward the project, the NFWA asked pickets to work there. Construction proceeded in stages, beginning with a gas station. Lewis pitched in, mixing adobe mortar for the bricks and laying red tile on the roof. His worst job centered on digging a service pit.

Of the hard work, done under the hot summer sun with shovels and picks, Lewis recalled:

> By noon we would be so tired that we would have to knock off and go for a beer. After that, I would have to take a nap. If we had enough energy, we would go back and dig some more in the evening. When we finished I was so proud of what we had done with our own hands. I photographed Mike Kratko, the NFWA mechanic and jack-of-all trades. Kratko had been a mechanic at Caratan and had gone on strike with AWOC. He could repair anything. I remember him sitting in one of the primitive latrines we had there, just covered in dust and dirt, smoking a cigarette. I snapped his picture, then made some pictures of the gas station at sunset. I photographed the pumps because I was fascinated by the "Huelga Gas" logo. The gas station was a failure. It never had enough traffic to stay open and eventually was abandoned.[2]

If there was one place that Lewis liked to photograph more than any other it was the West Side watering hole called People's Bar. Here, on a few evenings when he was not in his darkroom, Lewis played pool on well-worn tables and enjoyed a beer or two. "El Corrido de Delano" often played in the jukebox. Behind the bar was a large cartoon depicting the DiGiorgio ranch as an octopus — an obvious reference to the Frank Norris novel about the Southern Pacific Railroad and its tentacles of control extending far into the California countryside. Chávez came in often, and one of Lewis's best-known images shows the labor leader hunched over a pool table about to take a shot. Compared to heroic images of Chávez, it reveals a more human side to a man able to put aside the turmoil of the day and relax with friends.

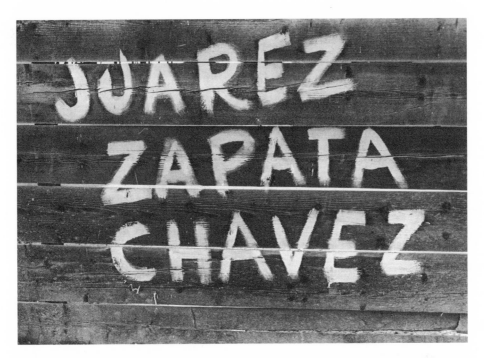

167. "History's progression as painted on a fence in the parking lot at the union's [NFWA] Arroyo Camp on the west side of town. A bit farther left was a 'VIVA PANCHO VILLA,' both done by Luís Valdéz, as I recall." Summer 1966.

As summer merged into fall, Lewis was amused by the photographers passing through. He had lost weight and was always hungry, always tired. He had never become acclimated to the heat. His face was gaunt and deeply tanned. Harassed by deputies and foremen, he was working with old, broken equipment. Although photographers like Streshinsky would soon publish photographic essays on César Chávez and the farmworker movement, freelancers who had been there all along — who had captured history by doing what it takes, who had put in the time and stayed with a story through thick and thin — continued to slave away in anonymity.

Most galling of all were the cowboy photographers who rode in on the standard overnight visit without having done any research or laid the required groundwork. Lewis encountered one such individual while taking Streshinsky around. The photographer was attached to a reporter for a national news magazine based in New York. Having flown in to the Delano airport, he was not sure where he was. Asking a few questions, he soon learned, much to his astonishment, that the San Joaquin Valley was not in the state of Washington, as he thought. The reporter, as Dunne later noted, would not have known a grape if he had seen it in Safeway. Lewis watched them at NFWA headquarters trying to hire a picket line for a photograph and advising

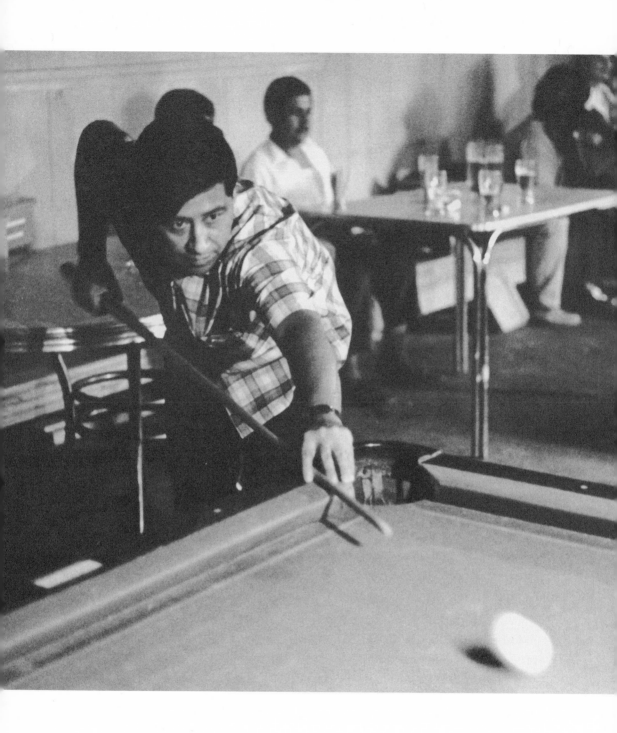

organizers to send the bill for gasoline to the magazine's New York headquarters.[3]

Even more depressing was what happened to those activist photographers who finally had a chance to show what they had done. After Ernest Lowe organized his work from the previous eight years and prepared to exhibit it in a huge show at the M. H. de Young Memorial Museum in San Francisco, Museum Director Jack R. McGregor notified him that the museum trustees had become alarmed by the controversial nature of Lowe's work and had cancelled his exhibition. Only after the American Civil Liberties Union threatened a lawsuit did the museum board reconsider its decision and allow the show to go forward. And Mark Harris, after pouring all of his energy into a preliminary cut of his documentary film, abandoned it after a first showing received horrible reviews. When Lowe left California to begin a career in business, never again to photograph in the fields, Lewis wondered if this was a portent of the future. Physically, emotionally, and financially drained, he feared that his work would never amount to anything. Then, just as he was about to quit, *Ramparts* magazine illustrated an essay by Luís Valdéz and a reminiscence by César Chávez with the color photographs Lewis had recorded on the bulk-loaded movie film. It was scant reward for his time and effort.[4]

168. "People's Bar gave us use of the pool tables, where else to hang out? César didn't come by too often, but he still had a touch on the table from his younger days as a pachuco." Summer 1966.

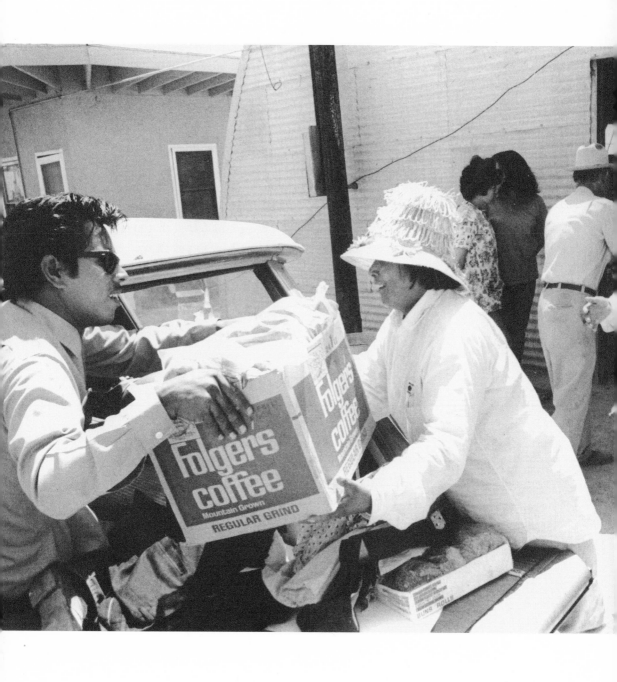

60. Departure

Lewis remained at Delano partly because he wanted to see how the merger between NFWA/AWOC and the AFL-CIO worked out. Chávez was now president of UFWOC. Larry Itliong, Gilbert Padilla, Dolores Huerta, Tony Orendain, Philip Vera Cruz, and Andy Imutan became vice presidents. Al Green was gone.

Lewis hoped that the united front would help overcome a growing tension between the Mexicans and Filipinos. But many of the Filipinos grumbled. Several organizers quit and joined the Teamsters union. NFWA volunteers were also upset.

Of the merger, Lewis recalled:

Some accused Chávez of having sold out. They hoped he would be more like Malcolm X. But Chávez was his own man. I understood why the merger was necessary. We had to win that election at DiGiorgio. If we did not win, we were finished. It would be the end of another farmworker union. We needed the support and money from the AFL-CIO. A whole platoon of AFL-CIO organizers were camped out over in the back of a barbershop on the west side of town. They were sleeping on cots, cranking out leaflets. They hated the Teamsters more than we did. You went over there and the

169. "Food caravans generally came on weekends, and some would be there for the Friday night meetings, where strikers and volunteers would get their $5 weekly stipends. Then we'd head for People's Bar. Fortunately, many visitors would spring for pitchers and pass them around. Before the march, after which things improved, we'd come in at 6:00 a.m. for breakfast and find only tortillas and coffee at times." Summer 1966.

first thing you saw were stacks of Kennedy's book attacking the Teamsters union, *The Enemy Within*. William Kircher, the head of the Delano operation, was a great man. Quiet. Strong. Some of the volunteers got pushed out of shape and did not like to see him around. That was just too bad. Kircher was the antithesis of Einar Mohn and his Teamster Union boss, William Grami, and those Teamster thugs who drove Cadillacs and T-Birds and hung out at the Stardust Motel and sat around the pool getting sunburned. I just tried to remember that I was working for the union and that we were dead without Kircher and the AFL-CIO.[1]

Between his arrival in fall 1965 and the DiGiorgio election in August 1966, Lewis had exposed 256 rolls of Tri-X. As he sized things up, he saw the strike and union moving in a new direction. UFWOC would soon dissolve all of the old AWOC agreements with labor contractors, clearly signaling that it was going to pursue a grassroots organizing policy.

There was no longer any room for Lewis at the Pink House. Gilbert Padilla needed it. Lewis recalled that

Gil was on my ass to get my stuff out. I just left the print dryer in the house. I had no way to take it with me on the bus to San Francisco. I hitched a ride to Del Rey with Luís Valdéz. He and César had parted ways and I spent a few weeks with him at Del Rey while he relocated El Teatro Campesino. I took my last shots there.[2]

With the boycott moving forward and El Teatro Campesino going its own way, the locus of conflict was shifting away from Delano into the big cities. Whatever happened on the picket lines now seemed of secondary importance.

Convinced that the farmworker movement had reached a major turning point, Lewis prepared to resume his studies and raise funds to publish a book of his strike photographs. When the union announced a rally in San Francisco to celebrate the DiGiorgio victory, Lewis caught a ride with Lauri Olman's parents, who left him in San Francisco on their way back to San Rafael.

Lewis was not happy. He recalled:

UFWOC had won a great victory. And the movement had spread into Starr County, Texas. But it was still a grim time in Delano. About thirty growers refused to bargain. [Jack] Pandol just kept saying it was all a sham, that the workers didn't want a union, it was all because of outsiders, and that farmworkers did not normally like unions. It was clear that just negotiating with DiGiorgio was going to take a lot of time. The growers were as defiant as ever. The strike was costing $40,000 a month, and the AFL-CIO was providing only one-quarter of the funds.

Food and clothing were arriving at Delano every week, and those donations were about all that kept many of the strikers going. A lot of the SNCC and civil rights volunteers were leaving town to return to school or because they were just burned out. Some of the AWOC organizers had thrown in with the Teamsters. I did not want to walk out in the middle of all that. I felt like a traitor.[3]

Lewis arrived in San Francisco on a foggy evening in mid-September with exactly $2 in his pocket. Too poor to pay tuition, he pawned his cameras for $130, just enough to get him through the month until his GI benefits arrived and he enrolled in the graduate journalism program at San Francisco State University. More determined than ever to publish his Delano grape strike photography, he financed his project by working as a press operator. At night he edited his book in his Castro Street apartment.[4]

As Lewis returned to his studies at San Francisco State University, Emmon Clarke picked up where Lewis had left off. Clarke had just married a woman from the small town of Dinuba, southeast of Fresno. Living in Mill Valley, just north of San Francisco, he became increasingly curious about agriculture and farm labor while traveling through the Central Valley on visits to his wife's family. He wanted to be part of the movement and use his photography to help. He went to Delano, talked to people in the Filipino Hall, and immediately set up operations in a house being used as a barracks for volunteers. "The place smelled musty," Clarke recalled, "like dirty socks. It was rough. I said, 'I'll give it a try for two months, and if I can't take it, I'll leave.'"

Soon a part of the *El Malcriado* staff, Clarke moved from the barracks into the same Pink House that Lewis had occupied. For his work, he received the usual $5 a week, food, and board, and an unlimited supply of bulk-loaded black and white film.[5]

Clarke settled into the same routine as Lewis — up early every morning, over to the Filipino Hall for a cup of coffee and whatever meal was being put together from donated food, meet with the picket captains, find out what was going on, and join the picket line. About 10 a.m., a truck arrived to feed the pickets buttered toast or tortillas. Around noon, picketing shut down, and Clarke returned to his darkroom-bedroom to print and develop. He tried to have all of the chemical work done so that he could breathe fresh air while sleeping.[6]

Over the next seven months, Clarke photographed the ebb and flow of events, including Thanksgiving fund-raisers in Los Angeles, El Teatro Campesino's performances, and picketing at Perelli-Minetti & Sons, a Delano wine grape grower with 2,280 acres of vineyards who had signed a contract with the Teamsters union

a day after Lewis departed for graduate school and a week after UFWOC members had walked out on strike.

Photographic coverage would prove especially important for the union and a challenge for Clarke. Because the union began boycotting Perelli-Minetti's products during the Thanksgiving holidays, 1966, Clarke spent much of his time in Los Angeles and San Francisco following veterans of the DiGiorgio campaign as they wreaked havoc with sales of Perelli-Minetti premium wines and its special Tribuno Vermouth and Ambassador Brandy. Most of this photography was uneventful — Chávez speaking, UFWOC members picketing and leafleting, fund-raising dinners, meetings with labor officials, and other mundane aspects of the boycott. But at least one assignment challenged Clarke's wits and demanded some quick thinking, even deception.[7]

Clarke was back in Delano photographing boycotted Perelli-Minetti wine labels in a Delano liquor store when the enraged store owner spotted him, locked the doors, and called the police. An officer arrived and demanded his film. Having picked up a few tips from other photographers shaken down by police, Clarke carried a dummy film canister and deftly substituted it for the real one. Once out of the store, he headed straight for the darkroom. Later that day he made prints of all the boycotted wine labels, cut them out, and pasted them into a mock-up for an *El Malcriado* issue focused on the Perelli-Minetti boycott and for various fliers used in the Perelli-Minetti campaign.[8]

As with his predecessors, Clarke wilted under the demands of his job. Burned out and missing his wife — who once visited Delano and was nearly run over while out on the picket lines — Clarke left *El Malcriado* and was replaced by Chris Sanchez, the farmworker who had learned photography from Lewis and Kouns while tending Porta-Potties on La Peregrinación.

170. "There was a mountain foothills retreat and planning session prior to the march to Sacramento where we had a few days off with a change of scene to get out of the rut. Here are three friends from those days — well remembered. Chris Sanchez has passed on now but became a fair photographer in the 1970s, and was with the movement from its start. Peggy McGivern, on the right, was the volunteer nurse who gave many years of tireless service. Esther Uranday, center, was one of the 'originales' at the start of the strike, and is working to this day at the union's headquarters in La Paz." Summer 1966.

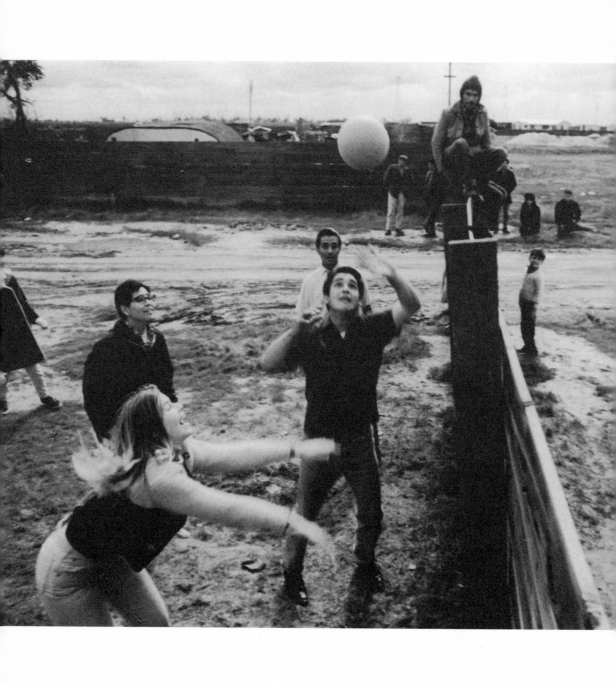

61. Hock

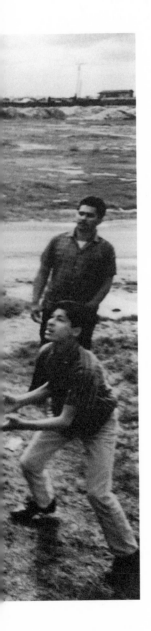

171. "A little R&R break at the union's Arroyo camp." Fall 1966.

To complete additional photography for his book, Lewis returned to Delano many times during the fall of 1966 and throughout 1967. He stressed:

A few growers raised wages. Most were as intransigent as ever. There had been a lot of wildcat strikes — at the Goldberg, Mossessian, and Hourigan ranches. A picketer [Manual Rivera] was run over and permanently crippled in a Goldberg packing shed. Local Mexicans and undocumented workers continued to work in the vineyards. Conditions were just as bad as ever. There were no toilets in the vineyards. You would still see workers using short-handled hoes on vegetable farms. Contractors were as evil as ever. Union workers were being purged. Two farmworkers in a Richgrove labor camp were asphyxiated by a defective heater. Fires destroyed part of the boycott office and printing room in the Albany Avenue headquarters, a room in the Pink House, and a Volkswagen bus parked next to the Farm Workers Service Center at 105 Asti Street.[1]

Lewis quickly realized that the Teamsters were up to their same old ricks. He remembered that

AWOC organizer Marcello Thomsi was fighting the union. Teamster thugs in San Francisco beat up a UFWOC organizer boycotting outside a Purity store. Teamster Local 964 brought in Oscar Gonzales, a well-connected former auto worker, and

Albert Rojas, a farmworker activist from Oxnard. Those guys formed a union and went to work in the coastal valleys around Watsonville, where the UFWOC had no base. The Perelli-Minetti boycott was heating up. *El Malcriado* was being sued for six million dollars in libel damages. A sit-in at DiGiorgio offices in San Francisco ended protracted negotiations over union representation elections at its Arvin ranch and led to UFWOC's second election victory and first outside of its base in Delano. Luís Valdéz and El Teatro Campesino were spreading the word far and wide from the stage on the back of a flatbed truck. And yet many were asking what had really changed. Farmworkers were still excluded from collective bargaining, minimum wage, and worker's compensation legislation. They were still second-class citizens, still an exploited and oppressed minority fighting for its freedom.[2]

With his cameras in hock, Lewis resorted to photographing with an Olympus half-frame camera that produced seventy-two images. To continue his work, he

would cut out of town by skipping a late class on Fridays and catch the 3 p.m. Greyhound bus. I wrote a lot of the text for my book on those long bus rides. I would arrive about 8 p.m., just in time for the evening meetings. Often that was the first and only meal of the day. I was just getting by. But it was all worth it. After getting fed I would head over to People's Bar for a beer. I'd meet old pals and catch up on developments.[3]

Lewis found that many orginales remained away on boycott duty. Eugene Nelson, now in Starr County, Texas, took his camera with him, leaving Nick Jones to handle most of the photography throughout the winter and into the spring. A conscientious objector, Jones had worked with the SDS in Chicago and was not shy about recording picket line confrontations. Along with Bill Esher and several other volunteers, he managed to keep *El Malcriado* supplied until Lewis began pitching in with more images.

At union headquarters, Lewis hardly saw familiar face. Few knew who he was or understood the pivotal work that he had done.

One of the biggest changes was the new UFWOC legal staff. Alex Hoffman burned out and left. Victor van Bourg, a well-known San Francisco lawyer who had been inherited from AWOC, had been sent packing. His replacement, a McFarland-based, former California Rural Legal Assistance lawyer named Jerry Cohen, was fighting various anti-picketing and anti-boycott injunctions, as well as the Texas Rangers and Border Patrol, often with new and amusingly innovative techniques. But it was hardly the stuff that made for dramatic photography. Only People's Bar — always

good for a game of pool and a bottle of Mountain Red or Mexican beer — seemed the same.[4]

Complicating matters, the Teamsters signed a peace agreement relinquishing any jurisdiction over field workers. The Teamsters would organize workers in food processing and trucking, and the UFWOC would handle field workers. Months later the UFWOC signed a contract with Perelli-Minetti, a victory that was especially sweet, given the central role that the Perelli-Minetti family played in the Delano community — one son had been mayor, and Mrs. Fred Perelli-Minetti had been president of the Delano-based fanatically anti-Chávez group Citizens for Facts. Perelli-Minetti was the first local grower to sign with the UFWOC.

Lewis was optimistic about developments. He thought that

> the union was on a roll. In ten months it had organized another boycott and brought Perelli-Minetti to the bargaining table. Using the "card check system" — obtaining pledge cards from a majority of a company's workers, then asking for collective bargaining without having to go through an election that would inevitably produce a union victory — the UFWOC amassed contracts with five of the state's major wineries, including Gallo, Almaden parent-company National Distillers, Christian Brothers, Paul Masson, and Franzia.[5]

Chávez and Huerta finally sat down with representatives of DiGiorgio to arbitrate their contract. Two labor relations attorneys — Sam Kagel and Ronald Haughton — acted as referees. The meeting, held in an old funeral home on Twelfth Avenue in Delano, was the first of its kind. On the third day, when the union concluded that DiGiorgio did not understand the issues, El Teatro Campesino performed an acto before a hundred strikers, reporters, and DiGiorgio employees in the arbitration room. In the performance, Patroncito, played by Valdéz, is finally beaten and learns to live with the workers. When the new DiGiorgio contract was signed it brought over 1,000 additional workers into the union, as well as a back pay award of nearly $100,000. When Schenley workers voted to extend their contract, the UFWOC for the first time began to generate a substantial part of its operating revenue.[6]

While dramatic, those contracts covered only five thousand of the state's farmworkers. It was going to be more of the same uphill battle. Somehow the still-fragile union had to broaden and deepen its operations and shore up its relationship with the churches, Mexican American groups, and the AFL-CIO. It would have to consolidate success, parry away challenges from the Teamsters, build pressure on the table grape industry, learn how to administer contracts, and move in new directions. And it would have to deal with new, festering problems, among them a growing rift between Mexican and Filipino members, old AWOC and NFWA organizers suspicious

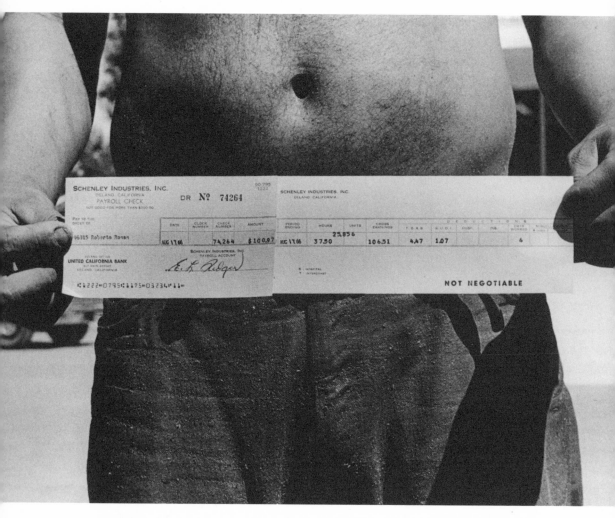

172. "Check and pay stub from the [NFWA] union's first contract with Schenley Industries. It looks as if he grossed $106.51 for 35.5 hours of work. That's $3 an hour in 1966 dollars." Summer 1966.

of one another, volunteers afraid that UFWOC would become just another bread and butter union, and clergy suspicious of drift and compromise.[7]

But there were hopeful signs. Schenley workers were electing ranch committees, the first of their kind in the agricultural industry. They were going to create a whole new layer of leadership, as well as new experiences. Dolores Huerta was learning how to establish and run a union hiring hall, the first ever such arrangement in agriculture.

Financial matters were looming large. AFL-CIO subsidies of $10,000 per month only partially offset expenses of $25,000 per month. Gasoline bills totaled $4,000.

Telephone bills averaged $1,600. Out of a total income for 1967 of $520,990, union dues accounted for $82,424. Collecting those dues from union members now became an important part of union business, along with fund-raising. The UFWOC somehow had to come up with another $27,000 per month, about half of its budget, just to remain solvent.[8]

New tasks were emerging daily. Already a spinoff from the Delano group was active in the Rio Grande Valley of Texas, where Antonio Orendain led a strike by melon harvesters and then organized a five-hundred-mile walk from the Mexican border to the state capitol in Austin. Farmworkers were organizing in Washington, Wisconsin, Ohio, Michigan, and Florida. The UFWOC was going to play a role nationally, and it was mobilizing its base to support and oppose politicians and advance legislation favorable to farmworkers. With its wine grape contracts, the union seemed poised to wrap up the wine industry. But the growers, as always, remained so vehemently set against Chávez that after a local grower, Goldberg, signed a contract, neighboring growers refused to sell him grapes or allow him to lease any vineyards. And the Teamsters continued to lurk about.[9]

62. Giumarra

Suddenly Lewis found himself photographing on the picket lines at Giumarra Vineyards. In retrospect, he thought it was almost inevitable that he would wind up there.

Everyone knew the Giumarra rags-to-riches success story, because the company told it so often. It dated back to 1900, when Giuseppe "Papa Joe" Giumarra traveled from Ragusa, Sicily, to Toronto, Canada, and began selling fruit from a pushcart. Giuseppe was frugal and disciplined, so the story went, and he had big plans. After ten years, he relocated to Los Angeles. Guimarra rented a corner of the Seventh Street Market and set up shop selling California fruit.

Like so many other Italian immigrants who made their names in California agriculture, Giuseppe teamed up with his brothers John and George and brother-in-law Dominic Corsaro. Together they established a wholesale fruit business. With their profits, they founded Giumarra Vineyards just north of Bakersfield. Over the next three decades, the Giumarras expanded into wine and tree fruit, built up their Grape King and Tree Ripened labels, and purchased a checkerboard of prime table grape vineyard land along Wheeler Ridge in the Southern San Joaquin Valley. By 1967, Giumarra had become a vast, interlocking, integrated complex of packinghouses, cold storage plants, wineries, and marketing facilities that grew, packed, and sold 6,340 acres of

173. "This photo isn't sharp, but neither was the photographer at 6:00 in the morning." Fall 1966.

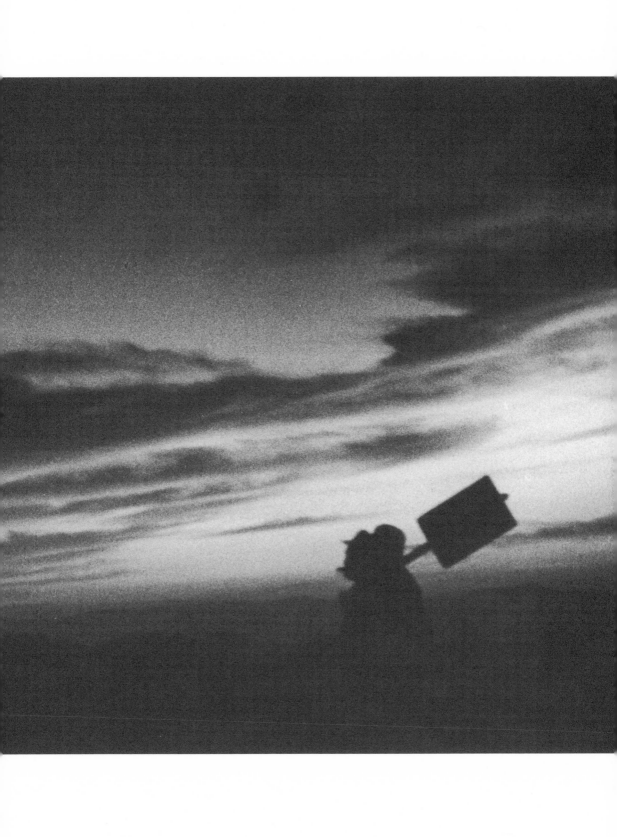

table grapes, along with 5,830 acres of wine grapes, tree fruit, and row crops in Kern and Tulare Counties.[1]

Giumarra grew only a small portion of its table grapes in Delano and had largely escaped the strike. But with $12 million in annual sales, 10 percent of the total California table grape crop, 200 permanent workers, and 2,000 temporary harvest hands, the company presented an inviting target.

Lewis knew that after the UFWOC had won its contract at DiGiorgio's Arvin ranch, more than 1,200 farmworkers had joined the union. Most of those workers lived in and around Arvin, Lamont, and Bakersfield and at times worked for Giumarra. Before he left, Lewis had listened to UFWOC leader Marshal Ganz explain how Giumarra offered the union an opportunity to expand the strike beyond Delano. Lewis understood that organizing the largest grower of table grapes in the world would place La Causa in the public eye. He had heard Chávez and other members of the union leadership predict that if they organized workers at Giumarra, the rest of the industry would follow. Even failure might offer benefits because it would recruit a cadre of followers to send out on a boycott. One problem was that Lewis and everyone else in the union admitted that they did not have even the slightest inkling of how to develop a boycott of Guimarra's table grapes. But as Lewis had learned, the union had not known how to boycott Perelli-Minetti or DiGiorgio until it tried and succeeded.[2]

While Lewis had been in San Francisco, Fred Ross had planted a team of thirty-five organizers in Lamont and Arvin. Giumarra immediately refused to recognize the union. On August 3, Lewis covered a huge rally. Two-thirds of Giumarra's five thousand harvest workers voted to strike.

On visits over the next few weeks, Lewis spent much of his time patrolling the company's vineyards and following UFWOC organizers into dozens of labor camps. Very quickly he discovered that the Giumarras were tough old Sicilians — well-financed, tough, and shrewd, with solid political connections and a stable of lawyers.

Under the direction of John Giumarra Jr., a Stanford University law school graduate who had left an Orange County law firm to run the family business, the company brought in green-card workers. Giumarra lawyers asked for injunctions that restricted the number of pickets and severely limited the use of bullhorns. Judges issued an injunction. Much later, when the union appealed the injunction, higher courts would rule that it had been an abridgement of free speech. But the court orders succeeded for the moment.

Out in the fields, Lewis photographed a strike that was stumbling along. Unable to picket Giumarra's ranches or boycott his labels, Chávez at first concentrated on cutting off the supply of strikebreakers. Although Secretary of Labor Willard

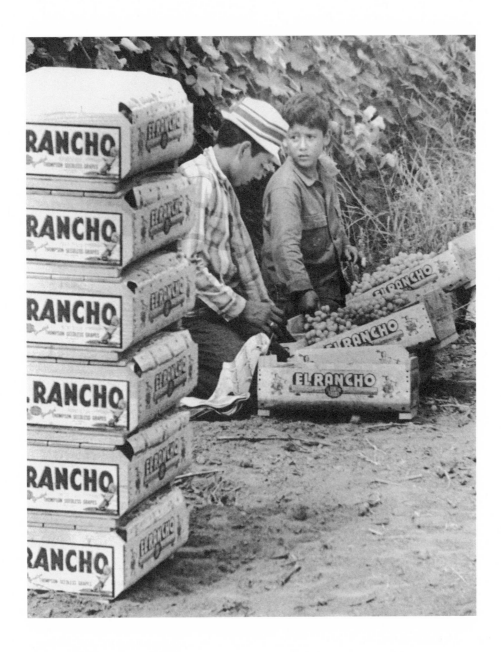

174. "I always printed the adjacent frame of the kid facing the camera while sitting on boxes at the end of the vine row. This view has gotten a nice response after remaining in negative form for 42 years." Summer 1966.

175. "Señor Campos was always whittling. Studying his hands, I thought they might exemplify what I was trying to capture." Fall 1968.

Wirtz attempted to stop the flow of Mexican workers, his orders did not decrease the number of green card workers and undocumented field hands, even though Border Patrol apprehension rates soared. Chávez then resorted to the boycott. Very quickly the union ran into problems. Unable to differentiate one pile of grapes in the supermarket produce bins from another, Chávez realized that there was no practical way to boycott a single grower.

At this point, Lewis again made an important photographic contribution to the cause. His revealing picture of a very young boy working in the vineyards as a strikebreaker provided the UFWOC with ammunition for its nationwide boycott.

Although his reportage continued apace, Lewis remained stalled on his book project. The problem was the cover image. In his mind's eye, Lewis had settled on the theme of human relationships to the earth.

When not on the picket lines, Lewis spent a lot of time at Delano unsuccessfully prospecting the right image. After making a series of close-up shots of a farmworkers sifting soil through their hands, he was at a point of despair when César Chávez's brother, Richard, volunteered his hand, picked up a palm full of dry soil, and let it sift through his fingers. Click! Lewis had his cover shot![3]

176. "The first dummy [book mock-up] I did of a cover and title page had just a bunch of dirt clods without a hand. On a subsequent trip to Delano I grabbed Richard Chávez, César's brother, who lent a hand in my search for the cover of my book *From This Earth*. First title was, "These Few . . ." on the thesis proposal." Fall 1968.

63. School

As Lewis resumed graduate studies in November 1967, the UFWOC won a union representation election at DiGiorgio's Arvin ranch. During contract negotiations, the company balked at requests to place ice in drinking water and provide sanitary individual paper drinking cups. Eventually DiGiorgio signed a contract that for the first time in the history of American farm labor provided a health and welfare fund, as well as a seniority system for evaluating promotions and layoffs. But months after the contract had been signed, workers would still have to produce copies of the document in order to take ten-minute rest breaks.

During his periodic visits to Delano, Lewis could see that the victories at DiGiorgio, Schenley, and Perelli-Minetti were dwarfed by the titanic struggle that was shaping up with Giumarra. By singling out one grower, the union had run into huge, unexpected problems.

Giumarra sold grapes under many different labels — over 105 by UFWOC's tally. Markets were able to easily dodge the boycott by placing grapes

177. "Handling the original 16-millimeter film with white gloves, prior to the A-b rolling with a hot splicer." [Jon Lewis self-portrait in the film lab while working on his documentary *Nosotros Venceremos.*] Fall 1969.

in different boxes in the supermarket produce section. To overcome these obstacles, Chávez had no choice other than to expand his boycott to include all grapes not bearing the union's black Aztec eagle logo — essentially a boycott of the entire table grape industry.

In January 1968 Dolores Huerta and sixty UFWOC members left Delano in an old bus headed to New York City, the largest single market for California table grapes. Within weeks, hundreds of UFWOC organizers were operating boycott offices in forty to fifty cities. Eventually more than two hundred strikers and their families would direct boycott activities in communities across the country.

At first the boycott accomplished nothing. Out in the fields the grape strike sputtered and stalled. Picket captains stopped showing up for duty. Union morale declined. Some activists grew so angry with the lack of progress that they blew up irrigation pumps, scattered tacks and nails across roads to puncture tires on police and grower vehicles, and roughed up individuals suspected of acting as spies for growers. Although no one admitted to the arson, mysterious fires that burned grape packing sheds and packing crates were blamed on the union.[1]

Lewis saw that young Mexican Americans wanted action. Back in Delano, he saw that farmworkers

> were growing restless and frustrated. It seemed like Chávez was in danger of losing his moral authority. A charismatic [Rodolfo] Corky Gonzalez was leading a call for Chicano nationalism and Chicano power while denouncing land-grabbing, racist *gabachos* (a perjorative term for English-speaking non-Hispanics; Mexicans use this term instead of "gringo"). In Northern New Mexico, Reis Tijerina and his followers seized a federal forest campground and took rangers hostage, then moved against the Rio County Courthouse, where a bloody shootout followed and Tijerina proclaimed the land belonged to indigenous people. I was not alone in wondering if the UFWOC might be pushed aside by far more militant "brown-power" leaders. I did not like the call to arms that the Black Panthers were using in their appeals to African Americans in riot-torn urban ghettoes. There was a heated debate over tactics developing within the UFWOC. Chávez could not go anywhere without his bodyguards and a German shepherd watchdog. An Indio, California, newspaper reported a $10,000 bounty on Chávez's head.[2]

"Some of our people accused us of cowardice," Chávez explained to *Fresno Bee* reporter Ronald B. Taylor. "They told me, If we go out and kill a couple of growers and blow up some of their storage plants and trains, the growers will come to terms. This was the history of labor; this was how things are done. No union movement," he added, "is worth the death of one farmworker or his child or one grower and his

child . . . social justice for the dignity of man cannot be won at the price of human life."[3]

Furious with the violence and fearing that his union might not survive, Chávez announced that on February 15, 1968, he would attempt to regain moral authority by embarking on a penitential fast. He would fast until union members renewed their pledges of nonviolence.

Of the fast, Lewis believed that

Chávez knew exactly what he was doing. He feared that his union was about to fall apart. He needed some dramatic event. He hoped to inject life into the faltering strike. He was always pulling something out of the hat. He was always rescuing the union from the edge of defeat. He believed that a fast would set off a spark that would jump-start the boycott, which he regarded as the key to victory. He knew that strikes would not work. So he walked to Forty Acres and plopped down on a cot in a small storage room inside the adobe service station. And he stopped eating.[4]

64. Fast

While photographing at Delano, Lewis had never been able to review his images properly. To move forward with his book project, he had to get a better sense of what he had done. This required making more than two hundred standard contact sheets. The process of removing his negatives from their glassine sleeves and arranging six images per line, six per sheet of paper, then sandwiching them between a plate of glass and photographic paper locked him into a dawn-to-dusk darkroom marathon.

Seeing many of his images for the first time, Lewis began selecting and printing individual frames. Dodging, burning, and then occasionally cropping his images to achieve the desired print quality was an equally exhausting process that yielded a half-dozen good prints a day. Lewis was especially frustrated by the printing problems caused by the harsh midday light under which he had photographed. With negatives that were overexposed in one section and underexposed in another, Lewis had to work hard to obtain acceptable results.

As one image after another appeared in his developing trays, Lewis greeted them as old friends. Every contact sheet held multiple images worth printing. Lewis poured his soul into each one as if they were his children. Soon hours turned into days. Days became weeks. Lewis kept at it from November 1967 until February 1968.

178. "Helen Chávez takes communion during the first week of César's fast." Spring 1968.

334

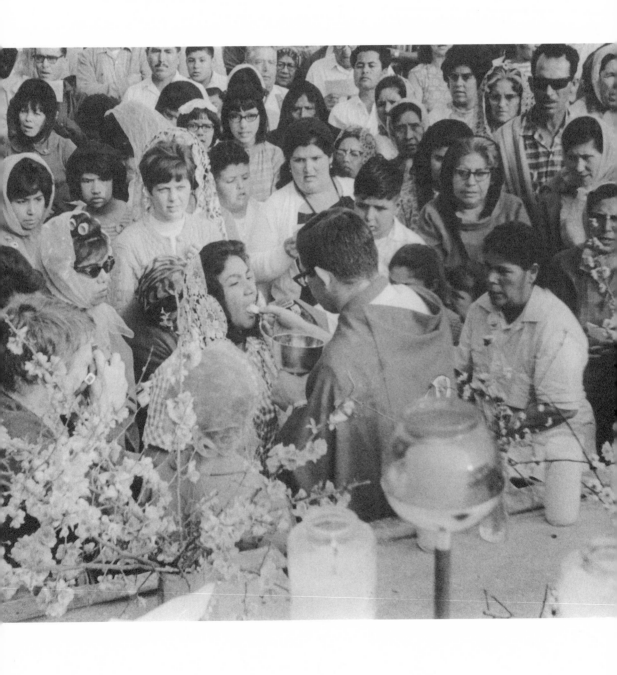

Emerging from long darkroom sessions hunched over with an aching back, he pushed himself to his physical limit. The more he printed, the more he realized that his Delano grape strike project was emerging as a powerful and accurate visual chronicle of massive change. His quest was at once a political effort that tried to bring greatness to the story and a photojournalistic endeavor that attempted to capture an honest understanding of the strike. But it was also an autobiographical rendering of Lewis himself—his values, tenacity, independence, spirit, and refusal to compromise his ideals. Every picture documented not only what had seen, but where he had been.

During his printing marathon, Lewis did not read a newspaper. He had no idea what was transpiring at Forty Acres. When he stepped off the bus on a visit to Delano late in February, he immediately recognized that something was going on. Picturing the scene at Delano, Lewis recalled:

> People were erecting tents all over Forty Acres. In one corner of the gas station that I had helped build the year before the union created a kind of shrine and chapel. Across the breezeway, César was holding forth in a room that only had a single bed and dresser. It resembled a kind of monastic cell. Long lines of people were standing there beneath a big, black union flag waiting to visit Chávez. They stood there for hours, quietly, just waiting their turn, hoping to meet the man before he died. Photographers had been coming and going, charting his health. They were documenting, perhaps for the first time, the physical changes of a man putting his life on the line for his cause. Growers were calling the whole thing a circus. A lot of UFWOC members were also uncomfortable with the fast. But for photographers it was just an endless string of opportunities. You saw farmworkers pitching tents, farmworkers maintaining a vigil for Chávez, elderly women crawling on their knees from a highway to the room at Forty Acres where Chávez lay in bed. Even for those of us who had seen it all, and who had covered the march on Sacramento, the pageantry of the fast seemed a visually spectacular, surreal admixture of metaphor and document. César was creating something from nothing. He was a magician. He was deadly serious. He was willing to die. He would talk to people privately and would attend a Mass every night. I could see that the fast had quickly become an amazingly powerful organizing tool. I remember Leroy Chatfield saying that it was just like the march, only instead of César going to the people, the people came to César.[1]

With press photographers unable to penetrate security, Lewis and others aligned with the union shot most of the images of Chávez at this critical point. Following him through the day, Lewis created a picture of life in the little room at Forty Acres

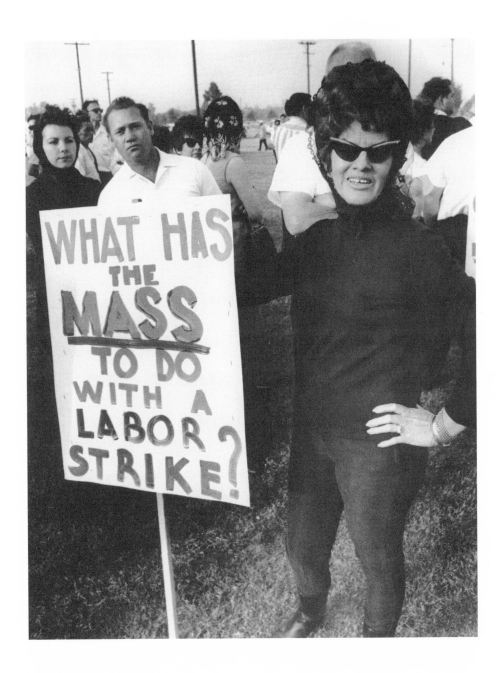

179. "A week after La Peregrinación, we had a march through the east side of Delano in way of a victory lap. The Sunday Mass to start things off was picketed by local townspeople. I was the proverbial 'outside agitator' and was a particular target. This 'babe' with the big hair was a redhead, as I recall." Spring 1966.

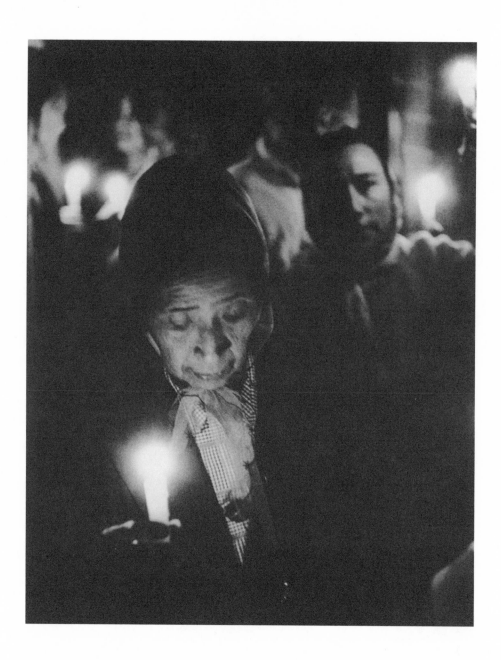

180. "I don't know her name and we never spoke, but there was a candlelight procession midway through César's 1968 fast and I saw her coming from some distance away. The planets were properly aligned as a very slow shutter speed was able to gather enough light to capture the image without blurring." Spring 1968.

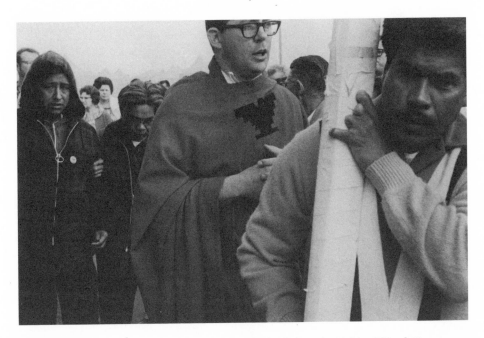

181. "I wasn't able to get back at the end when RFK broke bread with him [César]. You can see tents erected in the background for those who wanted to keep vigil through the night. They would trot him out for an evening Mass, as accompanied here by Philip Vera Cruz, priest Mark Day, and Lupe Murguia leading the procession. I didn't go too close as there was a certain reverence in the air, and who was I to block the crowd's view of an icon being born." March 1966.

where the leader of the UFWOC slept, read, and prayed. It was cramped, low-light photography.

Describing the challenges he faced while photographing at Forty Acres, Lewis stressed that

> you could not shoot worth shit in the corner of that gas station where César was staying. It was too dark. I got my best pictures when they took him out to attend Mass. They would trot him out from his bed and lead him to a front-row pew. He would be slumped over, tottering, not really listening, just out of it. I kept thinking, "Oh, my God, he's going to faint and fall over and crack his head open. Someone catch him." So many times he would just swoon and roll his eyes. I kept my camera on him because I thought this really might be the end, that this is it, he's going to die in front of me. He had a handkerchief on his head and looked to be at death's doorstep.[2]

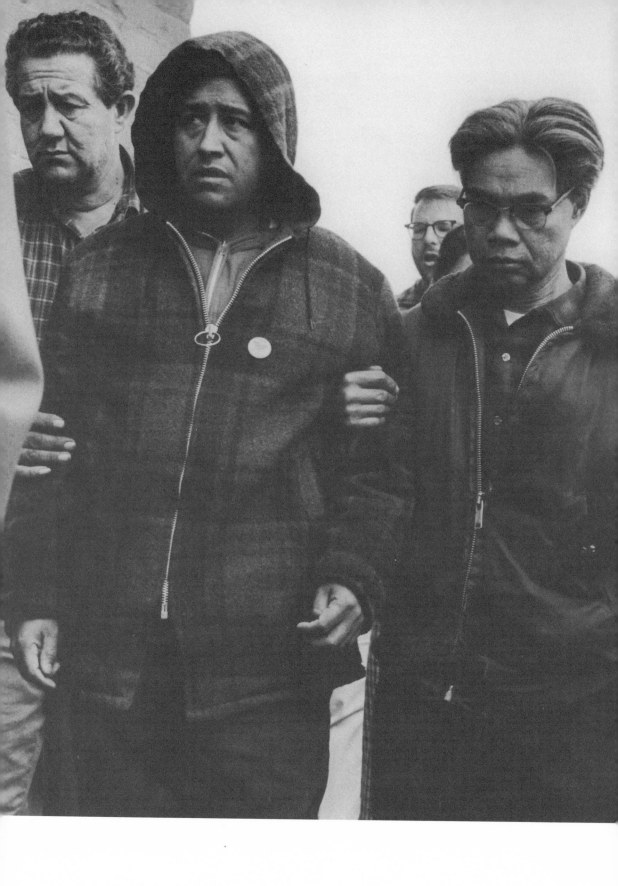

65. Stranded

Lewis stayed the weekend and then returned to San Francisco. As he departed, *Time* and *Newsweek* photographers arrived. Within a week, the fast grew into a national news event. As word reached farmworker communities in California and Arizona, families climbed into their old cars and made the journey to Delano.

A week after the fast started, Giumarra hauled Chávez into court for violating an injunction against mass picketing. Giumarra's attorneys cited twelve separate occasions where the union had violated the injunction. They wanted Chávez jailed for contempt. When a judge ordered Chávez to appear in court, the UFWOC got the dramatic media event that it wanted.[1]

Weak, unkempt, sporting a scruffy beard, and assisted by Leroy Chatfield and Jerome Cohen, Chávez appeared at the Kern County courthouse in Bakersfield early on the morning of February 26, 1968. Eight hundred to a thousand farmworkers belonging to various UFWOC ranch committees lined the courthouse steps. None spoke a word. Many knelt in prayer. They formed a continuous line that led through the entrance, through the main doors, into the hallways, and up the stairs to the corridor leading to the courtroom. John Giumarra Jr. and his attorneys called it all a "colossal hoax" and demanded that the judge kick all of the farmworkers out of the building. The judge took one look at them and refused, saying such an action would be taken as just another example of gringo injustice. He then looked at Chávez, who had lost more than thirty pounds and had fasted longer than Gandhi. Chávez was in no shape for a protracted court battle. The judge postponed the hearing.

As Chávez left the courthouse, countless camera flashes recorded the scene. Giumarra had no stomach for an even larger peaceful demonstration. His attorneys

182. "I came to town one weekend not knowing what to expect and found myself in César's 1968 fast. Often times coming down [traveling east from San Francisco] for just a few days, you didn't expect much." Spring 1968.

quietly withdrew his complaint. It was to be the first of many occasions when the union turned an apparent defeat into something that worked in its favor.

Lewis was stranded in San Francisco when Chávez ended his twenty-five-day fast on a drizzly March 11 afternoon in Delano Memorial Park. Still struggling to pay rent and put food on the table, Lewis missed an event that ended when Robert F. Kennedy walked for more than a mile between long lines of farmworkers, each one trying to touch him, kiss him, and shake his hand. Had Lewis been there, he would have had to elbow his way through the crowds, backing along in front of Kennedy, forcing his way through any opening to get a shot, all the time trying to keep from being swept off his feet and trampled underfoot.[2]

Seeing photographs of the fast in the San Francisco newspapers on the following day, Lewis was disappointed. Largely out of position, press photographers fighting their way through the crowds had been unable to stake out the best spots. Shooting from an elevated and distant perspective, AP and UPI photographers used wide-angle lenses that revealed too much extraneous detail and made Chávez and Kennedy appear small. Or, relying on medium telephoto lenses, they so severely focused on Chávez and Kennedy, or Chávez and his wife, Helen, that they ignored the emotions evident on the faces of union supporters and reporters standing nearby.

Because of their relationship to the union, freelance photographers grabbed the best shots. John Kouns, who had also served with Lewis as a union picket in the early days of the grape strike, knelt just in front of Kennedy and Chávez and recorded a series of images of Kennedy, César Chávez, and Helen, with a second tier of seven union supporters holding a NFWA flag behind them. His strongest image recorded Chávez moving in and out of consciousness, just as two union members stood by to grab him if he passed out. So weak that he could barely sit up and hold his mother's hand, Chávez at this point appeared childlike, fragile, and in such obvious distress that even the most cynical person could no longer claim the fast was a fraud.

Photographing from a slightly different perspective to the right, George Ballis recorded another series of images, including the moment when Kennedy comforted César's mother, and a concluding gesture when Kennedy broke bread with Chávez and symbolically ended the fast. *Fresno Bee* reporter Ronald B. Taylor recorded equally dramatic images while standing above and to the left. Back from his boycott duties, Chris Sanchez stood next to Ballis and caught another dramatic moment when Chávez accepted Holy Communion. *El Malcriado* quickly published the shots made by Ballis and Kouns. The general public would not see their photographs for many months, if at all, when they finally appeared in a few magazines.[3]

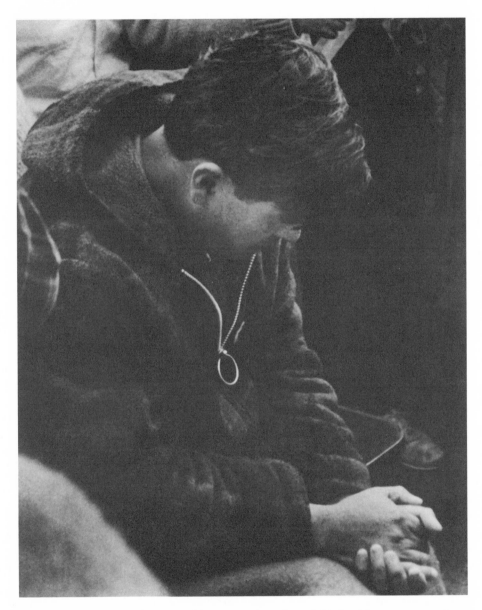

183. "César seated in the front row of the Mass midway through his fast. There was no way I was going to try shooting by sitting in front of him — way too intrusive." March 1968.

66. Book

While Lewis selected and printed his photographs, Chávez struggled to regain his health. He spent three weeks in the hospital with severe back pain and the remainder of the year in a hospital bed at home. His spine was twisted. Only with the help of Senator Kennedy's personal physician was he able to institute a regime of special exercises coupled with orthopedic shoes that allowed him to work while sitting in a rocking chair at his desk.

Despite suffering millions of dollars in lost sales, growers refused to relinquish power. Rather than allowing workers to conduct union representation elections, they spent millions of dollars in advertising and public relations campaigns. Growers wanted to discredit the UFWOC. Many secretly financed bogus farmworker unions, with no members, that claimed to represent "the true farmworker."

Following the assassinations of Martin Luther King and Robert Kennedy, the UFWOC pulled picket captains off the strike lines and threw everything into the boycott. With little activity at Delano, Lewis stopped photographing. "The story now was not in California," he recalled, "but in the urban areas and big cities."[1]

When Chávez finally jumped back into the headlines, he alienated many followers by reversing his stand on extending the NLRA to farmworkers. He had no choice. NLRA coverage would have brought union representation elections. But it also brought farmworkers under the provisions of subsequent amendments, among them prohibitions on the secondary boycott, which had become the union's principal

184. "I was able to get ten to twelve shots of Señor Huerta of Earlimart, and this was the one that stood out. The grainy and blurred hand perhaps imparts a sense of motion and outreach that make this a special image." Summer 1966.

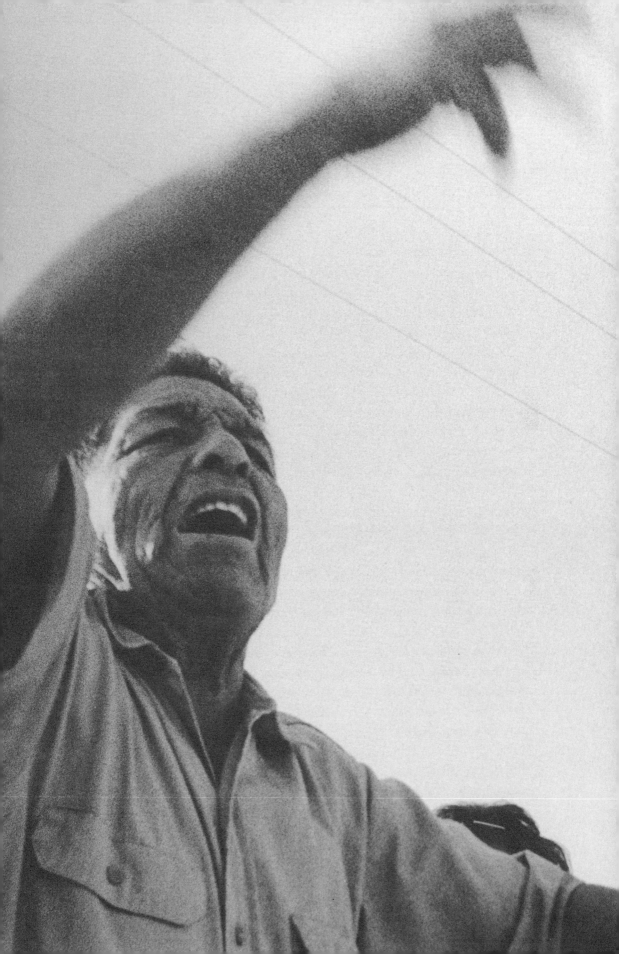

weapon. As if to verify his argument, Chávez immediately extended the boycott to include Safeway Stores, the largest grocery chain on the West Coast. Safeway sold more than 20 percent of Giumarra's grapes.

As the boycott momentum built, Lewis began experimenting with image sequencing and book layouts, then started to assemble his text. He had already written much of it while on his long bus trips to and from Delano. He was trying to find a voice that could condense a complicated history.

Lewis held strong ethical positions that guided his project. He did not want to produce another art book at the expense of the people he had documented. Nor did he want to issue another dry tract on poverty. He also understood the overwhelming odds stacked against him. Serious books about contemporary problems were not exactly a way to get rich. Serious books of photographs other than those by famous and established photographers were not considered marketable. Lewis might not even be able to find a publisher.

Very early in his project, Lewis decided that, as far as possible, he would do everything himself. This was not to be a career-building effort but rather an attempt at reaching the widest audience at a critical juncture in the farmworker movement. It would be a book about how people change and how some stay the same. It would be a book about dreams and perseverance. It would not end in triumph or victory but rather with farmworkers whose hands had been worn by a lifetime in the fields wondering what was ahead — defeat, more of the same, or change, or at least the prospect of change. Above all, it would be about a group of activists whose struggle revealed something fundamental about a society, about something at the heart of life in the Golden State, about the nature of an agricultural system enveloped in myth and hype.

For guidance, Lewis turned to a number of photo books. George Ballis had already collected his own images in *Basta: The Tale of Our Struggle*. With a text by Luís Valdéz, *Basta* was the first book-length photo essay on the Delano grape strike. Lewis was inspired by the effort and admired Ballis. But he was not going to copy him by stressing labor organizing. Determined to place his own imprint on the strike, Lewis continued with his theme of the human relationship to the earth.[2]

Like most photographers, Lewis was familiar with and admired *Let Us Now Praise Famous Men*, the powerful, uncompromising, and visually stunning report that writer James Agee and photographer Walker Evans had produced in the depths of the Great Depression. Focused on three tenant farming families in the cotton belt of the American South, the book was packed with images possessing what photographer Carl Mydans labeled "the spell" — the ability to capture the essence of something. Lewis wanted to capture that spell. He intended to follow the format

and spirit of such efforts, in which images are employed as separate documents equal to the text. *An American Exodus*, the pioneering collaboration that economist Paul S. Taylor and photographer Dorothea Lange had published in 1939, also furnished a useful model, especially in the way Taylor crafted a voice that spoke directly to the message being conveyed.[3]

Listening to Lewis discuss every page of the book project as it took shape throughout the winter of 1968 and spring of 1969, Gerhard Gscheidle and his wife Sandra began to think of it as a kind of "never-ending pregnancy." But Lewis kept at it. He called his book *From This Earth*, for it was about people who knew the taste of the land, breathed its dust, felt it in their hands, walked it daily, and had watered it with their sweat and blood.[4]

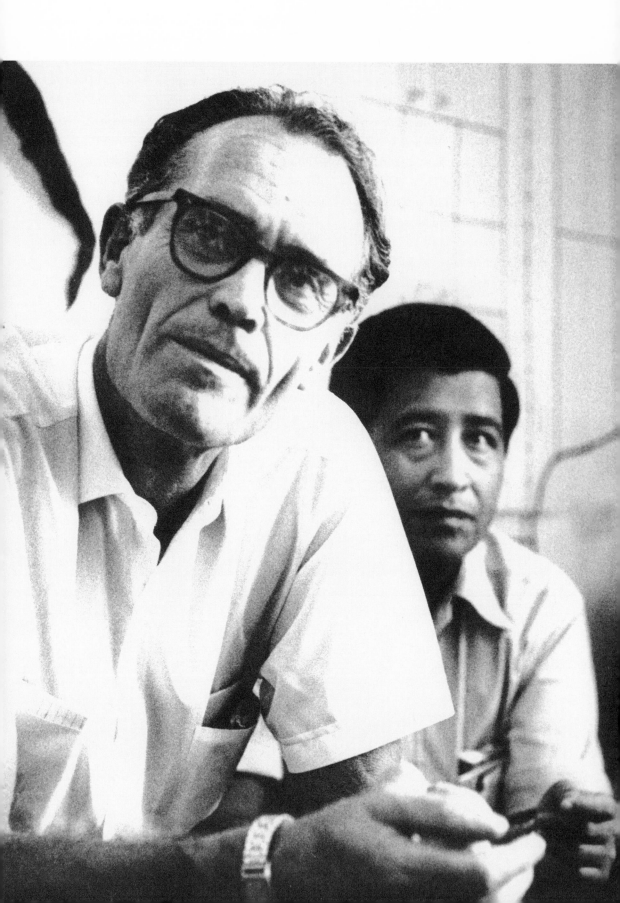

67. Voice

To properly convey his story, Lewis abandoned third-person narrative and cold academic voice. Without identifying himself as the speaker, he began his book with words from an omnipotent observer, part photographer, part huelgista. Relating what he had experienced, Lewis asked the reader:

How did it take hold here, this strike that will not be broken? Why does it last? Where can it head? Men with knowledge and position will give you reasons I would not understand. But the huelga came out of me and what is my life. I know of that in bones that have labored and a heart that has pride. I will tell you what I have seen, and what is my hope.[1]

And then, as if speaking to his *niños*, his children, gathered about. Be still. *Recuerda* — remember. A story about your mother and father and the huelgistas and their fight with the rancheros of Delano:

Our labor became a money crop harvested with the season. People swarm down the rows in a fever and go as locusts to the next crop. With winter, we draw together by the edge of these Valley towns, and manage the way we can. One day to Delano came a man to try his dream. He was of the fields with us, and had the migrant's road for his school. He talked about how we could get together by looking out for each other, we could claim our rights as men. From the dues of $3.50 a month we rented a building at the farthest edge of town. It would be long years before we had a voice in our day's labor. We were working together

185. "We had heard of Fred Ross as César's mentor in the cso [Community Service Organization], and he finally came aboard in the fall of 1966 to direct the organizing campaign for the August 30 DiGiorgio election. He was patient, thorough, and worked long hours. He led by example and earned incredible loyalty from the troops." August 1966.

and seeing what we could do, working for the day our daughters would not be at our sides in the fields and our sons would be as on the land.

In the most condensed and succinct account of the Delano grape strike ever written, Lewis added:

We had been building our union for over three years. By unanimous vote, we took a pledge of nonviolence and began our Strike of the Grape. That was September 16, 1965. We had $86 in the treasury. Growers and their armed guards couldn't scare us. The police started arresting us for calling "Huelga" to the workers. Days went into weeks. Just by holding on we lasted until people knew of the struggle. They came to walk the picket lines with us: Walter Reuther, Robert Kennedy, students. Then there was winter. A handful of men striking over four hundred square miles couldn't win just by picketing. What if a handful walked three hundred miles to the capitol to seek justice? The banner of our Virgin led the way through the endless fields of our labor. Instead of keeping on the outside of these Valley towns, we walked up their main streets. People saw us and came to our rallies. Three days before the march to Sacramento the announcement was made: Schenley had recognized our union. Our first victory! After all the broken strikes of this Valley, were these men and women around me the ones to do this thing, winning the first farm workers' contract in all of history? We looked at each other and knew our union would live. We were 10,000 at the capitol on Easter morning. We went back to the picket line and took on giant DiGiorgio, scourge of the unions. A death struggle we had to win. We went door to door, into DiGiorgio's camps at noon and after work. The Teamsters were there in fancy trucks, giving away free sodas and their plastic key chains. One of us sitting and talking to a group of workers was suddenly hit in the face with a beer can. He didn't fight back and was attacked. When we pulled the Teamster goon off of him, he said, "Is this the kind of union you want?" Some workers came from 1,000 miles away. We started by getting together with only a dream for our grandchildren, and had it came to us in our days. The Delano Grape Strike still goes on. The union will be a long time coming, and the seed will pass from our hands to others.[2]

Published late in 1969, *From this Earth* could not have appeared at a more crucial juncture in the grape strike. Safeway had endorsed NLRA coverage of farmworkers as a way to curb boycott activity. Boycott directors had choked off the market for nonunion grapes. Early-season table grape growers in the Coachella Valley, hard hit by the boycott, announced midway through the harvest that they were ready

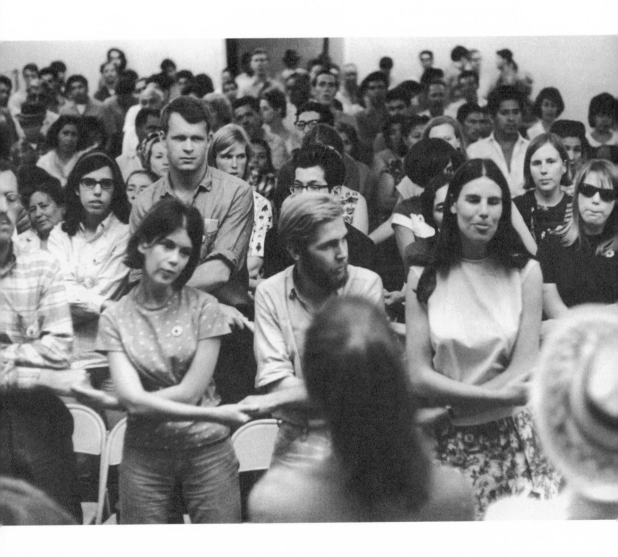

186. "The first Friday night meeting attended by student volunteers about to be sent off on the boycott. A number of them were with the union for years. The majority returned to school that fall — perhaps forever changed by the experience. Here they clasp hands while singing 'We Shall Overcome' in Spanish." Fall 1966.

to negotiate. Over a three-month period, UFWOC leaders met with ten table grape growers in sessions lasting fourteen hours a day.

While an agreement with these few growers would have been a major break-through, it would also have weakened the boycott against hundreds of other growers because shoppers would be unable to distinguish between nonunion grapes and those from vineyards with a UFWOC contract. Because UFWOC wanted an agreement with the entire industry, Dolores Huerta began dragging out negotiations by demanding control over hiring and the right to veto the use of certain pesticides. Under great pressure from all sides, anxious growers finally broke off negotiations after eighty-one other table grape growers filed a seventy-five-million-dollar lawsuit accusing UFWOC of violating anti-boycott provisions of the Sherman Antitrust Act. Although Coachella Valley grower Lionel Steinberg tried to settle independently, he withdrew the offer when federal mediators declared negotiations "hopelessly deadlocked" and nine growers asked President Richard Nixon to appoint a fact-finding committee to recommend a settlement.[3]

Underscoring the timeliness of *From This Earth*, veteran labor writer Dick Meister, who had been covering the strike since its inception, called the book "a genuine work of art" and gave it a glowing review. Calling attention to the "remarkable prose and poetic photography of a young San Francisco photographer," Meister's *San Francisco Chronicle* review praised Lewis as someone "who knows the how, and the what, and the why of the four-year-old phenomenon called the California Grape Strike in a way that 'men with knowledge and position' never have known it, even those who have made sympathetic attempts to tell it to those of us who wonder."

From This Earth — which also doubled as an MA thesis in photojournalism — was a completely hand-crafted effort, conceived, photographed, composed, written, bound, printed, financed, and marketed by one resolute man. It was perhaps the single most impressive effort in a long line of unique farmworker photo books. But Lewis never got much credit for his effort.[4]

While he slaved away on his book, a new photographer arrived at Delano. With much greater resources and extensive connections to photo agencies, magazines, and book publishers, Paul Fusco was already a famous, if not legendary, member of Magnum, the famous New York photo agency. Fusco had been shooting a *Look* magazine story on influential Californians when he learned of the grape strike. During three weeks in Delano, he shot several hundred rolls of film — more film than Lewis shot in three years — then returned to the *Look* offices, edited his film, and organized them into a photo essay that appeared under the title of "Nonviolence Still Works."

Laid out in story form, the images were accompanied by an interview with Chávez. Readers found it shocking in the way it justified the strike and explained the UFWOC's goals. Growers who saw it were furious. They dismissed it and news that it would soon be published in book form as more liberal propaganda from a biased and ill-informed press. A month later, the UFWOC generated more useful images with a mass march south from Indio through the Imperial Valley to the border town of Calexico.[5]

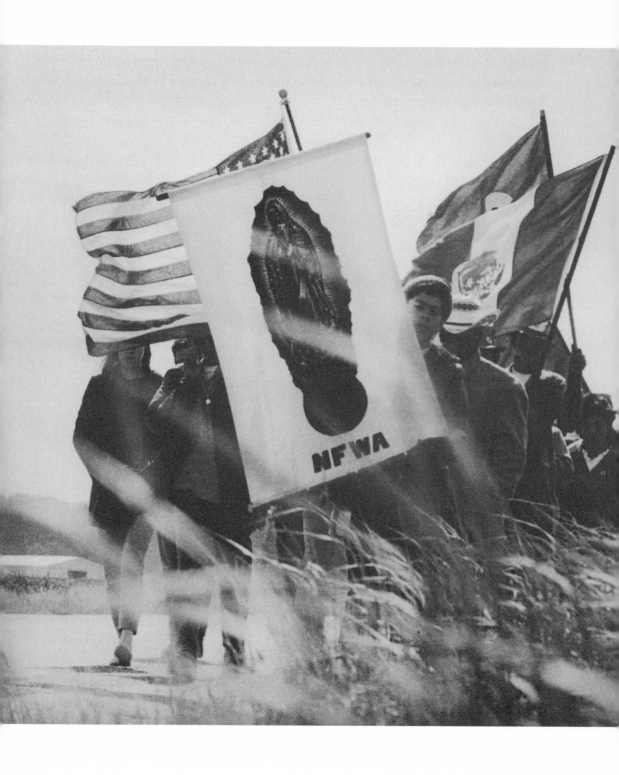

68. Film

After Lewis published *From This Earth*, he faced the same dilemma that had plagued other photographers. His conscience, his politics, and most important, his passion for photography and his belief in the farmworker cause told him to keep at it. He was sensitive to class problems, and he sincerely wanted to confront them. He accomplished this by filling his camera frames with people doing honest labor that was difficult and necessary and by capturing images that sprang from the earth and which he thrust into the viewer's face. Lewis was beginning to unravel an aspect of agricultural production that few were willing to admit. But he could only do so much.

But Lewis was short on funds. He lacked the connections necessary to continue. For all his talent, bravery, persistence, and generosity, he could not land a job with a newspaper or college. No photo agency picked him up, offered him a retainer, or asked for exclusive rights to his work. He had no real marketing plan. He was alone and immobile. Begging rides between Delano and San Francisco, he hung on as long as possible.[1]

Over the next year, Lewis continued with his photojournalism studies at San Francisco State University. He took every course in the program, and many outside it, including courses in art history, film studies and history, literature, and philosophy. By the time he received his MA in 1971, Lewis would have more than twice the number of units required for his degree.

187. "Perhaps my best shot of the head of the march. The bent, out-of-focus grasses in the foreground seem to suggest a flame spreading the movement across the Valley. Which is what the march did." March 1966.

Always happy to share his experiences and images, Lewis gave countless slide shows to audiences throughout the San Francisco Bay Area. At the San Francisco Universal Unitarian Church, Lewis was midway through one presentation when he dropped a carousel and scattered all of his slides on the floor. It was at that moment that he realized that he needed to transfer everything to film.

From his slide shows, Lewis obtained a clear idea of how he wanted to sequence his presentation, what themes to emphasize, the images that elicited strongest reactions, and which ones to dwell on. He had also started experimenting with sound. A striker named Eleasor Risco had made a half-dozen 5-inch reels on the picket lines and at confrontations, meetings, and performances by El Teatro Campesino. While "blocking out" his slide shows, Lewis had reviewed all of Risco's recordings and extracted the most useful parts. When he started transforming stills into a movie format, Lewis had a very clear idea of how it would all fit together. And he had a title. He called it *Nosotros Venceremos* (We Shall Triumph).[2]

Completely unfamiliar with filmmaking, Lewis did not even have access to the college film laboratory. His professors interceded on his behalf and he went to work learning everything from the bottom up.

Late at night when no one was around, Lewis made 11-by-14-inch prints. He then dry-mounted them, tacked them to the wall in the film laboratory, placed two lights at right angles to the prints, stationed a 16-millimeter Airflex camera on a tripod, panned across the images, and zoomed in and out. When the film laboratory was not available, Lewis tacked his prints to the walls in a nearby hall.

After he finished shooting his rough take, Lewis took it to a laboratory and had two prints made — an original and a work print. At times funds were so low that hundreds of feet of film sat in the laboratory for months before he had enough money to get it out.

Once he had his film, Lewis moved to the rewind bench to sync, cut, and stitch everything together. To learn more about the process of making a movie from still pictures he rented Barnaby Conrad's *Death of Manolete*, a wonderful documentary that provided Lewis with fine examples of pacing, building tension, and the way to intercut crowd shots into the narrative. He also studied Leni Riefenstahl's *Triumph of the Will*, a Nazi propaganda masterpiece that provided further insights into matters of structure and technique.

Lewis devoted nearly a year to assembling *Nosotros Venceremos*. It was tedious work. Of his routine, Lewis recalled:

> At night when the film laboratory was not in use, I cut my film using an Oxberry Animation Camera. The Oxberry was a type of rostum camera — a movie camera

especially adapted for frame-by-frame shooting of animation and stop action. It consisted of a camera body with lens and film magazines, a stand that allowed the camera to be raised and lowered, and a table, often with both top and underneath lighting, that allowed you to move the art. The artwork to be photographed was placed on this table. With the Oxberry, you could view your film one frame at a time. There were all kinds of dials to make slight adjustments and control your sequence. I basically cut the film sequences to coincide with sections of the sound from Risco's recordings. There might be a pan across a picture from the march. I wanted that pan to match exactly a phrase or speech or ten-second section of music. I had the sound on sprocketed magnetic tape. The trick was to sync it up exactly with the film. In the Oxberry camera you could get the two together. But it was very time consuming. Basically you exposed a single frame at a time.[3]

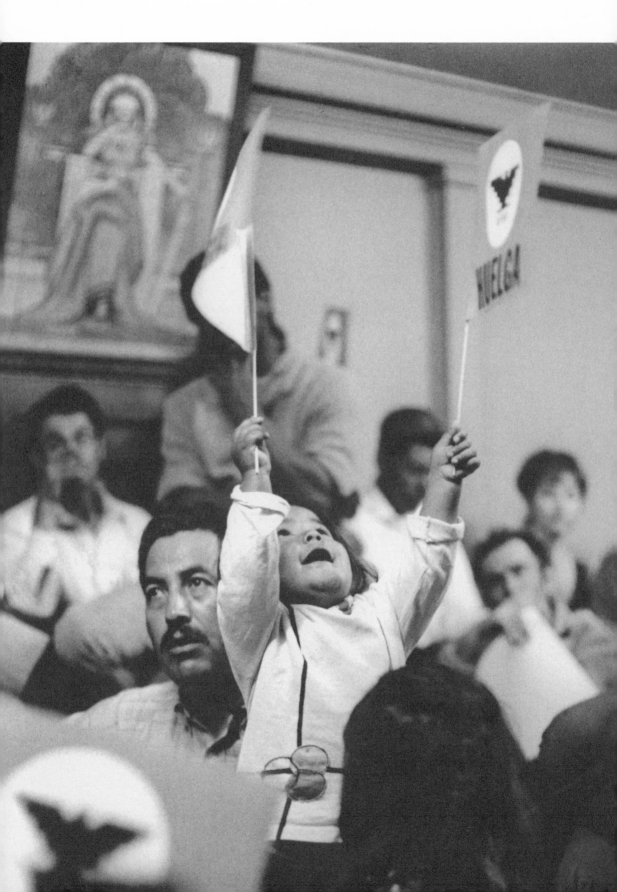

69. Contract

Shortly after Lewis started working on his film, the table grape industry began to think about bargaining with the UFWOC. Growers felt beaten. Everything seemed to be turning against them. Boycotters had cut the number of boxcars of table grapes unloaded in New York by 30 percent and reduced sales in Baltimore by half. With more and more supermarkets refusing to carry table grapes and the media apparently on the side of the union, Delano grape grower John Giumarra Jr. met with the UFWOC on July 25, 1970, at 4 a.m. in the Stardust motel in Delano. He said he was ready to sign a contract.

UFWOC attorney Jerome Cohen understood visual culture. He knew that a picture of a contract signing would have a huge impact on the movement, on the public, and most importantly, on farmworkers. He was not going to sign a contract out of sight in a motel room in the dead of night. And he was not going to sign contracts individually, as growers agreed. Cohen had read farmworker history. He understood the gravity of the moment. Nothing like this had ever occurred. No agricultural industry had ever sat down with a farmworker union leader to sign a contract. Now Cohen had a chance to create a photo opportunity the likes of which had never been seen previously in California. He told Giumarra to round up all twenty-six Delano grape growers and meet Chávez on July 29 for a public ceremony in the newly erected Walter Reuther Hall at Forty Acres.

Lewis took the bus to Delano, arriving just as the contract signing was about to begin. Stepping inside Walter Reuther Hall, he was overwhelmed by the sight before him. Four decades later it remained deeply imbedded in his mind. He recalled:

> Cohen created the kind of picture the farmworker movement needed. Volunteers and the union members had spent the past four days carefully preparing for the

188. "Each night of the march to Sacramento there was a new audience with all kinds of kids in tow. Some adults did not care for the camera pointed at them, but the kids were great subjects." Fall 1966.

big event. They hung banners, set up chairs, laid out microphones, and placed lights around that hall and then hit the telephones. They called everyone — friends and boycott leaders. Come to Delano. Come quick! It was so well planned. You could not point a camera in any direction without recording some union message, the union black eagle. Everything was directed toward the stage, which was just surrounded by banners and flags and ranch committee placards. The atmosphere was one of jubilation. They had done the impossible. But no one would believe it until they saw those growers on that stage. The union wanted pictures. They wanted that moment recorded from every angle so that it could not be disputed.[1]

At exactly 11 a.m. on the scorching hot morning of July 29, César Chávez stepped before a wildly enthusiastic crowd of 200 Mexican American and Filipino American field hands. Lewis recalled:

Everything was stage-managed for the cameras, even the smallest detail. Beside Chávez at a long table full of microphones and tape recorders were all of the other UFWOC leaders. Huerta. Itliong. Cohen . . . Next to them were representatives of the AFL-CIO. And next to them [representatives from] both the Catholic and Protestant churches. It looked like the world was on the side of the farmworkers. The grape growers were on foreign territory. Humiliated. Humbled. Outnumbered. There they were in their plaid shirts and long-sleeved white shirts. It was too hot for anyone to wear a tie. The growers seemed so powerless. I was between them and the crowd. There must have been dozens of photographers all around me maneuvering for position. Every photographer who had ever covered the farmworker movement and could make it to Delano was there. George Ballis was there. Ronald Taylor was there. A dozen newspaper photographers were there, photographers from the *San Francisco Chronicle, Los Angeles Times*, AP and UPI. Plus all kinds of stringers and freelancers. It was so noisy we could not hear one another talk. We were all sweating and anxious. I could hardly believe this was happening. And behind us the hall was packed with farmworkers just delirious with joy.[2]

Although Lewis took the event as it came, his colleagues were hardly passive observers. He had never seen them behave so aggressively. Of their role at the contract signing, Lewis recalled it as "a typical gang bang photo op" in which

the photographers dominated the event. They exerted a strong influence on the ceremony. They were very restless. Everyone was there for the same shot. No one wanted to be blocked. Everyone kept moving to make sure that they would

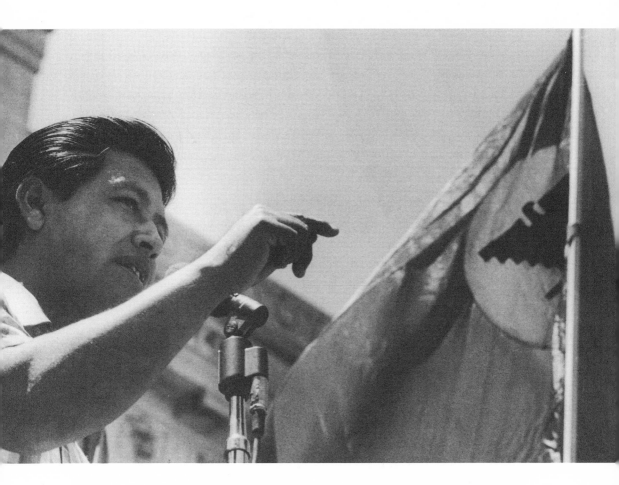

189. "César wasn't a dynamic, animated speaker, but he was methodical and forceful. You sought a telling gesture or expression and sometimes it happened, but often not." Fall 1966.

have a clear view. You staked out a spot and defended it. If you got between a photographer and the stage, you got shoved out of the way. When Chávez began to speak it was pandemonium. The room erupted in an explosion of strobe flashes. For the next ten or fifteen minutes, every gesture inspired a wave of shutter clicks and flashes. I tried to fit my shots into the ebb and flow of events, when my exposures would not be overwhelmed by all the light. I remember just staying focused. You were aware of all this commotion, but you kept everything framed in your viewfinder.[3]

Chávez ignored the commotion. Speaking to the packed hall, he recalled that when the strike had started, farmworkers asked $1.40 an hour and 20 cents for each field-packed box of grapes. Now they would receive $1.80 an hour and 25 cents per box. Chávez also stressed that growers had agreed to pay 10 cents an hour into the Robert Kennedy Health and Welfare Fund and 2 cents an hour into a special service fund, and would accept a union hiring hall arrangement. With that short speech, he prepared to sign the contract.

Sensing the historic picture, Lewis and the other photographers crowded even closer. A few fired off "cover your ass" shots of John Giumarra Jr. smiling uncomfortably as he rose from his seat, addressed the crowd, dismissed the past, and hoped for a new relationship. Chávez then moved to a position alongside him and said a few words. When Bishop Joseph Donnelly of Hartford, Connecticut, who had assisted in negotiations, leaned over between Chávez and Giumarra and thumbed through the agreement, Lewis snapped a picture. With that, the scene was set.[4]

Like most of the photographers present, Lewis had high hopes. He believed that with victory the UFWOC would organize farmworkers in all of the major California crops. From that base, it would branch out across the country to create the largest labor union in the United States.

"Today's really, truly, the beginning of a new day," Chávez announced.

"We thank God for all these things, and we thank you, too," Lewis said. "Amen."[5]

Whatever Chávez said next has forever been lost because one photographer, unable to wait for events to unfold naturally, shouted for Chávez to shake hands with John Giumarra Sr. At that moment, Giumarra Sr. threw his hands over his head in a victory sign. His son smiled. Bishop Joseph Donnelly and Monsignor George Higgins started clapping. Larry Itliong beamed. As the audience broke into uproarious applause, Lewis and every other photographer present started snapping pictures.

Vividly etched in his memory, Lewis remembered the scene as

a blur of flashes. We shot that historic moment from every possible angle. Photographers momentarily drowned out every sound in a whir of motor drives advancing film through their cameras. The shutters all releasing simultaneously sounded like a swarm of locusts. I had no motor drive, so I just kept advancing the film manually and shooting. I did not want to miss anything, so many of my shots were made in anticipation of a gesture that was about to happen.[6]

Following the contract signing, Lewis was saying goodbye to old friends when a representative from some Los Angeles trade union papers approached him and asked to borrow his film. Lewis recalled that

he said that he would pay for the film, return it, and that I would be given credit. I was so naïve. I let him have the film. I never saw it again. Otherwise I would have used it in my film.[7]

70. Broke

Back at San Francisco State University, Lewis slaved over his film. He considered it his best work and thought the Eleasor Risco recordings gave it a terrific sound. Chicano Studies programs, then just beginning to establish themselves, bought a half-dozen copies, as did libraries and museums. Lewis showed his film at various film festivals, then took it to Europe. He went on to show it at the London School of Economics and to audiences in the Netherlands and Italy. At the end of his tour, he put the film in his backpack and headed to Spain but returned home without unpacking the film. "It was probably for the better," he recalled. "Generalissimo Franco's spies would not have been pleased."[1]

Broke and without a job, Lewis fell on hard times. For several years he lived in a sequence of residential hotels. After getting back on his feet in 1972, he operated a storefront studio in the Castro District. For a time he made a good living selling silk-screened prints of pictures he had made years earlier of Machu Picchu, Mexico, and Egypt. Eventually he found work on the night shift as a photo offset press operator. After stripping film for eight hours, he rode the bus home at 2 each morning. His cameras were in disrepair. His lenses were scratched or broken. His camera bag was full of holes. He was overweight, diabetic, and on medications for high blood pressure. Lewis lacked the time, energy, money, mobility, and physical capacity to follow up his documentary work.

Lewis last photographed at Delano when the farmworker movement was triumphant, having won contracts with the entire table grape industry. In 1973, three years after Chávez appeared on the cover of *Time* magazine, growers refused to resign with the UFW. Another battle was on. A war with the Teamsters union culminated during July with the mass arrests of over three thousand farmworkers who clogged the rural jails between Indio and Delano. Two farmworker pickets were killed. No one ever served prison time for the murders.

After the grape strikes, UFWOC became the United Farm Workers (UFW) and attempted to regain lost momentum. Enactment of the Agricultural Labor Relations

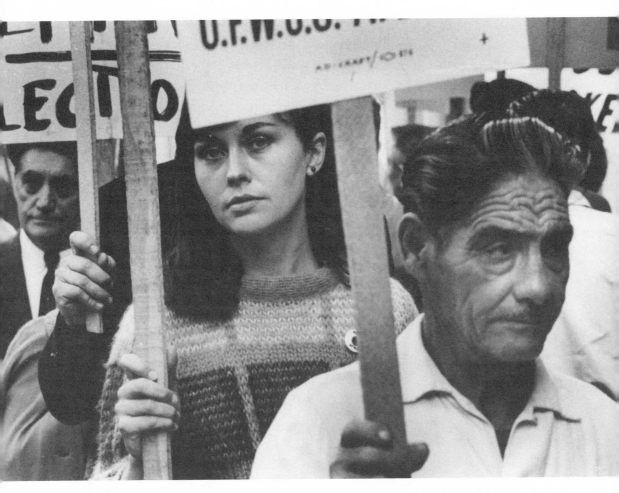

190. "Back in San Francisco to start grad school in September 1966, I plugged into the boycott office. I would join the picket line on weekends. Here a Delano striker walks the line in downtown San Francisco beside an attractive coed." Fall 1966.

Act in 1975 provided farmworkers with the right to union representation elections and collective bargaining and inspired a wave of representation elections, the majority of them won by the UFW.

Four years later, the union won a vegetable strike, pushing wages up significantly. An impressive legal staff, led by Jerome Cohen, won one victory after another. When the Teamsters union finally withdrew from the fields, the UFW was freed from a bitter rivalry that had sapped resources for a decade. Briefly it seemed that unionization of agribusiness was inevitable and that growers had either dropped their pathological hostility to Chávez or become reconciled to the inevitable.

Within a few years it all began to unwind. Republican governor George Deukmejian (1982–91) systematically undermined and gutted the state Agricultural Labor Relations Act, leaving union members without contracts decades after voting for a union. Within a few years the union lost all but a few of its contracts in the vegetable industry. Top organizers left or were purged. Executive board members who were purged or departed included Phillip Vera Cruz, a founder of the union; Gilbert Padilla, one of the NFWA's original team who had served as secretary-treasurer; and Jessica Govea and Marshall Ganz, two long-time organizers who had guided the union since its inception. Among the top aides who were fired were Eliseo Medina and Nick Jones. Rank and file leaders who were fired included Mario Bustamante, Hermilio Mojica, Aristeo Zambrano, Rigoberto Pérez, Sabino López, and Berta Bates.[2]

No longer closely connected to the UFW, Lewis learned through friends that internal struggles were further splitting the union. Hand-picked executive board members loyal to Chávez were pushing the boycott even as rank and file workers were demanding strikes and grassroots organizing. Ranch committees were protesting the undemocratic and increasingly hierarchical leadership, as well as decisions emanating from leaders in the union's isolated former tuberculosis sanitarium in the Tehachapi Mountains.

Lewis attended several of the annual union conventions but found them to be staged affairs with little conflict, where hand-picked delegates endorsed proposals by the executive board. Lewis was especially galled by the strange alliance that Chávez maintained with the Los Angeles–based drug rehabilitation organization Synanon and its megalomaniacal founder and cult leader, Charles Dederich. Friends were telling Lewis that César was adopting Synanon techniques and that union staff members were being kept in line through a groupthink ritual known as "The Game." Then came a series of newspaper exposés describing how Synanon-style games had become tools leading to purges that enforced unquestioned obedience and smothered the democratic, contentious, and creative engagement that Jon Lewis had once documented.[3]

During August 1988, Lewis watched Chávez try to rekindle the movement with yet another dramatic fast. To renew the table grape boycott and draw public attention to pesticide poisoning, Chávez broke bread with civil rights leader and presidential candidate Jesse Jackson. But on April 23, 1993, Chávez died suddenly in his sleep, not far from the Arizona homestead where he had been born. He had been giving testimony in a long and protracted court case against Bruce Church Co., a large Salinas Valley–based vegetable growing company that was about to win a $9.2 million lawsuit against his union. Chávez was 66 years old. He had led such an overloaded life full of crises and tension that close friends said he appeared to be 122.[4]

When Chávez died, Lewis thought that the UFW had become a shell of its former self. Over the years he had watched the union oscillate between dramatic highs and lows. Within a few years of each other, old friends Jim Drake and Fred Ross died and Dolores Huerta retired. Larry Itliong, with no power in the union, faded even further into the background. Jerome Cohen left the UFW for private practice. Lewis was disappointed when César's son, Richard, never stepped forward to fill his father's shoes. Watching union membership decline and union contracts expire, Lewis thought that the irreverent fighting organization that he had once known and loved seemed to be dissolving into a family-held small business of interlocking foundations.[5]

After Arturo Rodriguez assumed leadership of the UFW, Lewis saw hope flicker briefly. In yet another symbolic photo-op, Rodriguez met with Robert F. Kennedy's son to publicize the union and launch yet another organizing drive. But in the seventeen years that followed, organizing drives sputtered along, boycotts achieved mixed results, and old problems remained. As hostile as ever, growers developed new mechanisms to thwart unionization. And the labor force, constantly replenished by waves of new immigrants, had but a dim notion of Chávez and the farmworker movement and no idea where they were in California.[6]

What most irritated Lewis was the way symbolic victories increasingly passed for real progress. Lewis was thrilled in 1995 when politicians honored March 31, the birthday of César Chávez, as a mandated holiday for state employees and an optional one for public schools. But he saw few substantial changes in the fields.

Preparing for one of his last interviews, Lewis wondered whether he would be alive for another. He had spent a day carefully sorting through his library and scribbling notes. When we sat down to talk, he compressed this thinking into a typically cryptic statement.

He began in a characteristic fashion:

"Lordy, lordy," Same struggle. Same actors. Same villains. Same everything. Labor contractors even worse. Growers insulated from responsibility. Wages down 25 percent [from their highs in the 1970s]. Housing scarce. Some places resemble what we saw in the Great Depression. The revisionists are busy. César Chávez is no longer a saint. Who is the first president of the Chicano nation? The public is as apathetic as ever. We once had great hope. We thought we could change things. We did. Now it all seems problematic. So many contradictions. Too many betrayals.[7]

71. Redemption

Toward the end of his life, Jon Lewis went back into the darkroom to review old contact sheets and begin making master prints. When old friend and NFWA member Leroy Chatfield launched, in 2002, a massive and ongoing website devoted to the farmworker movement, Lewis for the first time had an outlet for his work. Posting his images at www.farmworkermovement.org, he suddenly found himself overwhelmed by requests from documentary filmmakers and historians and from old farmworker union volunteers who saw themselves in his images.

After the Beinecke Library at Yale University purchased his entire archive in 2008, Lewis began using his money to obtain photographic paper and darkroom time. Every day at 9 a.m. he rode the bus downtown to the one public darkroom available. Every evening at 6 p.m. he returned with a stack of prints.

Systematically examining his work, Lewis made the first archival prints since his student days at San Francisco State University. He was energized. For the first time in his life, he had time to review and scan contact sheets made in haste, in a primitive darkroom, under difficult conditions. He discovered countless images he had overlooked and neglected to print. On a good day he produced six to eight satisfactory images — and a huge stack of rejects that seemed just fine to everyone who viewed them.

Seeing his images, we discover a photographer trying to shake us free from a consumerist ethos contending that pain, suffering, exploitation, and oppression are accidental, not endemic. It is difficult to accept the tyranny that Lewis saw and recorded, for it requires acknowledging a ubiquitous and repressive ugliness.

Jon Lewis made his images as part of a political decision that directs people's eyes. Lewis stood in these spots. He looked this way. He framed this scene. He ignored the extraneous. He maintained his focus while engaged in an intricate intellectual process culminating in the instant when his eye triggered his brain to press the finger on the shutter.

Lewis had paid a steep price. He sweated bullets. He did not sleep for days. He stank and had no time to eat a proper meal. He climbed trees and telephone poles.

191. "Here comes that pesky gringo photographer to bug us as we're taking a break from the march." Spring 1966.

He walked hundreds of miles. He hopped on the back of motorcycles. He wedged into the back seats of old automobiles. He ate dust. He inhaled Valley fever spores. He scrounged and borrowed money and postponed his education. Foremen threatened him. Cops threatened him. Thugs slapped his camera. People borrowed his film and never returned it. News media refused to publish his work. Editors waved him away. He lived in obscurity and died in poverty.[1]

One effect that Lewis has on us is that we find ourselves sharing in his passion and commitment. Lewis was not a dispassionate observer. He had a point of view. Delano was never just an assignment. The farmworker cause was, and continued to be, at the core of his being, the high point and defining moment of his life.

Another effect Lewis has is to underscore the physical demands of good social documentary photography. Looking over his shoulder can be an exhausting exercise in tightwire walking, delightful to recall, but a test of physical endurance and mental stamina at the time. We want to ask Lewis how he was able to keep a steady hand.

A third effect Lewis has — perhaps as no other photographer before or since — is the way he captures key elements separating the agricultural labor environment from the urban. This cannot be overemphasized because it goes to the heart of perennial questions about why farmworker unions failed. Lewis carries us into a very different world in which everything conspires against labor organizing.[2]

72. Ubiquitous

Jon Lewis went deeper into California farm labor struggles than any other photographer before or since. Poor in resources, he was rich in time. Free of deadlines, he waited and watched. Belonging to no particular journalistic or academic tribe, he adopted an interdisciplinary perspective.

One day Lewis is taking us on a tour of Delano, darting away from the big Welcome sign, over to the railroad tracks to see the town, neatly split, east and west. The next day he is padding down a back alley, later bisecting a side road to a labor camp, then crossing the tracks, past the big cold storage and shipping sheds. He takes us past the magnificent Italian cypress–lined faux villa drives, out of the shadow of the Chamber of Commerce, into a flat, dusty environment of sand and killing heat. Through his lens we see an environment where irrigation canals interrupt the monotonous green of vineyards and yellow Thrush Commanders spewing plumes of who-knows-what roar straight up and over trucks hauling fruit on Highway 99.[1]

Looking at his images, one asks again and again the same question: how many hours and days did it take to get that shot? One finds in his work a passion for details, the need to see and amass, to poke about and scrutinize other people's lives without being oppressive or getting in the way. Other photographers went for the obvious. Lewis was nuanced, layered, and comprehensive. His work verifies a fact known to all of us who photograph strife and confrontation: danger strips away the fatuous, forcing a reflection on what is important and what is not. For anyone who is curious, exhaustion and hunger are the challenges that keep you alert, even while making your life difficult. A safe and predictable environment smothers visual engagement, which is why social documentary photographers like Lewis are a rare species in affluent times.

Dust and poverty, exploitation and anger, solidarity and failure, are all here in a photographic prose poem populated by leaders of the grape strike. So are growers, all second-generation Croatians whose parents had arrived in the Valley poor or poorer than the Mexicans they employed, and at the end of a far longer journey.

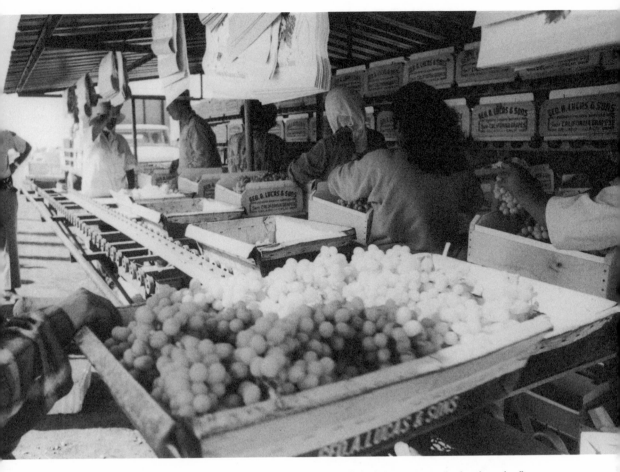

192. "Field workers packing table grapes in boxes that will find their way to the local market." Summer 1966.

Here are the Filipinos carrying their luggage and pruning shears into labor camps, Mexicans dishing out meals in the strike kitchen. Luís Valdéz is here, looking like Ché Guevara. Augi Lira is here, looking like a wild lunatic. Anonymous strikers are here, with their children, packed into crowded union halls, listening, holding their children up to see Chávez, saying remember this moment, do not forget. We see the daily minutiae that had heretofore escaped the camera as well as the dramatic events that became defining images for an era. Simultaneously a record and part of the struggle, this photography illustrates what it means to challenge authority and develop countervailing power at a time and place when such activity was often suicidal.[2]

73. Impact

Where does Lewis fit in the pantheon of California photographers? For determination, there was Leonard Nadel, a Los Angeles commercial photographer who tired of his work for *Forbes* and *Fortune* and in 1956 traveled deep into Mexico to produce a massive photographic essay on braceros. Full of strong and at times revolting images, Nadel's work went virtually unnoticed. But unlike Nadel, who returned to his commercial and travel photography and managed to make a good living, Lewis never worked again as a photographer.

For substantive work among the outcast and dispossessed we have Dorothea Lange and other FSA photographers. But unlike the FSA photographers, Lewis never drew a more or less steady paycheck, never had the backing of any government agency, and never received credit for his accomplishment. His one consoling reward was that unlike Lange and her cohorts, Lewis got to keep his precious negatives.[1]

Among his predecessors, Lewis seems to most closely resemble Otto Hagel, the German émigré photographer who, with his wife, Hansel Mieth, lived as a migrant while photographing in the fields in the early 1930s. But even here the analogy breaks down. While Hansel became a *Life* magazine photographer and Otto went on to a successful freelance career with *Fortune* and other magazines, Lewis struggled to survive.

Lewis illuminated a moment in time, then faded from the scene. A modest man, he remained a bachelor. He never told his story. Only once, toward the very end of his life, did he ever volunteer a thought about the fanatical, creative impulse

193. "There was a California congressional hearing in Delano in the fall of 1966. With the TV lights on you had a certain freedom of movement, but the telephoto lens didn't have the depth of focus to have both César and Dolores sharp. I have adjacent frames where I focused first on her and secondly on him. Am I a purist, 'What you see is what you get' documentary photographer, or will I fudge a bit and hire some Photoshop time to have the two frames combined so that both are in focus?" Fall 1966.

that kept him going. Delano, he said, was the type of story that demanded "an ability to edit out the extraneous and zero in on what was important, and to capture it in shades of black, white, and grey. I knew the story was of immense significance. I knew it was a personal test. All that I was really trying to do was capture a few enduring images. I don't think I ever found the kind of symbol that could serve as shorthand for the strike. Some people say that I did. It's for them to decide."[2]

Hearing such statements, old compatriots, new friends, and fellow photographers urged Lewis to complete his life's journey and share his work with an appreciative public. By then it was almost too late.[3]

194. "One of the pair of shots, in one of which César is in focus and Dolores in the other." Fall 1966.

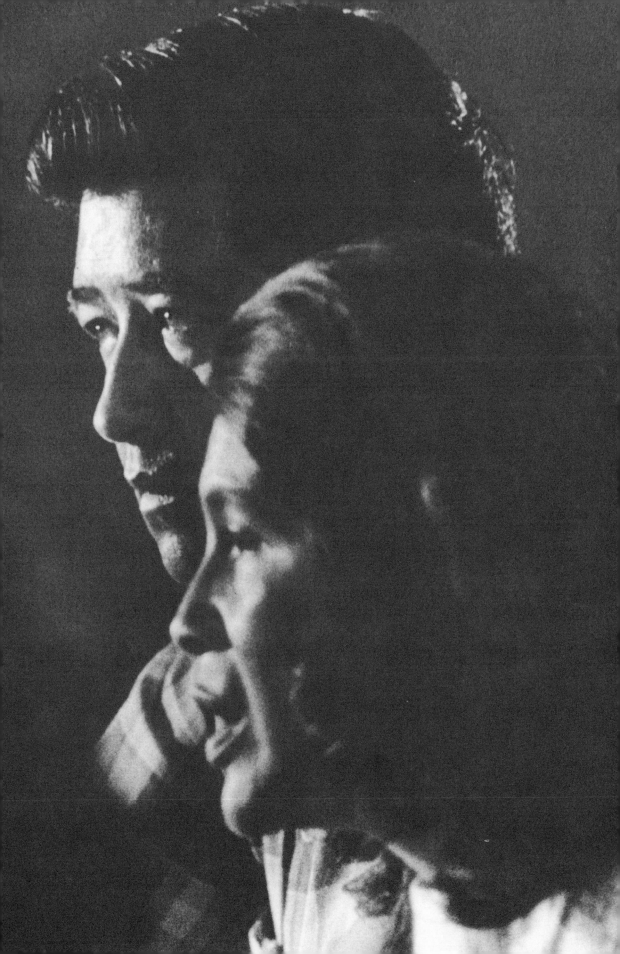

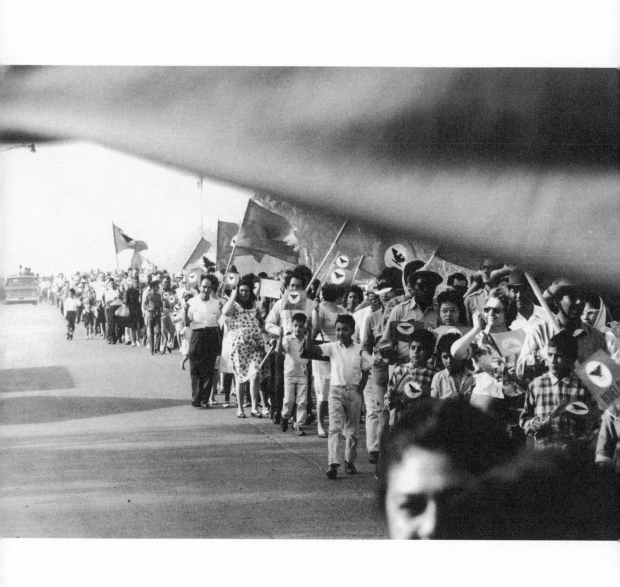

74. Decide

Jon Lewis inhabits that nebulous territory separating the persuasive objectivity of photojournalism from the emotional punch of propaganda. He had an instinctive sense of where to be, when to photograph, and when to keep quiet. This is why so many of his images convey a vicarious sense of what it felt like to be present on the picket lines or at Friday night strike meetings.

Studying photographers like Lewis helps us approach that which we all seek — understanding of ourselves. Observing him sleeping in a room saturated by chemicals, digging an automobile service pit, mixing adobe, scrounging for film, rising before dawn, living on beans and coffee, shivering in the fog, baking in the sun, spitting back at security guards, standing up to goons, and plugging away to take good pictures we glimpse many of those human qualities that we all admire.

We stand in awe of his courage. We marvel at his innovation. In Lewis we see a kindred spirit, yet another great photographer drawn to the fields, further evidence that engagement with farmworkers is the defining characteristic of so many California photographers not normally considered in the same breath.[1]

Assessing the impact of such photography, critics sometimes claim that it uglifies a picture and underscores the negative in order to advance a career. Or they say the opposite, that photographers like Lewis make suffering seem beautiful — that they are guilty of "aestheticizing" pain and turning it into profit. There is also a strain of thinking holding that through constant exposure to such work we develop a "compassion fatigue" that numbs our senses and craves ever more sensational images. Or that the proliferation of such images either clogs our optic nerves or blinds us in a storm of images.[2]

195. "This is a victory lap the weekend after the conclusion of the march to Sacramento. Just a half block ahead of me, [George] Ballis was taking his great shot of César in the line of the march. I was a block short and many bucks behind from that moment on." Spring 1966.

Lewis was not a visual vulture. He had a good, educated eye and a fine sense of composition. He was humble and patient. He was not the big shot training his lens on the less fortunate. He was not out scrounging up atrocities and composing them for exhibition on museum walls. He was substantive and anti-art. His images are seldom cute, clever, or detached. His work adds up. It is the antithesis of the isolated, disconnected moments of spot news. Lewis has a sustained gaze. His sequences link together in a picture that is larger than its individual parts. Lewis did not so much take photographs as store images that awaken a deeper interest in the farmworker cause. The result is a view of contemporary history peeled back and stripped clean.[3]

Lewis helped the NFWA launch a boycott of table grapes and projected the farmworker movement far beyond the vineyards into the larger public arena. His images force us to see agriculture differently. If we read his images as if they are words then we begin to glimpse more than a vast ocean of vines bursting with beautiful and delicious grapes. When we place those grapes in a bowl in our kitchens or offices, we now think about where they come from. We understand that vast networks of people pick, pack, prune, and cultivate those grapes. We understand that they work quickly and seldom stop, that their income depends in large part on their productivity. We think about their calloused hands, their lined and deeply tanned faces, and the clothes that protect them from the sun and dust. To pick those grapes, they stoop, crawl, kneel, snip, cut, lift, carry, bleed, and sweat. They are ordinary people who do ordinary things in an industrial environment where shouting matches occur, in a place of daily humiliations, fistfights, nervous breakdowns, numbness, and resignation.

Lewis makes us look more closely at a process that is taken for granted. He destroys pastoral myths. He demands that we become more fully conscious of the true cost of cheap fruit and vegetables. He calls our attention to the human price paid by a transnational class of landless peasants, excluded from the social and legal privileges enjoyed by most Americans, who are as important to fruit and vegetable farmers as the sun, water, soil, and technology.[4]

Through Lewis we see the sacrifice and courage required to challenge the rural power structure. We sense that it was a brave act for anyone to leave their job and walk the picket lines to be blacklisted, purged, labeled a troublemaker, or denounced as a "Chavista." Lewis shows us the farmworkers who lost jobs, the families that lost homes, the friends who parted forever, the communities that split, the students

196. "Jorge Saragosa, one of the march monitors, was our always-congenial presence, and it was hard to take a bad picture of him. I'm sure I managed to do that, but not this time." Spring 1966.

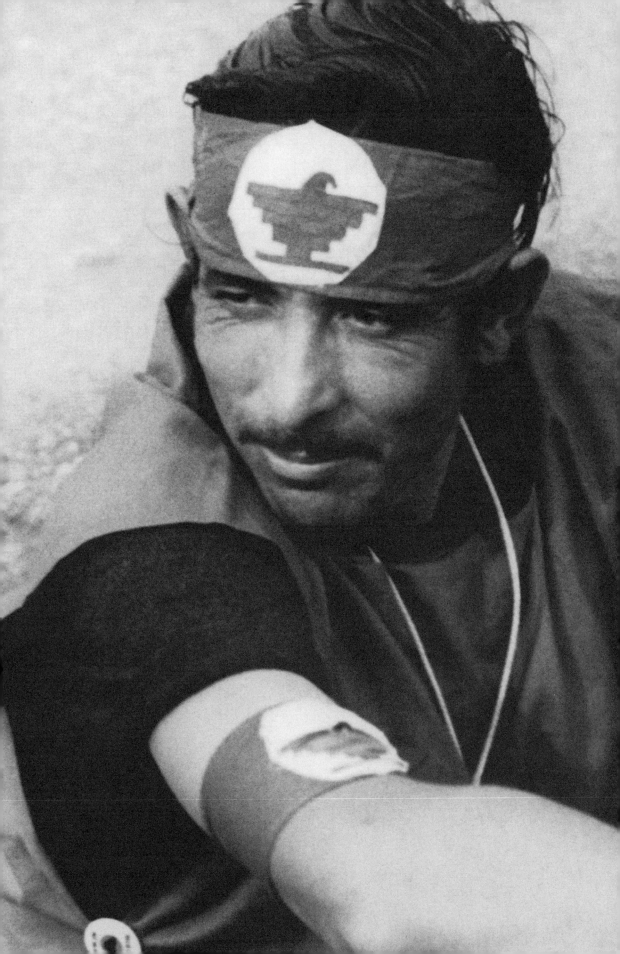

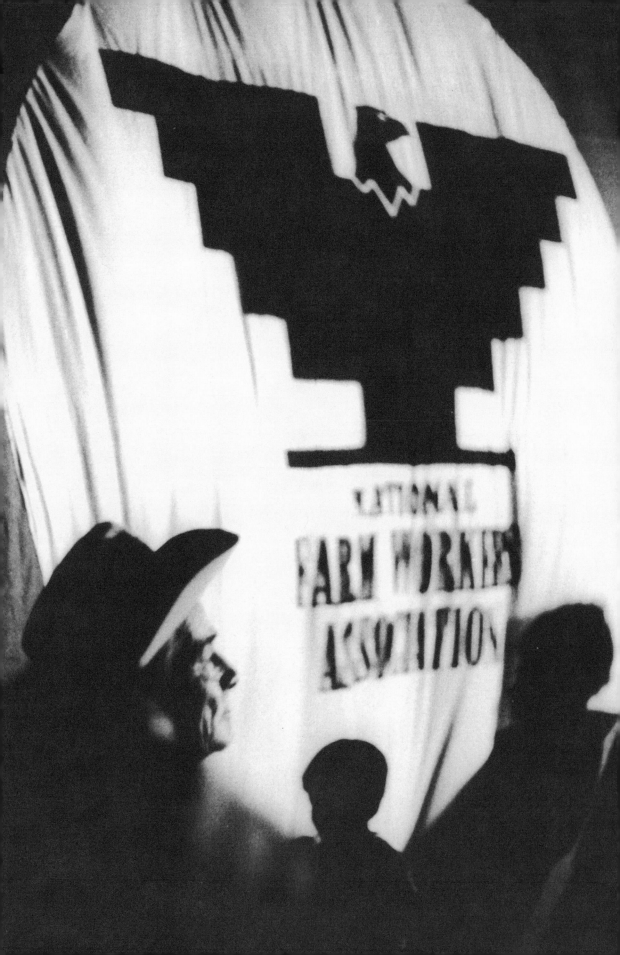

who were expelled from school, the contractors who had to leave town, and the strikers who gave up. He also shows us those who persevered, who would not stop or quit until they had organized a union and began to develop the countervailing power required to overcome a century and a half of abuse and exploitation.

This is the other gift that Lewis provides to those born after the tumultuous events of 1966–70. There is no better way to understand what the farmworker movement aimed to accomplish than to scrutinize the scenes he captured. Through his images we understand how far the farmworker movement has come — and how far it has to go — in overcoming a California variety of apartheid.

I wonder what Lewis would have accomplished if he had not fallen on hard times, if he had been able to control his diabetes and maintain his health. There was certainly plenty more to photograph, although Lewis would not have had the access that he once enjoyed. All of his old friends from Delano were either dead or had left the union. Nor would he have been in the middle of the action. Whereas Delano had been ground zero for the farmworker movement of the mid to late 1960s, no location played a similar role thereafter.

Perhaps some combination of fellowships, grants, and encouragement would have helped Lewis stalk the story across the decades. But Lewis used public transportation and never obtained a driver's license. He had become overweight, was often ill, and swallowed a handful of blood pressure pills each day. He had undergone heart oblation to restore proper function. He was not adept at writing grant proposals. He never received the guidance necessary for tapping into such resources. He preserved his negatives in their original glassine holders. He packed his prints inside manila envelopes and used photographic paper boxes stacked, floor to ceiling, under less than ideal archival conditions.

Lewis was obsolete and he knew it. He could not follow events. Still loyal to the UFW, he joined John Kouns and myself as we picketed a restaurant in San Francisco to protest the failure of Charles Krug Winery to bargain collectively with the UFW. Over beer that evening, Lewis said that he knew he was obsolete. At a time when instantaneous communication and digital pictures had pushed aside magazines and still-picture photo essays, he found no outlet for his work. Struggling to learn Photoshop and to acquire the digital technology required to scan his images into a computer, he was in a race with time. He feared that he would die before he finished.

197. "A year after the march to Sacramento we dedicated Forty Acres, where the union would build its first headquarters. The thunderbird banner once again was a backdrop on a flatbed truck. Another hand-held, out-of-focus gem, but maybe the bold compensates." Spring 1967.

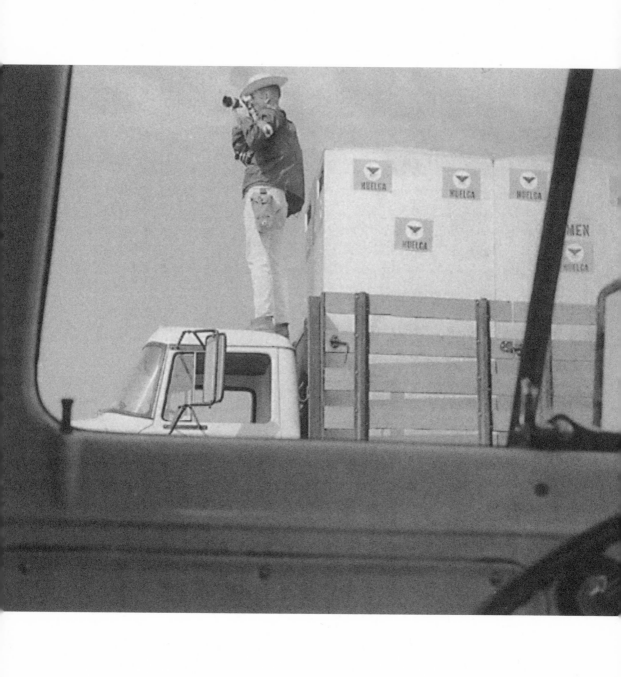

75. Parting

Jon Lewis helps us reach back into the era before cell phones and fax machines, websites and e-mail. We sense the challenge faced by organizers who could barely afford a telephone, who dismissed photocopies as too expensive, used donated manual typewriters, who could hardly scrape together money for postage, writing paper, pens, pencils, and gasoline.

LeRoy Chatfield remembers those dark days. He remembers Jon Lewis. A member of the UFW from 1965 to 1974, Chatfield became part of Governor Jerry Brown's staff and served as a member of the California Agricultural Labor Board (ALRB). In retirement he created the gigantic and ever-expanding Farmworker Movement Documentation Project website.

Countless memories from so many key detours along the winding road from Delano remain burned deeply in his mind. As if yesterday he recalls La Peregrinación, the March on Sacramento in 1966, when he walked the back roads and knew that farmworkers could not be harassed and intimidated because Lewis and other photographers were there. He often ponders how deputy sheriffs pulled over picket caravans, with no photographers present, and proceeded to harass and arrest pickets, leaving him angered when no one was around to record the intimidation. In 1970, after Teamster thugs near Salinas smashed the camera that journalist Jacques Levy was carrying and beat attorney Jerry Cohen into a coma, he understood what so often

198. Gerhard Gscheidle made this photo of Jon Lewis photographing from the Porta-Potty truck while on La Peregrinación. Spring 1966.

happened absent any journalistic eyes of conscience. When he saw deputy sheriffs in Arvin in 1973 rip cameras out of the hands of UFW members and spray mace in the eyes of photographers, Chatfield realized that there was an extraordinary visual component operating independently, but parallel to, the farmworker struggle. Photographers, he understood, were an essential part of the movement.

His most shattering experience — and his most personal realization of the role that photographers played — came in Sacramento, in 1975, when seventy-five Teamster thugs invaded the ALRB offices and, outside the view of photographers, attacked Chatfield and Bishop Roger Mahoney, pushing them up against the walls, covering them in dirt, beating them with sticks, and telling them to resign. Chatfield understood then, and still understands now, what can occur when there are no witnesses.

As Chatfield visualizes the struggle and how the UFW survived, he thinks about how easy growers had it as long as they remained outside of the probing lens of photographers. And he remembers the empowerment he sensed when photographers — "impartial eyes," he says of them — were standing on the picket lines and the loneliness he felt when they were absent.

The Delano grape strike, Chatfield realized in later life, had forever welded concerned photographers to the farmworker movement because

whenever people saw what happened during strikes, or just what farmworkers did to earn a living, there was always a public outcry and an understanding that helped us sustain our struggle and made it real to millions of people, not only in California, but throughout the United States. The farmworker movement survived and at times triumphed in part because there were hundreds of photographers who would not be intimidated and who were determined to be the eyes of conscience. They made a difference. They altered our place in society, made us real, put a human face on something that few could even imagine. They lived and worked on the ground — dawn to dark, seven days a week, shooting photos of picket lines, protest marches, union rallies and meetings, and the massive importation of Mexican workers hired by the growers to break the strike. They documented the slave-like working conditions of farmworkers, the utterly wretched and inhumane conditions in which they lived, and their sacrifice and determination to seek union recognition through the use of nonviolence. Jon Lewis was one of the most dedicated and talented of all those who came to shoot the farmworker movement.[1]

199. Gerhard Gscheidle photographed strike photographers Jon Lewis (center, bottom), John Kouns (right) and actor Luís Valdéz (center) on the march to Sacramento. Spring 1966.

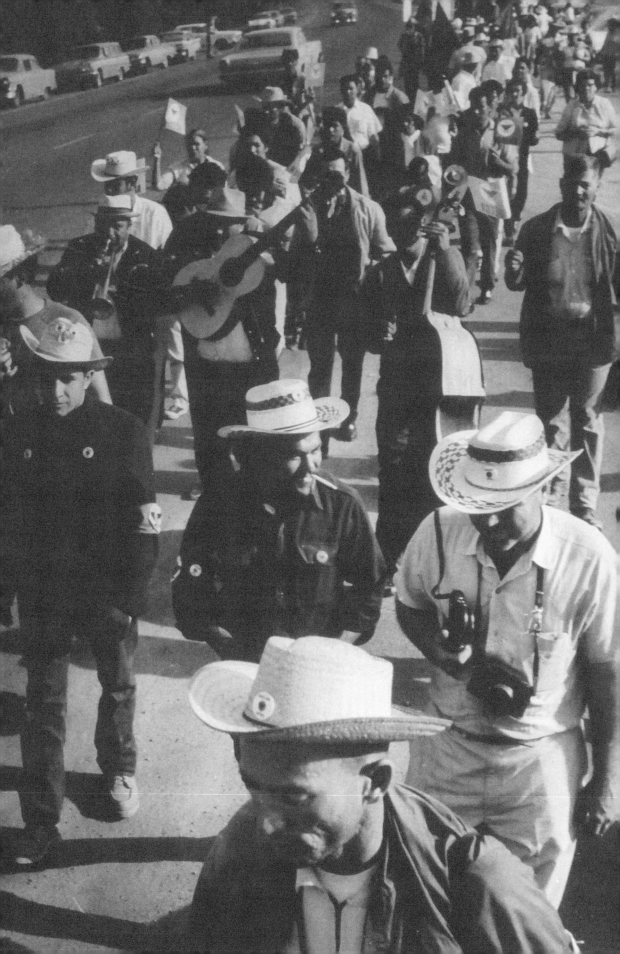

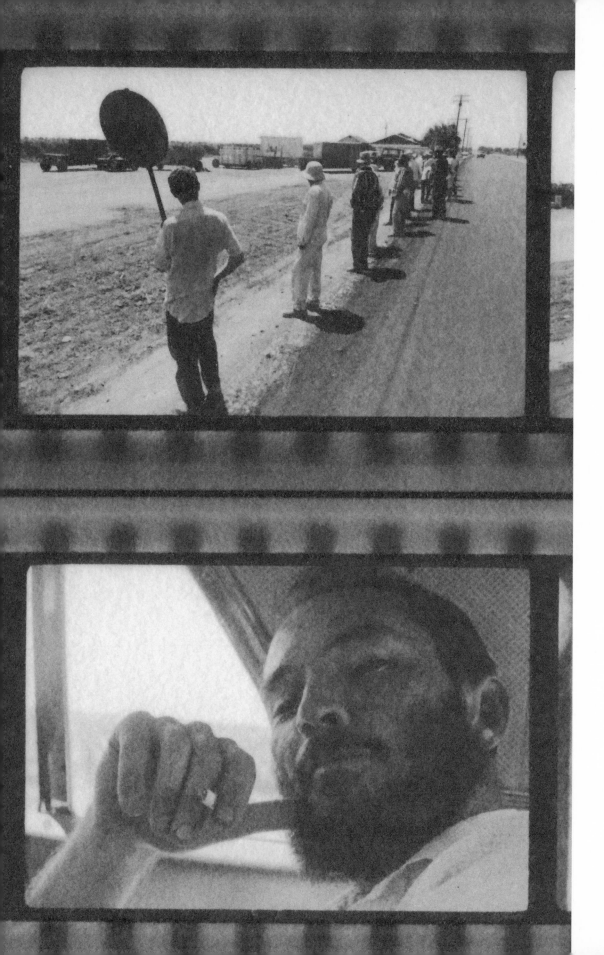

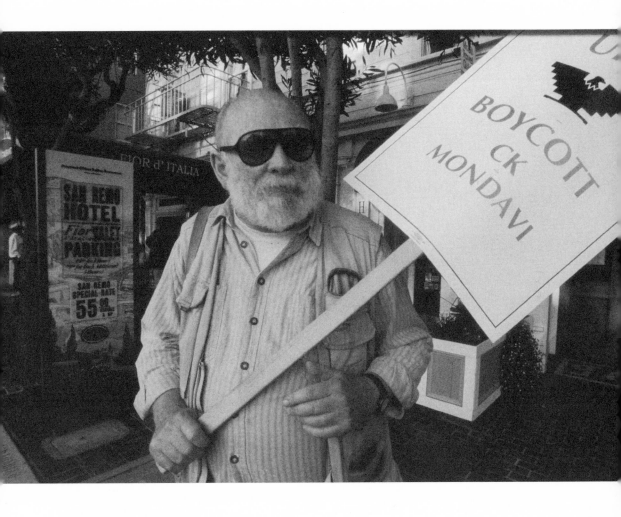

200. (*Left*) Enlarged frames from Jon Lewis contact sheet with this self-portrait. Summer 1966.

201. (*Above*) Jon Lewis on the picket line in San Francisco a year before he died. Photograph by Richard Steven Street.

Notes

INTRODUCTION

1. Richard Steven Street, "Photographing from the Bullpen on Assignment, When César Chávez Ended His Fast at Forty Acres, August 21, 1988," *Pacific Historical Review* 77 (Winter 2008): 151–53 (and photograph); Street, "Photographing César's Last Fast: A Personal Essay"; Street, "The Last Time I Saw César," History News Network, Apr. 21, 2008, http://hnn.us/articles/49532.html; Street, "Framing Farm Workers Through a Historian's Lens," *The Chronicle of Higher Education* (June 7, 2002): B13–15; "The Documentary Eye: How Economist Paul S. Taylor Pioneered Social Documentary Photography," *California Magazine* 120 (May/June 2009): 51–58; Street, "Shooting Farm Workers" (exhibition), Thacher Gallery, University of San Francisco, Aug. 6–Oct. 14, 2001.

2. Street, "Delano Diary: The Visual Adventure and Social Documentary Work of Jon Lewis, Photographer of the Delano, California, Grape Strike, 1966–1970," *Southern California Quarterly* 91 (Summer 2009): 191–235.

3. Rudyard Kipling, "In the Neolithic Age," in *Rudyard Kipling's Verse: Inclusive Edition* (Garden City, NY: Doubleday and Company, 1921), 32; Paul Von Blum, *The Art of Social Conscience* (New York: Random House, 1976), ix; Susan Sontag, *Regarding the Pain of Others* (New York: Farrar, Straus and Giroux, 2003), 117; Vicki Goldberg, *The Power of Photography: How Photographs Changed Our Lives* (New York: Abbeville Press, 1991), 19, 39, 59, 75, 103, 123, 163, 191, 217; Lili Corbus Benzner, *Photography and Politics in America: From the New Deal into the Cold War* (Baltimore: Johns Hopkins University Press, 1999), 1–12; David Freedberg, *The Power of Images: Studies in the History and Theory of Response* (Chicago: University of Chicago Press, 1989), 157. Composer, novelist, and photographer Gordon Parks put it this way: "No art form transforms human apathy quicker. Having absorbed the message of a memorable photograph, the viewer's sense of compassion and newfound wisdom come together like the two lips touching" (Parks, "This Rare Collection," in *Life, 100 Photographs That Changed the World* [New York: Time-Life, 1997], 7). See also Marianna Torgovnick, "Facing Death in a Culture of War," *The Chronicle of Higher Education* (July 23, 2005): B6-B8.

4. Lewis was hurt when old chums like El Teatro Campesino founder Luís Valdéz and UFW organizer-turned-Harvard University professor Marshall Ganz never thanked him for gifts of old photographs or responded to his letters, inquiries, and telephone calls.

5. "In Memoriam: Photographer Jon Lewis, 1938–2009," *Syndic Literary Journal* 1 (Aug. 2010), http://syndicjournal.us/syndic-no-1/in-memoriam-photographer-jon-lewis.

6. LeRoy Chatfield to author, e-mail, Dec. 22, 2009, author's possession.

7. Randy Shaw, *Beyond the Fields: Cesar Chavez, the UFW, and the Struggle for Justice in the 21st Century* (Berkeley: University of California Press, 2008), omits Lewis (as well as Eugene Nelson, who worked for *El Malcriado*, wrote the first account of the grape strike and went on to lead organizing efforts in the Rio Grande Valley of Texas) from his account of union volunteers. Jacques Levy, *César Chávez: Autobiography of la Causa* (New York: Norton, 1976; repr. Minneapolis: University of Minnesota Press, 2008) and Marshall Ganz, *Why David Sometimes Wins: Leadership, Organization, and Strategy in the California Farm Worker Movement* (New York: Oxford University Press, 2009), 270–73, also ignore Lewis. Levy uses images by Lewis throughout the book. Ganz uses images by Lewis on pages 152, 160, 189, 190, and 204 but does not include him in table A2, "UFW Volunteers," (271–73). For examples of how California historians have overlooked Lewis, consult Drew Heath Johnson, ed., *Capturing Light: Masterpieces of California Photography, 1850 to the Present* (New York: Norton, 2001), ix–xiv; Stephanie Barron, Sheri Bernstein, and Ilene Susan Fort, eds., *Made in California: Art, Image, and Identity, 1900–1902* (Berkeley: University of California Press) 2; and Louise Katzman, *Photography in California, 1850 to the Present* (New York: Hudson Hills Press in association with the San Francisco Museum of Modern Art, 1984), ix–x. For examples of this neglect in treatments of American photography see Naomi Rosenblum, *A World History of Photography* (New York: Abbeville Press, 1993) and Peter Stepan, *Icons of Photography: The 20th Century* (New York: Prestel Publishing, 1999).

8. John Berger and Jean Mohr, *Another Way of Telling* (New York: Pantheon Books, 1982), 100.

9. Andy Grundberg, *Crisis of the Real: Writings on Photography Since 1974* (New York: Aperture, 1999), 263 and elsewhere; David Levi Strauss, *Between the Eyes: Essays on Photography and Politics* (New York: Aperture, 2003), 6–7, 44; Michael Lesy, *Visible Light: Four Creative Biographies* (New York: Times Books, 1985), ix–xi; and Walter Jackson Bate, *Samuel Johnson* (New York: Oxford University Press, 1975), xix–xx.

10. The image sequence in *Jon Lewis* approximates a rough layout done by Lewis a month before he died. Lewis loved Berger and Mohr's *Another Way of Telling*. Readers familiar with their books will see that I have deployed a similar image sequencing that goes beyond illustration to create parallel and independent story lines.

11. Yolanda Cuomo, "The Photo Book," in *The Education of a Photographer*, ed. Charles Traub, Steven Heller, and Adam B. Bell (New York: Allworth Press/School of Visual Art, 2006), 162.

12. John Szarkowski, *The Photographer's Eye* (New York: Museum of Modern Art, 1966), 6–11; Fred Ritchin, *After Photography* (New York: Norton, 2005; Julianne Newton, *The Burden of Visual Truth: The Role of Photojournalism in Mediating Reality* (Mahwah, NJ:Routledge Communications, 2001). For similar examples of excellent photographic work that did not see the light of day for nearly a half century, see Don Normark, *Chávez Ravine, 1949: A Los Angeles Story* (San Francisco: Chronicle Books, 1999); K. Patrick Conner, "The Two Lives of Horace Bristol," *San Francisco Chronicle*, Sept. 2, 1990, 10–14; Connor and Debra Heimerdinger, *Horace Bristol: An American View* (San Francisco: Chronicle Books, 1996); Monica Sagullo, "A Journey Back in Time," May 1, 1999, www.thealvaradoproject.com/news/news_id=4; Gretchen Garner, *Disappearing Witness: Change in Twentieth-Century American Photography* (Baltimore and London: Johns Hopkins University Press, 2003), 46–68; and Jon Lewis oral interview at http://www.farmworkermovement.org/media/oral_history/swf/new/JLewisAudioClip01.swf.

1. EPICENTER

1. Jon Lewis, *From this Earth . . . of the Delano Grape Strike* (San Francisco: Self-published, 1969), 1.

2. Courtenay Edelhardt, "Dignitaries Honor Cesar Chavez, Forty Acres," *Bakersfield Californian*, Feb. 21, 2011; Mark Day, *Forty Acres: Cesar Chavez and the Farm Workers* (New York: Praeger, 1971).

3. *Valley Labor Citizen*, Mar. 24, 1967; Apr. 7, 1967; Ronald B. Taylor, *Chavez and the Farm Workers* (Boston: Beacon Press, 1975), 216; *El Malcriado* 42 (Apr. 14, 1967).

4. Street, "The Last Time I Saw César"; Street, "Photographing from the Bullpen," 151–53; Street, "Photographing César's Last Fast: A Personal Essay," Farmworker Movement Documentation Project, http://www.farmworkermovement.org; Street, *Everyone Had Cameras: Photography and Farmworkers in California, 1850–2* (Minneapolis: University of Minnesota Press, 2008), 452, 537.

2. MEMORY

1. Richard White, "History, Rugrats, and World Championship Wrestling," *Perspectives* 37 (Apr. 1999): 13; Peter Matthiessen, *Sal Si Puedes: Cesar Chavez and the New American Revolution* (New York: Random House, 1969).

2. Bill Baruch, *Big Dreams: Into the Heart of California* (New York: Pantheon Books, 1994), 331.

3. Street, interview with Stephen Pavich, Aug. 12, 1986, Delano, California; Street, interview with Jack Pandol, Nov. 13, 1986, Delano, California; author's possession.

4. Philip L. Martin, *Promise Unfulfilled: Unions, Immigration, and the Farm Workers* (Ithaca: Cornell University Press, 2003); J. Craig Jenkins, *The Politics of Insurgency: the Farm Worker Movement in the 1960s* (New York: Columbia University Press, 1985); Mireles Gilbert Felipe, "Picking for a Living: Farm Workers and Organized Labor in California's Strawberry Industry" (PhD diss., Yale University, 2005); Cletus Daniel, "Cesar Chavez and the Unionization of California Farmworkers," in *Working People of California*, ed. Daniel Cornford (Berkeley: University of California Press, 1995), 367–404.

5. Lewis is not included in any of the books on civil–rights era photography, which tend to focus overwhelmingly on the African American experience. See Steven Kasher, *The Civil Rights Movement: A Photographic History, 1954–68* (New York: Abbeville Press, 1996); Fred Powledge, *Free at Last? The Civil Rights Movement and the People Who Made It* (Boston: Little, Brown, 1991); and Manning Marable, Leith Mullings, and Sophie Spencer-Wood, *Freedom: A Photographic History of the African American Struggle* (New York: Phaidon, 2002).

6. R. Douglas Hurt, *American Agriculture: A Brief History* (Ames: Iowa State University Press, 1994), 366–67.

7. Street to Jon Lewis, Mar. 9, 2008; Street to Jennifer Watts, May 14, 2007; Street to Chris Eisenberg [Bonhams], Jan. 30, 2008; Street to Evie Nadel, e-mail, Jan. 30, 2008; Street, presentation to Smithsonian Institution curators, Sept. 3, 2006; Street to Denver Public Library, Mar. 10, 2006; Amy Rule to author, e-mail, May 10, 2007, all in author's possession. Also, George Miles to Leroy Chatfield, e-mail, June 16, 2009, in Chatfield to Lewis, e-mail, June 16, 2009, courtesy of Leroy Chatfield.

3. PREDECESSORS

1. Street, "Photographer's Double: The Photographer as Historian, the Historian as Photographer," *Visual Communication Quarterly* 13 (Spring 2006): 66–89.

2. John Mraz, *Nacho López; Mexican Photographer* (Minneapolis: University of Minnesota Press, 2003), 8.

3. Von Blum, *The Art of Social Conscience*, ix; Sarah Greenough, Joel Snyder, David Travis, and Colin Westerbreck, *On the Art of Fixing a Shadow: One Hundred and Fifty Years of Photography* (Chicago: University of Chicago Press, 1989), 129, 131, 135.

4. See Street, "Lange's Antecedents: The Emergence of Social Documentary Photography of California's Farmworkers," *Pacific Historical Review* 75 (Aug. 2006): 385–428; Street, "Poverty in the Valley of Plenty: The National Farm Labor Union, DiGiorgio Farms, and the Suppression of Documentary Photography in California, 1947–1966," *Labor History* 48 (Feb. 2007): 25–48; Street, *A Kern County Diary: the Forgotten Photographs of Carleton E. Watkins, 1881–1888* (Bakersfield, CA: Kern County Museum-California Historical Society, 1983); Street, "'We Are Not Slaves': The Photographic Record of the Wheatland Hop Riot: The First Images of Protesting Farmworkers in America," *Southern California Historical Quarterly* 114 (1982): 214–15; Street, "Pop Laval," *American Heritage* 31 (Oct.–Nov. 1980): 60–61; Street, "Everyone Had Cameras: Photographers, Photography, and the Farmworker Experience in California — A Photographic Essay," *California History* 83 (2005): 8–25.

5. Jim Hughes, *W. Eugene Smith: The Life and Work of an American Photographer* (New York: McGraw-Hill Publishing Company, 1989); Robert Frank, *The Americans* (New York: Grove Press, 1955); Eugene Richards, *The Knife and Gun Club: Scenes from An Emergency Room* (New York: Grove/Atlantic, 1989); Richards, *Below the Line: Living Poor in America* (New York: Consumers Union, 1985).

4. OBSCURITY

1. Street, interview with Jack Wellpot, Mar. 11, 1979, San Anselmo, author's collection; Anne Tucker Wilkes, *Robert Frank: New York to Nova Scotia* (Houston: Houston Museum of Fine Arts, 1986); Robert Frank, *Black and White Things* (Washington, DC: National Gallery of Art and SCALO, 1994).

2. Drew Johnson, "Forward," in Johnson, ed., *Capturing Light*, ix–xiii; Katzman, *Photography in California*, 24; Susan Kismaric, *California Photography: Remaking Make Believe* (New York: Museum of Modern Art, 1989), 50.

3. Michael S. Durham, *Powerful Days: the Civil Rights Photography of Charles Moore* (New York: Stewart; Tabori & Chan, 1991); Brigitte Buberl, ed., *Benedict J. Fernandez: Protest Photographs, 1963–1995* (New York: Museum für Kunst und Kulturgeschichte der Stadt Dormund, 1997); Julian Cox, *The Road to Freedom: Photographs of the Civil Rights Movement, 1956–1968* (Washington, DC: High Museum, 2008); Ronald W. Bailey and Michèle Furst, eds., *Let Us March on! Selected Civil Rights Photographs of Ernest C. Withers, 1955–1968* (Boston: Abbeville Press, 1992); Danny Lyon, *Memories of the Southern Civil Rights Movement* (Chapel Hill: University of North Carolina Press, 1992).

4. Street, interviews with Jon Lewis, Mar. 4, 1981, July 9, 1988, San Francisco, author's possession.

5. MARINE

1. Street, interview with Jon Lewis, Mar. 4, 1981, San Francisco, author's possession.

2. Nick Pavloff to author, Aug. 24, 2010, e-mail, author's possession. San Jose State University was at that time known as San Jose State College.

3. Luís Valdéz, oral interview, July 1995, California State University, Northridge, Provost's Committee on Chicano Labor. This interview does not mention Lewis. San Francisco State University was known as San Francisco State College until 1974.

4. John Gregory Dunne, *Delano: The Story of the California Grape Strike* (New York: Farrar, Straus, and Giroux, 1967; repr. 1971), 21; Stan Steiner, *La Raza: The Mexican Americans* (New York: Harper, 1970), 129–30, 132, 218, 224, 229, 237, 264–65; "El Teatro Campesino — Right Off the Picket Lines," *IUD Agenda* 3 (Feb. 1967): 16–17; Luís Valdéz, "El Teatro Campesino," *Ramparts* 5 (July 1966): 55–56; *El Malcriado* 63E (June 1967): 8.

5. Street, interview with Jon Lewis, Mar. 4, 1981, San Francisco, author's possession; Lewis, "Jon Lewis Photos, 1966–1968," http://www.farmworkermovement.org.

6. GANZ

1. For Roger Terronez, see *El Malcriado* 29 (Feb. 12): 1966.

2. Susan Ferris and Ricardo Sandoval, *The Fight in the Fields: Cesar Chavez and the Farmworkers Movement* (New York: Harcourt Brace, 1997), 103; Street, interview with Jon Lewis, Aug. 7, 2008, San Francisco, California, author's possession. Ganz, *Why David Sometimes Wins*, vii–ix, gives a somewhat different and more truncated account.

3. Rebecca Solnit, *A Field Guide to Getting Lost* (New York: Viking Press, 2005), 3–6, 9; Erwin G. Gudde, *California Place Names: The Origin and Etymology of Current Geographical Names* (Berkeley: University of California Press, 1949; repr. 1969), vii, 8; James D. Hart, *A Companion to California* (New York: Oxford University Press, 1978), 10. See also, Todd Gitlin, *The Sixties: Years of Hope, Days of Rage* (New York: Bantam Books, 1987), 406–7, 425–26; Jim Wasserman, "Valley Shows Grittiness of Feudal State," *Fresno Bee*, Nov. 16, 1996. Although Spanish missionaries, western explorers, and other travelers crossing the Altamont Pass into the Great Central Valley left behind vivid recollections, none painted a word picture to match that of Steinbeck. See for example Pedro Fages, "In the South San Joaquin Ahead of Garcés," in *Highway 99: A Literary Journey through California's Great Central Valley*, ed. Stan Yogi (Berkeley: Heyday Books, 1996), 2–3; William H. Brewer, diary entry for Oct. 13, 1861, in Brewer, *Up and Down California in 1860–1864: The Journals of William H. Brewer*, ed. Francis F. Farquar (Berkeley: University of California Press, 1930; repr. 1966), 202.

4. Gudde, *California Place Names*, viii, 8, 49; Hart, *A Companion to California*, 10; Warren A. Beck and Ynez D. Haase, *Historical Atlas of California* (Norman: University of Oklahoma Press, 1974); Wallace B. Smith, *Garden of the Sun: A History of the San Joaquin Valley, 1772–1939*, ed. William B. Secrest Jr. (Los Angeles: Lymonhouse, 1939; repr. Fresno: Better World Books, 2006),

5. Typed and handwritten notes, undated, author's collection.

7. CORNUCOPIA

1. Claire Perry, *Pacific Arcadia: Images of California, 1600–1915* (Palo Alto: Stanford University Press, 1999); Robert Dawson and Gray Brechin, *Farewell, Promised Land: Waking*

from the California Dream (Berkeley: University of California Press, 1999); Thomas Jefferson Mayfield, *Indian Summer: Traditional Life Among the Choinumme Indians of California* (Berkeley: Heyday Books, 1993).

2. Christopher Swan, "A Vision of the Valley," *San Francisco Examiner and Chronicle, California Living*, Dec. 30, 1979, 8–10; John Muir, *The Mountains of California: The Unpublished Journals of John Muir*, ed. Linnie Marsh Wolfe (1894; New York: Houghton Mifflin/The Riverside Press, 1938), 259–89, 399; George Derby, "Report of the Tulare Valley," in *Bright Gem of the Western Seas, California, 1846–1852*, ed. Peter Browning (Lafayette, CA: Great Western Books, 1991).

3. Doris Shaw Castro, *James H. Carson's California, 1847–1853* (New York: Vantage Press, 1997), 8–9, 46–50, 135; William Preston, *Vanishing Landscapes: Land and Life in the Tulare Lake Basin* (Berkeley: University of California Press, 1981), 68–70; Gary Snyder, "Covers the Ground," *Mountains Without End* (New York: Counterpoint, 1993), 12; Thomas Jefferson Mayfield, *Tailholt Tales*, Frank Latta, ed. (Santa Cruz, CA: Bear State Press, 1976).

4. Edwin Bryant, *What I Saw in California* (1848; Palo Alto, CA: Sierra Club, 1969), 13.

5. Philip L. Fradkin, *The Seven States of California: A Natural and Human History* (Berkeley: University of California Press, 1997).

6. Jon Carroll, "I Heard It on the Grapevine," *San Francisco Chronicle*, Mar. 6, 1996; Tyche Hendricks, "Central Valley Outpaces Bay Area in Population," *San Francisco Chronicle*, Mar. 23, 2007; *California's Central Valley — Confluence of Change*, ed. Harold O. Carter and Carole F. Nuckton (Davis, CA: Giannini Foundation, 1990); California State Department of Food and Agriculture, *Pesticide Use Report, 2006* (Sacramento: Department of Food and Agriculture, 2006); George Henderson, "John Steinbeck's Spatial Imagination in *The Grapes of Wrath*: A Critical Essay," *California History* 68 (Winter 1989/90): 211–13; James Parsons, "A Geographer Looks at the San Joaquin Valley," *Geographical Review* 76 (1986): 371–89; Preston, *Vanishing Landscapes*, 173, 198; David Wyatt, *The Fall into Eden: Landscape and Imagination in California* (Cambridge, UK: Cambridge University Press, 1986), 108.

8. STEINBECK

1. Stephen Johnson, Gerald Haslam, and Robert Dawson, *The Great Central Valley: California's Heartland* (Berkeley: University of California Press, 1993), 6, 12, 16, 199, 235, 238; Don Villarejo, *Getting Bigger: Large Scale Farming in California* (Davis: California Institute of Rural Studies, 1980); John Davis and Ray Goldberg, *A Concept of Agribusiness* (Cambridge: Harvard University Press, 1957), 2–5; Steven Stoll, *The Fruits of Natural Advantage: Making the Industrial Countryside in California* (Berkeley: University of California Press, 1998); Richard A. Walker, *The Conquest of Bread: 150 Years of Agribusiness in California* (New York: The New Press, 2004); Ellen Liebman, *California Farmland: A History of Large Agricultural Holdings* (Totowa, NJ: Rowman and Allanheld, 1984.

2. Carole Frank Nuckerton and Warren E. Johnston, *California Tree Fruits, Grapes, and Nuts: Location of Acreage, Trends in Acreage, Yields, and Production, 1946–1983* (Berkeley: University of California Press, 1985).

3. Carey McWilliams, *Factories in the Fields: The Story of Migratory Farm Labor in California* (Boston: Little and Brown, 1939), 7; William Braznell, *California's Finest: The History of del*

Monte Corporation and the del Monte Brand (San Francisco: del Monte Corp., 1982); Robert Couchman, *The Sunsweet Story: A History of the Establishment of the Dried Tree Fruit Industry in California and of the 150 Years of Service of Sunsweet Growers, Inc.* (San Jose: Sunsweet, 1967); William Friedland, Amy Barton, and Robert Thomas, *Manufacturing Green Gold* (New York: Cambridge University Press, 1981); Victoria Woest, *The Farmer's Benevolent Trust: Law and Agricultural Cooperation in Industrial America, 1865–1945* (Chapel Hill: University of North Carolina Press, 1998); Douglas Sackman, *Orange Empire: California and the Fruits of Eden* (Berkeley: University of California Press, 2005); Lillian Vallee, *Vision at Orestimba: Seven Poems of Place* (New York: Self-published, 1994.

4. Street, interview with Jon Lewis, Mar. 12, 2009, San Francisco, author's possession; Joan Didion, *Where I Was From* (New York: Vintage, 2003), 72–75, 189–191; Jackson T. Benson, *The True Adventures of John Steinbeck, Writer: A Biography* (New York: Viking Press, 1990).

5. John Steinbeck, "The Harvest Gypsies," *San Francisco News*, Oct. 5–12, 1936; reprinted by the Simon J. Lubin Society as *Their Blood Is Strong* (San Francisco: Simon J. Lubin Society, 1938; repr. 1988), 21, with an additional chapter.

6. Street, interview with Jon Lewis, Sept. 27, 2004, San Francisco, author's possession.

9. POWER

1. Goldberg and Davis, *A Concept of Agribusiness.*

2. Henry Schacht, "Agri-business," *San Francisco Chronicle*, Oct. 8, 1961.

3. William Metzler, *Farm Mechanization and Labor Stabilization* (Davis, CA: Giannini Foundation Research Report 280., 1965); B. F. Cargill and G. E. Rosmiller, eds., *Fruit and Vegetable Harvest Mechanization: Manpower Implications* (East Lansing, MI: Michigan State University Rural Manpower Center Report no. 17, 1969); Claude B. Hutchinson, ed., *California Agriculture* (Berkeley: University of California Press, 1946); Ann Foley Scheuring, ed., *A Guidebook to California Agriculture* (Berkeley: University of California Press, 1983).

4. Philip L. Martin, "Labor in California Agriculture," in Phillip Martin, ed., *Migrant Labor in Agriculture: An International Comparison* (Berkeley: Giannini Foundation, 1985), 1–17; Varden Fuller, "The Supply of Agricultural Labor as a Factor in the Development of California Farm Organization" (PhD diss., University of California, Berkeley, 1939); Paul Jacobs, "Man with a Hoe, 1964," *Commentary* 38 (July 1964): 26–29; Robert Coles, *Uprooted Children: The Early Life of Migrant Farm Workers* (Pittsburgh: University of Pittsburgh Press, 1970); Ken Light, Roger Minick, and Reesa Tansy, *In the Fields* (Oakland: Grizzly Bear Publishing, 1982); U.S. Department of Labor, *Farm Labor Fact Book* (Washington, DC: Government Printing Office, 1958), 210–12.

10. FANATICS

1. David Vaught, *Cultivating California: Growers, Specialty Crops, and Labor, 1875–1920* (Baltimore: Johns Hopkins University Press, 1999); Ann Loftis, *Witness to the Struggle: Imaging the 1930s California Labor Movement* (Reno: University of Nevada Press, 1998), 8–29, 77–88.

2. Street, "'We Are Not Slaves'," 205–26; Street, "Wheatland: Birth of the Farm Labor Movement," *Sacramento Magazine* 10 (Dec. 1984): 38–42, 63–66.

3. Paul S. Taylor, *On the Ground in the Thirties* (Salt Lake City: Gibbs Smith, 1983).

4. Eleven growers were arrested, tried for murder, and acquitted. See Ramón D. Chacón, "Labor Unrest and Industrialized Agriculture in California: The Case of the 1933 San Joaquin Valley Cotton Strike," *Social Science Quarterly* 65 (June 1984): 336–53; Paul Taylor and Clark Kerr, "Documentary History of the Strike of Cotton Pickers in California," in Taylor, *On the Ground in the Thirties*, 41–89; Bryan T. Johns, "Field Workers in California Cotton" (MA thesis, UCLA, 1947); Sam Darcy, "The Storm Must Be Ridden," MS, n.p., Sam Darcy Papers, Tamiment Institute Library, New York University.

5. McWilliams, *Factories in the Fields*, 44–45; Jerome Wolfe, "The Imperial Valley as an Index of Farm Labor Relations" (PhD diss., UCLA, 1974); William T. Vollemann, *Imperial* (New York: Penguin, 2009).

6. Kevn Starr, *Endangered Dreams: The Great Depression in California* (New York: Oxford University Press, 1996), 165–71; McWilliams, *Factories in the Field*, 44; Mike Quin [Paul William Ryan], *The C. S. Case Against Labor* (San Francisco: International Labor Defense, 1935).

11. FLIES

1. Stuart E. Jamieson, *Labor Unionism in American Agriculture* (Washington, DC: Bulletin no. 836, Bureau of Labor Statistics, 1945); Norman Lowenstein, "Strikes and Strike Tactics in California Agriculture: A History" (MA thesis, UCLA, 1940; Jerome Wolf, "The Imperial Valley as an Index of Agricultural Labor Relations"; Charles Wollenberg, "Huelga, 1928 Style: The Imperial Valley Cantaloupe Workers' Strike," *Pacific Historical Review* 38 (Feb. 1969): 45–58.

2. Street, interview with Danny Dannenberg, Jan. 12, 1974, El Centro, California, author's possession; "Wetbacks, Menace from the South," *Fortnight* 10 (June 25, 1951): 10; *New York Times*, June 11, 1972.

3. Jenkins, *The Politics of Insurgency: The Farm Workers Movement in the 1960s*; Anne Loftis and Dick Meister, *A Long Time Coming: The Struggle to Unionize America's Farm Workers* (New York; McMillan, 1977); Cletus Daniel, *Bitter Harvest: A History of California Farm Workers* (Ithaca: Cornell University Press, 1982); Paul E. Roy, *Collective Bargaining in Agriculture* (Danville, IL: Interstate Printers & Publisher, 1970).

4. U.S. Senate, 76th Congress, 2nd sess., Subcommittee of the Committee on Education and Labor, Violations of Free Speech and Rights of Labor, *Hearings* (Washington, DC: Government Printing Office, 1940), pt. 54, 19947.

5. Ernesto Galarza, *Farmworkers and Agri-business in California, 1947–1960* (Notre Dame, IN: University of Notre Dame Press, 1977) 146.

6. Alexander Morin, *Organizability of Farm Labor in the United States* (Cambridge, MA: Harvard Studies in Labor Agriculture no. 2–HL, 1952); Harry Schwartz, *Seasonal Farm Labor in the United States, With Special Reference to Hired Workers in Fruit and Vegetable and Sugar-Beet Production* (New York: Columbia University Studies in the History of Agriculture no. 11, 1945); Lloyd Fischer, *The Harvest Labor Market in California* (Cambridge, MA: Harvard University Press, 1953); Ronald D. Knutson and Bernard L. Evans, "Organizational and Institutional Changes Needed in an Industrialized Agriculture: Bargaining, Unionization, Unemployment Insurance," *American Journal of Agricultural Economics* 52 (Dec. 1970): 790–91; Karen Koziara, "Collective Bargaining on the Farm," *Monthly Labor Review* 91 (June 1968): 3–9; Clark Chambers, *California Farm Organizations* (Berkeley: University of California Press, 1952).

7. McWilliams, *Factories in the Fields*, 40; Joan London and Henry Anderson, *So Shall Ye Reap: The Story of Cesar Chavez and the Farm Worker Movement* (New York: Thomas Crowell, 1970), 10, 12, 16, 38.

8. Daniel Franz, "Problems of Union Organization for Migratory Workers," *Proceedings of the Spring Meeting of the Industrial Relations Research Association* (May 4–5, 1961); reprinted in *Labor Law Journal* 12 (July 1961): 636–43; Judith C. Glass, "Conditions Which Facilitate Unionization of Agricultural Workers: A Case Study of the Salinas Valley Lettuce Industry" (PhD diss., UCLA, 1966); Robin Myers, *The Position of Farm Workers in Federal and State Legislation* (New York: National Advisor Committee on Farm Labor, 1959); Fred Whitney, *Agricultural Workers Under National Labor Relations* (Urbana, IL: Institute of Labor and Industrial Relations Bulletin, series A, vol. 2, 1948); Gary Allen, "The Communist Wrath in Delano," *American Opinion* 9 (June 1966): 1–14; Henry Anderson, *To Build a Union: Comments on the Organization of Agricultural Workers* (Stockton, CA: Self-published, 1961), n.p.

12. DISPOSSESSED

1. Devra Weber, *Dark Sweat, White Gold: California Farm Workers, Cotton, and the New Deal* (Berkeley: University of California Press, 1994); Walter J. Stein, *California and the Dust Bowl Migration* (Westport, CT: Greenwood Publishing Company, 1973); Paul S. Taylor, "California Farm Labor: A Review," *Agricultural History* 42 (Jan. 1968): 49–53; Varden Fuller, *Labor Relations in California Agriculture* (Berkeley: Giannini Foundation, 1955o, vii–viii; California Senate Fact-Finding Committee on Labor and Welfare, *California's Farm Labor Problems* (Sacramento: California State Printer, 1961).

2. In 1913 the California legislature passed the Alien Land Law, which banned Japanese (and Indian Sikhs) from owning land. See Timothy J. Lukes and Gary Okihiro, *Japanese Legacy: Farming and Community Life in California's Santa Clara Valley* (Cupertino, CA: California History Center, DeAnza College, 1985); Akemi Kikumura, *Through Harsh Winters: The Life of A Japanese Immigrant Woman* (Novato, CA: Chandler and Sharp, 1981); Karl Yoneda, *Ganbatte: Sixty Years Struggle of a Kibei Worker* (Los Angeles: Resource Development and Publications, Asian American Studies Center, University of California, Los Angeles, 1983); Yuji Ichioka, *The Issei: The World of the First Generation Japanese Immigrant, 1885–1924* (Boston: Free Press, 1988); Jean Pajus, *The Real Japanese in California* (Berkeley: University of California Press, 1937; repr. 1971); Masakazu Iwata, *Planted in Good Soil: A History of the Issei in US Agriculture*, 2 vols. (New York: Peter Lang, 1992).

3. George D. Horowitz and Paul Fusco, *La Causa: The California Grape Strike* (New York: Collier, 1970), 28–30; Carlos Bulosan, *America is in the Heart* (Seattle: University of Washington Press, 1973 [1943]); California Department of Industrial Relations, "Filipino Study and Immigration Summary, 1919–1928" MS [1929], California State Archives, Sacramento; James Gray, "The American Civil Liberties Union of Southern California and Imperial Valley and Agricultural Labor Disturbances, 1930–1934" (PhD diss., UCLA, 1966); McWilliams, *Factories in the Fields*, 40; Mark Reisler, *By the Sweat of their Brow: Mexican Immigrant Labor in the United States, 1900–1940* (Westport, CT: Greenwood Press, 1976); Charles C. Derby, "Diaries" (entry for Aug. 10, 1923), Derby Papers, The Bancroft Library, University of California, Berkeley; Albert Camarillo, *Chicanos in a Changing Society: From Mexican Pueblos to American Barrios*

in Santa Barbara and Southern California, 1848–1930 (Cambridge, MA: Harvard University Press, 1979), 168–69; Paul S. Taylor, *Mexican Labor in the United States* (Berkeley: University of California Press, 1930), 7 vols.

4. Gilbert Gonzalez, *Labor and Community: Mexican Citrus Worker Villages in a Southern California County, 1900–1950* (Chicago: University of Illinois Press, 1994); James N. Gregory, *American Exodus: The Dust Bowl Migration and Okie Culture in California* (New York: Oxford university Press, 1989).

5. R. L. Adams, *Farm Management* (New York: McGraw Hill, 1921).

13. BRACEROS

1. John Mraz, Jaime Storey, and Jaime Velez, *Uprooted: Braceros in the Hermanos Mayos Lens* (Austin, TX: Arte Publico Press, 1996).

2. Erasmo Gamboa, *Mexican Labor and World War II: Braceros in the Pacific Northwest* (Austin: University of Texas Press, 1990), 51; Robert C. Jones, *Mexican Workers in the United States: The Mexico-United States Manpower Recruiting Program and Its Operation* (Washington, DC: Pan American Union, Division of Labor and Social Information, 1945).

3. Deborah Cohen, *Braceros: Migrant Citizens and Transnational Subjects in the Postwar United States and Mexico* (Chapel Hill: University of North Carolina Press, 2011); Galarza, *Strangers in our Fields: Based on a Report Regarding Complaince with the Contractual, Legal, and Civil Rights of Mexican Agricultural Contract Labor in the United States made Possible through a Grant-in-Aid from the Fund for the Republic* (Washington, DC: Fund for the Republic, 1956).

4. The first wave of braceros consisted of small farmers who had abandoned hillside patches of corn in Guanajuato; *ejidatarios* from collective farms in Sonora; day laborers from Zacatecas; sharecroppers from Nuevo Leon; taxi drivers, mill hands, porters, and elevator operators from the cities; Indians from Tiaxcala; and mountain men from Guerrero.

5. Richard B. Hancock, *The Role of the Bracero in the Economic and Cultural Dynamics of Mexico* (Palo Alto: Stanford University Press, 1959).

6. Truman Moore, *The Slaves We Rent* (New York: Random House, 1965), 83.

7. Galarza, *Farm Workers and Agri-business in California*, 35, 265; Galarza, *Merchants of Labor: The Mexican Bracero Story* (Santa Barbara: McNally and Loftin, 1964), 63; Kitty Calavita, *Inside the State: The Bracero Program, Immigration, and the I.N.S* (New York: Routledge, 1992), 1, 62–64; David Pfeiffer, "The Bracero Program in Mexico," in *Mexican Workers in the United States: Historical and Political Perspectives*, ed. George Kiser and Martha Woody Kiser (Albuquerque: University of New Mexico Press, 1979), 80–81; Henry Anderson, *Fields of Bondage: the Mexican Contract Labor System in Industrialized Agriculture* (Berkeley: Self-published, 1963); Donald Mitchell, *They Saved the Crops: Labor, Landscape, and the Struggle over Industrial Agriculture in the Bracero Era* (Athens, GA: University of Georgia Press, 2012); David Runsten and Phillip LeVeen, "Mechanization and Mexican Labor in California Agriculture," *Monographs in U.S.-Mexico Studies* 6 (1981), 51; President's Commission on Migratory Labor, *Migratory Labor in American Agriculture*, Report of the President's Commission on Migratory Labor (Washington, DC: Government Printing Office, 1951), 16, 38–40.

8. Galarza, *Farm Workers and Agri-business*, 34–35.

14. PANCHO

1. U.S. Department of Labor, *Farm Labor Fact Book* (Washington, DC: Government Printing Office, 1958), 168–72, 232.

15. MORDIDA

1. Grace Halsell, *The Illegals* (New York: Stein and Day, 1978), 8–9, 156; Eleanor Hadley, "A Critical Analysis of the Wetback Problem," *Law and Contemporary Problems* 21 (1956): 356; *The Wetback Strike: A Report on the Strike of Farm Workers in the Imperial Valley of California, May 24–June 25, 1951* (Washington, DC: U.S. Department of Labor, 1951); Kelly Lytle Hernándz, *Migra: A History of the U.S.-Mexico Border Patrol* (Berkeley: University of California Press, 2010).

2. National Advisory Committee on Farm Labor, Information Letter, Apr. 19, 1966; *President's Commission on Migratory Labor*, 68–59; Ernesto Galarza, "Personal and Confidential Memorandum on Mexican Contract Workers in the United States," (1943), Ernesto Galarza Papers, Stanford University Archives and Special Collections; Galarza, *Strangers in the Fields* (Washington, DC: Fund for the Republic, 1956); Larry Manuel García y Griego, "The Bracero Policy Experiment: U.S.-Mexico Responses to Mexican Labor Migration, 1942–1955" (PhD diss., UCLA, 1988); Street, interview with James Price, May 23, 1974, Bakersfield, California, author's possession; Robert D. Tomasek, "The Political and Economic Implications of Mexican Labor in the United States Under the Non Quota System, Contract Labor Program, and Wetback Movement" (PhD diss., University of Michigan, 1957), 52, 88, 107, 132; George Kiser and Martha Woody Kiser, eds., *Mexican Workers in the United States, Historical and Political Perspectives* (Albuquerque: University of New Mexico Press, 1979), 1–8, 67–124; Ellis Hawley, "The Politics of the Mexican Labor Issue, 1950–1965," *Agricultural History* 40 (July 1966): 157–76; Peter N. Kirstein, "Anglo over Bracero: A History of the Mexican Workers in the United States from Roosevelt to Nixon" (PhD diss., St. Louis University, 1973), 44–45, 131, 142–46, 159–60, 173–209; Leonard Nadel, "A National Scandal: the Plight of Mexican Workers in the U.S.," *Jubilee* 4 (Apr. 1957): 36–44; Nadel, "Between Two Worlds," *Pageant* 12 (Apr. 1957): 139–46; "AFL-CIO Organizers Go After Farm Labor," *Business Week* 32 (Sept. 24, 1960): 50–51; Henry P. Anderson, *The Bracero Program in California* (Berkeley: University of California School of Public Health, 1961; repr., New York: Arno Press, 1976).

3. Ernest Hover, Chief Examinations Branch, El Paso, Texas, memo to Marcus Needley, District Director, El Paso, Texas, May 31, 1956, Accession no. 58A733, Internal Memorandum, Records of the Immigration and Naturalization Service, Box 195, RG 174, National Archives, Suitland, MD.

4. Testimony of Henry Anderson in U.S. House of Representatives, "Extension of Mexican Farm Labor Program," *Hearings before the Subcommittee on Equipment, Supplies, and Manpower of the Committee on Agriculture*, 87th Cong., 1st sess. (Washington, DC, 1961), 354, 361–62.

5. The term "Between Two Worlds" appears regularly in descriptions of Mexican immigration, most recently by another photographer of Mexican immigration, Don Bartletti, in *Between Two Worlds: The People of the Border* (Oakland: Oakland Museum, 1991). Nadel used it in about the same way 35 years earlier. See Nadel, "Between Two Worlds," 139–46.

16. UNIONS

1. *Farm Labor News* (Aug. 1947): 2, 4; *Farm Labor News* (Nov. 1947): 1; NFLU, confidential memo, "Plans for Organization of Agricultural Labor," n.d. [1947]; DiGiorgio Strike Report No. 2," n.d. [Nov. 2, 1947]; Robert Gilbert to H. L. Mitchell, Dec. 1, 1947, Southern Tenant Farmers Union (STFU) Papers, Archives and Special Collections, University of North Carolina, Chapel Hill; Street, *Everyone Had Cameras*, 343–47, 362–66.

2. DiGiorgio Fruit Corporation, "Notice of Annual Meeting of Stockholders," Mar. 23, 1948, n.p.; NFLU, "Statement on the DiGiorgio Strike," Nov. 12–13, 1949, STFU Papers; *Associated Farmer*, Oct. 25, 1947; Ruth Teiser, "Robert DiGiorgio and Joseph DiGiorgio: The DiGiorgios, from Fruit Merchants to Corporate Innovators," (Oral Interview, Regional Oral history Project, The Bancroft Library, 1983), 97–103, 205,.

3. Street, "Poverty in the Valley of Plenty," 25–48; Street, interview with Hank Hansiwar, Mar. 22, 1974, Bakersfield, author's possession; Ulla E. Bauers Jr., "The DiGiorgio Strike" (master's thesis, University of California, Berkeley, 1949).

17. AWOC

1. The newly established National Advisory Committee on Farm Labor (NACFL) did more than any other organization to advance the farmworker cause. After holding well-publicized hearings in Washington, DC, NACFL issued numerous reports and investigations that a *New York Times* editorial writer praised for raising "public pressure for badly needed action." See the *New York Times*, Feb. 23, 1959.

2. Richard Mines, "The AFL-CIO Drive in Agriculture, 1958–1961" (master's thesis, Columbia University, 1974).

3. Steve Allen, intro., *Farm Labor Organizing: A Brief History* (Washington, DC: National Committee on Farm Labor, 1967), 36–37.

4. Fred Ross, *Conquering Goliath: Cesar Chavez at the Beginning* (Keene, CA: United Farm Workers, 1989); Richard Griswold del Castillo and Richard Garcia, *Cesar Chavez: A Triumph of Spirit* (Norman: University of Oklahoma Press, 1995); clipping, "Stockton Hub for State Farm Labor; Contractors Bid for Migratory Workers," *Stockton Record*, n.d., Raymond P. Roth Collection, Archives and Special Collections, University of California, Davis. For a photograph of the 4:30 a.m. shape-up in Stockton, see London and Anderson, *So Shall Ye Reap*, 69.

18. AFL-CIO

1. *New York Times*, Dec. 16, 1961; Lamar B. Jones, "Labor and Management in California Agriculture, 1864–1964" *Labor History* 11 (Winter 1970): 23–40.

2. Grant Cannon, "Farm Labor Organizes," *Farm Quarterly* 16 (Spring 1961): 60–64, 160; "AFL-CIO Organizers Go After Farm Labor," *Business Week* 32 (Sept. 24, 1960): 50–54; London and Anderson, *So Shall Ye Reap*, 48–49; Joe Munroe, *Changing Faces On Our Land* (Des Moines, IA: Meredith, 1990), 172–73.

3. Mark E. Thompson, "The Agricultural Workers Organizing Committee, 1959–1962" (master's thesis, Cornell University, 1963), 161–62.

4. Meister and Loftis, *A Long Time Coming*, 110–14; Craig Scharlin and Lilia V. Villanueva, *Phillip Vera Cruz: A Personal History of Filipino Immigrants and the Farmworker Movement* (Seattle: University of Washington Press, 1992; repr. 2000).

5. *The Delano Grape Story . . . From the Grower's View* (Delano: Citizens for Facts, 1968); Wayne Hartmire, *The Church and the Delano Grape Strike—A Partial Report* (Los Angeles: National Farm Worker Ministry, 1966); Pat Hoffman, *Ministry of the Dispossessed* (Los Angeles: Wallace Press, 1987); David G. Guttièrrez, *Walls and Mirrors: Mexican Americans, Mexican Immigrants, and the Politics of Ethnicity* (Berkeley: University of California Press, 1995); "It Occurs to Me," n.d. [pamphlet], Fred Ross Papers, Stanford University Archives and Special Collections; "The Saga of Sal Si Puedes," Herman Gallegos Papers, Stanford University Archives and Special Collections; Father Donald McDonnell to Archbishop John J. Mitty, Feb. 15, 1951, and "Reports: Missionary Apostolate," Donald McDonnell Papers, Archives of the Archdiocese of San Francisco Chancery Archives, Menlo Park, California.

19. CHÁVEZ

1. Richard Etulian, ed., *César Chávez: A Brief Biography with Documents* (Boston: Bedford/ St. Martins, 2002), 1–22; John C. Hammerback and Richard J. Jensen, *The Rhetorical Career of César Chávez* (College Station: Texas A&M University Press, 1998), 101–2.

2. Jacques Levy, Interview with César Chávez, n.d., Jacques Levy Papers, Beinecke Library, Yale University; Peter Mattiessen, *Sal Si Puedes: Cesar Chavez and the New American Revolution* (New York: Random House, 1972); Ann McGregor, comp., Cindy Wathen, ed., George Ballis, photog., *Remembering Cesar: The Legacy of Cesar Chavez* (Sanger, CA: Quill Driver Books/ Word Dancer Press, 2000); Jack Eisenberg, "To Be a Farm Worker," *American Federationist* 77 (July 1970): 12–17; "Stories from the Past," *El Malcriado* 32 (Mar. 3, 1966), English edition.

3. Arturo Cabrera to Chávez, July 30, 1954, UFW, Office of the President Collection, Archives of Urban and Labor History, Wayne State University, Detroit; Chávez Activity Reports [for examples], Nov. 19, 1954; Feb. 15, Mar. 20, Apr. 4, 11, 29, May 20, 21, 1956; Feb. 26, July 22, 1957, Fred Ross Papers, Stanford University Archives and Special Collections; Santa Clara County CSO Chapter Report, Jan. 1–June 30, 1956, Gallegos Papers, Stanford University Archives and Special Collections; CSO, "Help Us Build This Bridge," pamphlet, 1957, Galarza Papers.

20. ORGANIZING

1. Taylor, *Chavez*, 107–8; Henry Anderson, "To Build a Union," *Farm Labor* 4 (Mar. 1966): 6–7; César Chávez, "Mexican Americans and the Church," in Octavio I Romano, *Voices: Selected Readings from El Grito* (Berkeley: Quinto Sol Publications, 1970); Stan Steiner, *La Raza: the Mexican Americans* (New York: Harper and Row, 1970); Gerald E. Sherry, comp., *Farm Labor Problems: the Anguish of Delano* (Fresno: Central California register, 1968); Al Howard, "Delano: the General Strike in the Grapes," *Insurgent* 2 (Jan.2–Feb., 1966): 7–12; Andrew Kopkind, "The Grape Pickers' Strike: A New Kind of Labor War in California," *New Republic* 154 (Jan. 29, 1966): 12–15.

2. Kaye Briegel, "The Development of Mexican-American Organizations," in *The Mexican-Americans: An Awakening Minority*, ed. Manuel P. Servin (Beverly Hills: Glencoe Press, 1970).

3. London and Anderson, *So Shall Ye Reap*, 180; Sam Kushner, *Long Road to Delano* (New York: International Publishers, 1975), 147–51; correspondence between Chávez and Eugene Nelson in the Eugene Nelson Papers and Collection, Petaluma, California, courtesy of Ted Lehman.

21. HUELGA!

1. Victor Salindini, "The Short-Run Socio-Economic Effects of the Termination of Public Law 78 On the California Farm Labor Market for 1965–1967" (PhD diss., Catholic University, 1969); Fred Schmidt, *After the Bracero; An Inquiry into the Problems of Farm labor Recruitment* (Los Angeles:California State Department of Employment, 1964); "End of the Bracero Program," *America* 108 (June 22, 1963): 878–79; "Effects of Ending of the Bracero Program," *America* 116 (Apr. 15, 1967): 546; Mary Ellen Leary, "As the Braceros Leave," *Reporter* 32 (Jan. 28, 1965): 43–44; Galarza, *Farm Workers and Agri-business*, 264–76; U.S. Congress, House of Representatives, Committee on Education and Labor, *Report on the Farm Labor Accident at Chualar, California, on September 17, 1963* (Washington, DC: Government Printing Office, 1964), copy in Galarza Papers.

2. Taylor, *Chavez*, 99–105; Henry Anderson, "Dubious Battle, 1965," *Farm Labor* 3 (May 1965): 5–7; Meister and Loftis, *A Long Time Coming*, 90. Some growers tried to obtain additional workers through Public Law 414, which allowed the Immigration and Naturalization Service Act to bring in farmworkers if a serious labor shortage developed. Under this arrangement, workers could not be hired for less than $1.40 an hour. When the number of braceros dropped from 128,000 to less than 21,000 in spring 1965, field hands quickly realized that they could no longer be fired outright and replaced. In the lettuce industry wages jumped sixfold within a week.

3. *Fresno Bee*, Sept. 10, 1965.

4. *Fresno Bee*, Sept. 18, 20, 1965; *Los Angeles Times*, May 13, 1965; *Valley Labor Citizen*, June 4, Sept. 17, Oct. 1, 8, Nov. 5, 1965; *People's World*, Oct. 2, 8, 23, 1965; *California Farmer*, Sept. 17, 1965; UFW, "A Summary of Events in the Grape Strike" (mimeo), n.p.; UFW, "A History of the Delano Grape Strike and the DiGiogio Evictions," 1, California Migrant Ministry Collection, Wayne State University Labor History Archives.

22. DELANO

1. Anne Draper and Hal Draper, *The Dirt on California: Agribusiness and the University* (Berkeley: Independent Socialist clubs of Ameria, 1968).

2. "Delano: Another Selma?" *Ave Maria* 103 (Jan. 1, 1966): 16–17; James G. Dowling, "Delano Views: An Open Letter to Ave Maria Magazine," *Ave Maria* 103: 16; James P. Degnan, "Monopoly in the Vineyards: The Grapes of Wrath Strike," *Nation* 202 (Feb. 7, 1966): 151–54; "Dispute in Delano," *Commonweal* 84 (Jan. 28, 1966): 491.

23. GROWERS

1. Horowitz and Fusco, *La Causa*, 53.

2. Street, "Jack Be Nimble," *California Business* 4 (Apr., 1988): 32–40, 48–50; Cameron E. Wood, "Mexican Agricultural Labor in California" (master's thesis, Fresno State College, 1950); Robert F. Barnes, *The California Migrant Farm Worker: His Family and the Rural Community* (Davis: University of California, Davis, Department of Applied Behavioral Sciences Research

Monograph no. 6, 1967); Bertrand Renaud, "The Allocation of the California Grape Production: An Econometric Study" (PhD diss., University of California, Berkeley, 1966); Arthur D. Angel, "Political and Administrative Aspects of the Central Valley Project of California" (PhD diss., UCLA, 1944).

3. Smith, *Garden of the Sun*, 539; Elizabeth J. duFresne and John J. McDonnell, "The Migrant Labor Camps: Enclaves of Isolation in Our Midst," *Fordham Law Review* 40 (Dec. 1971): 279–304; Frank Bergan and Murray Norris, *Delano — Another Crisis for the Catholic Church* (Fresno: Catholic Ministries,1968); Chris Bergtholdt, *A Different Look at Farm Labor Ideas* (Yuba City, CA: California Migrant Ministry, [1965]); Ralph deToledano, *Little Cesar: The First full Story on Cesar Chavez's War on the Grape Pickers of California* (New York: Anthem, 1971); Jed Adams, "The Grape Industry: Production and Marketing Situation," Bureau of Marketing, California Department of Agriculture (Feb. 4, 1966), California State Library.

4. American Farm Bureau Federation, *The Truth About the Grape Boycott* (Fresno: American farm Bureau Federation, 1969); Sandra Weiner, *Small Hands, Big Hands: Seven Profiles of Chicano Migrant Workers and Their Families* (New York: Pantheon, 1970); United Farm Workers Organizing Committee, *What About the Boycott of California Grapes? A Reply to the California Grape Growers* (Delano: United Farm Workers Organizing Committee, 1968); South Central Farmers Committee, *Which Road to Farm Labor Peace?* (Delano: South Central Farmners, 1969); Galarza, *Farm Workers and Agri-business*, 55–58; William G. Jeff, "The Roots of the Delano Grape Strike" (master's thesis, California State University, Fullerton, 1969); Marc Cooper, "Sour Grapes: California Farm Workers' Endless Struggle 40 Years Later," *LA Weekly*, Aug. 12–18, 2005.

5. John Bergez, "The Grape Strike in Delano: A Three-Part Case Study of Labor Problems in California Agriculture," in *Minorities in California History*, ed. George E. Frakes and Curtis B. Solberg (New York: Random House, 1971), 269–73.

24. POVERTY

1. Idwal Jones, *Vines in the Sun* (New York: William Morrow, 1949), 165.

2. Horowitz and Fusco, *La Causa*, 56.

3. Joan Didion, *Slouching Towards Bethlehem* (New York: Farrar, Straus and Giroux, 1968), 180–82; Jacques Levy, interview with Manuel Chávez, Jacques Levy Collection, Beinecke Library, Yale University; Levy, *César Chávez*, 173–75; Taylor, *Chavez*, 116; Meister and Loftis, *A Long Time Coming*, 122; Dick Meister, interview with Manuel Chávez, n.d, Dick Meister Collection, The Bancroft Library. *El Malcriado* 25 (Nov. 22, 1965), English edition gives the number of labor camps at 60. For the West Side of Delano see *El Malcriado* 32 (Mar. 3, 1966).

4. A form of Jim Crow, California style, had emerged in the 1920s and 1930s, when the Ku Klux Klan served on boards of supervisors, police departments, and school districts around the Valley. For a generation, routine news reports in the *Corcoran News*, *Fresno Morning Republican*, and *Delano Record* described KKK picnics, basket lunches, sack races, and cross burnings at the Fresno baseball stadium. When the KKK finally petered out during World War II, the Valley still provided a haven for the racial bigotry that Okies and Arkies both suffered from and transferred from the Dust Bowl states. Children of the 30,000 to 40,000 black Okies who had come to California in the late 1940s to work in the cotton fields soon learned to stay on their side of the tracks. Gravitating to unincorporated areas outside the city limits of Hanford, Tulare,

Pixley, Bakersfield, Fresno, and Corcoran, they dug silver dollars out of old Karo syrup cans and purchased one-acre $400 lots on alkali land — at $25 down and $15 a month — then erected "shotgun shacks" (so named because you could see holes from the front to rear, as if blasted by shotgun pellets) and dubbed their fringe settlements Teviston, Sunny Ares, Bootville, and Boot Hill. To survive, the black Okies followed a harvest circuit radiating out 150 miles: cotton chopping [thinning] in May, digging onions and potatoes in June, picking table grapes in July and August, and finally pulling their twelve-foot canvas sacks during the cotton picking season through the fall and into the winter, children beside them on weekends. After a few years, they used their accumulated savings to add a room, replace the tarpaper roof with galvanized steel, add a wooden floor to their shacks, and raise some chickens and pigs. On the job, they knew what to expect: crooked crew bosses and rigged scales that gave credit for 95 pounds when they had picked 100. In their isolated hamlets, they learned that the police never patrolled their streets and that the sewer lines never reached that far from town. At Hiett's Drive-In, where roller-skating girls in short dresses delivered the best malted milk shakes in Tulare County, blacks had to walk up to the windows and shout their orders through the plate glass. They were also banned from The Plunge, an indoor swimming pool on the south side of Delano, and the Curb Inn, a popular cafe that refused to serve them. See Mark Arax, "Black Okies," *Los Angeles Times*, Aug. 25–27, 2002; Mark Arax and Rick Wartzman, *The King of California: J. G. Boswell and the Making of a Secret American Empire* (New York, 2003), 93, 263–69, 278–79; McWilliams, *Factories in the Fields*, 215–17; Galarza, *Farm Worker and Agri-business*, 38.

5. *El Malcriado* 29 (Feb. 12, 1966).

6. Dunne, *Delano*, 59; Taylor, *Chavez*, 102.

25. WELCOME

1. Street, interview with Jon Lewis, Nov. 6, 2008, San Francisco, author's possession.

2. Street, interview with César Chávez, Aug. 7, 1979, Salinas, California, author's possession; Gene Roberts and Hank Klibanoff, *The Race Beat: The Press, the Civil Rights Struggle, and the Awakening of a Nation* (New York: Knopf, 2006), 406–7; Kasher, *The Civil Rights Movement*, 7–8.

3. Street, interview with Jon Lewis, Mar. 4, 1981, San Francisco, author's possession.

26. SLAVES

1. Francisco Jimenez, *The Circuit: Stories from the Life of a Migrant Child* (Albuquerque: University of New Mexico Press, 1997); Ann Aurelia López, *The Farmworkers' Journey* (Berkeley: University of California Press, 2007).

2. A farmworker's annual income in 1965 was $1,378.

3. Moore, *Slaves,* 35; Fischer, *The Harvest Labor Market*, 7–9; Morin, *The Organizability of Farm Labor*, 3–8.

27. FRIENDSHIPS

1. Street, interview with Jon Lewis, Oct. 11, 2008, San Francisco, author's possession.

2. Brian Coe, *Cameras, from Daguerreotype to Instant Pictures* (New York: Crown, 1988), 50, 232; Street, interview with Bob Fitch, Mar. 23, 1978, San Francisco, author's possession.

3. Street, Interview with Jon Lewis, Nov. 11, 2002, San Francisco author's possession.

28. PHOTOGRAPHERS

1. *Bakersfield Californian*, Sept. 14, 1965. At least one of these photographers had been commissioned by union supporters. Requiring good photographs of a food caravan to Delano in December, 1965, Anne Draper, Regional Director of the Amalgamated Clothing Workers of America, hired San Francisco photographer Larry Kenney to document the event. Although one picture appeared in a Clothing Workers Union publication, most remained unseen by the public and sat unused in Draper's archive for the next forty years. See Larry Kenny, Proof Sheets, Anne Draper Collection, Stanford University Archives and Special Collections. See also *Delano Record*, Nov. 21, 1965, carrying an anti-strike statement by Al Espinosa, a labor contractor, who represented himself as a member of CSO.

2. Taylor, *Chávez*, x, 129; Street, interview with Ronald B. Taylor, May 23, 1974, Fresno, California, author's possession. See also *Fresno Bee* clipping files and photo morgue files, *Fresno Bee* (accessed in the 1980s, no longer available).

3. Kushner, *Long Road to Delano*, xiii. "Protest March Against Rent Hike on 27 Year-Old Metal Shacks," *Valley Labor Citizen*, July 23, 1965; Ballis to author, July 6, 1998, author's possession, enclosing Ballis, "Narrative of Career." See also "Citizen Editor on Photo Project," *Valley Labor Citizen*, July 31, 1964; *New York Times*, Nov. 26, 1961.

29. WITNESS

1. Several photographers got their start at Delano, including one who arrived with a little plastic Koni camera. Riding 250 miles by motorbike from San Rafael, Happ Stuart learned photography at Delano and later went on to a photographic career in New York City. See Street, interview with Jon Lewis, Aug. 9, 1998, San Francisco; Street, interview with John Kouns, Aug. 23, 1998, Sausalito, California, author's possession. A preliminary list of photographers, volunteers, and NFWA members with cameras at Delano on and off between Sept. 1965 and Sept. 1966 includes Henry Anderson, George Ballis, Bill Berg, Mike Bry, Gene Daniels, Anne Draper, Arthur Dubinsky, Bill Esher, Gerhard Gscheidle, Joseph Gunterman, Howard Horowitz, Nick Jones, John Kouns, Jim Kunz, Sam Kushner, Jacques Levy, Jon Lewis, Ernest Lowe, Eugene Nelson, Lauri Olman, Steve Pinskey, Harvey Richards, Victor Salandini, Chris Sanchez, Eric Schmidt, Gerald Sherry, Blair Stapp, Ted Streshinsky, Hap Stuart, Ronald Taylor, and Bob Thurber. Stapp's work is collected in the Oakland Museum.

2. Street, interviews with Ernest Lowe, Mar. 14, 1995, Mar. 22, 2002, Oakland, California, author's possession; Lowe to author, Oct. 8, 1976, author's possession; Street, interview with John Collier Jr., Mar. 12, 1978, Muir Beach, author's possession; Joe Munroe, *Changing Faces*, 100–101; Paul Richards, *Critical Focus: The Black and White Photographs of Harvey Wilson Richards* (Oakland; Estuary Press, 1986); Matthew Taylor, "Harvey Richards," *San Francisco Chronicle*, Apr. 29, 2001; McGregor, *Remembering Cesar*, vi; Galarza, *Spiders in the House and Workers in the Field* (Notre Dame: University of Notre Dame Press, 1970), 213; "Prints as Politics," *Fresno Bee*, Sept. 30, 1973; *People's World*, Oct. 16, 1965; *El Malcriado* 27 (Dec. 15, 1965); Eugene Nelson, *Huelga: The First Hundred Days of the Great Delano Grape Strike* (Delano: Farmnworker Press, 1966), 81; Kern County Sheriff's Office Records, Sept. 25, 1965; Records of the California Senate Fact-Finding Committee on Un-American Activities, California State Archives; California State Legislature, Senate, *Fourteenth Report of the Senate Fact-finding*

Subcommittee on Un-American Activities (Sacramento: California State Legislature, 1967), 28–29; "Six Year-Old Strikebreakers," *Valley Labor Citizen*, Oct. 1, 1965; *People's World*, Oct. 2, 10, 30, 1965; *San Francisco Examiner*, Oct. 17, 1965; A. V. Krebs, "Strikers Seek Church Help," *National Catholic Reporter* 50 (Oct. 20, 1965): 6, Victor Salandini Collection, Stanford University Special Collections and Archives; William O'Brien, "The Grapes of Wrath in Delano," *San Francisco Examiner*, Oct. 17, 1965; photographs by Richards in the *People's World* Collection, Labor Archives, San Francisco State University. J. Edgar Hoover's men would spy on the farmworker movement for the next ten years, eventually compiling a file of about fifteen hundred pages that uncovered not one instance of subversive or illegal activity. See Street, "The FBI's Secret File on César Chávez," *Southern California Quarterly* 128 (Winter, 1996/97): 347–84, FBI Director to SAC, Los Angeles, Oct. 11, 1965, Catha DeLoach to Milton Jons, "Communist Infiltration of the National Farmworkers Association, Delano, California, Internal Security-C," Oct. 15, 1965, Hoover to SAC, Los Angeles, Oct. 18, 1965, all in Declassified FBI File 100–444762. Besides discovering the home address of Harvey Richards (14 Flood Circle, Atherton, California), the FBI noted that Richards drove a 1965 Oldsmobile station wagon, California license plate S75763. For later concerns with Richards see A. Jones to Robert Wick, Mar. 11, 1965. One informant supplying information on Richards was apparently close to Chávez, as he "asked" Chávez about the photographer and was "told" he was a freelancer. I have not been able to identify the informant, who may have passed as a photographer. See Street, interviews with Jack Pandol, Nov. 11, 13, 1987, Delano, California; Del Castillo and Garcia, *César Chávez*, 45; John Bloom, *Photography at Bay: Interviews, Essays, and Reviews* (Albuquerque: University of New Mexico Press, 1998), 172–74.

3. Street, interview with Jack Pandol, Nov. 13, 1986, Delano, California, author's possession.

4. Street, interview with Jack Pandol, Nov. 11, 1986, Delano, California, author's possession.

5. Ballis, "Justice, San Joaquin Style," *Valley Labor Citizen*, Oct. 15. 1965; "Citizen Fouls Up On Dispoto Bullying," *Valley Labor Citizen*, Nov. 19, 1965; *The Movement*, Dec. 1965.

30. ADVOCATES

1. The whereabouts of much of the UFW photographic material still remains a mystery. For example, NFWA volunteer Father Victor Salandini packed a camera and shot hundreds of photographs, but after searching the Salandini Collection I failed to find any negatives. For an anecdote describing his photography see Dunne, *Delano*, 126. Leroy Chatfield has copies of some of Chávez's photographs. See Chatfield to author, Jan. 2, 2005, author's collection.

2. Street, interview with César Chávez, Aug. 7, 1979, Salinas, California, author's possession; Street, interview with Jon Lewis, Aug. 8, 1998, San Francisco, author's possession; Meister and Loftis, *A Long Time Coming*, 122; Jon Lewis, "Jon Lewis Photos, 1966–1968," http://www.farmworkermovement.org. For a photograph of Chávez photographing organizers departing California on the grape boycott in 1969 see the UFW Collection, Archives on Urban and Labor History, Wayne State University. See also Ferriss and Sandoval, *The Fight in the Fields*, 151, 175.

3. Street, interview with Jack Pandol, Nov. 13, 1986, Delano, author's possession. See also, Street, interview with Stephen Pavich Jr., Sept. 27, 1989, Richgrove, CA, author's possession.

4. Eugene Nelson to author, Oct. 29, 1976, author's possession.

5. On December 2, *El Malcriado* editor Bill Esher discovered just how far some would go to eliminate unfavorable images. Photographing badly packed table grapes being dumped into gondolas headed for a local winery, Esher was chased back to his car by an irate company employee who followed him down the highway and tried to run him off the road. See Nelson, *Huelga*, 119. For Dubinsky, see Steve Allen, *The Ground Is Our Table* (Garden City, NJ 1966), 95–99. See also Jenkins, *The Politics of Insurgency*, 142–43; Linda C. Majka and Theo J Majka, *Farm Workers, Agribusiness, and the State* (Philadelphia: Temple University Press, 1982), 174–75; Street, interview with Ballis, June 6, 1979, Fresno, author's possession; Kushner, *Long Road to Delano*, 153; *El Malcriado* 25 (Nov. 3, 1965), English edition.

6. Austin Morris, "Agricultural Labor and the NIRA," *California Law Review* 54 (1966): 1939–89; Beverly S. Tangri, "Federal Legislation As an Expression of United States Public Policy Toward Agricultural Labor, 1914–1954" (PhD diss., University of California, Berkeley, 1967).

7. "List of Boycott Centers, National Boycott Schelely Liquors and Delano Grapes," Memo 1, Jan. 1966, Eugene Nelson Collection; *Valley Labor Citizen* 26 (Dec. 17, 1965); Sidney Smith, *Grapes of Conflict* (Pasadena: Hope Publishing House, 1987), 136; Street, interview with Rev. Jim Drake, Tripple-S Produce tomato strike, Stockton, California, Aug. 28, 1975, author's possession.

8. AFL-CIO Executive Council, "Statement on Boycott of DiGiorgio Products," May 6, 1966, Fred Ross Collection, Stanford University Archives and Special Collections; Alan Altman, "A Financial Survey of Schenley Industries and Distillers Corporation, Seagams Limited," (master's thesis, Brown University, 1951); American Arbitration Association, "Memorandum to the Governor of California: Concerns Fact Finding Procedure with the DiGiorgio Corporation: Report and Recommendations," July 14, 1966, California State Library; *El Malcriado* 11 (May 1965); *Sacramento Bee* (Apr. 1, 1965); *Valley Labor Citizen* 44 (Apr. 1965); *Farm Labor* 1 (May 1965).

9. Street, interview with Fred Ross, Apr. 23, 1978, Mill Valley, California, author's possession.

31. BOYCOTT

1. Nelson Lichtenstein, *The Most Dangerous Man in Detroit: Walter Reuther and the Fate of American Labor* (New York: Basic Books, 1995), 410; Arthur Schlesinger Jr., *Robert F. Kennedy and His Times* (Boston: Houghton Mifflin, 2002), 790–92; United Automobile Workers, *Proceedings of the Twentieth Constitutional Convention, Long Beach, California* (May 16–20, 1966): 230, Jacques Levy Collection; Levy, *César Chávez*, 202–3; del Castillo and Garcia, *César Chávez*, 51; UPI Telephoto DEP121602-12-16-98-Delano, CA; *El Malcriado* 26 (Dec. 22, 1965).

2. Street, interview with Jon Lewis, Mar. 4, 1981, San Francisco, author's possession.

3. Street, interview with LeRoy Chatfield, Oct. 22, 2010, e-mail, author's possession.

4. Elaine Graves, "*El Malcriado* Anthology, 1965–1972" (master's thesis, Fairfield University, 1973); National Advisory Committee on Farm Labor, *The Grape Strike* (New York: National Advisory Committee on Farm Labor, 1966); *Los Angeles Times*, Dec. 4, 1965; *Valley Labor Citizen* 34 (Jan. 8, 1966); *The Movement* (Jan. 20, 1966); *California AFL-CIO News* (Feb. 18, 1966).

32. ZOO

1. Street, interview with Doug Adair, Mar. 12, 2002, Thermal, California, author's possession.

2. Street, interview with Jon Lewis, Aug. 3, 2008, San Francisco, author's possession.

3. Street, interview with Jon Lewis, Mar. 4, 1981, San Francisco, author's possession. Lewis was alluding to a photojournalism term describing how one never missed the action by setting the lens aperture at f.8 and shooting quickly to get the picture before even thinking about proper exposure.

4. Street, interview with Lewis, Aug. 23, 1998, San Francisco, author' possession; Chatfield, "John A. Kouns Photos, 1966–1970, 1973–1974, 1995–1996," http://www.farmworkermovement.org.

5. Street, interview with Jon Lewis, Oct. 17, 2008, San Francisco, author's possession; *El Malcriado* 30 (Feb. 28, 1966).

33. DARKROOM

1. Street, interview with Jon Lewis, Aug. 2, 2008, San Francisco, author's possession.

2. Oral interview, Doug Adair, California State University, Northridge, Mar. 10, 1995, Provost's Committee on Chicano Labor; Street, interviews with Adair, Feb. 10, Mar. 12, 2002, Mecca and Thermal, California; Adair to author, e-mail, Aug. 1, 2004, author's possession; Street, *Everyone Had Cameras*, 424–26.

3. Nelson, *Huelga*, 129; London and Anderson, *So Shall Ye Reap*, 173; Adair to author, e-mail, Aug. 1, 2004, author's possession; Street, interview with Bill Esher, May 29, 1981, Sebastopol, California, author's possession. With issue number 22, in Nov. 1965, *El Malcriado* began running photographs. See Bill Esher, "Coyotes in the Cantaloupes: Notes from the Melon Harvest," *Farm Labor* 2 (Aug. 1964): 9–10; Henry Zon, "Huelga," IUD *Agenda* 2 (Jan. 1966): 22–26.

4. Susan Drake to author, May 23, 2003, author's possession. See also Doug Adair to author, June 3, 2003, author's possession; Lewis, *From This Earth*; Street, interview with Gerhard Gscheidle, May 8, 2003, Stuttgart, Germany; Gscheidle to author, May 15, 2003, author's possession; Lewis photo essay on DiGiorgio's Sierra Vista Ranch [extensively captioned sequence of eleven photographs], Ann Draper Collection, Stanford University Archives and Special Collections.

5. *El Malcriado* 28 (Jan. 22, 1966).

6. *El Malcriado* 29 (Feb. 12, 1966).

34. ROUTINE

1. Quote from Street, interview with Jon Lewis, Mar. 4, 1981, author's possession. See also Bill Esher to Lowe, n.d., Lowe Collection.

2. Street, interview with Jon Lewis, Aug. 3, 2008, San Francisco, author's possession.

3. Street, interview with George Ballis, June 6, 1979, Fresno, California, author's possession; Street, interview with Eugene Nelson, Aug. 12, 1979, Sebastopol, California, author's possession; Street, interview with Harvey Richards, Mar. 23, 1976, Atherton, California, author's possession.

4. Street, interview with Lewis, Aug. 23, 1998, Oakland, author's possession. "It was day to day," recalled Lewis. "You would wait for the weekends. Everyone would go to People's Bar. The strike caravans would come in. There would be food. Groovy chicks. I had a cigarette habit and the $5 a week wage was tough. You were just like one of the pickets. It was the experience of a lifetime." Street, interview with Jon Lewis, Aug. 8, 1998, San Francisco, author's possession. Lacking in resources, Lewis shot Tri-X film developed in Acufine. The practice irritated Jack Welpott, his photography instructor at San Francisco State University. Welpott thought that

Lewis was compromising quality. But Lewis had no choice. He had to develop his film with whatever was available. Street, interview with Jon Lewis, Mar. 4, 1981, San Francisco, author's possession. See also, Lewis, "From this Earth . . . from the Delano Grape Strike" (master's thesis, San Francisco State University, 1969).

35. LESSONS

1. Jacques Levy, interview with Manuel Chávez, n.d., Jacques Levy Collection, Beinecke Library, Yale University; Levy, *César Chávez*, 173–75; Taylor, *Chavez*, 116; Meister and Loftis, *A Long Time Coming*, 121–22; Dick Meister, interview with Manuel Chávez, n.d, Dick Meister Collection, The Bancroft Library.

2. Street, interview with Jon Lewis, Sept. 25, 2008, San Francisco, author's possession. For Jim Holland's recollections, see http://www.farmworkermovement.org.

3. Street, interview with Jon Lewis, Sept. 7, 2008, San Francisco, author's possession.

4. National Advisory Committee on Farm Labor, *The Grape Strike*, 29; Nelson, *Huelga*, 129. Both pamphlets used images by George Ballis, Harvey Richards, *El Malcriado* editor Bill Esher, and freelancer Bill Berg. See also Frank P. Graham and Philip Randolph to Friend, Mar. 30, 1966, Raymond P. Roth Collection, University of California, Davis.

36. DOUBTS

1. Street, interview with Jon Lewis, Mar. 24, 1981, San Francisco, author's possession.

2. Dolores Huerta to Irwin DeShetler, Mar. 13, 1966, Irwin DeShetler Papers, Archives of Urban and Labor History, Wayne State University; Dunne, *Delano*, 96; Charles McCarthy, "Diary of a Grape Strike, *Ave Maria* 103 (Jan. 15, 1966): 19–22; *El Malcriado* 27 (Jan. 11, 1966).

3. Street, interview with Jon Lewis, Aug. 31, 2008, San Francisco, author's possession.

4. Street, interview with Eugene Nelson, July 14, 1976, Sebastopol, author's possession; Street, interview with Lewis, Sept. 11, 1981, San Francisco; Nelson, *Huelga*, 73.

5. "Communist Infiltration of the National Farmworkers Association, Delano, California — Internal Security-C," Oct. 20, 1965, Declassified FBI File LA-100-444762. See also National Advisory Committee on Farm Labor, *The Grape Strike*, 29; Taylor, *Chavez*, 165; A.V. Krebs, "Strikers Seek Church Help," *National Catholic Reporter* 50 (Oct. 20, 1965): 6; Kushner, *Long Road to Delano*, 137–39; Dunne, *Delano*, 28; *Valley Labor Citizen*, Oct. 1, 1965 [describing one incident]; Levy, *Chávez*, 190; "Dear Don," memorandum, California Migrant Ministry Papers, Archives of Urban and Labor History, Wayne State University; A. Phillip Randolph to Dear Friend, Mar. 30, 1966, Raymond P. Roth Collection, University of California, Davis.

6. Street, interview with Jon Lewis, Apr. 17, 1998, San Francisco, author's possession; Levy, *Chávez*, 190; Street, interview with Henry Anderson, May 22, 1978, Berkeley, California; Street, interview with George Ballis, Mar. 17, 1981, Fresno; Street, interview with Sam Kushner, Aug. 7, 1973, Arvin, California, author's possession.

37. EXHAUSTION

1. Gary Allen, *The Grapes: Communist Wrath in Delano* (Belmont, MA: American Opinion, 1966), 3–12, in Raymond P. Roth Collection, University of California, Davis. See also Gary Allen, "The Grape Communist Wrath in Delano," *American Opinion* 9 (June 1966):

1–14; "Communist Infiltration of the National Farmworkers Association, Delano, California — Internal Security — C," 3, Oct. 20, 1965, Declassified FBI File 100–444762; California State Legislature, Senate, *Fourteenth Report of the Senate Fact-finding Subcommittee on Un-American Activities*, 42, 68–69, 72–75.

2. Edgar Z. Friedenberg, "Another America," *New York Review of Books* (Mar. 3, 1966): 23–25; LeRoy Chatfield, "Mark Jonathan Harris Photos 1966," http://www.farmworkermovement.org; Bill Esher to Lowe, n.d., Lowe Collection. Harris would go on to a distinguished career and win three Academy Awards for documentary filmmaking.

3. Mark Jonathan Harris, "On Making *Huelga*," MS, July 2005, http://www.farmworkermovement.org.; Street, interview with Mark Harris, Mar. 4, 2004, telephone, author's possession.

4. Street, Interview with Jon Lewis, Mar. 22, 1981, San Francisco, author's possession.

5. Street, Interview with Jon Lewis, Mar. 22, 1981, San Francisco, author's possession. See also Jerald Brown, "United Farm Workers Grape Strike and Boycott, 1965–70: An Evaluation of the Culture of Poverty Theory" (PhD diss., Cornell University, 1972), 161–62; Marshall Ganz, "Five Smooth Stones: Strategic Capacity in the Unionization of California Agriculture" (PhD diss., Harvard University, 2000), 337–40. According to *El Malcriado* 33 (Apr. 10, 1966), Chávez in 1957 considered leading a mass march from the Mexican border to Sacramento in order to call attention to terrible working conditions in the Imperial Valley.

6. Lewis recalled that Chávez announced that 75 farmworkers would participate in La Perigrinación, although only 67 began the march in Delano and 51 finished. See Street, interview with Jon Lewis, Sept. 9, 2008, San Francisco, author's possession; *El Malcriado* 33 (Apr. 10, 1966), Souvenir Edition. Also present at the meeting, Marshall Ganz, *Why David Sometimes Wins*, 147, identifies the meeting as taking place at a supporter's home in Santa Barbara.

7. César Chávez, "Peregrinación, Penitencia, Revolucion," *Town and Country Church* 188 (May–June 1966): 16; Mike Miller, "The Strike of the Grapes," *Commission on Religion and Race Reports* 2 (May 1966): 1–7.

8. John Jacobs, *A Rage for Justice: The Passion and Politics of Phillip Burton* (Berkeley: University of California Press, 1995), 97–98; *Farm Labor* 4 no. 2 (Mar. 1966): n.p.; Peter Schrag, *California: America's High-Stakes Experiment* (Berkeley: University of California Press, 2006), 97; Lou Cannon, *Governor Reagan* (New York, 2003), 147.

9. Street, interview with Jon Lewis, Sept. 7, 2008, San Francisco, author's possession.

10. Squirrely from the beginning of the march and indifferent to the strike, Brown was a close personal friend of DiGiorgio. Growers liked Brown and appreciated his leadership in the State Water Project, a masterpiece of plumbing that had allowed agriculture to farm vast swaths of land. Now Chávez planned to pin Brown down — either for or against the strike — it did not matter. Street, interview with Jon Lewis, Sept. 7, 2008, San Francisco, author's possession.

38. KENNEDY

1. Edwin O. Guthman and C. Richard Allen, eds., *RFK: Collected Speeches* (New York: Viking, 1993), 197–207.

2. Street, interview with Jon Lewis, Sept. 7, 2008, San Francisco, author's possession.

3. U.S. Senate, Committee on Labor and Public Welfare, *Hearings of the Subcommittee on Migratory Labor*, 89th Congress, 2nd sess., (Washington, DC, 1966), 369–70; Taylor, *Chavez*, 165–66; Levy, *César Chávez*, 205; *El Malcriado* 32 (Mar. 3, 1966).

4. *El Malcriado* 32 (Mar. 3, 1966) carries a full layout of the work that Jon Lewis did at the Senate subcommittee hearings and the beginning of La Peregrinación.

5. Ferriss and Sandoval, *The Fight in the Fields*, 117–23; Peter Matthiessen, *Sal Si Puedes*, 127–29. Some question the assertion that the march on Sacramento was the longest mass march up to that point in American history. To some extent it depends on how one defines a protest march. See Lucy G. Barber, *Marching on Washington: The Forging of an American Political Tradition* (Berkeley: University of California Press, 2003).

39. THE MARCH

1. Gerhard Gscheidle to author, May 7, 28, June 3, 2003, author's possession; Doug Adair to Marshall Ganz, June 8, 2004, e-mail, UFW Documentation Project, NFWAleroy@listerve.com.

2. Street, interview with Sam Kushner, July 31, 1973, Arvin, California, author's possession. Blair Stapp's photographic archive is in the Oakland Museum.

3. John A. Kouns, "John A. Kouns," http://www.farmworkermovement.org. For additional information on Kouns see James B. Moore, "Photographer with a Social Conscience: An Oral History with John Kouns and a Discussion of His Photographs," (master's thesis, California State University, Northridge, 2005); Taylor, *Chavez*, 121–22.

4. Street, interview with Sam Kushner, July 31, 1973, Arvin, California, author's possession.

5. Quotes from Street, interview with Mike Bry, Apr. 22, 1982, San Francisco; Street, interview with Bob Fitch, Mar. 22, 1982, San Francisco. See also Street, interview with Ernest Lowe, Mar. 14, 1995, Oakland, California; Street, interview with Doug Adair, May 22, 1986, Thermal, California, author's possession.

6. Street, interview with Jon Lewis, Apr. 25, 1982, San Francisco, author's possession; also Street, interview with John A. Kouns, Mar. 24, 1981, Mill Valley, California, author's possession; Kouns, "John A. Kouns," http://www.farmworkermovement.org; Street, interview with Chris Schneider, Mar. 22, 1987, El Centro, author's collection.

40. PARTICIPATING

1. Street, interview with Jon Lewis, Aug. 7, 2008, San Francisco, author's possession; Brown, "United Farm Workers," 168; *El Malcriado* 33 (Apr. 10, 1966). King's age is sometimes given as 67.

2. Street, interview with Jon Lewis, Apr. 26, 1982, San Francisco, author's possession. For biographical material on McGivern see *El Malcriado* 26 (Dec. 22, 1965).

3. *El Malcriado* 32 (Mar. 3, 1966).

4. Gerhard Gscheidle to author, May 1, May 28, 2003; Street, interview with Gerhard Gscheidle, May 12, 2003, Stuttgart, Germany, author's possession; Dunne, *Delano*, 133; Moore, "Photographer with a Social Conscience," 79; César Chávez Declassified FBI Report, Mar. 17, 1966.

5. Street, interview with Jon Lewis, Aug. 8, 1998, San Francisco, author's possession.

6. Street, interview with Jon Lewis, Aug. 8, 1998, San Francisco, author's possession; *Sacramento Bee*, Mar. 18, 19, 1966; *Fresno Bee*, Mar. 17, 18, 19, 1966.

41. LA CAUSA

1. Street, interview with Jon Lewis, Aug. 8, 1998; Moore, "Photographer with a Social Conscience," 142.

2. Moore, "Photographer with a Social Conscience," 144.

3. Street, interview with Jon Lewis, Oct. 17, 2008, San Francisco, author's possession; *San Francisco Chronicle*, Mar. 23, 24, 25, 26, 1966; Luís Valdéz, "The Tale of the Raza," *Ramparts* 5 no. 2 (July 1966): 40–43.

4. Gerhard Gscheidle to author, June 3, 2003, author's possession; Street, interview with Lewis, Aug. 8, 1998; Street, interview with Kouns, Mar. 26, 1981, Mill Valley, California, author's possession; "March of the Migrants," *Life* 60 (Apr. 29, 1966): 93–94.

5. Street, interview with Kouns, Mar. 26, 1981, Mill Valley, California, author's possession; Street, interview with Harvey Richards, Apr. 23, 1978, Menlo Park, California, author's possession.

6. Street, interview with Jon Lewis, Aug. 8, 1998, San Francisco, author's possession. For the images Lewis made on the march see *El Malcriado* 32 (Mar. 3, 1966), 33 (Apr. 10, 1966).

42. BLISTERS

1. Nicolas Kanellos, "Folklore in Chicano Theater and Chicano Theater as Folklore," *Journal of the Folklore Institute* 15 (1978): 60; Street, interview with Felipe Cantu, Aug. 23, 1987, Sanger, California, author's possession.

2. Yolanda Broyles-Gonzales, *El Teatro Campesino: Theater in the Chicano Movement* (Austin: University of Texas Press, 1994), 13, 27, 76, 13–20, 235–36; Betty Ann Diamond, "Brown-eyed Children of the Sun: The Cultural Politics of El Teatro Campesino" (PhD diss., University of Wisconsin, 1977). For an early published photograph from El Teatro's New York City tour see Edwin Bolwell, "Strike Message Put to Music Wins Cheers," *New York Times*, July 22, 1967, photograph by John Orris. One of the few women photographers active among the farmworker movement at this time was Stockton-based Elizabeth Sunflower, who did a long interview and photo essay on Luís Valdéz and El Teatro Campesino for the *Tulane Drama Review*. She died in 2008.

3. Ferris and Sandoval, *Fight in the Fields*, 112.

4. Street, interview with Kouns, Mar. 26, 1981, Mill Valley, California; Street, interview with Jon Lewis, Aug. 23, 1998, author's possession; Dunne, *Delano*, 132–33; Levy, *César Chávez*, 211. For the work of *Sacramento Bee* photographer Ward Sharrer see the *Sacramento Bee*, Apr. 11, 1966. See also the captioned photographs by Jon Lewis, Ann Draper Collection, Stanford University Archives and Special Collections. "There was no question that the symbolism . . . provided dramatic visual scenarios," recalled Gscheidle, "but this was a side product of the event itself. I never had the impression that we as photographers were only welcome because we provided the union with photographs, but that the human element was a strong connection. We came down from the big city and became part of a movement to further the cause of the farmworker without any immediate financial reward." See Gerhard Gscheidle to author, June 3, 2003, author's possession.

5. Street, interview with Jon Lewis, Aug. 31, 2009, San Francisco, author's possession.

6. Gerhard Gscheidle to author, May 28, 2003; Doug Adair to author, June 3, 2003, author's possession. See also Street, interview with John Kouns, Mar. 26, 1981, Mill Valley, California, author's possession; Street, interview with Jon Lewis, Aug. 23, 1998, San Francisco, author's possession.

7. Gerhard Gscheidle to author, June 3, 2003, author's possession.

8. After the march Sanchez went on to document the union's day-to-day activities for the next five years. "As he got better and better," recalled *El Malcriado* editor Doug Adair, "he let it be known he preferred being called 'Chris' (his name was Manuel Christobol Sanchez) . . . He actually did some of his best photography after I left the *El Malcriado* staff in 1970." Adair to author, Mar. 12, 2003, e-mail, author's possession. A short list of Mexican American photographers who covered the NFWA and its successors includes Victor Alemán, Oscar Castillo, Ben Garza, Alexis Gonzales, George Rodriguez, and Chris Sanchez.

43. SACRIFICE

1. Street, interview with Jon Lewis, Apr. 12, 1982, San Francisco, author's possession.

2. Victor Reuther, *The Brothers Reuther* (New York, 1976), 368; Taylor, *Chavez*, 158–59, 171–72; Street, interview with Ted Benson, Mar. 23, 2002, Modesto, California, author's possession; *Modesto Bee*, Mar. 30, Apr. 1–2, 1966.

3. Levy, *César Chávez*, 147, 213.

4. Jenkins, *Politics of Insurgency*, 155; *Stockton Record*, Mar. 21, 22, 1966; *San Francisco Examiner*, Mar. 21, 22, 1966; *San Francisco Examiner, California Living*, Dec. 21, 1980; Street, interview with Rich Turner, Mar. 12, 1976, Stockton, author's possession.

5. Street, interview with Jon Lewis, Sept. 7, 1981, San Francisco; Fran Ortiz Daily Journal, Mar. 20–22, 1966, courtesy of Fran Ortiz, San Francisco.

6. Street, interview with Jon Lewis, Sept. 7, 1981, San Francisco. See also "Day by Day with the FWA," *Farm Labor* 4 (Apr. 1966): 18–24.

44. ST. MARY'S

1. Street, interview with Fran Ortiz, Mar. 22, 1989, San Francisco, author's possession. Ortiz said that the *San Francisco Examiner* lost both the negatives and prints. See Street, interview with Elizabeth Martin, May 23, 1998, San Francisco, author's possession.

2. For religion and popular culture see Warren Susman, *Culture and Commitment, 1929–1945* (New York: Braziller, 1973). For the Virgin Mary motif see Maria Warner, *Alone of All Her Sex: The Myth and the Cult of the Virgin Mary* (New York: Salem Press, 1976), 203, 223; Pat Hoffman, *Ministry of the Dispossessed*, 35. For the crucifixion photograph see George Ballis, *Basta! The Tale of Our Struggle* (Delano, CA: Farmworker Press, 1966), 23. See also Paul Jacobs, "Clear the dignitaries! Clear the dignitaries! The platform is reserved for the originales!" *Ramparts* 5 (July 1966), 32; Street, interview with Jon Lewis, Aug. 23, 1998, San Francisco, author's possession. For Ballis see Ballis, "Narrative of Career," Ballis to author, July 6, 1998, author's possession; McGregor, *Remembering Cesar*, vi; Street, interviews with George Ballis, May 2, 1982, Fresno; Mar. 12, 1998, Toll House, author's possession. See also Mary Rudge, "Their Art Comes from the Fields," *San Francisco Examiner, California Living*, May 17, 1981.

3. Levy, *César Chávez*, 215–17; Taylor, *Chavez*, 176–78.

4. Street, interview with Jon Lewis, June 2, 2009, San Francisco, author's possession.

5. *El Malcriado* 34 (May 5, 1966), English edition.

6. *San Franciso Chronicle*, Apr. 6, 9, 1966; Feb. 14, 1991; Taylor, *Chavez*, 178; Levy, *César Chávez*, 221–23; Ruth Teiser, "The Digiorgios: From Fruit Merchants to Corporate Innovators,"

Regional Oral History Project, 1983, The Bancroft Library; "A History of the Delano Grape Strike and DiGiorgio Elections," mimeo, n.d,, 1–2, California Migrant Ministry Collection, Archives of Urban and Labor History, Wayne State University.

7. Street, interview with Jon Lewis, Sept. 22, 2009, San Francisco, author's possession.

8. *San Franciso Chronicle*, Apr. 7, 8, 1966.

45. SACRAMENTO

1. Street, interview with Jon Lewis, June 1, 2009, San Francisco, author's possession.

2. Ganz, *Why David Sometimes Wins*, 3, 161, states that 51 "originales" made it to Sacramento. *El Malcriado* 33, (Apr. 10, 1966), Souvenir Edition, lists 63 "originales" but notes that the list is incomplete and that there were more people than those on the "List of Honor." I have not resolved this accounting discrepancy.

3. For Blair Stapp's work see his disorganized but extremely valuable collection in the Oakland Museum. For press photographers see the work of Joseph A. Frisina and Walt Porter in the *Fresno Bee*, Mar. 25, 1966. Some photographers recall the atmosphere on the steps of the state capitol as resembling that of a class reunion, as old radicals and liberals put aside animosities and jeered Governor Brown for refusing to meet the marchers in favor of spending Easter at Frank Sinatra's home in Palm Springs.

4. Hansel Mieth Hagel Collection, Center for Creative Photography, University of Arizona, Tucson.

5. Street, interview with Jon Lewis, May 13, 1998, San Francisco, author's possession. Lewis refreshed his memory during this interview and others by referring to various issues of *El Malcriado*.

6. *El Malcriado* 34 (May 5, 1966), English edition; *Farm Labor* 4 no. 3 (Apr. 1966); Brown, "United Farm Workers Grape Strike," 157–59; Taylor, *Chavez*, 186.

7. Street, interview with Jon Lewis, Mar. 13, 1982, San Francisco, author's possession; Street, interview with Jim Marshall, Oct. 15, 2004, San Francisco; Marshall to author with enclosures, Oct. 18, 2004, author's possession; Jim Marshall, *Proof* (San Francisco: Chronicle Books, 2004), 119–22, back page. Abrupt and patient, generous and hard-assed, given to drug-induced rants, Marshall would later be recalled by *San Francisco Chronicle* music critic Joel Selvin as "a man who can give being difficult a bad name." He was the last person one would except to see at a farmworker rally or even associate in any way with photographic coverage of California farmworkers. Human "be-ins," rock concerts, "love-ins," and various other events were his realm. But like all good photographers, Marshall was far more versatile and curious than anyone understood. His interests ranged from spot news to documentary projects. In 1963 he completed an assignment on Appalachian poverty for *Saturday Evening Post* and then spiked the harrowing photo essay. In order to preserve the integrity of his work he gave it to *Jubilee* magazine editor Ed Rice. Marshall's best shot at Sacramento shows a young Chávez who could have easily been mistaken for a Mexican organizer during any of a number of strikes and protests during the preceding fifty years. Only the NFWA eagle on his armband gave any sense of who Chávez represented. No one wanted the picture, and Marshall filed it away with its corresponding contact sheet. Forty years later the public saw the image for the first time when Marshall used it in his retrospective book *Proof* — yet another example of the extent to which

farmworkers attracted the attention of so many of California's best photographers. See Street, interview with Shirley Streshinsky, Aug. 12, 2003, Kensington, California, author's possession; Emma Brown, "Jim Marshall Dies," *Washington Post*, Mar. 26, 2010. No longer close to the dockworkers she had photographed in the mid-1930s and alienated by the "pork chop unionists" she encountered in the modern Longshoreman's Union, Hansel Mieth Hagel had become fascinated by César Chávez, whose fight for basic human rights seemed "a strata . . . worth further investigation." Now coming out of a period of semiretirement, she was contemplating a book about farmworkers in general and their children in particular. Joining the march at Sacramento, she used a new, motorized 35 millimeter Nikon camera and shot both color and black and white film. By far the most experienced photographer on the steps of the state capitol that day, Hagel brought almost thirty-six years of experience to her work — although few, if any, of the photographers there recognized her. One of her best color shots was a portrait of George Ballis. See Hansel Mieth Hagel Contact Sheets and Color Slides, "Grape Strike March," Mar. 10, 28–30, 1966; "Cesar Chavez, San Francisco," June 1966; "Farmworkers Grape Strike, San Francisco," July, 1966; Hagel, "Toward a Conclusion," MS, Dec. 8, 1966, 48; Hagel, "The Headstart Story, a Reappraisal," MS, July 14, 1969, 5–6; Hagel to Otto [handwritten, undated]; "A Publishable Story," [handwritten notes] Dec. 1968, Otto and Hansel Mieth Hagel Collection.

8. Gscheidle to author, e-mail, June 3, 2003, author's possession; Grant Cannon, "Labor — Strike, Boycott and Contract," *Farm Quarterly* 21 (Fall 1966): 20–26. As one of his last projects in Delano, Gerhard Gscheidle photographed the Schenley elections on assignment for *Newsweek*, snagging the job through a connection that SNCC's Los Angeles office had with the local *Newsweek* office.

46. ALONE

1. Valdéz, "The Tale of the Raza," 40–43.

2. Street, interview with Jon Lewis, Sept. 13, 2008, San Francisco, author's possession.

3. Street, interview with Jon Lewis, Sept. 7, 2008, San Francisco, author's possession. Street, interview with Jon Lewis, Sept. 7, 2008, San Francisco, author's possession.

4. Street, interview with Jon Lewis, Mar. 5, 1981, San Francisco, author's possession.

5. Street, interviews with Jon Lewis, Mar. 4, 1981, Mar. 29, 2008, San Francisco, author's possession. When Lewis left Delano, he gave fifteen of twenty rolls of film to Helen Chávez. He never saw the film again.

6. *El Malcriado* 35 (May 19, 1966), 36 (May 19, 1966); *Fresno Bee*, May 16, 1966; Dunne, *Delano*, 143.

7. Ganz, *Why David Sometimes Wins*, 164–66.

8. *Farm Labor* 3 no. 5 (Oct. 1965); *Farm Labor* 4 no. 3 (Apr. 1966); Brown, "United Farm Workers Grape Strike," 170–80; Margaret Rose, "Woman Power Will Stop Those Apes: Chicana Organizers and Middle-Class Female Supporters in the Farmworkers' Grape Boycott in Philadelphia," *Journal of Woman's History* (Winter 1995): 6–32.

47. PARTICIPANT

1. Street, interview with John Kouns, Mar. 26, 1981, Mill Valley, California, author's possession.

2. Street, interview with John Kouns, Mar. 27, 1981, Mill Valley, California, author's possession.

3. Mark Jonathan Harris, "On Making *Huelga*." Harris followed the routine for three weeks. Returning to Portland in June, he spent several months editing what he believed would be a powerful film conveying the importance of the Delano grape strike.

48. DIGIORGIO
1. Street, interview with Jon Lewis, Sept. 12, 2008, San Francisco, author's possession.
2. Street, interview with Jon Lewis, Sept. 2, 2008, San Francisco, author's possession.

49. SWEETHEART
1. *El Malcriado* 36 (May 1966); Taylor, *Chavez*, 187–90; Levy, *César Chávez*, 223–27; Dunne, *Delano*, 141–43; DiGiorgio election documents, Ronald Haughton Papers, Wayne State University.
2. Lewis, Strike Diary, June 10, 1965, courtesy of Jon Lewis.
3. Street, interview with Jon Lewis, June 23, 2008, San Francisco, author's possession.

51. ALTAR
1. Jon Lewis, Strike Diary, July 11, 1965, courtesy of Jon Lewis.
2. Street, interview with Jon Lewis, Oct. 17, 2008, San Francisco, author's possession.
3. Jon Lewis annotations in his copy of Henri Cartier Bresson, untitled essay (1952), often called "The Decisive Moment," courtesy of Jon Lewis.

52. FRAUD
1. Street, interview with Jon Lewis, Oct. 17, 2008, San Francisco, author's possession.
2. *Fresno Bee*, June 25, 1966; *San Francisco Chronicle*, June 23, 1966; Levy, *César Chávez*, 229–30; Taylor, *Chavez*, 189–92.
3. Lewis, Strike Diary, June 26, 1965, courtesy of Jon Lewis.
4. Lewis, Strike Diary, June 26, 1965, courtesy of Jon Lewis.
5. Ronald Haughton, "Report and Recommendations," Ronald Haughton Collection, Archives of Urban and Labor Affairs, Wayne State University; Chávez to Senator Harrison Williams, n.d., Fred Ross Papers, Stanford University Archives and Special Collections; *Fresno Bee*, June 26, 1966; *San Francisco Chronicle*, June 25, 1966; UFW, "Friday Night Meeting Minutes [handwritten]," June 22, 28, 1966; UFW "Chronology of the Strike" [a compilation of newspaper clippings], June 10, 14, 17, 22, 29, 1966, United Farm Workers Organizing Committee Papers, Archives of Urban and Labor Affairs, Wayne State University.
6. Brown, "United Farm Workers Grape Strike," 191–92; *El Malcriado* 39 (June 30, 1966); Levy, *César Chávez*, 231–34; Dunne, *Delano*, 147–50; Taylor, *Chavez*, 194–95; *Los Angeles Times*, July 10, 15, 1966.
7. Jon Lewis, Strike Diary, June 26, 1966, courtesy of Jon Lewis.

53. PRINTS
1. Dunne, *Delano*, 21; del Castillo and Garcia, *César Chávez*, 16, 50–53, 77–78.
2. Street, interview with Jon Lewis, Oct. 17, 2008, San Francisco, author's possession.
3. Street, interview with Jon Lewis, Oct. 17, 2008, San Francisco, author's possession.
4. Jon Lewis, "Prints Sent Out — June 1966," Jon Lewis Collection, San Francisco.

54. VIOLENCE

1. Dunne, *Delano*, 151; Levy, *César Chávez*, 235–36.

2. Fred Ross, "El Mosquito Zumbador," May 24–Aug. 30, 1966, Fred Ross Collection; *El Malcriado* 41 (July 28, 1966), 42 (Aug. 11, 1966).

3. Ganz, *Why David Sometimes Wins*, 192, spells Chavarria's name "Cheverria." Taylor, *Chavez*, 199–200, spells it "Chevarria." I have followed Jon Lewis and Dunne, *Delano*, 159–62.

4. Taylor, *Chavez*, 199–201; Levy, *César Chávez*, 234–35.

5. Street, interview with Jon Lewis, May 15, 2007, San Francisco, author's possession.

6. Street, interview with Jon Lewis, May 15, 2007, San Francisco, author's possession.

7. Street, interview with Jon Lewis, Mar. 4, 1981, San Francisco, author's possession; Street, "The FBI's Secret File on César Chávez," 347–84; Scharlin and Villanueva, *Philip Vera Cruz*, 34–36; Del Castillo and Garcia, *César Chávez*, 38–39; Martin, *Promises to Keep: Collective Bargaining in California Agriculture* (Ames:Iowa State University Press, 1996), 86–87. Some sources put the number of farmworkers present at the Guadalupe Church strike vote meeting at 2,700; others say it was no more than 500. For Herschel Nuñez see *El Malcriado* 34 (May 3, 1966).

8. Street, interview with Jon Lewis, Aug. 6, 2008, San Francisco, author's possession.

55. CHAVARRIA

1. Street, interview with Shirley Streshinsky, Aug. 29, 2003, Kensington, California, author's possession; Street, interview with Streshinsky, Aug. 25, 2003, Kensington, California; Kelly St. John, "Ted Streshinsky — noted photojournalist," *San Francisco Chronicle*, Mar. 2, 2003; Majka and Majka, *Farmworkers, Agribusiness, and the State*, 182–84.

2. Dunne, *Delano*, 160–61; Taylor, Chavez, 197; *Los Angeles Times*, July 28, 1966; Street, interview with Jon Lewis, Aug. 6, 2008, San Francisco, author's possession.

3. Street, interview with Jon Lewis, Aug. 6, 2008, San Francisco, author's possession.

4. Street, interviews with Lewis, Aug. 6, 8, 1998, San Francisco, author's possession.

5. This and subsequent parts of the picket line encounters with Chavarria are triangulated from three slightly different recollections. I accomplished this by reading Dunne, *Delano*, 85–86, 161–63, to Lewis and Strashinsky who added, subtracted, verified, and corrected it. In this part of the dialogue, Lewis remembered Chavarria always prefacing the harangue with "hey," a characteristic of his speech. Lewis detested Chavarria and had an especially acute memory of the picket line encounters.

6. Dunne, *Delano*, 161; Street, interview with Jon Lewis, San Francisco, Aug. 6, 2008, author's possession, recalling the promise of beer in the quoted dialogue.

7. The last sentence is from Street, interview with Jon Lewis, Mar. 13, 1982, San Francisco, author's possession. The rest of the dialogue is from the Lewis interview and Dunne, *Delano*, 159, 162.

8. Lewis recalled saying to Chavarria that "you 'make' a good picture." Lewis verified Dunne's account, but added his observations about Chavaria's "double ugliness."

9. Dunne, *Delano*, 162; interview with Jon Lewis, Mar. 13, 1982, San Francisco, author's possession, adding "fat chance" to the exchange.

10. Dunne, *Delano*, 162; interview with Jon Lewis, Mar. 13, 1982, San Francisco, author's possession, recalling "and you are?" during the exchange.

11. Dunne, *Delano*, 162; interview with Jon Lewis, Mar. 13, 1982, San Francisco, author's possession, recalling the comments about the slipping blade and "one less commie" at the end of the exchange.

12. Dunne, *Delano*, 162; interview with Jon Lewis, Mar. 13, 1982, San Francisco, author's possession, recalling a more extensive dialogue with Chavarria using "stink" not "smell" in the dialogue, as well as "stinking", going "downwind," and the "De-Ode-Dore-Ent" anecdote.

13. Street, interview with Jon Lewis, Mar. 13, 1982, San Francisco, author's possession.

14. Dunne, *Delano*, 162; Street, interviews with Jon Lewis, Sept. 6, 8, 1998, San Francisco, author's possession; Street, interview with Ted Streshinsky, Sept. 15, 1998, Kensington, California, author's possession; Street, interview with Fred Ross, Mar. 13, 1979, Mill Valley, California, author's possession.

56. RALLIES

1. Street, interview with Jon Lewis, Mar. 23, 1983, San Francisco, author's possession.

2. Street, interview with Jon Lewis, Aug. 31, 2008, San Francisco, author's possession.

3. "Century of Progress," Archives of Labor History and Urban Affairs, Wayne State University.

57. VOTING

1. *El Malcriado* 42 (Aug. 11, 1966). Not all of the AWOC members were happy with the merger. After NFWA absorbed AWOC and became UFWOC, AWOC leader Ben Gines resigned and denounced Larry Itliong for joining UFWOC. Marcello Thomsi also resigned. Besides their divergent views and personalities, Gines and Thomsi were unhappy over their pay cut. Under AWOC, they had earned $125 per week. Under the UFWOC, they would have to work for striker's benefits. See Scharlin and Villanueva, *Phillip Vera Cruz*, 197.

2. California State Senate, Fact Finding Committee on Agriculture, "Special Report on Farm Labor Disputes" (Sacramento: State Printing Office, 1967), 26, California State Archives; Taylor, *Chavez*, 195–97; Levy, *César Chávez*, 237–38, 244; *Southern California Teamster* 26 no. 35 (Aug. 17, 1966), no. 36 (Aug. 24, 1966).

3. Street, interview with Jon Lewis, May 28, 2008, San Francisco, author's possession.

4. Street, interview with Harry Bernstein, Sept. 26, 1986, Los Angeles, California, author's possession.

5. Street, interview with Jon Lewis, Oct. 3, 2008, San Francisco, author's possession.

6. Street, interview with Jon Lewis, June 12, 2008, San Francisco, author's possession.

7. *Los Angeles Times*, Sept. 1, 1966; Taylor, *Chavez*, 202; Dunne, *Delano*, 166.

8. Street, interview with Jon Lewis, July 14, 2008, San Francisco, author's possession.

9. Street, interview with Jon Lewis, July 15, 2008, San Francisco, author's possession.

58. AUGUST

1. Lewis, Kouns, and Gscheidle were never acknowledged as one of the "originales" who had walked the entire distance from Delano to Sacramento.

2. Street, interview with Jon Lewis, July 29, 2008, San Francisco, author's possession.

3. Dunne, *Delano*, 86; confirmed in Street, interview with Jon Lewis, July 15, 2008; Street, interview with Streshinsky, Aug. 25, 2003.

59. PEOPLE'S

1. Dunne, *Delano*, 95, 160–61.

2. Street, interview with Jon Lewis, Oct. 17, 2008, San Francisco, author's possession.

3. Street, interview with Jon Lewis, Oct. 17, 2008, San Francisco, author's possession, 58, 159–61.

4. When Lowe complained that he could not possibly reduce his show to 60 or 70 images, Stewart and Osborne said, "Let's see hundreds of them. These are too good not to use." Completely redesigning the layout, the architects dramatically expanded the number of images to include two full galleries for a total of 300 to 400 photographs. One wall would hold 16-by-20-inch prints. Another would hold 30-by-40-inch prints. Several long lines of 8-by-10-inch prints would weave between the two walls, providing an environment for the larger pictures. Jack R. McGregor to Lowe, Nov. 5, 1965, Jan. 5, 1966; Lowe to McGregor, Feb. 25, June 29, 1966; Press release, M. H. deYoung Memorial Museum, Sept. 3, 1966, Lowe Collection. Quote from Jack R. McGregor to Ernest Lowe, June 23, 1966; McGregor to Beaumont Newhall, June 23, 1966, Lowe Collection. See also Arthur Bloomfield, "Message of Misery," *San Francisco Examiner*, Sept. 19, 1966; Lowe to Ernest Besig, June 27, 1966; Besig to Public, June 29, 1966, Lowe Collection; Street, interview with Lowe, Mar. 14, 1995. Through no fault of his own, Lowe's photography would remain hidden and suppressed. Nearly forty years would pass before it finally surfaced for public view. Shortly after the exhibition debacle, and in part because of it, Lowe abandoned photography and turned over his entire archive of some 5,000 negatives to the Oakland Museum. Moving on to a career as an environmental consultant, Lowe went about his business believing that the museum was making the material available to scholars and students of farm labor. But lacking space and short on funds, the museum filed the entire collection away in a warehouse, where it sat, unused, unseen, uncataloged, and unknown for more than a generation. After searching for the material over three decades, I tracked down Lowe and contacted museum director Robert Powers, who located the material. Lowe withdrew his collection and placed it with Matt Herron/Take Stock Collection, San Rafael, California. See Street to Lowe, Oct. 8, 1976; Lowe to author, Nov. 15, 1976; Street to Therese Heyman, Dec. 8, 1976, Mar. 5, 1977, July 8, 1982; Street to Powers, Mar. 5, 1995; Drew Johnson to author, June 12, 1998, author's collection. See also Harris, "On Making *Huelga*."

60. DEPARTURE

1. Street, interview with Jon Lewis, Sept. 12, 2008, San Francisco, author's possession.

2. Street, interview with Jon Lewis, Apr. 9, 2006, San Francisco, author's possession.

3. Street, interview with Jon Lewis, Apr. 9, 2006, San Francisco, author's possession.

4. For the collaboration of Kouns and Lewis see Luís Valdéz, "Huelga! Tales of the Delano Revolution," *Ramparts* 5 (July, 1966): 37–50. For photographs at Sierra Vista see AFL-CIO News, Oct. 29, 1966; Ballis, *Basta*, 4; *El Malcriado* 37 (June 2, 1966), 42 (Sept. 12, 1966).

5. Street, interview with Emmon Clarke, Mar. 4, 2001, Rohnert Park, California, author's possession. For Clarke see Street, interview with John Kouns, Mar. 22, 2000, Sausalito, author's possession; Street, interview with Emmon Clarke, Apr. 27, 2001, Rohnert Park, California, author's possession; Doug Adair to author, e-mail, Aug. 1, 2004, author's possession. For a photograph of Emmon Clarke and the *El Malcriado* staff see Folder 5, Anne Draper Collection,

Stanford University Special Collections and Archives. For the atmosphere at Delano during the summer of 1967 see *New York Times*, July 30. For Texas see Ray Robert Leal, "The 1966–1967 South Texas Farm Worker Strike: A Case Study of Farm Worker Powerlessness" (PhD diss., Indiana University, 1983), 280–305.

6. Street, interview with Emmon Clarke, Mar. 4, 2001. See also César Chávez, "The Case Against Perelli-Minetti: An Appeal for Justice," Jan. 19, 1966, and various enclosed materials containing Clarke's photographs, Irwin DeShetler Papers, Archives of Urban and Labor History, Wayne State University.

7. For a layout of Clarke's work see *El Malcriado* 55 (Mar. 1, 1967).

8. Street, interview with Emmon Clarke, Mar. 4, 2001. See also Jenkins, *The Politics of Insurgency*, 163–66; Taylor, *Chavez*, 218–21; London and Anderson, *So Shall Ye Reap*, 173.

61. HOCK

1. Street, interview with Jon Lewis, Aug. 28, 2008, San Francisco, author's possession.

2. *El Malcriado* 38 (June 16, 1966), 42 (Apr. 14, 1967), 45 (Sept. 1966), 59 (Apr. 26, 1967), 60 (May 10, 1967), 61 (May 24, 1967), 63 (June 20, 1967); "UFW Chronology," Sept. 3, 1966; *Valley Labor Citizen* 62 no. 39 (Mar. 24, 1967), no. 41 (Apr. 7, 1967); *San Francisco Chronicle*, Oct. 25, 1966; Levy, *César Chávez*, 258–59; LeRoy Chatfield, "Nick Jones Photos, 1966–1976" and Nick Jones, "Nick Jones, 1966–1976," http://www.farmworkermovement.org. Before his camera was lost or stolen in 1975, Jones shot over 1,500 photographs, many of them documenting the boycott in Boston and Oregon. See also London and Anderson, *So Shall Ye Reap*, 158

3. Street, interview with Jon Lewis, Aug. 27, 2008, San Francisco, author's possession.

4. *El Malcriado* 57 (Mar. 15, 1967), 58 (Apr. 12, 1967).

5. Street, interview with Jon Lewis, Aug. 27, 2008, San Francisco, author's possession.

6. *El Malcriado* 53 (Jan. 13, 1967).

7. "UFW Chronology," Apr. 28, May 11, 1967; *El Malcriado* 60 (May 10, 1967), 61 (May 24, 1967).

8. *El Malcriado* 42 (Apr. 14, 1967); Ganz, *Why David Sometimes Wins*, 227.

9. *El Malcriado* 37 (June 2, 1966), 38 (June 16, 1966), 40 (July 14, 1966), 42 (Aug. 11, 1966), 45 (Sept. 23, 1966), 46 (Oct. 7, 1966), 47 (Oct. 21, 1966), 48 (Nov. 4, 1966) 49 (Nov. 18, 1966), 50 (Dec. 2, 1966), 53 (Jan. 13, 1967), 60 (May 10, 1967); "UFW Chronology," Oct. 2, 16, 27, Nov. 5, 1966; *UFWOC Newsletter*, Jan. 19, 1967; *San Francisco Examiner*, Dec. 4, 18, 1966; *Farm Labor* 5 (Jan. 1967); *Los Angeles Times*, July 25, 1967.

62. GIUMARRA

1. Brown, "United Farm Workers Grape Strike," 134; Taylor, *Chavez*, 38–39; www.giumarra.com; Salvatore J. LaGummia and Frank J. Cavaioli, eds. *Italian American Experience in America: An Encyclopedia* (New York: Taylor and Francis, 2000), 2–3; Hans Palmer, "Italian Immigration and the Development of California Agriculture" (PhD diss., University of California, Berkeley, 1965), 234–41.

2. Ganz, *Why David Sometimes Wins*, 228; Street, interview with Jon Lewis, Mar. 11, 1987, San Francisco, author's possession.

3. LeRoy Chatfield, "Mark Jonathan Harris Photos 1966," http://www.farmworkermovement.org; Bill Esher to Lowe, n.d., Lowe Collection.

63. SCHOOL

1. Janet Marie Yett, "Farm Labor Struggles in California, 1979–1973, in Light of Reinhold Niebuhr's Concepts of Power and Justice" (PhD diss., University of California, Berkeley, Graduate Theological Seminary, 1980).

2. Street, interview with Jon Lewis, Aug. 27, 2008, San Francisco, author's possession.

3. Taylor, *Chavez*, 152.

4. Street, interview with Jon Lewis, Aug. 27, 2008, San Francisco, author's possession.

64. FAST

1. Street, interview with Jon Lewis, Aug. 31, 2008, San Francisco, author's possession; Meister and Loftis, *A Long Time Coming*, 151–55; Majka and Majka, *Farm Workers, Agribusiness, and the State*, 186–87; Ferris and Sandoval, *Fight in the Fields*, 144. Photographing in both color and black and white, Ballis made close-up portraits showing the strain on the face of César Chávez, wide views of the large scene, as well as side-by-side portraits contrasting Kennedy's Irish Catholic face with the Mexican face of Chávez. For press coverage see *San Francisco Examiner*, Mar. 11, 1968; *Fresno Bee*, Mar. 10, 1968 [photographs by Ronald B. Taylor]; reprinted in Taylor, *Chavez*, 221–22; UPI Telephoto HCP1585938, Mar. 10, 1968; UPI Telephoto HCP031031, Mar. 10, 1968. For more on Ballis see Kushner, *Long Road to Delano*, 137, 187. For volunteers see Hub Segur (aka Ojo Negro), "Hub Segur Photos, 1969–1973, 1987–1989," http://www.farmworkermovement.org.

2. Meister and Loftis, *A Long Time Coming*, 151–55; Majka and Majka, *Farm Workers, Agribusiness, and the State*, 186–87.

65. STRANDED

1. Ferris and Sandoval, *Fight in the Fields*, 144.

2. Guthman and Allen, eds., *RFK: Collected Speeches*, 204–6.

3. For press coverage see *San Francisco Examiner*, Mar. 11, 1968; *Fresno Bee*, Mar. 10, 1968 [photographs by Ronald B. Taylor]; reprinted in Taylor, *Chavez*, 221–22; UPI Telephoto HCP1585938, Mar. 10, 1968; UPI Telephoto HCP031031, Mar. 10, 1968.

66. BOOK

1. Street, interview with Jon Lewis, Oct. 20, 2008, San Francisco, author's possession.

2. Ballis, *Basta*.

3. James Agee and Walker Evans, *Let Us Now Praise Famous Men* (New York: Houghton Mifflin, 1941); Paul Taylor and Dorothea Lange, *An American Exodus: A Record of Human Erosion* (New York: Reynold and Hithcock, 1939).

4. Gerhard Gscheidle to author, June 3, 2003, author's possession.

67. VOICE

1. Lewis, *From this Earth*; Street, interview with Jon Lewis, Aug. 31, 2008, author's possession.

2. These quotations have been paraphrased from Lewis, *From This Earth*, i–12.

3. Street, interview with Lionel Steinberg, June 2, 7, 1988, Coachella, California, author's possession.

4. Dick Meister, "From this Earth," *San Francisco Chronicle*, Oct. 5, 1969. Quote from Gerhard Gscheidle to author, June 3, 2003, author's possession. A year later Lewis used his still photographs to produce an eleven-minute film *Nosotros Venceremos!* [We Shall Over-come] (Berkeley, 1969), copies in San Francisco Public Library and Labor Studies Archive, San Francisco State University.

5. Fusco and Horowitz, *La Causa*, 44–45; Fusco to author, Aug. 28, 1998, author's posses-sion; Street, interview with Paul Fusco, Feb. 19, 1980, Mill Valley, author's possession; Tom Moran, *The Photo Essay: Paul Fusco and Will McBride* (New York: Peterson Publishing, 1974), 26, 30; Leroy Chatfield, "Paul Fusco Photos, 1967–1988," http://www.farmworkermovement. org; Meister and Loftis, *Long Time Coming*, x.

68. FILM

1. Street, interviews with Dick Meister, Oct. 22, 2008, San Francisco; Street, interview with Leroy Chatfield, Oct. 26, 2008, Sacramento, author's possession.

2. One of many books using his images is Rodolfo Gonzales, *I Am Joaquin/Yo Soy Joaquin; An Epic Poem* (New York: The Crusade for Justice, 1967), 6.

3. Street, interview with Jon Lewis, Mar. 14, 2008, San Francisco, author's possession.

69. CONTRACT

1. Street, interview with Jon Lewis, Oct. 26, 2008, San Francisco, author's possession.

2. Street, interview with Jon Lewis, Mar. 10, 2008, San Francisco; Street, interview with George Ballis, May 6, 1982, Fresno; Street, interview with Ronald B. Taylor, May 28, 1974, Fresno, California, author's possession.

3. Street, interview with Jon Lewis, Oct. 22, 2008, San Francisco, author's possession.

4. Street, interview with Jon Lewis, Apr. 9, 2006, San Francisco, author's possession. See also Jacques Levy Research Collection on César Chávez, Series I, Audiotape 47, Transcript File 15, Box 5, Folder 141.

5. Meister and Loftis, *Long Time Coming*, x. See also, Street, interview with Sam Kushner, Aug. 7, 1973, Arvin, California, author's possession; "Beyond Peace at Delano," *America* 123 (Aug. 22, 1970): 80; Roy Bongartz, "La Raza in Revolt," *Nation* 210 (July 1, 1970): 664–66; William F. Buckley, "Victory of César Chávez," *National Review* 22 (Sept. 8, 1970): 965; "The Candor That Refreshes," *Time* 96 (Aug. 10, 1970): 59; "César Chávez: La Causa and the Man," *American Labor* 4 (Feb., 1971): 20–30; "Chávez Strikes Again," *Newsweek* 77 (Jan. 25, 1971): 64–65. I have not been able to identify all of the photographers present at the contract signing. In the center was Chris Sanchez. Far right of the table was a *Delano Record* photographer. Also present was George Ballis.

6. Street, interview with Jon Lewis, Aug. 7, 2008, San Francisco, author's possession.

7. Lewis identified the individual as Sal Perata. [sic] I have been unable to track him down. It was one of three such incidents in which Lewis loaned out his images to people who exploited his generosity and rewarded him by failing to carry through with their promise. After the march on Sacramento, Lewis loaned a roll of film to Jude Walinsky [sic], who said he represented an East Coast newspaper. He was leaving in the afternoon and would quickly use the images, then return them with payment. "The big city hustlers and the farm boys," Lewis recalled.

"I never saw the film again." Decades later Lewis saw Walinsky working for Arthur Leffer group, promoting Reaganomics and supply side economics and thought that he had really been a neoconservative, not at all interested in using his work. When he left Delano to return to college, Lewis gave Helen Chávez a box of color slides that he had developed and sealed in their mounts with a hot iron. The whereabouts of the slides remains unknown. I have not been able to verify the spelling of Sal Perata or Jude Walinsky's names. Street, interviews with Jon Lewis, Aug. 31, Sept. 1, Oct. 17, 2008, San Francisco, author's possession.

70. BROKE

1. Street, interview with Jon Lewis, June 2, 2008, author's possession.

2. Bernard Wideman, "Cesar Chavez Hails Philippines Rule," *Washington Post*, July 29, 1977; "Panel Critical of Chavez Visit to Phillipines," *Washington Post*, Sept. 23, 1977; Richard D. Lyons, "Philip [sic] Vera Cruz, 89, Helped to Found Farm Worker Union," *New York Times*, June 16, 1994.

3. Street, "Maggio Strikes Back," *California Farmer*, 265 (Dec. 13, 1986): 6–7, 16–19; Street, "Gutting the Farm Labor Law," *The Nation* 240 (Mar., 23, 1985): 330–32; Philip Martin and Susan Vaupel, "Agricultural Labor Relations in California," in *California Farm Labor Relations*, ed. Walter Fogel (Los Angeles: Institute of Industrial Relations Monograph and Research Series no. 41, 1985), 1–15; Richard Ofshe, "The Social Development of the Synanon Cult: The Managerial Strategy of Organizational Transfomation," *Sociologial Analysis* 41 (1980): 109–27; 67–76; Cheryl Miller, "The UFW: Faded Glory?" *California Journal* 36 (Oct. 1, 2002): 20; Robert Lindsay, "Criticism of Chavez Takes Root in Farm Labor Struggle," *New York Times*, Feb. 7, 1979.

4. Street, "We Are Not Slaves: A Narrative History of California Farmworkers, 1769–1869, Formative Years" (PhD diss., University of Wisconsin, 1995), 30–31; Susan Ferriss, "Fields of Broken Dreams," *San Francisco Examiner Sunday Image Magazine*, July 18, 1993; *Arizona Republic*, Apr. 22–23, June 11, 1993; Jacques Levy, interview with Larry Itliong, Apr. 4, 1969, Jacques Levy Collection, Bienecke Library, Yale University.

5. Frank Bardacke, "Cesar Chavez: The Serpent and the Dove," in *The Human Tradition in California*, ed. Clark Davis and David Igler (Wilmington, DE: Rowan and Littlefield, 2002), 220; also 209–25; Frank Berdache, *Tramping Out the Vintage: Cesar Chavez and the Two Souls of the United Farm Workers* (New York: Verso, 2011; Matt Garcia, *From the Jaws of Victory: The Triumph and Tragedy of Cesar Chavez and the Farm Worker Movement* (Berkeley: University of California Press, 2012; Jeff Coplon, "Cesar's Fall from Grace," *Village Voice* (Aug. 14, 21, 1984); Cletus E. Daniel, "César Chávez and the Unionization of California Farm Workers," in *Labor Leaders in America*, ed. Melvyn Dubofsky and Warren Van Tine (Urbana and Chicago: University of Illinois Press, 1987), 350–82.

6. Miriam Pawal, "UFW: A Broken Contract," *Los Angeles Times*, Jan. 8–11, 2006; Pawal, "Linked Charities Bank on the Chavez Name," *Los Angeles Times*, Jan. 9, 2006; Pawal, "Decisions of Long Ago Shape the Union Today," *Los Angeles Times*, Jan. 10, 2006; "Nuts and Bolts Unionism," *Washington Post*, Jan. 30, 1978; Matt Weiser, "Inside the UFW," *Bakersfield Californian*, May 10–12, 2004; Robert Lindsey, "Union Lettuce Worker Shot Dead in Clash with Nonstriking Pickers: Dispute Involves Wages," *New York Times*, Feb. 12, 1979; Lindsay, "Chavez's Union, Once Fighting to Survive, Senses Victory, Growers Reject Demands," *New*

York Times, Sept. 10, 1979; Lindsay, "Glory Days Are Fading for Chavez and UFW," *New York Times*, June 12, 1987; Lindsay, "Chavez Faces Internal and External Struggles," *New York Times*, Dec. 6, 1981; Lindsay, "Judge Backs 9 Farm Workers Aides Who Were Dismissed by Chavez," *New York Times*, Nov. 19, 1982; Lindsay, "Chavez and Farm Workers Adapt Tactics to the Times," *New York Times*, July 31, 1983; Lindsay, "Glory Days Are Fading for Chavez and the UFW," *New York Times*, Dec. 23, 1984; Carey Goldberg, "Farm Workers Sign Accord with Lettuce Growers, Ending a Long and Bitter Conflict," *New York Times*, May 30, 1996; Steven Greenhouse, "Chavez Son-in-Law Tries to Rebuild Legacy," *New York Times*, June 30, 1997; *Rural Migration News*, Jan. 1, 2002, Jan. 19, 2005; Miriam J. Wells and Don Villarejo, "State Structures and Social Movement Strategies: The Shaping of Farm Labor Protections in California," *Politics and Society* 32 (Sept. 2004): 291–326.

7. Street, "Life in the Canyons: Photographs of San Diego's Shantytown Communities," *Labor's Heritage* 11 (Winter 2001): 36–59; Street, interviews with Pablo Espinoza, June 12, July 17, 2005, May 3, 2006, Woodlake, California, author's possession; Kevin Starr, introduction to Street, *Photographing Farmworkers in California* (Palo Alto: Stanford University Press, 2004), xi–xiv.

71. REDEMPTION

1. David Levi Strauss, *Between the Eyes*, 17.

2. Johnson, ed., *Capturing Light*, ix–x; Katzman, *Photography in California*, 24; Street, "Valley of the Shadow of Death," *San Diego Magazine* 37 (Dec. 1984): 220–29; "With Our Own Eyes," *Network* (California Council for the Humanities) (Aug. 2005): 1, 4–5; Jonathn Cape [Samuel Butler], *Erewhon: or Over the Range* (London: Trubner, 1872).

72. UBIQUITOUS

1. Street, *Everyone Had Cameras*, 143–66, 232–47; Street, "Salinas on Strike: News Photographers and the Salinas Lettuce Packers' Strike of 1936: The First Photo Essay on a California Farm Labour Dispute," *History of Photography* 12 (Apr.–June, 1988): 165–74.

2. "Delano Grower Comments on Strike," *California Farmer* 224 (Jan. 15, 1966): 21.

73. IMPACT

1. Street, "Leonard Nadel's Photo Essay on Bracero Laborers in California," *Center 27: Record of Activities and Research Reports*, June 2006–May 2007, National Gallery of Art, Center for the Advanced Study in the Visual Arts (Washington, DC: National Gallery of Art, 2007), 152–55; Pete Daniel, Marry A. Foresta, Maren Stange, and Sally Stein, *Official Images: New Deal Photography* (Washington, DC: Smithsonian Institution Press, 1987); Jerome D. Prescott, *America at the Crossroads: Great Photographs from the Thirties* (New York: Smithmark, 1995); Roy Emerson Stryker and Nancy Wood, *In This Proud land: America 1935–1943, As Seen in the FSA Photographs* (New York: New York Graphic Society, 1973).

2. Street, interview with Jon Lewis, Nov. 14, 2009, San Francisco, author's possession.

3. Stadt Felbach, *Simple Life: Hansel Mieth/Otto Hansel: Photographs from America, 1929–1971* (Stuttgart, Germany: Verlag Dokumentation, 1991); Andrei Codrescu and Terrence Pitts, *Points of Entry: Reframing America* (Tucson: Museum of Photographic Arts, 1995), 30–50.

74. DECIDE

1. Try Jollimore, "Anatomy of a Meal," review of Michael Pollan, *The Omnivore's Dilemma: A Natural History of Four Meals* (New York: Penguin, 2006), in *San Francisco Chronicle*, Apr. 16, 2006; Steve Allen, *The Ground Is Our Table* (New York: Doubleday, 1966), 30, 43–44. While the 350,000 figure is commonly cited, it is also misleading. Using Social Security and payroll reporting data, California state statistician Dr. Akbar Kahn estimates that there are really about one million farmworkers in the state at peak harvest around Aug. 5. Of those million farmworkers, about one-third are employed at that moment, one-third are unemployed and looking for work, and another one-third are coming off one job and heading to another.

2. Jana Prikryl, "Erosion," *The Nation* 146 (Dec. 12, 2011): 23–32. Howard Chapnick, "Forward," in *Eyes of Time: Photojournalism in America*, ed. Marianne Fulton and Estell Jussim (New York: Little Brown, 1988), iv–vi; Chapnick to author, e-mail, May 12, 1983, author's possession; Errol Morris, *Believing is Seeing* (New York: Penguin Press, 2011).

3. John Tagg, *The Burden of Representation: Essays on Photographies and Histories* (London: MacMillian, 1988); Charles Shindo, *Dust Bowl Migrants in the American Imagination* (New York: Oxford University Press, 2003), 2; John Berger, *About Looking* (New York: Randon House, 1980); Holly Edwards, "Cover to Cover: The Life Cycle if an Image in Contemporary Visual Culture," in *Beautiful Suffering: Photography and the Traffic in Pain*, ed. Mark Reinhardt, Holly Edwards, and Erina Duganne (Chicago: University of Chicago Press, 2007), 75–95.

4. Street, *Everyone Had Cameras*, vii–12; Mark Klett, Kyle Bajakian, William Fox, Michael Marshall, Toshi Ueshina, and Byron Wolfe, *Third Views: Second Sights: A Photographic Survey of the American West* (Santa Fe: University of New Mexico Press, 2004); Robert Dawson and Gray Brechin, *Farewell, Promised Land: Waking from the California Dream* (Berkeley: University of California Press, 1999).

75. PARTING

1. Leroy Chatfield to author, Oct. 20, 12010, e-mail, author's possession.

Index